Makeup Artist Film and Television

In this comprehensive handbook, author, makeup artist, and educator Christine Sciortino offers a detailed introduction to the conceptual foundations, techniques, and on-set practices of the makeup design process, going beyond technique-centered makeup education to provide an in-depth look at the workings of the film and television world.

Through personal stories, interviews, demonstrations, and insights from Sciortino and her colleagues, this book explores the business of makeup artistry, including tailoring a resume, building a kit, self-marketing, breaking down a script, researching and creating makeup looks, working as part of a production team, and different ways to get paid. It further delves into on-set procedures and theory such as anatomy, skin science, color theory, and lighting design. With high-quality step-by-step photo tutorials, this book will help readers to learn and hone techniques for beauty makeup, character makeup, and light special effects including aging and dirtying, grooming, bruises and prosthetics, tattoos, and more. An emphasis is placed on working with actors of all ages, skin tones, and gender identities.

This approachable and engaging blend of practical techniques and professional practice is ideal for both introductory-level and established artists.

An online resource also offers downloadable templates and sample paperwork for on-set use and practice.

Christine Sciortino is a Chicago-based makeup artist and visual storyteller with recent projects including *Come As You Are, Captive State, Proven Innocent* (Fox), and *Fargo* (FX). As a member of the IATSE Local #476 Studio Mechanics Union, she designed and leads the Local's first Sexual Harassment training program, making our film sets safer spaces. She also created and instructs the Cinema Makeup curriculum in the school of Cinema and Television Arts at Columbia College Chicago where she has the joy of educating the next generation of filmmakers.

Makeup Artistry for Film and Television

Your Tools for Success On-Set and Behind-the-Scenes

Written by Christine Sciortino

Photographed by Tony Santiago

Routledge
Taylor & Francis Group
NEW YORK AND LONDON

First published 2021
by Routledge
52 Vanderbilt Avenue, New York, NY 10017

and by Routledge
2 Park Square, Milton Park, Abingdon, Oxon, OX14 4RN

Routledge is an imprint of the Taylor & Francis Group, an informa business

© 2021 Taylor & Francis

The right of Christine Sciortino to be identified as author of this work has been asserted by her in accordance with sections 77 and 78 of the Copyright, Designs and Patents Act 1988.

All rights reserved. No part of this book may be reprinted or reproduced or utilised in any form or by any electronic, mechanical, or other means, now known or hereafter invented, including photocopying and recording, or in any information storage or retrieval system, without permission in writing from the publishers.

Trademark notice: Product or corporate names may be trademarks or registered trademarks, and are used only for identification and explanation without intent to infringe.

Library of Congress Cataloging-in-Publication Data
Names: Sciortino, Christine, author. | Santiago, Tony (Antonio), photographer.
Title: Makeup artistry for film and television : your tools for success on-set and behind-the-scenes / written by Christine Sciortino ; photographed by Tony Santiago.
Description: New York, NY : Routledge, 2021. | Includes bibliographical references and index. | Identifiers: LCCN 2020017340 (print) | LCCN 2020017341 (ebook) | ISBN 9780367205386 (hardback) | ISBN 9780367205393 (paperback) | ISBN 9780429262104 (ebook)
Subjects: LCSH: Film makeup--Handbooks, manuals, etc. | Television makeup--Handbooks, manuals, etc.
Classification: LCC PN1995.9.M25 S35 2021 (print) | LCC PN1995.9.M25 (ebook) | DDC 791.4302/7--dc23
LC record available at https://lccn.loc.gov/2020017340
LC ebook record available at https://lccn.loc.gov/2020017341

ISBN: 978-0-367-20538-6 (hbk)
ISBN: 978-0-367-20539-3 (pbk)
ISBN: 978-0-429-26210-4 (ebk)

Typeset in Garamond
by KnowledgeWorks Global Ltd.

Visit the eResources: www.routledge.com/9780367205393

For my Cinema Makeup students - your questions were the blueprint for this book. Your enthusiasm and creativity never cease to inspire me.

Contents

Acknowledgements — xiii
Introduction — xv

Section I Behind the Scenes — 1

Chapter One Getting the Job — 2

Résumés — 3
 What Do You Need in Your Film and Television Résumé? — 3
Social Media/Web Content — 7
Marketing and Networking — 9
Your Best Interview — 12
Contracts and Deal Memos — 15

Chapter Two Pre-Production — 18

Your Work — 19
 How to Read a Script — 19
 Script Breakdowns — 22
 Research/Design — 27
 Mood Boards — 32
 Meetings/Actor Contacts — 34
 Test Shoots — 38
 Budgets — 39
 Setting Up Your Binder — 43
Production Documents — 44
 Scripts and Script Revisions — 44
 Stripboard — 45
 Day-Out-of-Days — 48
 Call Sheets — 51

CHAPTER THREE	Production	60
	Who's Who in the Makeup Department	61
	Assistant	61
	Day Player	61
	Makeup Artist	62
	Key Makeup Artist	63
	Department Head	63
	Attire	64
	Your Station and Sanitation	66
	How to Sanitize Everything in Your Kit	69
	Working in Trailers and Out of Actor Bags	74
	What You Need in Your Kit	76
	Set Etiquette	79
	Last Looks	86
	Continuity	87
	Face Charts	90
CHAPTER FOUR	Wrap	94
	Invoices and Timecards	95
	Wrap Procedures	99

SECTION II Theory 101

CHAPTER FIVE	Color Theory *by Christine Sciortino with Katie Middleton*	102
	The Basic Color Wheel	103
	Undertones	107
	Color Relationships and Makeup Design	108
CHAPTER SIX	Lighting *by Tony Santiago*	112
	Commonly Used Types of Lights	114
	Tungsten Lights	114
	Artificial Daylight Sources	114
	Fluorescent Lights	114
	LEDs	114

	Lighting Design	115
	Placement	115
	Color	117
	Quality	119
	Quantity	120
	The Lighting Department	120
CHAPTER SEVEN	Camera	122
	Motion Picture Cameras *by Tony Santiago*	123
	Camera Technology *by Tony Santiago*	124
	Manufacturers	124
	Lenses	125
	High Definition (HD)	125
	Camera Setups	126
	Camera Movement by Tony Santiago	126
	Types of Shots by Tom Ciciura	127
	Additional Camera Department Terminology *by Tom Ciciura*	128
	Camera Department Prep and Test Shoots *by Tony Santiago*	129
	Camera Department and Makeup Department Collaboration *by Tom Ciciura*	129
CHAPTER EIGHT	Anatomy	132
	The Skeleton	135
	The Muscles	138
	The Blood	142
	Injuries and Illness	143
CHAPTER NINE	Skin	146
	Skin Science Basics	147
	Consultations	149
	Skin Types	151
	Acne-Prone Skin	151
	Sensitive Skin	153
	Oily Skin	153
	Dry Skin	154

	Normal Skin	154
	Combination Skin	155
	Skin Disorders, Markings, and Conditions	155
	Striae Distensae ("Stretch Marks")	155
	Vitiligo	155
	Melasma	156
	Eczema	156
	Cold Sores	156
	Psoriasis	157
	Rosacea	157
	Contact Allergies	157
	Sunscreen allergies	158
	Skin Tones	159
	Skin and Age	162
	Additional Skincare Considerations	165
	Shaving	165
	Sun/Weather Protection	166

SECTION III Technique 169

CHAPTER TEN	HD "No-Makeup" Makeup	172
	Shade Matching	173
	Reducing Shine	176
	Color Correcting	178
	Basic HD Makeup on Children	179
	Considerations for HD Makeup on Aging Skin	180
CHAPTER ELEVEN	Grooming	184
	Shaping Facial Hair	185
	Clean-Shaven	186
	Mustaches	190
	Stubble or Scruff, Up To Ten-Days' Growth	190
	Beards (Groomed)	192
	Beards (Natural)	193
	Additional Grooming	194
	Skin Care	195

CHAPTER TWELVE	Beauty Makeup	198
	Beauty Makeup I: Focus on Correcting Imperfections and Creating symmetry	199
	Beauty Makeup II: Focus on Contouring and Highlighting of Features	206
	Adding Drama to the Face	211
	Lips	211
	False Lashes	212
	Individual Lashes	213
	Strip Lashes	214
	Winged Liner	215
CHAPTER THIRTEEN	"Out-of-Kit" Special Effects	216
	Bloody Nose	218
	Black Eye	220
	Split Lip	221
	Bloody Knuckles	222
	Road Rash	223
CHAPTER FOURTEEN	Burns	226
	Gelatin Burns *by Christopher Payne*	227
	Silicone Burns *by Christine Sciortino*	232
CHAPTER FIFTEEN	Applying pre-made prosthetics	238
	Encapsulated Silicone Prosthetics	239
	Pros-Aide Transfers	242
CHAPTER SIXTEEN	Age Makeup	248
	Paint-Only *by Rochelle Uribe-Davila*	249
	Stretch-and-Stipple *by Dina Cimarusti*	252
	Prosthetics *by Christopher Payne*	255
CHAPTER SEVENTEEN	Applying Facial Hair	258
	Lace Facial Hair Pieces	259
	Hand-Laid Hair	262
CHAPTER EIGHTEEN	Dirt and Sweat	266
	Dirt	267
	Sweat	270

CHAPTER NINETEEN	Additional Character Design Techniques	272
	Covering Tattoos	274
	Adding Tattoos	279
	Nails	283
	Basic Manicure	284
	Teeth	286
	Eyes and Contact Lenses	288
	Working with Contact Lenses as Part of Character Design by Kimberly Boundas and Christine Sciortino	291
	On-Set Protocol	292
	Conclusion	294
	Appendices	
	A Note on Harassment	298
	Glossary of Common On-Set Terminology and Slang	302
	Other Positions On Set and What They Do	304
	Where To Buy Products	310
	Contributors	314
	Photo Credits	317
	Works Cited	320
	Index	321

Acknowledgements

Tony – "Thank you" doesn't even cut it. The photo tutorials included here are top-notch because of you, and your knowledge in the "Theory" section adds so much to this book as a film education resource. You are a passionate, patient, and inspiring co-teacher. I'm so grateful.

Chris – Thank you for encouraging me to write this book from the beginning and for your incredible expert contributions to it.

This book's many amazing contributors: Katie, Rochelle, Dina, RoseMary, Tom, Anthony, Anna, Kim, Robin, Jon, Linda, Joanna, Ken, Kelli, Nick, and Mike – Your knowledge included here is invaluable and offers great insights across all facets of the film and TV industry. I'm lucky to call you my collaborators.

Our photoshoot assistants: Charlie, Karena, Julia, and Bre –You rock. Thank you for your time and effort.

Our models: Ashley, Bre, Casey, Christian, Jorge, Miguel, Natasha, Patrick, and Paul – Thank you for donating your time and talents to makeup education. You all look perfect.

Lola – You were an enormous help in so many ways, especially at the 11th hour! Thank you for your hard work, your organizational skills, your excellent writing, and overall dedication to helping complete this project.

Simon Jacobs – Thank you for bringing this book along in its conception.

Alyssa Turner – Thank you for keeping me on-time and organized.

Rob Benevides – Thank you for taking me under your expert wing starting in 2009 at NYU and convincing me that makeup artistry was a real career and not just a pipe-dream.

All the department heads, designers, and key makeup artists who have hired me since I started out – THANK YOU! I deeply appreciate all the opportunities and tutelage.

My brother Paul – Thank you for being my longest running hair and makeup model; starting in your infancy and all the way through this book!

Mom + Dad – Thank you for making sure I had the skills and knowledge I needed to be successful.

Aimée – Thank you for nurturing my creativity early on.

Karuna – Thank you for helping me stay aligned as I finished this book amidst chaos and life transition.

Big – Thank you for welcoming the Cinema Makeup curriculum into your program and offering me the opportunity to lead it.

My Columbia College Chicago Cinema Makeup students (past and present) – Your excitement, your interests, and your educational needs inspired this book. I learn just as much from you as I hope you do from me.

Introduction

Welcome to the invigorating world of makeup artistry for film and television! In this book, I aim to set you up with the practical knowledge and the techniques that you will need to succeed in this exciting career.

In the first section, we will explore how to break into the industry through networking and self-marketing. Once you have obtained your first film or TV job, you will need to know how to prep and plan before the shoot begins, designing characters step-by-step based on the script. We will cover these behind-the-scenes skills, along with how to behave on set, and how to finish or "wrap" a project.

Section II delves into different foundational theory you will need in your work as a makeup artist – knowing how to work with the body and the skin, the basics of color theory, and the fundamentals of camera and lighting are all invaluable as you progress in your career.

The third and final section contains photo tutorials of techniques commonly used on film and television sets. Through this section, myself and several wildly talented makeup artist friends of mine will show you our own favorite tricks for basic skills you can add to your makeup artistry repertoire.

I have had incredible support in creating this book – with knowledge included from other educators and makeup artists, as well as crew members from all different areas of the film and television world, and even product developers. I hope you find these expert contributions as valuable as I do. Throughout the text I will also recommend to you my favorite resources for further study.

With all that being said, I do not consider this a "beauty industry" book because I am not really here to promote the idea of the beauty industry. I invite you to suspend any notions of having someone sit in your chair and you magically making them look "better" as well as any conception that you yourself must appear a specific way to make this your career.

Beauty is not something we paint on with products. The job of the film and TV makeup artist is not simply using cosmetics to make someone look more in accordance with societal standards. Beauty is inherent in our consciousness. It is all around us and within us – it's not only the qualities we were taught are beautiful. Many of us learned symmetry is beautiful, that harmonious colors are beautiful, that blemish-free skin is beautiful. I'm going to debunk that. I'm here to say that scars are beautiful, that vomiting is beautiful, that dirt under the nails is beautiful. Because true beauty is in our human experience at all moments. Each one of us is already perfect in

our imperfection, just for the fact that we exist as part of this world. We do not need to pluck that one last stray eyebrow hair to be worthy of love, happiness, or success.

As makeup artists for film and television, we are in service of the entire human condition. We create characters in order to tell their authentic stories – the stories of the humans and creatures who have come before us, those who co-exist with us now, and those who could or will exist in another timeline or land. Our job is so wildly exciting because we have the honor of telling these stories.

With designs based on the script, you will be channeling the lives of the characters and transforming your actors into them. The work comes with incredible creativity and responsibility as well. The choices of the makeup artist must always serve the narrative.

I can tell you how to create these looks, how to read the scripts, and offer tips for building your business and navigating logistics such as unions and invoices. But I cannot give you a magic pill that will make you rich and famous in three years. Ultimately, all the success will flow through you: the artist. There is art around us at every moment. You will work long days on your feet in sometimes extreme weather or conditions but if you are enjoying your storytelling, if this work is flowing through your soul, it will be worth it and you will flourish in the industry.

If your heart has brought you to this book and to this career path, I am cheering you on with gratitude for the opportunity to support you. I hope that this text gives you knowledge and skills that will empower you – both as a makeup artist and as a human with their own story to tell.

SECTION I

Behind the Scenes

Getting the Job

In This Chapter

- **Résumés**
- **Social Media/Web Content**
- **Marketing and Networking**
- **Your Best Interview**
- **Contracts and Deal Memos**

Résumés

So you would like to become a makeup artist for film and television? Great choice! You may have had people in your life tell you that this is a pipe dream and that you should pick something more "practical." I'm here to tell you that this is not just a dream! It is a real career in which you can make real money. Sure, it may be less "traditional" than some career paths, but there *is* still a path you can follow to make it happen. Even if you don't go to makeup school, there are countless resources you can use to learn makeup techniques, including books (I'll share my favorites in Section III) and some online videos. But how do you monetize it? In this text I am going to do my best to illuminate the behind-the-scenes and the business aspects of this exciting industry.

To become a film and television makeup artist, you can practice all the technique you want – you've still got to *get the job*. What is the classic tool we've all learned about in school for getting jobs? Your résumé! Of course a film and television **résumé** will be different than a résumé created for other industries.

What Do You Need in Your Film and Television Résumé?

- **Your Name**

 If you have a specific name that you would like listed in the credits of films you work on, this should also be the name on your résumé.

- **Your Online Portfolio**

 I suggest having a website as opposed to using social media to display photos and videos of your work. We will discuss this in the next section. Whatever format you use, the link to this online portfolio should be clearly written on your résumé.

- **Your Contact Information**

 I personally do not believe mailing addresses are necessary on résumés anymore. This is a hold-over from a time in which employers might have sent you a letter in the mail to notify you whether or not you got a job. You will most likely receive a call on your cell phone so the best phone number for you should be clearly visible. I also suggest an

email address that is professional. If you are currently a student, it will behoove you *not* to use your student email address, but to get an account on a common email server that has your name in the address. You won't be a student forever, and you don't want to have to notify your clients of a change of email address in two years and risk losing some clients.

- **Your Relevant Work Experience**

 This may be the most challenging section to create on your résumé, because anything can be relevant. If you have worked in Hair/Makeup Departments for films in the past you would of course want to include that experience. If by chance you have worked in other departments on set, that is also applicable because it helped you learn the on-set workflow and etiquette. If you have worked in many different departments on set, I do not suggest listing all of them – it gives the impression that you can't commit, or are not specialized. One or two is okay. Work as a beauty professional in another venue, such as in a salon or a cosmetics line, is great to include. Now let's say you have no work experience in film or beauty but you have done some training and you want to career change. Your previous work experience can still be included in your résumé – you will simply want to make sure you describe it in such a way that connects to your future career in film and television. For example, I used to work as a hostess at a restaurant – great experience developing charisma, patience, and working with all different types of people! A retail job? That's basically character design if you swing it a certain way! A medical professional? You are accustomed to taking care of people, as well as long shifts on your feet. Anything can be relevant experience.

- **Your Education**

 Your education information should include the school of your highest level of education, your major or concentration, and if you graduated with any honors or awards. *You do not need your GPA on a film industry résumé.* It is simply not relevant. If your highest level of standard education is high school, your high school should be listed with the year you graduated. If you went to college, you do not need to list your high school as it is implied that you had to finish high school to get into college. If you went to graduate school or a relevant vocational school (such as Cosmetology school or Makeup school) list those institutions and when you graduated or received a license. If you went to an *unrelated* continuing education program such as real estate training, or nursing school, I do not believe this is relevant to have on your résumé. However, if you have been a nurse for ten years and are now changing career, you might want to include that education *and* a note in your cover letter or introductory email that you are now embarking on a new career.

- **Any Special Certification or Training**

 Outside of your education, you may have received special training like weekend workshops or tutoring from a makeup master. You might also have

received a certification in another beauty procedure such as eyebrow threading or eyelash tinting. These experiences should absolutely be on your résumé as they have contributed to a skill set that makes you marketable. If you have accumulated a lot of these trainings, you may even have a section for "Training and Certifications" on the résumé.

I was once told that people reviewing résumés for hiring will look at your résumé for an average of six seconds. Therefore, you have a very short amount of time to impress them! As you can probably imagine, attention to detail is incredibly important as makeup artist. It is a visual and artistic job. So when I review résumés for artists who want to work for me, one of the first things I look for is the consistency. You can have training from a prestigious makeup or film school … but if you have spelling, grammar, and formatting errors in your résumé, I get the impression that you don't truly value your work. Why would I want to hire someone who doesn't pay attention? Why would I want to hire someone who doesn't care about how things *look?* Spell-check and proofread your résumés repeatedly before sending them out. Then, get a second opinion from someone you trust – they may point out errors you have not noticed. Here are a few of my pet peeves that I see in résumés:

- **Having Words That Are Formatted One Way In One Section of the Résumé, and Another Way Someplace Else**

> **" A flat container with several different types or shades of makeup laid out in it is called a palette.** This is also what a painter mixes their colors on. A **'pallet'** is a large piece of wood used for transporting things and is often used in construction. And the roof of your mouth is called the **'palate.' "**

Are you sometimes writing "Makeup Artist," with capitals on the titles, and then "makeup artist," lowercase somewhere else? To me, nothing indicates a lack of attention more than mistakes like this. If you are not a native English speaker and are prone to making grammatical errors, I do not hold anything against this. What bothers me is a *lack of consistency.* Whatever you are writing,

Getting the Job 5

even if it is technically "wrong," by the rules of English grammar, just *write it the same every time.* Commit!

- **Using the Wrong Form of Makeup-Related Words**

I'll say it once and never again – a flat container with several different types or shades of makeup laid out in it is called a **palette**. This is also what a painter mixes their colors on. A *"pallet"* is a large piece of wood used for transporting things and is often used in construction. And the roof of your mouth is called the *"palate."* Again, even if you are not a native English speaker, you probably have access to the Internet and I like to see that my artists have taken time to do their research.

Feel free to look up any and every word that you have a question about, especially ones that relate to makeup.

- **Inconsistent Spacing**

When done properly, formatting and spacing will make your résumé attractive and easy to read. It goes relatively unnoticed, as the viewer may just subconsciously think "this résumé looks nice." Poor formatting, however, sticks out like a sore thumb. I might instantly toss a résumé to the side and stop considering someone without even reading the words of the résumé if it looks messy and difficult to read. Mistakes I see often look like this:

Boutique Down the Street January 2011 – September 2012
 Sales Associate
Local Makeup Store December 2012 – June 2015
 Makeup Artist
A Theater in My Town July 2015 – Present
 Makeup Supervisor

Feels clumsy and difficult to read, right? Templates and tables can be excellent for avoiding this kind of formatting error. Plus, poof-reading to make sure all your spacing, tabs and hyphens have the same amount of space before and after can go a long way. The corrected résumé might look like this with geometric and consistent spacing:

Boutique Down the Street January 2011 – September 2012
 Sales Associate
Local Makeup Store December 2012 – June 2015
 Makeup Artist
A Theater in My Town July 2015 – Present
 Makeup Supervisor

- **Hyphens Instead of Bullet Points**

Regardless of what program you are using to create your résumé, find out how to create and format bullet points rather than using a hyphen or dash "-" to make a list. It just looks more professional. Most software now offers résumé templates or you may be able to download a résumé template online if you are

> **I was once told that people reviewing résumés for hiring will look at your résumé for an average of six seconds.**

looking for something unique. In my opinion, there is no shame at all in using a pre-made template. Even if the reviewer has seen the template before, it will still look better to them than a complete mess.

- **Redundancy**

 You are a creative person, right? Why say the same thing repeatedly? When I make a résumé, I strive to never use the same verb or adjective twice. Why say, "Did makeup for this student film," over and over and over and over? Boring! Instead, you could say "Designed and implemented creative character looks on-set of three thesis-level films at The Name of My School." The more "active verbs" you can employ in your résumé, the better, for the simple reason that it just makes you sound more interesting.

Active verbs for résumés might include:

(Adapted from the University of Houston Bauer-Rockwell Career Center)

Accomplished	Facilitated	Performed
Achieved	Founded	Planned
Activated	Guided	Prepared
Addressed	Handled	Processed
Arranged	Illustrated	Provided
Attained	Implemented	Researched
Authored	Increased	Revamped
Collected	Initiated	Revised
Coordinated	Launched	Scheduled
Conducted	Managed	Selected
Created	Mastered	Simplified
Delivered	Mediated	Staged
Designed	Modeled	Streamlined
Established	Monitored	Supported
Examined	Motivated	Trained
Executed	Negotiated	Updated
Expanded	Originated	Visualized

Social Media/Web Content

When I first started out doing makeup, I carried a hard-copy portfolio to interviews. It was a large, heavy black leather book in which I would put photos of my work and some of my design drawings and face charts. I would cringe while at the printer's when they told me the price to print each high-quality photo, but I would sigh and cough it up because having those images *could* help me get my next job. In the interview, usually at a centrally-located coffee shop somewhere, I would wait nervously across the table as the Designer or Department Head flipped through the pages of my "book." While physical portfolios are still used in some departments and some industries, they are much less common 14 years later. Most people in the film industry now expect instant access to digital images of your work that they can access from the comfort of their own homes any time of day or night. Thanks to email, the workday simply never stops.

I suggest having an **online portfolio** that has your name somehow in the web address. If you can include your full name or your company/brand name, that's great. There are many services now that offer templates to build professional-looking websites that do not cost much to host per year. To me, it is worth it to use a service like this. In the past you may have had to pay a web designer with a background in computer science to build the website for you. The problem with this is that you have to contact them, wait for them, and

pay them every time you want to add a new photo or a project to the site. Maintaining your own site might come with a bit of a learning curve in the beginning, but it will make your life a lot easier in the long run!

You can divide different types of makeup into different categories on your site. For example, my website currently includes slideshow galleries for "Beauty," "Grooming," (the standard term for light makeup and facial hair trimming/styling) "Special Effects/Character Makeup," and "Commercial" (which includes videos of commercials I have done makeup for). Of course, you will find the categorical system that works for you.

On your site, it is also beneficial to feature your résumé, and a section with a brief and engaging biography of you. Do not forget a page with your contact information or a specific contact form where people can email you directly through the website. You want to get hired!

When you are first beginning to build your portfolio, focus on variety. Practice your skills on as many people as possible – especially ones who do not look like you. It can be tough at first working with a skin tone that is unlike yours or someone who is a lot older or younger than you. You might make mistakes, but there's no harm in that because makeup washes off! Ultimately, it will be worth it when you can confidently work on any single person who sits in your chair. Once you are happy with a look, you can even take photos of it yourself – on a neutral background and with a good source of light – and use those in your online portfolio.

In the past few years, social media has become an important part of just about any industry and I will not discredit its importance. Having a social media presence can help you with networking and you can use it to learn from artists around the globe. Your local market might have private Facebook groups where artists can be in communication about tips, questions, and jobs they need help with. There are plenty of companies to help you grow your social media "brand," and even apps that can tell you what time of day to post. With that being said, I can tell you that most Department Heads or Producers still view social media as an unprofessional way to showcase your work as far as getting hired on a film or television show. For one thing, the person doing the hiring may not have any social media accounts. Secondly, there are tons of incredibly talented artists who have huge followings on social media and YouTube – and maintaining these outlets requires a large portion of their time, if not their *full* time. Unfortunately, however, there are also some artists or aspiring artists out there who may be using products that are not professional-film-standard products, or who may not be using proper sanitation methods, etc. For that reason, I see a bit of an unspoken division between artists who focus mainly on social media vs. artists who work in TV and film – for better or for worse. A Department Head may not view your Instagram, Facebook, or YouTube channel as a professional outlet because they may not really know the quality of your work. Another reason for this is because many artists with social media followings do a lot of the work on themselves. This work is often

creative, detailed, and truly incredible – but it doesn't mean the person can do makeup on someone of any age, any gender identity, any skin tone or texture. When I hire a team, I look for a large variety of work in their portfolios.

Additionally, artists who do work full time in television and film may sometimes struggle to even maintain a social media presence! For one thing, during a 15-hour day, you will not have a lot of time to be on your phone posting well-lit photos of your own makeup. If you have woken up at 3:00am to get to set, or are working late until 3:00am (both of which are completely plausible options) you may not even have much makeup on at all! If you do, it might be a "hot mess," after the first couple of hours of the day. Another factor that poses difficulty for film and TV artists is the **non-disclosure agreement**. Many productions do not want anything about the story revealed before the release of the content – *if* they want anything revealed at all. You may need to keep your work a complete secret. In the instance of feature films, this may last years, until the film is edited and released in theaters. So if you have been working consistently on a project, you may not even really have any content to post unless you are doing photoshoots on the weekends or putting makeup on yourself with a beautiful light done in the middle of the night. If that's the case – more power to you! Chances are, however, most nights and most weekends, you'll probably just want to sleep. It may be worth it for you to do photoshoots and practice makeup on yourself when you are not working on a project, and then you can post them gradually throughout the times when you are busy on set.

If you do intend to build a social media presence, it may be beneficial to have two separate profiles – a professional and a personal account. On your personal account you will feel more free to post photos of your food or of your loved ones and maybe you want to use that page to connect with a more intimate group of people – your friends and family. Your professional page could host more photos of your work and you could also use it to follow other makeup artists or brands. This may help you in the long run, especially if you are working on a film and a cosmetics brand offers you product sponsorship. It is both courteous, and conventional, to post something about the product and a message of gratitude to the company. You are getting help for the film, the brand is getting a little bit of advertising, and if there are products you really love, you are helping your followers learn about them with product reviews: a win-win-win situation!

Marketing and Networking

You will quickly come to learn that our industry has an informal networking vibe – with a ton of unwritten rules under the surface. As you begin your career as a freelancer, you are not only selling your skill – you are, in a way, selling yourself. You must be professional, likeable, humble, hardworking, and always open to learning. Confident, but not egotistical. Kind, but

not a pushover. It can be a delicate balance. The film communities of most cities are small and even in the large markets, there are different niches and everyone is connected by only a few degrees of separation. The early impressions you make are crucial.

First, you will want a great branding strategy with a sleek online portfolio, a well-done résumé, and a professional social media presence. You may consider having some headshots taken for different websites such as LinkedIn or IMDb, or you may consider having a logo designed for your makeup artistry brand.

Although social media and technology are ubiquitous now, I am a firm believer in the idea that the good old-fashioned business card will never die. Business cards are an efficient and inexpensive way to make yourself memorable. Many websites have templates you can use to design and order your business cards and most services allow you to upload your own images so you can include your logo or a photo of your work. You will also want to include the following information:

- The name you will use for working or crediting
- Your cell phone number – so you can be hired for a job quickly!
- Your email address – remember, something recognizable and professional
- The link to your online portfolio
- Your professional social media profile(s) if applicable

The basic gesture of handing someone a business card creates a connection between you and a prospective employer. Having them on you gives you an air of professionalism and preparedness that sends a great subliminal message. Of course, they will be able to check out your work and contact you without the awkwardness of giving them your number or spelling out your Instagram handle and waiting while they try to find you. You can hand over the business card and simply say, "I'd love to work with you! All the information to check out my work and contact me is on my card!"

This style of in-person networking can be challenging at first. You may be nervous about attending a networking event and self-promoting. You have to be careful about coming on too strong but, at the same time, you want to create friendly working relationships with potential colleagues.

A great way to start is to use the Internet to find physical locations where other makeup artists will be. One option is to look on Facebook or other meet-up websites for makeup artist groups in your area. These groups often host networking events, classes, and nights out. You can also get involved by attending tradeshows such as IMATs, The Makeup Show, or America's Beauty Show. Trade shows have lots of educational opportunities and often do have fundraising events or parties throughout the show. You will be surrounded by other makeup artists at these events, and do not be afraid to strike up a conversation!

Film festivals are another great way to connect with other filmmakers. Tickets for film festival screenings are typically available to the public, and you may be able to attend industry networking events after the

screening or at other times during the festival. Search online for film festivals near you.

If you are just starting out, honesty is the way to go. It is totally acceptable to say something like "I just finished makeup school and I am really looking to get involved in the industry – I'm so excited to be here!" You won't be directly asking for advice or asking for a job opportunity, but you are starting the conversation and leaving it open-ended so the other artist can ask you questions. When I first moved from New York to Chicago, I went to every event I could find and honestly told people I had just changed markets and I didn't know anyone. So many artists were happy to help me by asking me to assist them, to cover jobs they couldn't do, and by offering advice. Of course, you will always have the edge of competition and not everyone will be warm and fuzzy. If that's the case, just move on. I'm still great friends with many of the artists who first helped me out in Chicago, as well as with many artists in Los Angeles, New York, and other cities who I have worked with in the past. Our departments sometimes involve many people and Department Heads need good artists they can rely on. Even if you don't become best friends with some artists, that's okay – they may still recommend you for jobs they can't do because it looks good for them to recommend someone who is talented and respectful.

If you meet someone you feel like you really click with, you will of course give them your business card before saying goodbye so you can continue to stay in touch and they can contact you if they ever need someone.

What if you can't find an in-person event, but you know of some makeup artists in your area and you would like to connect with them? I have had emerging artists email me directly through the contact page on my website to send me their résumés for consideration. I think this is a great way to connect! As long as your message is professional and not invasive to their privacy, you may actually get a great job or meet a great mentor. Keep your email brief, but include a little bit about how you found their information, your background in makeup (work and education), and your website. Attach your résumé, and let them know "I've attached my résumé for you to keep on file. Thank you so much for your consideration!" Even if they do not have a job they need someone for right at the moment, even if they completely ignore your email (which they might), as long as you have attached your résumé, you have a good chance of staying in the back of that artist's mind. Maybe eight months from now

Everyone who you view as "established" in the industry, whether that's an artist who is well-respected for their work doing bridal makeup in your town, or a famous Hollywood makeup designer, had to start somewhere.

they need an assistant for something small, none of their regular assistants are available, and they'll say "Oh, there was that one person who emailed me!" In this case, you are helping them out big time!

Everyone who you view as "established" in the industry, whether that's an artist who is well-respected for their work doing bridal makeup in your town, or a famous Hollywood makeup designer, had to start somewhere. If you keep a positive attitude, you will make some great connections and as you move further along in your career, you will be able to help future emerging artists too!

Your Best Interview

Once you have your professional self-marketing materials and you have begun to put your name out there, the hope is that other makeup artists or producers of productions will start to hire you. This is always an exciting time but it can be scary too. Just like in networking, you want to make a good first impression, but if you are called in for an interview, the setting will be more formal.

When preparing for your interview, make sure you keep in mind this one fact: it is natural to be nervous. If you are nervous, don't beat yourself up – just accept your nervousness and imagine yourself channeling it into creativity. Nervousness often comes from self-doubt and unfortunately, if you enter an interview believing that you *may not* be the best person for the job, the interviewer will usually

> **"There is a good chance you will never know everything, and no matter how long you have been in the business, you can always learn from fellow artists."**

leave thinking the same thing. The best strategy here is to familiarize yourself with the project and the position ahead of time by doing a little research. Then, try to anticipate which of your skills you would need for the project. Imagine yourself performing these tasks to the best of your ability and succeeding. Enter the interview mentally holding the truth that you *can* do this! If there are skills that you don't possess at the moment, be honest about this. You can emphasize your eagerness to learn and your ability to take direction. I believe those are the most important qualities to have when just starting out. There is a good chance you will never know *everything,* and no matter how long you have been in the business, you can always learn from fellow artists.

In addition to your mental preparation, your physical preparation is important in making the best

possible impression. As a beauty industry professional, you will want to make sure your personal hygiene is always on-point. Take care of your grooming and avoid any strong fragrances. You will be in close proximity to other people and just as smelling strongly of body odor, cigarettes, or fried food can be off-putting to some people, so can the strong fragrance of lotions or perfumes. I opt for something natural and subtle when it comes to fragrances – that's not to say you shouldn't wear whatever you want when you are not working, but keep in mind that when you are, some people are more sensitive to smells than others.

I personally don't think adhering to any specific hairstyle is necessary as long as your hair is clean and it looks like you put a little bit of thought into it. The last thing you want to do is show up for an interview looking like you just rolled out of bed. When it comes to makeup, I believe natural is better – as long as it is expertly applied. Express your signature style of course, but do keep in mind that when you get on set you will be working very long hours in sometimes extreme weather conditions. Showing up to an interview – or work – with false eyelashes, fake nails, and extravagant lipstick on can send the impression that you don't take the job seriously. The film industry is not glamorous! So you should look nice, professional, and look like *you* but try not to look fake when you go to your interview.

Pick clothes that are true to your style and professional-looking. Again, this does not mean you have to wear a business suit that you might wear to an office – just an outfit that sends the impression that you take this job seriously. When I am hiring prospective team members, I get the wrong impression if someone is showing a lot of skin – regardless of their gender. This is not even necessarily because of the sexual connotations revealing outfits may have in our society – it is more about practicality. Film jobs can be dangerous and there is a good chance you may get insect bites, scrape your legs, get sunburned, or have equipment dropped on your foot if you do not take proper precautions. We will touch on that in Chapter 3.

When you go to the interview, I suggest bringing printed résumés in a folder so they don't get crumpled – one for yourself to reference and one for the interviewer. If you can print them on high-quality paper (or purchase résumé paper from an office supply store) even better! This may seem antiquated and there is a chance the interviewer will turn down your offer to provide them with a printed résumé, but it still shows good form. If nothing else, you can use your printed copy to reference so you remember your own work that you want to mention or say something like "as you can see, with my salon experience, I worked with many different types of clients …" You may also want to have photos or videos of your work easily available offline on a mobile device, tablet, or laptop computer. They might tell you "this project has a lot of false facial hair – are you comfortable with that?" and you can respond by quickly pulling up photos of your false facial hair work. Bring a notebook to take notes if needed, as taking notes on your phone about the dates, pay rates, and necessary skills can look unprofessional.

I recommend you arrive about five minutes early. If you need to park or navigate public transportation in your city, you may want to give yourself additional time. Regardless of how early you do arrive, find a place to wait outside of the meeting location until about five minutes before the interview. Showing up slightly early is good form and sends the message that you will be on time for work. Showing up *too* early might inconvenience your interviewer. When you meet them, a traditional handshake is appropriate. If you are worried your handshake is not strong enough (or even too strong) practice with some friends. If you are meeting in a public space and the interviewer arrives after you have already sat down, it is respectful to stand to greet them and shake their hand when you introduce yourself.

Once you are seated at the table, keep both feet firmly on the floor and sit up straight. Hunched and wobbly posture send the non-verbal signals of being unstable or lacking confidence. In her book *Feminist Fight Club: An Office Survival Manual for a Sexist Workplace*, Jessica Bennett also notes that keeping a hand on the table (not hunching over it, but just one hand lightly placed on it) sends a message of ownership and comfortability in your space. Avoid crossing your arms as this can be interpreted as closed off or angry. Try not to fidget and do make eye contact, no matter how nervous you are. So much of an interview is in your ability to connect, and not in your work experience. If you seem open and confident in your body language, this will create a positive, lasting impression.

Do not be afraid to ask questions. I once heard the advice to "remember that it is not only them interviewing you, it is also you interviewing them." A job may want you very badly, but that does not mean you have to want the job. Once the interviewer has finished asking their questions of you, this would be a good time to find out more about the project. If you find that the subject matter of the film or the schedule of the production is something that really doesn't resonate with you, it is better to know this before you accept the job.

Regardless of if you want to accept the job or not, it is important to follow up (even more important if you *do* want the job.) Handwritten letters are a nice way to go, but especially if you are not interviewing at an office, it may be rare that you have a mailing address for your interviewer. Plus, you may want something more immediate. A nice email goes a long way. Your message can be as simple as the following:

> "Hi Interviewer's Name,
>
> It was nice meeting you yesterday! Thank you for taking the time to sit down and discuss (Project Name) with me. I would love to be a part of your team and I think I could offer a lot to the project. Please let me know if you have any more questions for me.
>
> Thanks again for your consideration and I hope to hear from you soon,
>
> Your Name
> Your Contact Info."

The last important thing I can tell you about your interview, your networking, your follow-up letters —

pretty much anything involved in getting a job is this: just breathe! This may sound basic and you may hear it a lot, but it really is the best advice. Taking a good, slow deep breath gives you time to think about what to say next and it helps you connect with your body so you can feel comfortable just being your best self. Good luck!

Contracts and Deal Memos

I hope your first interview went fabulously! Hopefully the interviewer even offered you the job, and it's one that you would like to accept. Even if you do have a verbal expression of interest from an interviewer, the job is typically not official until you have signed a **contract** or **deal memo**. These terms may be used interchangeably but they refer to different documents. When you receive paperwork, it is important to read it cover-to-cover as every production has different rules.

Television Production Supervisor RoseMary Prodonovich illuminates the difference between a contract and a deal memo:

The deal memo comes first. It is a quick reference that has contact information for performer/crew member and agent/manager if applicable with the rate, guaranteed work period, credit information, trailer information and any other information that was negotiated in the deal. Deal memos usually state the length of the job with the start date and end date. Once Production has the deal memo, the contract is built off of the information that the deal memo has confirmed.

Labor unions also may negotiate a contract with a production for pay rates, labor hours, and dues allocation, while each crew member also has a deal memo and/or an individual contract under a larger-scale contract.

Crew contracts are different. To begin with, there are no union guidelines or requirements for the paperwork packets besides a form stating that dues will be submitted to the applicable union. Crew members should get an email breakdown from their Department Head or the Unit Production Manager (UPM) to confirm their deal. [This email may act as an informal deal memo]. This email should break down all the applicable rates, box rentals, additional pay and/or outline the work period. In start paperwork packets, the crew contracts are presented blank so referencing this email will help crew members complete their contract properly when filling out paperwork.

In the subsequent pages of a payroll packet crew members should read the policies from the studio and what they are agreeing to. Including, but not limited to, non-disclosure information, social media guidelines, harassment policy, box rental information and reimbursement if damage or loss, etc. This packet outlines all items that the crew member is agreeing to for that show. No studio or independent company has the same paperwork or policies so it is imperative that crew members (union and non-union) read what they are agreeing to and where their responsibilities lie and rights stand as a member of the crew.

One specific type of paperwork you may be asked to sign at the beginning of a production is called a **non-disclosure agreement** (**NDA**). RoseMary explains:

NDAs are often submitted to potential crew members prior actually making a deal with them for the show. Crew members sign an NDA, then read the script or have conversations with executives to talk about the show but the NDA secures that the information is confidential. Once a crew member is officially hired there is typically an NDA in the start paperwork packet for the show. It is not necessarily a separate document. NDAs are also given to vendors/work-for-hire contacts for the same reason.

One of the things you must determine in your paperwork and when negotiating your contract is how you will get paid. For your rate, you may be paid a **day rate** – which is flat rate for any work performed on set for a day of a determined length (this may be eight hours, though most commercials want a rate for a ten-hour day, and most film productions that would use a day rate system want a rate for a 12-hour work day). Otherwise, you may have an hourly rate. According to most Union contracts, the Union sets the hourly rate for the type of work on a film or television production. This rate often varies by departments or by the position. Most unions negotiate an hourly rate for a minimum of eight hours that goes into overtime after eight hours. After eight hours, you may receive "time-and-a-half" payment, and after 12 hours you may receive double your hourly rate, or "double-time."

You will also negotiate a **kit fee**, also known as a **box rental**. This is a small daily stipend that allows you to continuously restock your products. Kit fees can range anywhere from $20–$60 per day or higher, but generally are about 0.5–1.5% of the value of your kit. To figure out the value of your kit, you will need to tally up the price of each and every product and tool you have. I suggest keeping your own list and updating it often as your kit expands, so you always know its value. This list is called a **box rental inventory** or a **kit inventory**. On most productions, you will need to submit this list or fill out a form with the inventory details in order to receive your kit fee. Make sure you have a firm daily kit fee amount listed in your deal memo or contract.

Whatever your agreement, make sure you have the details in writing and signed by both parties *before* you start a project. If you have any questions, speak with the Producer or perhaps a trusted friend with a background in law!

At some point in the process of interviewing and contract-signing, you will need to find out if the project is being produced as a **Union** project, or **Non-Union**. If it is Union, you may need to be a Union member to work on it, depending on the city or the shooting location. On a Union production, the Union will work out the contract and the rates for all crew members, and then you will sign a deal memo for yourself that aligns with this larger contract. In addition to contracted rates for each

position, the Union will negotiate overtime pay, maximum work hours, benefits, penalties, and other health and safety guidelines. Production will pay the Union a percentage of the overall budget; if you are a Union member, a percentage of your payment will go to the Union as well. This percentage goes towards benefits like insurance, educational funds, pensions, and more.

As hair and makeup artists, our Union is the **International Alliance of Theatrical Stage Employees (IATSE)**. While IATSE oversees film, TV, and theater productions across North America, there are different local branches, or "Locals," governing different cities, towns, and/or regions. Each Local has its own set of requirements for becoming – and staying – a member, as well as qualifying for benefits.

Of course, you can also stay non-union and have a flourishing career as a freelancer. It will depend on your personal goals, the types of projects you want to work on, and the regulations of your city or town. To learn more, and decide what's best for you, visit www.iatse.net, or research the closest IATSE Union office and stop in to ask for information about membership.

Pre-Production

In This Chapter

- **Your Work**
 - **How to Read a Script**
 - **Script Breakdowns**
 - **Research/Design**
 - **Mood Boards**
 - **Meetings/Actor Contracts**
 - **Test Shoots**
 - **Budgets**
 - **Setting up your Binder**
- **Production Documents**
 - **Scripts and Script Revisions**
 - **Stripboard**
 - **Day-Out-of-Days**
 - **Call Sheets**

Your Work

If you picked up this book, my guess is, you love makeup and you are itching to get on set for a film. I don't blame you! But how do you know what to do when you get there?

The planning process for a film or television show is called **pre-production**, and the Makeup Department Head, or Makeup Designer, has *a lot* of planning to do! The better the research and organization during pre-production, the smoother each day will be on set. Especially with a technically complicated film (for example, a story that jumps back and forth between time periods) or with a large volume of cast members, this planning stage is crucial for saving time once you are on set. Pre-production is an exciting time during which you will generally go over the story, meet with the Director to learn about the characters, talk with the actors about how they envision the character presenting themselves, connect with other designers about the overall "look" of the world in the script, and many more fun collaborations. Then it's on you to research your inspiration and come up with the design for each character at every moment throughout the story.

Of course, every designer has a different approach to pre-production and you will undoubtedly find the system that best works for you. In this chapter, I'll show you a few of my favorite ways to prep for a film and trust that you will adapt them to your needs throughout the course of your ever-evolving career!

How to Read a Script

Our work starts with the script, also called the **screenplay**. One of the most thrilling moments for me when I'm designing a film is being presented with a

new script. Where does it take place? When does it take place? Who are these people? What are their challenges? How do they wake up every morning? What is this world I'm entering into? Receiving the script reminds me of the Book Fair days in elementary school – the excitement I'd feel in my whole body as I picked out a new book and got to delve into that new story.

Now imagine you're watching a film set in the 1920s about vampires. A woman is being attacked by a vampire whose bite will transform her into one. The costumes are perfectly matched to the historical period, the lighting is dark and dramatic – but she's there with hair in a messy topknot being attacked by a guy with perfectly normal teeth, and a modern haircut. When he bites her, no blood flows from her neck and as her transformation is initiated, she looks exactly the same as she did the first time we saw her. Did she turn into a vampire? Is *he* even a vampire? He doesn't have fangs … What's going on? If I'm an audience member, I don't believe a moment of it. Even if the incongruities are more subtle, I just *know* as a viewer that something about what I'm watching seems … *wrong*.

The story cannot be effectively told without hair and makeup. This is where your work comes in.

When I'm given the script for a new film, the first thing I do is a basic read-through to get an understanding of the story. I may do this electronically if the script has been emailed to me. Screenplays are a combination between stage direction, dialogue, and introductions to the characters – each element being equally important.

On the second read, I want either a hard-copy of the script, or a tablet format on which I can take notes. I'm armed with a pencil (in case I need to erase) and a set of different colored highlighters.

I highlight each character and on a separate page I write or type a list of each character I've encountered. Note that this may not only be the named characters, but also background characters such as "Dive Bar Patrons." The script may or may not detail how many of them there are. These people should *not* be overlooked when you're making your list!

With a different colored highlighter, I'll highlight every single character description present. Some writers are very detailed with their descriptions, explaining that "LYDIA (32) a painter, has a Bohemian look, with long, flowing hair and tattoos of flowers on both arms." Others may only give you an age or an age range: "LYDIA (30's)." Either of these scenarios are fine – take as much information as is given and add it to your notes. If you are left with questions (for instance, "What is Lydia's job?") you can note those and ask the Writer or the Director. As the designer, you may feel that someone who is a painter, struggling to make ends meet, may look different than someone who works as a highly-paid attorney. That's your own design choice, but you need to learn as much as you can about who they are before you make any decisions. We'll discuss that process more later.

> *The better the research and organization during pre-production, the smoother each day will be on set.*

Once I've made my character list and notes, I go through the script a third time and with a different highlighter I'll keep track of what I call **makeup moments**.

Makeup moments can be everything from "LYDIA begins to cry as she watches her HUSBAND board the boat," or "Blood pours from LYDIA's neck as the VAMPIRE sinks his fangs into her." These makeup moments are explicit instructions for us – we know we need:

1. A tear stick, in case the actress cannot cry on her own
2. Blood – we will want to ask the Director how much blood he wants and if she envisions it being a bright or dark color
3. Fangs – we want to talk to the actor about getting a set of custom-fitted fangs made for him and see what he's comfortable wearing.

All of these script indications are helping you plan your shopping list, your questions for upcoming meetings, what you will need to research, and what you'll actually do using makeup to tell this story on set.

You may also have more subtle makeup moments that require you to do a little more forward thinking. If I read, "LYDIA runs through the street," I'm going to still highlight it and make a little star with a note "Does the Director want sweat here?"

Other times you could find a simple sentence like "A fight erupts in the bar." That's a place where I'll

```
                                                              14
14          INT. MATT'S HOUSE, BEDROOM - NIGHT

            Matt takes out his aggression on a SPEEDBAG. He's lightning
            fast, precise. We can see he was a terrific boxer... Until
            he's completely winded. The bag slows to a settle as he
            catches his breath.    ☆ Sweat

15          INT. MATT'S HOUSE, BEDROOM - LATER                15

            Matt sits at his desk, typing "Le Chateau Paradis, Montreal"
            into the search bar on his laptop and hits "ENTER".

            Up comes the website Scotty visited. Scantily clad women and
            all. Just then, Matt's adorable 13-year old sister JAMIE
            barges in. Matt SLAMS the laptop closed.

                                    MATT
                        Can't you knock?

            She places two pills and a glass of water next to him.

                                    JAMIE
                        Mom says dinner in five minutes.

            She leaves. At the door she turns back --

                                    JAMIE (CONT'D)
                        Nice pictures, by the way.

                                    MATT
                        Out!
```

want to make a note to myself to find out more about this fight. How long does it last? Is anyone seriously injured? If so, how? Are there stunt performers or stunt doubles involved and if so, what can I find out about this fight choreography? You're preemptively planning your department's work and reminding yourself to ask important questions as you go into each meeting. A good designer tries to get ahead of the questions, and therefore of the designs themselves. Some Writers and Directors may tell you exactly what they want in every single moment, but many do not. That's why they hired you – the expert!

Additional factors you'll want to note are setting and time period – aspects you may want to research later.

Once you have a good sense of the story, each character, and specific things that happen to them, you are ready to dissect the script even further and make a concrete plan for each and every makeup that will cross the screen. You're ready to do your **script breakdown**.

Script Breakdowns

While **script breakdowns** take time in pre-production, they will make your life so much easier! The theory behind doing a breakdown is that by mapping out each character's looks and creating a chart, you have very little thinking to do once you're actually on set, because it's all visually laid out for you and your staff. Each department breaks down the script in different ways.

The first step of breaking down your script is to create your chart. In my breakdowns, I include all the information from the **scene heading** of the screenplay itself.

" A good designer tries to get ahead of the questions, and therefore of the designs themselves. "

The scene heading in a screenplay "Always consists of at least two elements:

1. an interior or exterior indicator
2. a location or setting

Unless the scene is part of a continuous sequence, the heading also includes a time of day" (www.storysense.com).

The first element of the scene heading will include if the scene takes place inside (Interior or "INT.") or outside (Exterior or "EXT.") and the setting itself. Most scripts will also include the time of day, or an indication of time passing such as "LATER." The time period might also be indicated, or time/space elements such as a dream or a flashback.

A standard scene heading might say: INT. ABANDONED WAREHOUSE (1988) – NIGHT. If the next scene happens in chronological order as a character leaves the warehouse, you might see: EXT. ABANDONED WAREHOUSE (1988) – NEXT MORNING. Input all this information for your chart – it's going to help inform your design choices later on.

If you ever have any questions about when or where a scene is occurring, a great person to ask would be the Script Supervisor. The Script Supervisor keeps track of the way the script is being shot on set, but they also do their own breakdown before production so they have an intimate understanding of the progression of the story. They can often clear up any confusion you may have. In their breakdown of the script, they will also include the **script day**, meaning the day on which the scene takes place in order of the story. These are split into Day and Night, designated by "D" and "N." The first scene is Day 1, "D1." If the next scene in the story takes place four days later, it will still be considered Day 2, "D2," because in the chronological world of the script, it is the second day within this world that the audience will see. If the next scene takes place the following night, this will be labeled Night 3, "N3," and so on. Script days are very important to include in your breakdown as they will help you keep track of the looks for each day.

Once you have all of your scene headings laid out in your chart, you're ready to input your character names and numbers.

The Assistant Director is the person who assigns a number to each character in the script – these numbers are generally in order of importance, with your lead character being your "#1." Actors may be referred to by their numbers (when they aren't listening) on set so make sure to memorize the numbers for at least your characters 1–5. Stunt doubles will have the same character number as the person they're doubling, plus an X – so your lead actor's stunt double will be 1X on the call sheet and in your script breakdown. If you have stunt performers who are playing their own characters, such as "STUNT POLICE OFFICER," they will have their own character number, but their numbers will start in the 100s. For example, the Police Officer is her own character with a name but she is played by a stunt performer because she may have to jump off a building or participate in a shoot-out at some point in the script. Her number might be 109 but you'll still treat her as you would any other non-stunt actor.

Now you have all the necessary information in your chart, it's time to begin actually designing your look. This process goes hand-in-hand with processes outlined in the next few chapters including research and inspiration boards, but for now we are just making the lists. Each and every character in each and every scene needs to be analyzed. You may make notes in your script or lists on a separate document – whatever works for you. The good news? This analysis will be simplified because of all the color-coded highlighting and note-taking you did after the last chapter!

I approach each scene and character's look the same way you probably learned how to write stories in elementary school, by asking the key "5 W Questions" – "Who?" "What?" "Where?" "When?" and "Why?"

Let's imagine we are on Scene 1 and the scene heading reads INT. SUBURBAN HOME (Present) – BEDROOM – MORNING and DEREK (52) has just gotten out of bed, while his wife, CARRIE (52) is still in bed sleeping. Start with "Who?" Who is the first character in the scene? Let's say it's Derek and he's your lead, your #1.

Next is "What?" What is his look at this moment? I'm going to go ahead and say Derek has a modern

haircut, but it's rather disheveled as he has just woken up. His makeup is a general "no-makeup-makeup" HD look, nothing special, just taking care of the actor's skin and smoothing it out.

Our next question is "Where?" and you may ask yourself about the geographical location as well as the location itself like a house or a park. This will influence your decision. Our story takes place in the United States, and Derek is in his bedroom. It might be a different haircut or a different look if it took place in Japan, or if he was in his office – that's why it is important to pay attention to scene headings. It influences your design choices.

"When?" indicates the time of day or time passing, but it can also indicate a period. It's easy to deduce that a contemporary look would be different from one that takes place in a historical period. The time of day also influences your look – we said Derek's hair is disheveled – that's *because* we read in the script that it's morning and he's just gotten out of bed. So, the "When" is also the inspiration for the design choice of his look.

Which leads us to our "Why?" At the end of every single look you design, you should be able to rationalize it with a full answer for "Why?" Derek's (who) look is a basic HD makeup with disheveled but contemporary hair (what) *because* the scene takes place in his bedroom (where) in the present day in the morning (when). This is his *first* look, so I label it "A."

Now let's try his wife.

Who? CARRIE, age 52 (let's imagine Carrie is more of a supporting character, so even though she is the second person we see, her character number might be #5, because numbers are assigned in order of importance, not order of appearance).

What? "No-makeup-makeup" look as she sleeps, with her hair in a messy, slept-in braid – note that this is the first look we see her in.

Where? Their suburban home, in the bedroom.

When? First thing in the morning, in the present day.

Why? Because she is still asleep, *because* she's in her bedroom (where) first thing in the morning (when). It's important to note that, as the designer, I'm not only choosing her current look, I'm also deciding something about who she is as a person – making the choice that she washes off all her makeup before she goes to bed and takes the time to brush and braid her hair before going to sleep every night. From this, the audience might subtly pick up facets of her personality that are present later in the film, like perhaps she is very organized and fastidious. She sticks to a bedtime skincare and haircare routine. Her age and her environment contribute to this as well. If she was a college student (who, her age) sleeping in a dorm room (where) first thing in the morning (when), she might have her hair in a messy bun, which is a more youthful and careless hairstyle, and she might have not washed her makeup off after a night of going out, so we might see black eyeliner and mascara

Scene	Location	Year	Int/Ext	Hour	Script Day	1. Derek	2. Y. Derek	3. Kyri	4. Tiana	5. Carrie	6. Armann	7. Y. Carrie	8. Lola
1	Suburban Home	2020	Int	Morning	D1	A				A			

A script breakdown with the first scene filled in. Actors who are not in the scene are still listed in the script breakdown chart, but their columns are left blank until they appear

smudged on her face – those small details would also tell us something about who *that* sleeping person is – and she's a totally different type of person in a totally different life situation than the 52-year-old Carrie who methodically prepares her skin and hair for bed every night. But it's all *your* choice as the designer. Because this is her first look in order of appearance, we mark this "Look A."

Let's keep practicing. Imagine Scene 2 is our warehouse scene: INT. ABANDONED WAREHOUSE (1988) – NIGHT. It is a flashback so it gets FB1 (Flashback 1) for the day.

The main character in this scene is Young Derek, and he's our second most important character in the script, played by a different actor, so he gets character #2. If the action says "YOUNG DEREK (21) sits, huddled in the corner of the ABANDONED WAREHOUSE, blood still dripping from his nose." Of course you've highlighted your bloody nose "makeup moment!" (Remember those from the last section?) and because you've already read the script and you understand the storyline of the flashbacks, you know that Young Derek has been in a fight with some guys from his neighborhood here in the warehouse and he winds up sleeping there in the corner. This is our first time meeting Young Derek so this first time we see him, his look is A. We take all the information from the scene heading, the makeup moments in the script, and the story itself to design and justify this first A look and put it into our script breakdown.

Who: YOUNG DEREK, age 21

What: Messy late-1980s hair, a little dirt/dust on his hands and face, fresh blood dripping from his nose. You read that it's after a fight scene and you asked the Director if she'd want some sweat on Young Derek and the Director told you yes, along the hairline, so this look includes a little sweat, even though it's not explicitly stated.

Where: Abandoned warehouse.

When: Night, 1988.

Why: The hair is messy and 1980s *because* it takes place in 1988 after a fight (when), the blood dripping from his face is fresh because the fight has just happened and *because* the scene takes place at night, you'll want to use a bright red blood color because you assume it'll be dark (also when). He is dirty and dusty *because* you're in an abandoned warehouse (where) and sweaty because he's been fighting (why).

If that's Young Derek's A look, then logic tells us his B look will be the next time we see him chronologically, if time has passed and the look has changed.

Remember this scene? EXT. ABANDONED WAREHOUSE (1988) – NEXT MORNING.

If that's the next scene (Scene 3) and Young Derek is leaving the warehouse after spending the night there, he's probably no longer sweaty, he's still dusty because he hasn't had the chance to clean up, and the blood around his nose and maybe on his hand (from wiping his nose) is kind of brown in color, now that it's crusty and dry. This is his look B, so I put B in the breakdown chart.

One more to try. Imagine Scene 4 flashes forward to the present day. EXT. SUBURBAN HOME (PRESENT DAY) – MORNING. DEREK, dressed in a suit, gets in his car to go to work.

I'll call this Derek's (present-day Derek, remember him?) look B, because his first look, look A, was disheveled hair and now he has gotten ready for work and maybe combed his hair back into a classic-looking style to match his clean-looking suit. This becomes his second look, look B.

As you continue through your breakdown, closely examining every person at every moment in the story and designing a look for them that makes sense, you label each of those looks with a letter *and* make sure you are also noting what those letters correspond to. I like to have those on the bottom of the same page as my chart, but some people prefer to have a separate page for notes – it's up to you. While this may seem abstract, I promise it will make sense as you start to practice it, and it will save your life on set. Remember, films do not shoot in chronological order so there is ample opportunity for confusion if you don't have a good system.

The idea is, every morning you get the call sheet from the Assistant Directing Department, you see what scene number is up first. First scene of the day is Scene 4? You go straight to your chart and you know exactly what Scene 4 is (Scene heading), who is in it (Derek), and what his look is (Look B – work day look). You don't even have to look at your script!

Scene	Location	Year	Int/Ext	Hour	Script Day	1. Derek	2. Y. Derek	3. Kyri	4. Tiana	5. Carrie	6. Armann	7. Y. Carrie	8. Lola
1	Suburban Home	2020	Int	Morning	D1	A			A				
2	Abandoned Warehouse	1988	Int	Night	FB1		A						
3	Abandoned Warehouse	1988	Ext	Morning	FB2		B						
4	Suburban Home	2020	Ext	Morning	D1	B							
5	Derek's Office	2020	Int	Day	D1	B							
6	Derek's Office - Lunchroom	2020	Int	Day	D1	B					A		
7	Downtown Sidewalk	2020	Ext	Day	D1	B							
8	Dance Club	1988	Int	Night	FB3		C	A	A			A	
9	Downtown Sidewalk	1988	Ext	Night	FB3		C					A	
10	Suburban Home - Kitchen	2020	Int	Evening	N1	B			B				

Research/Design

As you break down your script and get acquainted with its characters, your mind is probably filling with ideas about how they might look. You now have one of the most exciting jobs there is – to design your characters. The process of researching and designing characters is one of my favorite elements of this job. Here, you have endless opportunities to tell a story through visuals. Each and every one of your choices should be motivated to serve the narrative, whatever that narrative may be.

You might find yourself needing to know anything from which exact shade of lipstick was most popular for ladies in London in 1923, to what a bullet wound from a particular gun looks like after three days of the victim lying dead before being found, from the rules imposed upon Marie Antoinette's servants as to how much makeup they were allowed to wear, to the placement of bruises on the neck of someone who has been strangled by hand. The list goes on and on. To learn about the history of makeup uses, products, and technology I highly recommend Lisa Eldridge's gorgeous book *Face Paint: The Story of Makeup*.

The best piece of advice I can offer on research is: do *not* rely on Google Images. The main reason for this is that because there is such an enormous amount of user-generated content, it can be difficult to know if the information is accurate and the sources are credible. Another important element of researching makeup is to seek primary sources, rather than secondary sources. Let's say you want to research Queen Elizabeth's makeup. You could find a portrait of Queen Elizabeth painted in or around the specific year in which the story takes place – that would be a primary source. A secondary source would be, for example, going to YouTube and typing in "Queen Elizabeth makeup," and watching a blogger's video from when she did a Queen Elizabeth look on herself for Halloween. Which one do you think will be more precise and historically accurate?

For historical accuracy, the best place to go to, believe it or not, is the library. Here, you can find countless primary sources of research material, making sure your study will be as accurate as possible. You can use photography books, magazines, newspapers, art history books – any materials that will give you accurate information, *generated in* (or slightly before) the year you need to re-create. If you are designing a piece that involves a fantasy world or is set in the future, you may get a reference of looks from the past to inform your designs.

If you live near a history or art museum, I highly suggest visiting there as well. Here, you can find painted portraits from before the existence of film and photography that may influence your designs if you are researching a specific time period. Sculptures can offer insight into the ideal body types of an era as well as hairstyles and facial adornments.

If you visit a museum, make sure you note the years in which the art pieces you reference were created. I suggest bringing a notebook with you to take notes and asking a security guard if you can take pictures. If you're looking at a painting of a noblewoman, make

sure you note that her style would be different than that of a working-class woman.

While at a library, you may find old catalogs, magazines, newspapers, or photographs to aid you in your research. I try to check out as many of these as possible so I can then scan them and add the images to my mood boards as reference for myself and my team. Locate books on the history of different cultures – often sections on beauty standards and grooming products are included. For example, I'll never remember where I read this, but I learned from a textbook that Roman women would use stones to scrape against their legs to remove hair! Many different cultures had practices like this according to what was considered "beautiful" at the time. I make note of cultural standards like these and add them to my mood boards as well.

If it's hair or facial hair styles you are seeking, one book I suggest is *Fashions in Hair: The First Five Thousand Years* by Richard Corson. Makeup Designer, Effects Makeup Artist, and Developer of K.D. 151 products Ken Diaz considers this beautifully-illustrated resource to have been "invaluable" as he was creating looks for *The Mask of Zorro*, *The Legend of Zorro*, and the *Pirates of the Caribbean* films.

Different characters will require different types of research. For example, if you are designing a railroad worker in the 1800s, it may be valuable to visit a railway museum. You will likely find photos or drawings of the workers and get a better insight into facial hair styles and dirtiness levels. I visited my local Holocaust museum and the library within it three times while researching a film, to make sure that the tattoo found on a survivor's arm accurately depicted the year he was imprisoned and the country from which he originated. This type of research can sometimes be unpleasant or triggering, but keep in mind that by depicting the stories of your characters with accuracy, you tell their stories with respect and grace.

Once you have compiled each and every historical detail of your period look, it's time to make a plan to achieve it. This often involves consultations with your actors. For example, a man might need to be shaved into a certain style. A woman may be required to allow her leg hair to grow in or her eyebrows to be shaved into a different shape. Having distinct reference images and notes to explain to them *why* the components are necessary for the look will help you in these conversations.

One challenge you may encounter when creating historical looks is knowing what products to use. If the film takes place in the 20th or 21st centuries, cosmetics brands may actually make some of the same classic colors. However, for all other periods, you will have to find modern products that create looks that appear accurate, and not contemporary, on-screen. Know that "long-wearing" products are a recent invention, so it is highly likely that our ancestors' products – often made from wax and other plant and animal products – did not look "perfect." This imperfect look actually increases the

28 Behind the Scenes

authenticity of your work. That being said, you still need to keep continuity, so you may still need our modern products such as primer, setting powder, and setting spray to get your looks to stay while you are shooting.

For period looks, I highly recommend testing the products and the looks all together. If a camera test is not scheduled, talk to the Director or the Assistant Director about scheduling one. If this is not an option, test the designs on a friend or model and take some well-lit photos of them. This testing process will help you see what products look historically accurate and which do not, plus you will refine your look more and more.

As you move into the 20th century, primary sources are available in many other places as well. I once designed a piece that took place in 1978 in a Midwestern suburb. I went to eBay and bought several magazines – not exactly high fashion magazines, but magazines that would apply to the lives of a Midwestern housewife, such as *Good Housekeeping*. Because it's safe to assume when you design a piece that takes place in the "heartland" of the US, the characters are generally less on-trend than a character living perhaps in New York, Hollywood, or Paris, I bought a magazine from early 1977, assuming that maybe the newest trends of 1978 hadn't quite reached our characters yet. To research the looks for her hip teenage daughter, I bought a 1978 edition of *Cosmopolitan*, the demographic for which skews a little younger. Cosmetics and clothing advertisements are a great place to look for references and inspiration, with magazines and catalogs dating back to over 100 years ago. Beauty manuals and magazines with step-by-step tutorials can also be a fantastic tool to learn *how* people achieved the looks they did.

For periods beginning in the 1920s, film becomes a great resource as does television, beginning in the 1950s. I'll look up top films or TV shows from the year I'm researching, watch them, and pull screenshots of characters who are similar to the characters I'm designing. These research endeavors have inspired fun marathons of everything from *Leave it to Beaver*, to *Cheers* to *Friends* – all with a notepad in hand.

Just make sure the media you are viewing is contemporary to the period in which it is made – *Gone With The Wind*, for instance, was released in 1939 but set during the Civil War, making it a poor candidate both for Civil War style research *and* late 1930s research. Period pieces tend to exhibit an interesting kind of "mash-up" of historical styles and contemporary styles.

For a piece set anywhere in the 1980s and beyond I will often look at music videos. Just search "top songs of (the year you're researching)." Prepare to take some screenshots and enjoy!

There are a few circumstances in which social media would be a valuable tool for your research. One would be if the character *is* a social media influencer, or someone who aspires to look like one. The second is if you are styling a piece that takes place in modern day, but in a country where you do not live. I once had to

do makeup for a scene that took place in a nightclub in Prague, Czech Republic. To create the inspiration board for this, I opened Yelp, found a few popular night clubs in Prague, and then looked up those nightclubs on Instagram. Inevitably, I found great pictures of people partying at the clubs and the looks were indeed different from those that are popular in the United States!

Maybe you're simply looking for images of what's trendy and trying to get inspired around certain color palettes and themes. In that case I'll look at recent red-carpet photos or I like Pinterest as a resource too. There are some really creative designs out there – just don't rip off anyone else's work.

As you research and design your characters, do not forget to examine the influence of socio-economic status, age, and profession. If it is a woman you're designing, where does she buy her cosmetics? How much money does she spend on them? Does she get manicures or do her own nails? Does she get her hair colored in a salon or at home? What does she wear to work every day (if she is employed)? Does she do absolutely nothing to her appearance at all? For men, does he do his own grooming or go to a barber shop? What is his job? This is a great opportunity to talk with the Costume Designer who likely has ideas for the character's style. Send an email and request they pass along any inspiration images they have so far for the purpose of collaborating. The Production Designer will also be able to help you with elements, including the way a character's home is furnished, or what the general color palette of their life is.

Every choice you make needs to support the narrative so being on the same page with these other designers will play a large role in that. A middle-aged Congresswoman who lives in a luxurious, pristine home, is likely going to present herself differently than a 22-year old student living in a messy, vintage apartment with many roommates just as the same Congresswoman's wealthy middle-aged husband will likely present himself differently than your student's 25-year-old boyfriend who works in a juice bar and plays in a band. Making sure your makeup choices align with *who the characters are* is of utmost importance.

You also want to pay special attention to the character's identity – if that character is transgender, identifies their gender as non-binary, or queer, they may (or may not) present themselves differently than someone who is cis-gendered. Often the Director or writer has a vision for each of their characters, but you want to make sure you are telling each characters' story with accuracy and respect – not displaying a stereotype. Whether or not you belong to the LGBTQ community, it can be beneficial to talk to some people who do belong to it to gain some insight on different groups within those distinctions. For example, if you are working with a character who is transitioning from male to female, she may want additional contouring to diminish the appearance of her Adam's Apple, or to create more traditionally "feminine" features. Don't be afraid to have those respectful conversations and to design characters that reflect the knowledge you gain.

Similarly, if you are designing looks for a religious or cultural group to which you do not belong, you'll want to interview members of this group. People are generally happy to help if you approach them with respect and a willingness to learn. You may ask the significance behind certain adornments or what a cultural standard of beauty would be. People may also be open to discussing the history of their traditions or even showing photos.

When you delve into special effects makeup, research can be a bit trickier. You may need very specific references for illnesses or injuries, and you want to be as accurate as possible. Poorly done special effects makeup can pull the audience out of the moment immediately – somehow, even those who are not doctors can still instinctively tell what looks unrealistic. Special effects makeup involves an extensive knowledge of the human body, its anatomy, its healing process, and its disease progressions.

One resource I love for understanding anatomy, such as bones and muscle structure, is drawing textbooks including Joseph Sheppard's 1975 classic *Anatomy: A Complete Guide for Artists*, or *Anatomy for the Artist* by Jeno Barcsay. You will also want to know about the layers of the skin and its blood vessels, including which parts of the body bleed the most, which heal the fastest, and the locations of the major arteries. Additionally, it is important to have knowledge of scar tissue and how it is formed. For these purposes, I love medical textbooks and scientific journals, so if you have any friends in medical school, try to borrow their books whenever you can! You can purchase these from school bookstores or check them out in libraries as well. Here you will also find accurate information about infections of the skin and the effects of different illnesses.

For a violent death or injury, the research must often be incredibly specialized. Say you are doing the makeup for someone who has been killed by stabbing two days ago. You will not only want to research the process of death and decomposition so you know what tone the skin should be, you also need to communicate with other departments. Contact the Props Department and ask for a photo of the weapon with which the character was stabbed – that will help you design the size of the wounds. Next, speak with the Stunt Coordinator to find out the details of the fight – was the assailant stabbing with his right hand or his left? How many times did he stab his victim and how vigorously? An excellent place to look for references like this is forensic journals or papers for crime scene investigators such as *The Journal of Forensic Sciences*, *The Journal of Forensic and Legal Medicine*, and *The American Journal of Forensic Medicine and Pathology*. They often contain detailed images of people who have been killed or wounded so this type of research is not for the faint of heart! That said, it is important to tell our stories in the most realistic and engaging way.

Once you have compiled your research, I suggest doing a few sketches to express your ideas. You can use colored pencil, chalk pastel, marker, watercolor, even

digital sketches done on a tablet are fantastic. As long as you have some kind of visual aid that shows the colors of your design, the medium is often not important – it's whatever works for you. Doing sketches at this early stage helps, not only as visual note-taking for yourself, but also for your meetings with your Director. The Director will want to be able to visualize how the characters are going to look and illustrations are a great way to express your ideas. You are the expert and they are trusting you to tell the story through makeup – a process which blends the vision of the Director (and sometimes Writer), with your own vision, and the research you have found. Some characters go through dozens of concept sketches and re-conceptualizations before finally making it onto the screen. Don't underestimate the truth in the old saying "Back to the drawing board!"

Mood Boards

In addition to any sketches and illustrations you may do for your meeting, it is a good idea to make a **mood board** for every character or group of characters. A mood board is a compilation of images that give off the general "vibe" of your character. These may be your sketches, research images you pull from magazines, books, art history, or the internet, sometimes even images of objects or places that represent your character's interests, environment, or color palette.

Mood boards can be created physically, by adhering your images to a poster board, or digitally by organizing images in a document using software such as Photoshop, InDesign, or even Microsoft PowerPoint. Some artists choose to organize Pinterest boards, or online shared folders using databases including

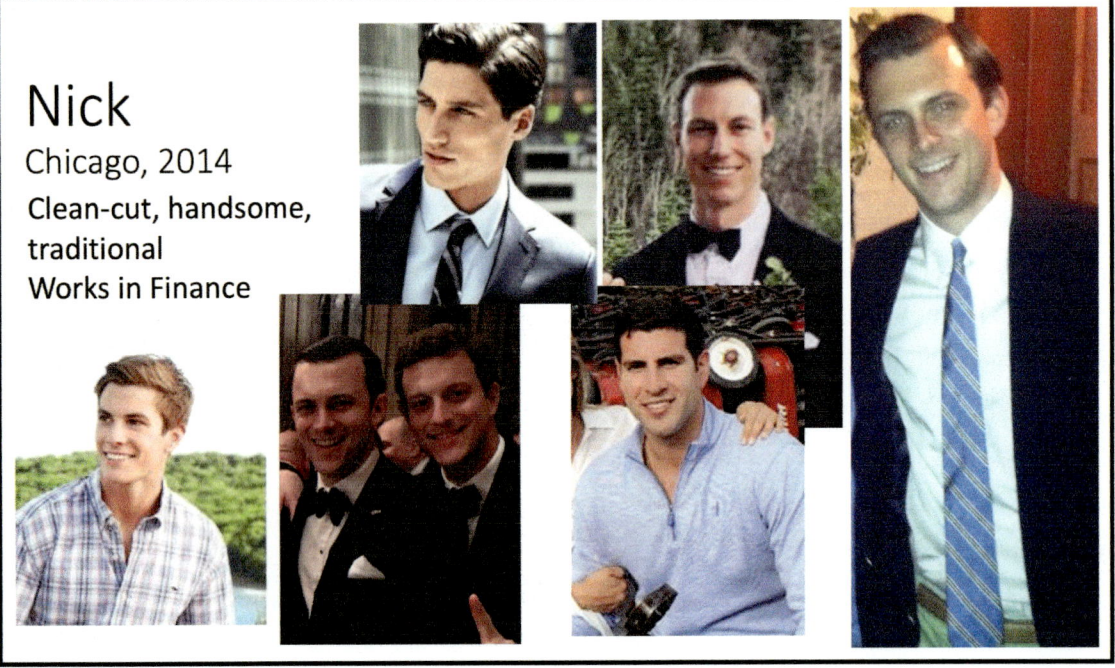

Nick
Chicago, 2014
Clean-cut, handsome, traditional
Works in Finance

Dropbox or Google Drive. These are not my favorite methods because it is more difficult to add your notes, and it can be impossible to view all the images at once. I do suggest compiling the visual inspiration for each character into one cohesive board for that character. You will find a medium that works best for you. Any format of creating mood boards is fine, as long as you can somehow digitize and share it as one document via email or online sharing platforms. The mood board might be sent to the costume designers, production designers, directors, writers, actors, and of course your own staff.

If you have a specific idea in mind for each and every look of your breakdown, make a mood board with inspirations for each look on your breakdown. Once you have the images from your research laid out, add the letter of the look from your breakdown and the script notes. If you have a sketch of the idea you can insert it into the same document. Set life moves at a rapid pace, so anything you can do to consolidate information and make it more visually organized is going to help you.

Keep in mind that if you are the Designer or Department Head, you will not be doing every makeup application in the entire project. You will have other makeup artists working for you and they will need to know how to implement your designs. Mood boards are a fantastic way to express your ideas to your team. Then the artists can use their judgment and creativity to come up with looks that match your vision. For example, you may have a scene that takes place at a White House fundraiser with 300 people

Janice
Chicago, 2014

Look B: Previous night's makeup, smudged (wasn't removed) and loosened, messy waves
←

Look C: "Fresh from the gym" (high pony, makeup and a little sweaty)
→

Pre-Production 33

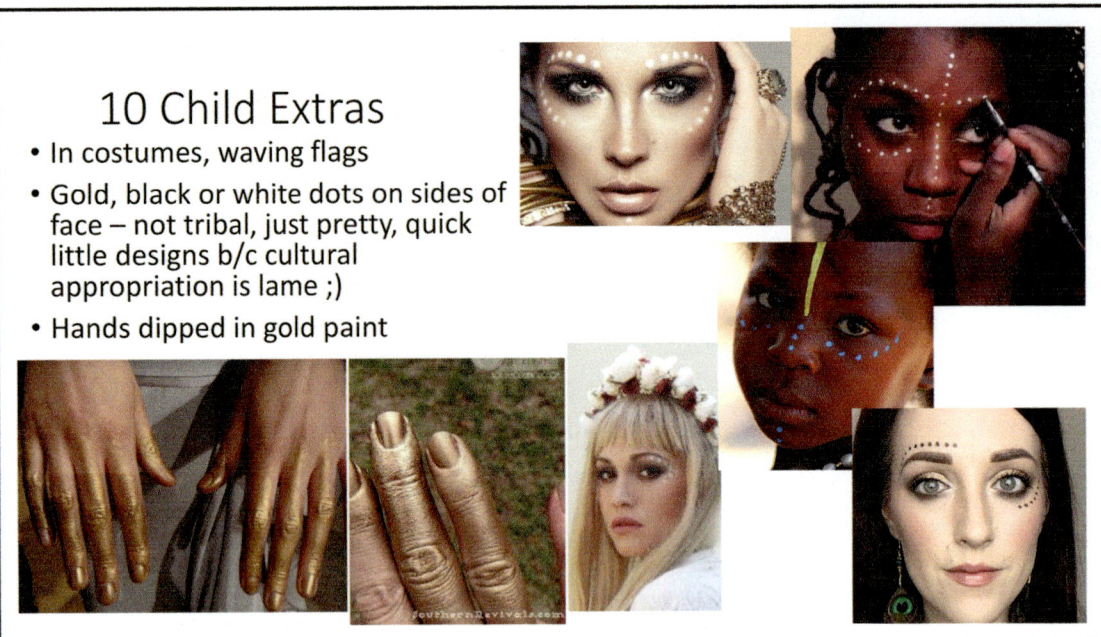

in attendance. These people will be local background actors — not necessarily senators and socialites. As the Department Head, you might dispatch a few makeup artists to take charge of making these background actors look the part. In order for the makeup artists to know what aesthetic you're looking for, you can send a mood board with them to their prep area and they can pick and choose looks from there. Conversely, if you are a day-player or trainee, you are going to want to make sure you clearly understand your Department Head's mood board so that you know what they want. Don't be afraid to ask questions!

Another important perk of creating mood boards is using them as a visual aid in your meetings with your Director or Production team. You then have a visual representation of your ideas to share with them to make sure you are all on the same page about how a character should look. They may tell you they like certain hairstyles or certain lipstick colors more than others, but presenting them a mood board offers them lots of options to choose from. It is a great way to move forward with all of you having the same aesthetic in mind.

Meetings/Actor Contacts

Now that you have done your research, your sketches, and your mood boards, you are ready to present them to your production team. You want to effectively express your ideas to the Director who is usually the person with the final say on creative choices. They may not like everything you have designed, so remember to take feedback with grace. Collaboration involves revision and a peaceful blending of many different visions. It is possible that the Director will leave every single decision up to you, as you are the expert. Even if that is the case, there are other peoples' visions that do come into play.

I suggest connecting with the following Department Heads: Director, Cinematographer/Gaffer, Assistant Director, Costume Designer, Production Designer, Stunt Coordinator. If you are the Makeup Designer and Hair is considered a separate department, you will be working in close collaboration with the Hair Designer throughout production. You may find yourself meeting with even more departments than this – it will be based off of your specific production needs. Connecting with the Director is especially nice to do in person because you can easily share images and research. Some productions will have someone from the Assistant Director (AD) Department or Production Department creating the Director's schedule and scheduling all their meetings. Others will be okay with you contacting the Director directly, so check in with the person who hired you to find out what the best way is to get in touch. Ample communication between departments during pre-production will ensure a cohesive vision for the project.

In this pre-production stage, it is also crucial that you contact your actors. You will have to get their contact information from the Production Department once casting is finalized. Sometimes you will be communicating with them through their agent, manager, or assistant so don't be put off by this, just be respectful. In the case of child actors, you may be coordinating with their parent or legal guardian.

In your cast contacts, do not forget your stunt performers. You will rarely be reaching out to the performers themselves, but rather to the Stunt Coordinator. Stunt Coordinators are accustomed to sending photos as well as height, weight, and other measurements to the Hair/Makeup, Costume, Props, and other departments. If you have a question for a stunt double ("Can he come with a beard?" or "Is she okay with a haircut?") that should be directed to the Stunt Coordinator as well. I have learned to make sure I ask the right questions if I don't get enough information from the photos. I once received a photo of a stuntwoman in a long-sleeved shirt and didn't think anything of it. On the day she arrived to set, it turned out she had a full sleeve of tattoos and she was doubling an actress who did *not* have full sleeves and would be wearing a tank-top in the scene. I needed an extra hour with the double to cover her tattoos and we stalled the entire production. I will never make that mistake again! The planning stage is imperative because you will need to match the stunt double to the actor they are doubling and this needs the time in the schedule!

My preferred way to contact my cast is first via email. You may have actors who then prefer to call you or video chat you. No problem there, just remember to take notes. Since you will be spending lots of time with your actors and working very closely with them, it's nice to introduce yourself and create a bond early

Pre-Production 35

on. Some things you will want to find out during the first communication will be:

1. **Any allergies**

 You will not only need to know cosmetic product allergies, but *all* allergies. For instance, you will need to choose non-latex sponges and non-latex-based special effects materials for an actor with a latex allergy.

2. **Any product requests for you to have in stock**

 Product requests are quite common and they may be as simple as "coconut oil and cotton swabs to take my eye makeup off with" and you can run out to the grocery store to get them. On the other hand, the actor may give you a laundry list of specific products from high-end brands. In this case, you need to budget wisely. It may help to reach out to the specific brands to discuss sponsorship options. There are cosmetics companies that are happy to support the art-making of film and television productions and you can help them advertise their brand by having their name mentioned in the credits and/or on social media.

3. **The actor's current hair length, color, and facial hair style**

 The actor may have cut or colored their hair or even gotten extensions or braids since the last time you saw them TV! With male actors, facial hair styles are a huge part of our job. An actor may be required to keep a certain facial hair look for a different production and that is important to know ahead of time. The Director might also want facial hair approval, in which case you would bring the photo to the Director and say "Andre has a beard right now – do you like the beard, or should we change the shape or ask him to shave?" If the actor can shave at home it saves you time – if not, just make sure you schedule that time in with your AD so you can shave the appropriate style, *or* add false facial hair if necessary.

4. **Any tattoos**

 Tattoos are very common as you likely know. What an actor has chosen to put on his or her body may not match the time period or the general look for a character in the script, however. This means, you need to schedule in time to cover their tattoos every day and maintain the cover-up throughout the day. If the Director likes the actor's tattoos and wants to keep them for the film, there is a process of getting legal clearance for the image. Each tattoo is technically the property of the tattoo artist who created it, so you will need signed permission from the artist to show the tattoo on screen. You might be in charge of this or your Production Department might handle it, but either way most networks and studios have standardized forms for the tattoo artist to fill out and you are the one who needs to initiate that process.

5. **If they have any visions for the character's look**

 Remember, we are collaborating! Although you have lots of ideas, the actor has likely been thinking deeply about this character and their

emotions and motivations. They also might have something specific they want to tell you about their own appearance such as "I have a birthmark on my forehead I always would like covered up," or "I generally get eyelash extensions from a studio near my house and I would like to be able to wear them for this show." They might have lots of ideas for how their character is presented, or they might leave it totally up to you. Either way, you have a fun opportunity to create a collective vision.

You will coordinate between the Director and the actors as well. The Director may have already told you he wants a specific actor clean shaven. Then the actor writes you back that he has to keep his goatee for a recurring role on another television show, so you have to tell the Director that. The Director might say fine, he can keep the goatee, or he might re-cast another actor who is permitted to clean shave. Regardless, it is important that you keep those conversations flowing.

I always format the subject lines of my emails in this way: (Name of Film – in all capitals)//Hair and/or Makeup//(Name of Character)

For example: COME AS YOU ARE//Hair and Makeup//Scotty

That way, it is more accessible to the actor because they know it's work-related, and it is also more accessible to you. When you are searching your own inbox and sifting through tons of emails about the film, you know exactly the subject to search to find the actors' replies.

An example email might read:

Hi Grant,

Christine Sciortino here – Hair and Makeup Designer for COME AS YOU ARE! Nice to e-meet you! Before we get started with shooting, I wanted to introduce myself and also need to bug you with a few questions.

First, do you have any allergies? Any products you'd love for me to have in my kit for you?

Secondly, do you mind sending photos of or describing any tattoos you have?

Lastly, can you send a quick selfie or very recent photo? Everyone looks a little different from their headshots and publicity photos so I just want to make sure I know exactly where we are starting from in terms of your hair and facial hair styles.

Please do let me know if you have any thoughts regarding Scotty's overall "look" or if you have any questions for me at all.

Looking forward to working with you!

Thanks,
Christine

You may have highly specific questions for your actors and that is great. These may include things like:

- "Do you envision this character sleeping with her hair wrapped in a scarf or under a bonnet?"
- "In Scene 34, when we see Cheryl put lipstick on in the bathroom, are there any particular colors you associate with her?"
- "The Director imagines this character having a mustache – what do you think? Are you typically able to grow a full mustache and how quickly does your facial hair generally grow?"
- "Can you come to set having clean-shaven the night before?"

Trust me when I say that no question is too small. Early on in my career, I was designing an independent film and I emailed *most* of the cast members. There was one actor who was only coming in to shoot one day and he was very famous. I figured, "He's too famous and busy to deal with this, plus it's only one day." What an error in judgment that was! See, one of our main cast members had requested a specific product and on his last day of shooting he said he loved it and asked if he could take it home with him. I knew I'd have no problem replenishing it at a later date so I said sure. The next day, the previously mentioned "famous" actor arrived on set and requested *the same product!* I was mortified. I told him I had just given it away a mere ten hours before – which he thought was a ridiculous excuse. So please, learn from my mistakes! From then on, I have contacted every actor in every production to get their ideas, allergies, and product requests.

Test Shoots

Now that you have done lots of research, had lots of conversations, drawn out a few ideas, you and the production team may want to see how these ideas look on-camera. Not every production will have a **test shoot** (also sometimes called a **"camera test"** or a **"makeup test"**) but if your production does schedule one, it is a great opportunity for you.

At the test shoot, you can try out different products and looks – for example, the Director may be deciding on a bright red blood vs. a darker, more burgundy-toned blood. For this reason alone you may be called in for a test shoot. You would apply each blood onto the actor (or sometimes a stand-in or model) and then it would be lit with different variations of lighting and shot on the camera. Occasionally, you may need to come in just to do straight makeup on someone as the Director of Photography (DP) might still be deciding on which camera to use, what lenses, or what color temperature of the lights. They might not be evaluating your makeup per se, more so evaluating how the actors will look with different camera options.

I've been on test shoots testing everything from different costumes, to different guns, and even a shoot where I was on set the entire day making tiny changes to a handsome actor trying to make him look "rougher." Even though we painted scars on him, sunken eyes, uneven skin tone, and a little bit of acne,

he eventually wound up losing the part because he looked too "nice" on camera, and they went with an actor who naturally had more uneven skin, some old scars, and an overall more "intimidating" look.

Before your test shoot, you'll want to be as prepared as possible by asking what looks the Director wants to test and planning which materials you will need to bring. It is a good chance for you to try out different products. Maybe an actor requested a specific product that contains sunscreen and you aren't sure if it will reflect the light in a strange way (lots of sunblocks do, due to their high talc content). You can try out the sunscreen at the test shoot and then let the actor know whether it will work or not.

As prepared as you might be, know that test shoots can be a bit of a toss-up sometimes. You cannot expect the same standardized procedure. There are often lots of "cooks in the kitchen" with the Director, the Director of Photography, the Producers, sometimes the Executive Producers, all having opinions on the looks that are being tested. Do not be intimidated by this. Try to accept constructive criticism and last-minute changes as gracefully as possible. Take advantage of the opportunity to narrow down some color choices and looks for your characters. View the test as a learning experience and you will have fun!

Budgets

After this pre-production phase of meetings, tests, conversations, research, and design, you should have a pretty good idea of the look for each character – and the products required to create these looks. With this information in hand, you are able to create your budget.

The most common scenario in film production is that you will be told a dollar amount allotted to the Makeup Department and you will have to figure out a way to make it work. It is up to you to spend this money on the best assortment of products possible. It's possible that the Director may come up with a new vision for a character, or you may have a last-minute issue with an actor, such as he has unexpectedly shaved his head and you need to buy a wig the night before shooting. In this case, you may need to approach production and ask for more money.

Once in a while, a production may approach you, tell you some very specific makeup effects they have in mind, and ask you what your proposed budget would be to create this look. In this case, you would tally up every product you would need to buy in order to create the effect and propose the budget to the production team. They might tell you they cannot afford that number, in which case they might change their idea for the look, or on rare occasions, they might go with another artist. Know that if a production chooses a different artist solely because that artist works for a cheaper rate or uses lesser-quality materials, you have dodged a bullet. Of course, cheaper does not *always* mean worse, but if a production is trying to nickel-and-dime you, it isn't worth it. You want to work on productions that value your time and resources.

Whenever a job is offered to you, you should always ask to read the script and ask what the Makeup Department budget is. This will give you a good idea of the scale of the production and what your department's

needs will be – not only so you can plan to purchase products, but also so you can schedule artist labor. Every additional artist needs to be paid of course, so the producers might tell you "We have the money to hire additional artists at the rate of $X/day for five shooting days." It's up to you as the department head to make the decisions on the best shooting days to hire your additionals – a factor usually determined by the amount of cast members and background actors scheduled for a day. More actors means more makeup artists needed.

Another determining factor of budget is called a kit fee. Every production should budget for a daily kit fee for their makeup artists. As discussed in Chapter 1, the kit fee, or "box rental" is a small daily stipend you receive to be constantly replenishing your kit. We use little bits of our kit products every day, so while a certain foundation or lipstick may take months to run out, at some point we will have to re-purchase it. Having a kit fee allows you to stay on top of your kit as you use your makeup over time, and to consistently replenish those disposables that are necessary for sanitation practices such as tissues and cotton-swabs.

Regardless of how the budget discussion goes and *how* a number is reached, once a number is decided upon, do your best to stay within that limit. Schedule a time to receive your budget allotment while you are still in the pre-production phase so you can do your shopping. Sometimes this is referred to as a "float" – an advance on your budget. Productions may give you the entire budget up front, or they may give you half up front and half at the halfway-point of the shoot, or a portion of the budget every week. Each production is different, but make sure to communicate your needs clearly to the producers. You'll want to make sure you have enough to buy everything you need for the start of the film and then you likely need to replenish supplies throughout the shoot. To give you your budget, production might give you cash, they might issue you a check for you to deposit into your own account and then spend, or they might even give you a company credit card. Try to avoid ever spending money out of your own pocket – getting reimbursed can often be a lengthy and complicated process, even for a small amount of money. I typically aim to spend $^{2/3}$ of the budget prepping in pre-production and save the rest to be used during the shoot for unexpected items.

Keep track of every single item you purchase. Create a list or chart including the following information:

- Receipt Number
- Date
- Vendor
- Amount Spent
- Items purchased and what character/actor/effect they are for

This can be a hand-written sheet in your binder, or a document on the computer that you update daily – I actually do both, just to make sure I'm organized. Once all the information is added in using your chosen system, be sure to put the receipt in a very safe place. As I shop a film, I actually keep tape in my purse so I can tape the receipt right onto a blank sheet of paper in my binder. The production will

NAME OF PRODUCTION Following out of a $300 Petty Cash Advance

Hair/Makeup Department Budget

Total

$299.20

Date	Vendor	Item	Cost
6/27/19	Walgreens	Disposables, paper towels, misc.	$26.98
6/27/19	Amazon	Cheyenne Wig	$18.99
6/27/19	Best Buy	Labels	$14.17
6/28/19	Cosmoprof	Christian Hair Product	$19.88
6/28/19	Heads and Threads	70s Cop Mustaches/Sideburns	$35.25
6/28/19	Ulta	Hair Accessories Golfers	$10.46
6/29/19	Michaels	Leather Straps for Viking Beard	$4.67
6/30/19	Chicago Costume	Matt Wig	$33.59
6/30/19	Ulta	Misc. Makeup	$126.40
6/30/19	Amazon	Tattoo Paper	$8.81

Christine Sciortino // Hair and Makeup Designer
Phone Number // Email
Address

Behind the Scenes

typically guide you as to whether they would like one or two receipts taped to each page that you will turn in at the end of the shoot. At my desk, I have a three-hole punch so if I have made an online purchase, I immediately print the invoice and put it directly into the binder.

I also number each receipt corresponding to the line of the spreadsheet I create.

Some productions may give you a form or an envelope with lines to write all the info on by hand. Again, communication is key. Ensure that you understand the system of your production. The producer, production coordinator, or production accountant can likely answer any of your questions.

Something else the production may inform you of is about your state's tax incentive. If you are shooting in a state that offers a tax credit to productions shooting there, the film commission of that state typically stipulates that as many purchases as possible must be made within that state. Therefore, producers may ask you to limit the number of online orders you place from out-of-state vendors. Even if you locate a certain product at a retailer out-of-state for a lower price, check with the producer to see if it is better for the production's tax credit for you to buy the more expensive option locally.

Once you reach the end of your shoot, you will have been keeping track of every purchase, and you will have all your receipts neatly laid-out. Copy them or take photos of them for your own records and then turn them in to the producers, with your budget spreadsheet as the top-sheet. The total amount that you spent for your department should be easily legible. Return any cash change to the producers in an envelope, delivered by you to the office in-person. Note that some productions may ask you to perform this process weekly or monthly. That won't be a problem for you because you are so organized!

Setting Up Your Binder

By now you see that makeup design for film and television is not *only* about showing up and making people look pretty. All this planning is a necessary part of the job and the more organized you are, the easier your job will be once the shoot starts. One final task of your pre-production logistical work is to create a binder containing all the documents you have prepared. Even with all of the technology at our fingertips, productions still do require a lot of hard copy paper. You may find yourself filming in a location that is without internet access, in which case, your binder will be a lifesaver to you and your team.

Pre-Production 43

The first thing I put in my binder is the most recent draft of the script at the front. Next, I label my tabs and arrange my documents as follows:

1. Breakdown
 - Script breakdown chart
 - The notes corresponding to each look on the breakdown
 - Any breakdown you receive from the script supervisor to help with the timeline
2. Mood Boards/Research
 - Mood boards and inspiration images
 - Magazine or newspaper clippings that inspired you
 - Notes you've taken in your research
 - Sketches or design illustrations
3. Budget
 - Spreadsheet to track your spending
 - Blank paper to tape receipts on to/receipt pages
4. Schedules and Call Sheets (The following two lists of documents are generated by the Assistant Directing Department and are detailed in the next section)
 - Any schedules like one-liners or extras breakdowns
 - Day-Out-of-Days
 - Call Sheets distributed each day
 - Your own scheduling notes for hiring additional artists
5. Additional Documents and Timesheets
 - Crew List
 - Timecards to give to new artists on your team
 - Daily Timesheets to turn in to production

Production Documents

As you move through your pre-production work, other departments will also be working on theirs. At meetings and via email, other departments will be distributing documents that are incredibly important for your planning. The documents that will be most important to you come from the Assistant Director's (AD) department.

Scripts and Script Revisions

As we've examined, your work with any film or television program starts with the script. In her book *Running the Show: The Essential Guide to Being A First Assistant Director*, author Liz Gill suggests you "Try to read it as an audience will see it, and understand what it is you are all trying to make." When a script is "locked," it means that, although story elements or dialogue may change, the scene numbers will not. The locked script is also called the "shooting script," "production draft" or the "white script" – as it is issued on white paper. Therefore, every script revision has to be clearly issued and designated. This is done through different drafts each with different colors. The US and the UK differ on the color systems. "In the US, each new batch of script pages are all issued on the same color paper, with the date and color of the page at the header of every page (the color will be written out, 'GREEN,' as when you're making a photocopy you might not have handy access to

green paper." (Gill 15) The draft colors are issued in chronological order as follows:

> WHITE
> PINK
> BLUE
> YELLOW
> GREEN
> GOLDENROD

Once you get into shooting, the writers will often make revisions and production may not send out an entire new script. Rather, they will only send out the "pages." You will receive an email and usually a colored hard copy of these revised pages. The pages are typically also dated so everyone knows when the revisions occurred. If you are working as a third artist or assistant, it may be one of your tasks to keep your Department Head's script collated – meaning insert the new colored page revisions to their hard copy script. Make sure you check with your Department Head if you should throw out the old pages or keep them somewhere separate.

Within revisions, scenes may be added to a locked script, in which case letters are added. For instance, if a scene is added to a locked script between scenes 92 and 93, you will need to make sure your breakdown reflects the new scenes – which are now 92A and 92B. If scenes are cut from a locked script, the scene number stays the same, but the content will simply say "OMITTED." Make sure to adjust this in your breakdown as well. You can also double check with the script supervisor if you are unsure whether or not any script days have changed.

Stripboard

Another important document you will receive from your AD is a **stripboard**. This term traditionally refers to actual strips of colored paper that the AD office would attach to a board on the wall and move around as the schedule changed. Now, most schedules are made electronically through specific software that can generate the schedule with a click of a button. Because of this, the term **one-liner** has become popular for this document. You may see either name, but know that this is just a simplified schedule, with each line in a chart referring to a different scene.

Stripboards are also typically color coded, showing the time of day that the scene takes place, as well as days off during the shoot. The traditional colors are as follows:

Day Interior – White

Day Exterior – Yellow

Night Interior – Blue

Night Exterior – Green

Day Separator – Black (Grey if the schedule was made with Movie Magic Scheduling software)

Week Separator – Orange (Corresponds to a Sunset Exterior/Evening if the schedule was made with the software Scenechronize or Movie Magic Scheduling)

Free Day – Grey

Holiday – Red

Different software each has slightly different conventions so don't be afraid to ask your AD if you'd like clarification. The sample stripboard included here, for instance, does not follow the exact conventions listed, however, a key is included to indicate which colors hold which meaning.

When the stripboard is being created, the AD assigns numbers to each cast member. As mentioned, #1 is usually your lead actor, and the numbers continue chronologically from there. Typically, the higher the number, the smaller the role. If there is a child actor, you will find a "K" next to their name. If there is a stunt double, they will have the same number as the actor they are doubling, but with an X. For example, the stunt double for actor #6 will be #6X. If you have stunt performers playing their own roles, their numbers begin in the 100s.

The stripboard shows each shooting day and the order of the scenes that will be shot on that day, with the date itself being the last "strip." Very rarely are films shot in chronological order. The AD has carefully arranged the schedule likely based on location, time of day, actor availability, picture vehicles, stunts, and many other elements. You may be at a certain location all day, but you may shoot multiple scenes facing one direction in the location then "flip the world," meaning the camera faces the opposite way. This is generally easiest for Lighting and Set Decoration Departments who have large equipment and furniture to move. For departments like Hair, Makeup, and Wardrobe, however, this type of shooting can be tricky. If you are changing scenes and the scenes take place on different script days, you will be changing makeup looks several times throughout the shooting day and you may have to go back and forth between script days. The AD should also know that this takes time. The time for a large makeup setup that the actor has to then remove for the next scene, and then do both looks again when the camera moves, may still take less time than moving the lights and furniture. It's tough for you, but that is part of why it is so important to have good continuity photos so you can match looks. We'll cover continuity in Chapter 3. Talk to the AD if you think this could be avoided in the schedule, and if not, make sure you express how much time you will need for the changeovers.

If you are a Department Head, the stripboard will be especially helpful in booking additional labor. You will quickly be able to see how difficult or cast-heavy a particular day will be and plan to hire additional makeup artists to work.

Information you can generally find on the stripboard includes:

The scene number
The scene location
If the scene is interior or exterior
The time of day the scene takes place (Morning, Night, Day, Dusk, etc)
The number of pages of the scene
Which actors are in the scene – listed by their numbers.

Check on your stripboard every day to make sure you are always planning ahead and be aware that there may be revisions. The schedule revisions also follow the same general color convention as script revisions.

TADAIMA SCHEDULE - BLUE PAGES

White = Interior Day

Yellow = Exterior Day

Orange = Evening

Green = Interior Night

Blue = Exterior Night

Day 1

Sheet #: 3 1/8 pgs	Scenes: 3	EXT Day	Creek The truck crosses a wood bridge.	1, 3, 4	Est. Time
Sheet #: 4 3/8 pgs	Scenes: 4	EXT Day	HOUSE - FRONT The truck drops off the family.	1, 2, 3, 4	Est. Time
Sheet #: 5 2/8 pgs	Scenes: 5	EXT Day	HOUSE - FRONT LAWN The family looks at the house. Akiko walks indoors	1, 2, 3, 4	Est. Time

Company Move

Sheet #: 2 4/8 pgs	Scenes: 2	EXT Day	Ocean Side Road The family rides on a pick up truck.	1, 3, 4	Est. Time

End of Shooting Day 1 -- Thursday, June 20, 2013 -- 1 2/8 Pages -- Time Estimate: 0:00

Day 2

Sheet #: 6 1/8 pgs	Scenes: 6	EXT Day	HOUSE - BACK Akiko runs behind the house.	2, 4	Est. Time
Sheet #: 8 1/8 pgs	Scenes: 8	EXT Day	HOUSE - BACK George follows his sister.	3, 4	Est. Time
Sheet #: 12 2/8 pgs	Scenes: 12	EXT Day	ALCOVE George and Akiko dig out a box.	3, 4	Est. Time
Sheet #: 13 2/8 pgs	Scenes: 13	EXT Day	HOUSE - BACK Akiko runs around the house, calls for Mama.	4	Est. Time
Sheet #: 14 2/8 pgs	Scenes: 14	INT Day	MUD ROOM Akiko runs through mud room.	4	Est. Time
Sheet #: 7 2/8 pgs	Scenes: 7	INT Day	MUD ROOM Kaori enters the house.	2	Est. Time
Sheet #: 10 1/8 pgs	Scenes: 10	INT Day	KITCHEN Kaori enters the kitchen.	2	Est. Time
Sheet #: 19 2/8 pgs	Scenes: 20	INT Evenin	KITCHEN Burning wood in furnace.	2	Est. Time

The first page of a stripboard shooting schedule for the short film *Tadaima*, directed by Robin D'Oench

Day-Out-of-Days

"The **Day-Out-of-Days** [DOOD] is an unwieldy term for a chart in grid form that shows how many days a given actor/vehicle/animal or any other element is required over the course of the schedule" (Gill 54). For you, in the Makeup Department, think of the DOOD as the quickest way to know when your actors are working. This chart lists each character's name and number down one column, and then cross-references it with every day of the shoot across the horizontal column. Abbreviations fill in the boxes for each actor's work status on a given day.

The most common abbreviations are:

- WS – Work Start – The actor's first day of multiple days of work, may also be listed as SW for Start Work.
- W – Work – A day of work for the actor that is neither their first day nor their last day
- WF – Work Finish – An actor's last day of work
- SWF – Start, Work, Finish – Meaning, it is an actor's first and *only* day of shooting, they will start their work and finish it on that same day.

By looking at the statuses on the DOOD you also can get an overall picture of the supplies you will need. Let's say you need to paint an actress's nails. If she is the lead (#1) and works every day of a 60-day shoot, you will want to stock several bottles of her nail polish color for frequent re-application. If you look at the DOOD and you see her SW (Start Work), the next day W (Work), then she's off for a day, then the next day WF (Work Finish), you'll know that she only works three days the entire shoot. She may be traveling in just for that week, and then may not be involved in the rest of the shoot. This is quite common, as productions save money when they "shoot out" actors, meaning, film all their coverage in a short amount of time so they can release the actor – regardless of whether or not that actor's coverage is indeed continuous or spread throughout the film.

This method of checking the DOOD works for every character-specific product you will need to stock. If an actor who needs a large mustache fabricated is in the DOOD as a SWF – meaning he only works one day, I would make sure I have his mustache for that day. I would *also* still make sure I have one made for a test, and one or two backups in case the original gets lost or damaged, or if production calls him back for future days.

Of course, continuity – the process of keeping track of each look and making sure looks that need to stay the same over time, do in fact stay the same – is *always* important for our department. When you check your DOODs, you will notice where it is *especially* important – for example, if an actor works for 25 days and he is in the same look each day.

On the DOOD you may also see the following abbreviations:

- H – Hold – An actor is not officially scheduled in the scenes planned for that day, however the production may be anticipating a weather change or last-minute schedule change and they would want that actor to come in. In that case, make sure you still have their products ready.
- T – Travel – The actor is traveling in from out of town or leaving town. This is especially important when scheduling makeup tests, eyelash appointments, haircuts, or other modifications that are best done ahead of time.
- R – Rehearse – The actor is called in for rehearsal but not filming that day. This is especially common for stunt performers who often practice dangerous stunts or complicated fight scenes outside of the days they are filming. If you see a rehearsal in the schedule and you know you want to meet an actor in person – maybe you have a specific question for her, or want to see the current length of an actor's beard – you may sometimes want to arrange to be present for the rehearsal.
- FT – Fit – The actor has a costume fitting scheduled. There are instances in which you may want to coordinate the makeup with the clothes or take other inspiration from the costume. If you see a fitting on your DOOD, this is an excellent time to contact your Costume Designer or Wardrobe Department to ask for photos of the costume that was decided upon. If fittings are taking place nearby, you may also be able to visit.

In addition to the DOOD for your main cast, you will usually also receive a Background DOOD and, depending on the production, you might receive them for vehicles, weapons, or animals. These last three tend to be less pertinent to the Makeup Department, however, it is good to be aware of what is planned.

You will definitely find yourself referencing your Background DOOD. This is an easy way to view how many background actors/extras are working and over how many days. The "type" of extra is usually defined on the DOOD as in the script – for example, "8 Dive Bar Patrons." The DOOD will designate maybe these same eight people are W (Work) for three days so you will have to make sure their looks stay the same. Sometimes the DOODs will reveal a high number of background actors – for example "300 Graduation Ceremony Attendees." When you see these high numbers, that is also a good time to plan the additional artists you will hire for that day. The numbers on the DOODs should be the same as on the stripboard, but if you have any questions, ask your AD.

Pre-Production

Dec 19, 2019
10:49 AM

A MOVIE DOODS

Page

	Month/Day	11/10	11/11	11/12	11/13	11/14	11/15	11/16	11/17	11/18	11/19	11/20
	Day of Week	Sun	Mon	Tue	Wed	Thu	Fri	Sat	Sun	Mon	Tue	Wed
	Shooting Day		6	7	8	9	10			11	12	13
1.	MARCUS LUND		W	W	W	W	W			W	W	W
2.	WENDY		W	W	W	W	W			W	W	W
3.	ALYSSA LUND											
4.	DOMINIC LUND											
5.				WD								
6.			H	WD								
7.			H					FT		SW	WF	TR
8.				TR	SW	WF	TR			TR	FT	SWF
9.							TR					
11.												
12.												
13.												
14.												
17.												
27.			TR	W	W	W	W	TR		TR	SWF	H
28.			TR	W	W	W	W	TR			W	
30.				TR	TR	W	TR				H	
34.					SW	W	TR					
x100.						SWF	TR			TR		
x101.												
x102.												
x103.				TR	TR	SWF	TR					
x104.												
x122.												
x123.												
x126.												
x127.												
x129.												TR
x130.												
x131.												
x132.												
x133.												

Sample Day-Out-of-Days – created by Robin D'Oench

Call Sheets

The **call sheet** is arguably the most important document in all of film production – as Liz Gill calls it, "the daily bible" (Gill 95). The call sheet is a scheduling document distributed by the AD Department the day before a shoot happens. Schedules change often in the world of film and television, so a call sheet for a workday cannot be distributed until the end of the previous day. The most basic information you will find on the call sheet is where you're going for work and what time you need to be there – your **call time**. However, there is so much more. Let's examine a full call sheet and break it down because the amount of information can sometimes seem overwhelming.

The top of the front of the call sheet will list the general crew call time. In small letters, you will typically notice "see back for individual call times." This is incredibly important! In the Makeup Department you will *rarely* be called at the same time as the rest of the crew. Many productions want the actors to have their hair and makeup finished, or at least mostly finished, by the time the crew arrives on set so rehearsals and shooting can begin right away. That means the Hair, Makeup, and Wardrobe Departments (collectively referred to as **Vanities**) frequently have a **pre-call** – a call time that is earlier than the general crew call. While this does mean a longer day for you, nationwide unions allow you breakfast breaks and overtime payment.

Unions also require a certain amount of **turnaround** time – the time you spend from leaving set until the time you come back. If your union guarantees you a nine-hour turnaround and you are still shooting at midnight, the AD might approach you and tell you to go home because they need you to come back at 9:00AM. This is common in departments of several people where call times are staggered based on which artist does the makeup for specific actors. There might be times where your Department Head will leave set and you will stay to cover set until the end of the night. If shooting goes very late, you may be given a call time that is later than the rest of your department's in order to account for your turnaround, or if your Department Head doesn't need you in the morning and is kind enough to let you get some sleep. When you are first starting out, try not to negotiate your call time if you can avoid it. The Department Head is in frequent contact with the Assistant Directing Department and there is a lot of thought that goes in to each call time. When you are selected to be a full-time artist on a project, it is typically expected that you are available 24 hours a day. So do make sure you flip to the back of the call sheet, where every crew member is listed with individual call times because you truly never know in advance what it will be.

On the front under the general crew call time you will sometimes see a shooting call. Let's say the general crew call is 8:00AM and the shooting call says 9:00AM. This means the crew has one hour to set up, actors may be finishing up in Vanities or rehearsing with the Director during this hour. Regardless, you know you have to be on set for touch-ups and ready to shoot by 9:00AM.

In the top left corner of the front of the call sheet, you will see the production office and production

company details. This can be helpful if you need to have packages of supplies sent to the office or if you are filling out your start paperwork and don't know who the production company is. The Director, Executive Producer, Producers, and Writers will be listed right under that.

The top right of the call sheet will say the calendar date as well as the day of production. If it is the 19th day of a 37 day shoot it will read "Day 19 of 37." Below this, you will see the weather forecast for the day. We will discuss appropriate weather dress in the next chapter. This section of the call sheet will also list the nearest hospital to the location. Hopefully you don't need it, but it's good to be aware of just in case.

Before the next section of the call sheet, you will sometimes see a horizontal row with notes specific to that day or production. "No visitors" may be listed or there might be other production notes about rehearsals, prep work, or company moves.

In the main body of the call sheet, a chart lists the scenes scheduled for that day, in shooting order. The first column lists the description, the next column the scene number, the next the cast numbers, then the script day, then the number of pages, and the last column will list the location. This may be an address, a street name, or the number of a specific soundstage. You may be moving throughout the day so be sure to check your addresses. At the bottom of this chart you will see the total page count of the day. Looking at the number of pages can be a good gauge of how long a scene will take to shoot, but you

can never really be sure. Sometimes you will notice between scenes the announcement "COMPANY MOVE." A **company move** is when the entire production must break down at one location and everyone must transport themselves or be transported to the next location. The AD will generally provide the information on whether the moves will be with crew members taking transportation vans or self-driving. Either way, a company move typically means that the hair and makeup trailer will close up and drive to the next location as part of the move. Therefore, if you see a move in your schedule, you will have to plan time to break down your station and secure all your products, then to take everything back out at the next location once the trailer has been powered back up. Keep in mind that even if you are self-driving to the next location, you are still on the clock and expected to report to the trailer at the next Basecamp as soon as possible.

The next section of the sheet may be the most important for our department. This lists all the actors called and their call times. The first column will list their character number, then the actor's name, then their character name, then their work status. These statuses are the same as on the DOOD and can be helpful to know even if an actor is coming in for a fitting or rehearsal. Especially when actors are traveling in from out of town for a shoot, they often are picked up by production transportation ("transpo") drivers and brought to the location where they all have their own trailers. These next columns often say

"Leave" – what time they are being picked up from their hotel – and "Report" – what time they need to be at work. Many call sheets now have the next column "HMU" meaning "Hair and Makeup." That reflects what time the actor will be in your chair. The next column says "REH," meaning "rehearsal." Check these carefully. Is the actor rehearsing before they come to hair and makeup or after? Either option will affect your timing. Finally the column that says "Set" is crucial. That means the actor has to be on set ready to shoot. You will frequently hear AD lingo such as "in the chair," meaning the actor is in hair and makeup being worked on, or "through the works," meaning he or she is completed in hair and makeup. Other terms for this may be "100," or "camera-ready." If an AD asks you, "Is she 100 with you?" that means "Are you completely finished with her makeup?" and it is often at that point that an actor is "invited" to set. In the far column you might see notes that may or may not be relevant to your department like "pick up from airport," or "haircut at end of day."

This chart also offers you information about your stunt performers. These are particularly important to schedule as the Stunt Department often rehearses extensively before they shoot their scene. They may want to do hair and makeup before or after rehearsal. You also may request with a stunt double that they come in at the same time as the actor they are doubling so you can have them side by side and "match" them. Sometimes in the cast list on the call sheet you will see "ND" next to the stunt performers as in "ND Stunt Driver," or "ND Stunt Prisoners." ND means **non-descript**. This means these performers can look however you want them to as long as they fit within the context of the scene. With ND, usually any period-appropriate beard or hairstyle is fine. In contemporary films, the ND stunt performers might even wear their own clothes and if they are driving cars or part of a crowd, they may not even need makeup, perhaps just a little sunscreen.

The creation of this entire chart of performer call times largely hinges upon the Hair and Makeup Departments. If you are the only artist or the Department Head, you will be in constant communication with the 2nd Assistant Director (the person who makes the call sheets) about the needs of your department. Each day at lunch the 2nd AD will circulate a "Draft Call Sheet," also called a "Preliminary Call Sheet" ("Prelim") that has a tentative schedule for the next day. At this time it is your responsibility to connect with him or her to discuss the flow for the top of the day. The 2nd AD may tell you "we will need this actress on set at 7AM." If you know it takes you half an hour for you to do her makeup, and the 2nd AD knows it takes her about 15 minutes to put her clothes on, they may call her at 6:00AM, have her change clothes first, then her HMU call time would be 6:15AM. Hair and makeup artists are typically given a courtesy of 15 or 18 minutes to set up their stations in the trailer before their first actor. So your call time might be 6:00AM as well or

even 5:45AM. Once the actress gets in your chair at 6:15AM, if you told the 2nd AD you need half an hour, you will be given *exactly* half an hour before she is escorted from your chair to travel to set. It is therefore incredibly important to be as accurate with your time estimates as possible. If you are running behind schedule, the actors are late to set – that means the entire production, which sometimes includes hundreds of people, is behind schedule.

One important factor to note when considering call times is the particular time of each union or each production. Some productions use the 24-hour clock, "military time," for all production-related documents including call sheets and timecards. Others use the 12-hour clock and designate between AM and PM. Productions may use traditional, quarter-hour timing (i.e. "9:00, 9:15, 9:30, 9:45, 10:00") or they may divide the hour into fractions of ten. This can be confusing at first. Think of the hour as 60 minutes, divided into ten is six. If your union or production runs on "10ths of an hour," every call time appears as a multiple of six (i.e. "9:06, 9:12, 9:18, 9:24, 9:30, 9:36, 9:42, 9:48, 9:54, 10:00). If this is the measuring system of your production, you will typically receive 18 minutes to set up before your first actor. So if your first actor comes in at 5:00AM, your call time will be 4:42AM. If the system includes military time *and* 10ths, and you have an afternoon or evening call, it may not be a time system you are familiar with. The call time 16:42 would be 4:42 PM in order to prepare for an actor whose call time is 17:00, or 5:00PM.

The 24-hour clock time is as follows:

12AM	00:00
1:00AM	1:00
2:00AM	2:00
3:00AM	3:00
4:00AM	4:00
5:00AM	5:00
6:00AM	6:00
7:00AM	7:00
8:00AM	8:00
9:00AM	9:00
10:00AM	10:00
11:00AM	11:00
12:00PM	12:00
1:00PM	13:00
2:00PM	14:00
3:00PM	15:00
4:00PM	16:00
5:00PM	17:00
6:00PM	18:00
7:00PM	19:00
8:00PM	20:00
9:00PM	21:00
10:00PM	22:00
11:00PM	23:00
12:00AM	24:00
(End of workday)	(Confirm with your union)

To complicate matters even more, when your production divides into 10ths of an hour, they usually want you to fill out your timecards using decimals of ten – again, based on increments of six. For example:

4:00	4.0
4:06	4.1
4:12	4.2
4:18	4.3
4:24	4.4
4:30	4.5
4:36	4.6
4:42	4.7
4:48	4.8
4:54	4.9
5:00	5.0

54 Behind the Scenes

Don't worry – it seems confusing if this information is new, but if it is your union's system, it will soon become second nature!

Moving down beyond the actor call times, you will see on the call sheet stand-ins and background actors – how many are called and what time they are reporting. The background call time is particularly important if you are a Department Head and you need to arrange for additional artists to go to the background holding location in order to check those background actors.

On the right of this, you will see a special instructions box. This is information for each department that the AD has isolated in their breakdown as important for the scenes of the day. It may list "Props: 2 Guns, Scene 4," "Additional Labor: Animal Wrangler," or for our department "Makeup: Bloody head wound, Scene 14." These notes are a courtesy reminder from the AD Department. They are *not* a replacement for your own breakdown. It's possible that the AD has missed a makeup element in this list but it is in your breakdown. Conversely, it is possible that you have overlooked something so the note on the call sheet comes as a surprise. If either of these occurs, check in with your AD to make sure you are on the same page. Make sure to check these notes and cross-reference with your own every day.

Below the notes, the call sheet will also list addresses for the following spaces:

- **Holding:** This refers to talent or background actors – a large space they are given to stay and relax until they are needed on set. If you are a makeup artist assigned to cover background, you may be asked to report straight to Holding to begin your day.

- **Catering:** This is where breakfast and lunch are set up – note that these meals are not always served in the same place.

- **Basecamp:** Basecamp is the "home base" for cast, production, and vanities – an off-set location where the trailers will set up in a cluster and get the cast ready for the top of the day. At Basecamp you can find the actors' trailers, the "Honeywagon" – a truck which includes both the AD Department offices and usually bathrooms, the wardrobe truck, and the Hair and Makeup trailer. As a full-time makeup artist on a production, you will typically report to Basecamp unless otherwise noted. There you will set up in the trailer or pick up supplies, whatever you need to begin your day. Basecamp is sometimes right next to set, and sometimes it is quite a distance away. It also may or may not be near Crew Parking. In the case of spread out locations like this, production station vans at each location to shuttle crew members from place to place. Once you get your actors ready at Basecamp, you will often get in the van with them and you will all travel to set together. In the event that breakfast is far from Basecamp and your call time does not allow you to travel to and from the breakfast location (it could take up to an additional half-hour or more), some productions will have the Production Assistants (PAs) pick up breakfast for you when they get breakfast for the actors. Keep in mind this is a courtesy not to be taken advantage of. That said, if you have a pre-call, union and labor laws do require you to take a breakfast break (called a "Non-Deductible Breakfast" or "NDB") for a

A Company

A MOVIE

Tuesday, May 21st, 2019

Director/Writer: Terry Malloy
Producer: Miranda Priestly
Producer: Erica Berry
Producer: Vincent Hanna
Producer: Moe Green
Exec. Producer: Frank Ricard
Line Producer: Bud Fox
Production Office
Production Office Info

Day: 12 out of: 27
Pink Screenplay (4/29/19)
Pink Schedule (4/30/19)

General Crew Call
Shoot-Call 9:45am
8:00AM

Weather: Mainly Sunny, 15-25mph winds
Predip: 0%
Humidity: 46%
Hi: 68° Lo: 50°
Sunrise 5:33AM | Sunset 8:13PM

TRUCK PARKING \| HMU \| WARD \| 2BANG	HOLDING \| SATELLITE HMU	BREAKFAST \| CREW PARKING	NEAREST HOSPITAL
On Site	The 1896 Studio 592 Johnson Avenue Brooklyn, NY 11237	At Holding RTS @7:00AM	Wyckoff Heights Medical Center Emergency Room 337- 381 Stanhope Street Brooklyn, NY 11237 DIAL 911 IN EMERGENCY

NEARBY SUBWAY: L Train to Jefferson St.

PLEASE SEE THE REVERSE FOR YOUR INDIVIDUAL CALL TIME ***ALL PRE-CALLED CREW MUST NDB***

No Forced Calls or Overtime without Prior approval of LP/UPM

All Calls Subject to Change by Assistant Director Department	No Photography/Social Media Posting	No Visitors Without Prior Approval from Producers

Scene	Description	D/N	Cast	Pages	LOCATION DETAILS
	DANCE TOURNAMENT ON SEAMLESS				
12	INT. DANCE TOURNAMENT *The Family of Four Dance Tourney: JAKE, KYRA, MIKA, YANG*	N 1	1, 2, 3k, 4	3 /8 Pages	
12B	INT. DANCE TOURNAMENT *The Family of Four Dance Tourney: RUSS' Family competes*	N 1	8	1 /8 Pages	
12A	INT. DANCE TOURNAMENT *The Family of Four Dance Tourney: GEORGE's Family competes*	N 1	6, 11, 12k, 13k	1 /8 Pages	
12C	INT. DANCE TOURNAMENT *The Family of Four Dance Tourney: CLEO's Family competes*	N 1	7	1 /8 Pages	
12D	INT. DANCE TOURNAMENT *The Family of Four Dance Tourney: ADA's Family competes*	N 1	5	1 /8 Pages	Studio 10 Johnson St. Brooklyn, NY 11237
	BLUE SCREEN				
16pt3	INT. BOTANICAL LABS - KYRA LAB (SCREEN CALL PT.3) *Screen Call Pt. 3 - KYRA urges Mika to calm down*	M 2	1 (OS), 2	3 /8 Pages	
23pt2	INT. BOTANICAL LABS - KYRA LAB (SCREEN CALL PT.2) *Screen Call Pt. 2 - KYRA thinks they should have bought new*	D 2	1 (OS), 2	5 /8 Pages	
84pt2	INT. BOTANICAL LABS - KYRA LAB (SCREEN CALL PT.2) *Screen Call Pt. 2 - KYRA tells Jake he needs to pick up Mika*	D 5	1 (OS), 2	4 /8 Pages	
	USE STAGE MEZZANINE AS SET FOR 66A				
66A	INT. CONCERT *MEMORY: (Yang POV) at a Concert with ADA*	N	5	3 /8 Pages	

Total Pages: 2 6/8 pgs

#	Cast	Character	Stat.	P/U	Arr.	Reh.	HMU/Ward.	Set Call	Remarks
1	Thomas A. Anderson	JAKE	W	8:00AM	8:30AM	9:00AM	8:30AM	9:30AM	Rpt. HMU; Rehearsal w/ Choreo
2	Vivian Ward	KYRA	SW	6:30AM	7:00AM	9:00AM	7:00AM	9:30AM	Rpt. HMU; NDB @8:15AM
3k	Vada Sultenfuss	MIKA	W	7:30AM	8:15AM	9:00AM	8:15AM	9:30AM	Rpt. HMU; Rehearsal w/ Choreo; School at Res: 3hrs.
4	Daniel LaRusso	YANG	W	7:20AM	8:15AM	9:00AM	8:15AM	9:30AM	Rpt. HMU; Rehearsal w/ Choreo
5	Alabama Whitman	ADA	WD	10:15AM	10:45AM	12:45PM	10:45AM	1:15PM	Rpt. HMU; Rehearsal w/ Choreo
6	Ted Kazanski	GEORGE	SW	9:50AM	10:30AM	11:15AM	10:30AM	11:45AM	Rpt. HMU; Rehearsal w/ Choreo
7	Patience Phillips	CLEO	WF	10:00AM	10:45AM	12:00PM	10:45AM	12:30PM	Travel together with MM
8	Josh Baskin	RUSS	WF	8:30AM	9:45AM	10:30AM	9:45AM	11:00AM	Rpt. HMU; Rehearsal w/ Choreo
11	Andie Anderson	VICKY	SW	S/R	10:00AM	11:15AM	10:00AM	11:45AM	Rpt. HMU; Rehearsal w/ Choreo
12k	Adrien Cronauer	TWIN #1	SW	S/R	10:00AM	11:15AM	10:00AM	11:45AM	Rpt. HMU; Rehearsal w/ Choreo
13k	Daniel Hillard	TWIN #2	SW	S/R	10:00AM	11:15AM	10:00AM	11:45AM	Rpt. HMU; Rehearsal w/ Choreo

Background / Stand-Ins | **Special Instructions & Elements**

#	Character Description	Scene	Arr.	Reh.	HMU/Ward.	Set Call
1	SI - KYRA	12, 16pt3, 23pt2, 84pt2	8:00AM			8:00AM
3	RUSS' FAMILY	12B	7:00AM	10:30AM	7:00AM	11:00AM
3	CLEO'S FAMILY	12C	7:00AM	12:00PM	W/N	12:30PM
3	ADA'S FAMILY	12D	8:00AM	12:45PM	W/N	1:15PM
25	CONCERT GOERS	66A	10:00AM	5:30PM	W/N	5:45PM

BACKGROUND/STAND IN NOTES: 2 STAND IN, 9 DANCERS, 25 BG

PROPS
DANCE Universal Gaming System

SOUND
DANCE Playback
CONCERT Playback

CAMERA
16pt3 Screen Call Ozu Shot-Reverse-Shot

WARDROBE
Sc. 66A Someone in the crowd wears a Lily Chou Chou Shirt

Advanced Schedule - Wednesday, May 22nd, 2019

Scene	Description	D/N	Cast	Pages	LOCATION DETAILS
74	EXT. GEORGE'S HOUSE *JAKE asks GEORGE's family about Ada. The TWINS don't know her, but VICKY does*	D 4	1, 6, 11, 12k, 13k	3 6/8 Pages	
	COMPANY PUSH				
67	INT/EXT. GEORGE'S HOUSE *GEORGE asks JAKE how he's holding up. Jake gets choked up*	D 4	1, 6	4 /8 Pages	LOCATION #1 2 Perth St. New York, NY 10977
73	EXT. FLEMING HOUSE *JAKE walks towards his house, but decides to visit GEORGE*	D 4	1	2 /8 Pages	LOCATION #2 130 Grotke Avenue New York, NY 10977
57o	INT. FLEMING HOUSE - LAUNDRY ROOM *MEMORY: (Yang POV) Clothes hanging.*	D/N Flex	N/A	1 /8 Pages	
79	EXT. FLEMING HOUSE - ATRIUM *Atrium Tree sways in the night.*	N 4	N/A	/8 Pages	

1st Assistant Director | Line Producer | Unit Production Manager | 1st Assistant Director
2nd Assistant Director:
2nd 2nd Assistant Director:

Unit Production Manager:
Production Coordinator:

Sample Call Sheet, Front Side – created by Robin D'Oench

A MOVIE

Tuesday, May 21st, 2019 Shoot Day: 12 of 27

#	DEPT/POSITION	NAME	CALL
	DIRECTOR / WRITER / PRODUCERS		
1	Director / Writer		8:00AM
1	Producer		O/C
1	Producer		O/C
1	Producer		O/C
1	Producer		O/C
1	Exec. Producer		O/C
1	Line Producer		O/C
	ASSISTANT DIRECTORS		
1	1st Assistant Director		8:00AM
1	2nd Assistant Director		6:30AM
1	2nd 2nd Assistant Director		7:00AM
1	Key PA		6:30AM
1	First Team PA		6:30AM
1	Ppwk PA		6:30AM
1	BG PA		6:30AM
1	Set PA		6:30AM
	CAMERA		
1	Director of Photography		8:00AM
1	"A" Cam 1st AC		8:00AM
1	"A" Cam 2nd AC		8:00AM
1	Digital Loader		8:00AM
1	Stills Photographer		9:00AM
	ELECTRIC		
1	Gaffer		6:30AM
1	Best Boy Electric		6:30AM
1	Generator Operator		6:30AM
1	Company Electric		6:30AM
1	Additional Electric		6:30AM
1	Additional Electric		6:30AM
	GRIP		
1	Key Grip		7:00AM
1	Best Boy Grip		7:00AM
1	Dolly Grip		7:00AM
1	Company Grip		7:00AM
1	Company Grip		7:00AM
1	Company Grip		7:00AM
1	Additional Grip		7:00AM
1	Additional Grip		7:00AM
	RIGGING ELECTRICS		
-	Rigging Gaffer		O/C
-	Rigging Best Boy Elec.		Per R.G.
-	Rigging Electric		Per R.G.
-	TBD		Per R.G.
	RIGGING GRIPS		
-	Key Rigging Grip		O/C
-	Rigging Best Boy Grip		Per R.G.
-	TBD		Per R.G.
-	TBD		Per R.G.
	EDITORIAL		
0	Post Supervisor		N/C
0	Editor		N/A
0	Assistant Editor		N/C

#	DEPT/POSITION	NAME	CALL
	ART		
0	Production Designer		O/C
0	Art Director		O/C
0	Graphic Designer		Per P.D.
0	Art Dept. Coordinator		Per P.D.
0	Art Dept. PA		Per P.D.
	PROPS		
1	Prop Master		8:00AM
1	Assistant Prop Master		8:00AM
	SET DRESSING		
0	Set Decorator		O/C
0	Asst. Set Decorator		O/C
0	Leadman		O/C
0	Dresser		O/C
0	Dresser		O/C
1	Key On-Set Dresser		8:00AM
1	On-Set Dresser		8:00AM
	CONSTRUCTION		
0	Construction Coordinator		O/C
0	Key Carpenter		O/C
0	Key Grip		O/C
0	BB Grip		O/C
0	Shop PA		O/C
	SCENIC		
0	Charge Scenic		O/C
0	Scenic Industrial		O/C
1	Camera Scenic		8:00AM
	GREENS		
0	Key Greens		O/C
	SOUND		
1	Sound Mixer		8:00AM
1	Boom Operator		8:00AM
1	Audio Playback		8:00AM
	COSTUMES		
1	Costume Designer		O/C
1	Assistant Costume Designer		O/C
1	Wardrobe Supervisor		6:30AM
1	Key Costumer		8:00AM
0	Costume Coordinator		Per C.D.
0	Tailor		Per C.D.
1	Additional Costumer		6:30AM
	CASTING		
0	Casting Director		N/C
0	Casting Director		N/C
0	Casting Associate		N/C
0	BG Casting Director		N/C
0	BG Casting Assoc.		N/C
	ACCOUNTING		
0	Production Accountant		N/C
0	1st Assistant Accountant		N/C
0	Payroll Accountant		N/C
0	Accounting Clerk		N/C

#	DEPT/POSITION	NAME	CALL
	PRODUCTION		
1	Unit Production Manager		O/C
0	Production Coord.		O/C
0	APOC		Per UPM
0	Prod. Secretary		Per UPM
0	Office PA		Per UPM
	CONTINUITY		
1	Script Supervisor		8:00AM
	HAIR / MAKE UP		
1	Make Up Dept. Head		6:30AM
1	Makeup Key		6:30AM
1	Additional Make Up		6:30AM
1	Additional Make Up		6:30AM
1	Hair Dept. Head		6:30AM
1	Hair Key		6:30AM
1	Additional Hair		6:30AM
1	Additional Hair		6:30AM
	TRANSPO		
-	Transpo Captain		O/C
-	Co-Captain / Driver - Camera		Per T.C.
-	Driver - Grip		Per T.C.
-	Driver - Electric		Per T.C.
-	Driver - Props		Per T.C.
-	Driver - 2 Banger		Per T.C.
-	Driver - HMU/W Combi		Per T.C.
-	Driver - JAKE		Per T.C.
-	Driver - Rigging Truck		Per T.C.
-	Driver - 15 Pass #1		Per T.C.
-	Driver - 15 Pass #2		Per T.C.
-	Swing Truck		Per T.C.
	VFX		
1	VFX Supervisor		O/C
0	VFX Producer		O/C
0	VFX Producer		O/C
0	VFX Data Wrangler		O/C
0	VFX Coordinator		O/C
	ADDITIONAL LABOR		
1	Choreographer		8:00AM
1	Choreo Assistant		8:00AM
1	Set Tutor		8:00AM
1	Medic		8:00AM
1	SFX		3:00PM
	LOCATIONS		
1	Location Manager		O/C
0	Assistant Location Manager		Per L.M.
0	Locations Coordinator		Per L.M.
1	Location Assistant		Per L.M.
1	Unit PA		Per L.M.
0	Parking Coordinator		Per L.M.
	CATERING / CRAFTY		
-	Caterer		See Below
-	Head Chef		See Below
-	Craft Services		8:00AM
1	Crafty PA		8:00AM
	LEGAL		
0	Production Counsel		N/C
0	Production Counsel		N/C
0	Cinereach Counsel		N/C

NOTES

***A Safety Meeting will be Held at Call on Set

CATERING

BRKFST FOR	66 CREW	1 BG	2 CAST	RDY @	7:00AM	AT:	Base Camp #1	
LUNCH FOR	66 CREW	36 BG	10 CAST	RDY @	1:30PM	AT:	Base Camp #1	
DINNER FOR					N/A			

Sample Call Sheet, Back Side – created by Robin D'Oench

Pre-Production 57

specific length of time. If there is any confusion on how to take your break or when, ask your department head what they prefer for you to do.

- **Crew Parking:** Crew Parking is usually a designated parking lot where crew members can park for free. If this is a commercial parking lot in a city, the Production Department usually has parking validation tickets so make sure to grab one before leaving for the day so you won't have to pay. Again, Crew Parking may be far from Basecamp or Holding. Especially if you have a pre-call, when there aren't a lot of crew members arriving, vans may be scarce. You'll need to make sure in the morning that you know where to report and that you give yourself *plenty* of time to find a parking space and get a van to shuttle you to the trailer at Basecamp or the Holding location. Your call time reflects your 15 or 18 minutes to set up and you do *not* want to spend that time traveling rather than getting ready for your actor. I generally give myself at least an extra 20 minutes in the morning to park and I look up the addresses of each location the night before to see if this is sufficient.

Luckily, along with the call sheet, the AD Department also distributes a map with all these locations clearly marked. *Check the production map every morning!* I have gotten lost or shown up to the wrong location and been late – it is bad form and very embarrassing!

Next on the bottom of the front side of the call sheet, you will see an "Advance Schedule" – this is the anticipated schedule for the following day. This is always subject to change and frequently does, so take it with a grain of salt.

At the very bottom of the front of the call sheet you can find the phone numbers for the 1st AD, the 2nd AD and sometimes the Locations Manager. If you are lost, confused, or need a transportation van from Crew Parking, these can be good people to call.

When you flip to the back of the call sheet, there is a large chart, with the name and call time of every crew member, divided by departments. You may see additional abbreviations "N/C" ("Not Called") or "O/C" ("On-Call"). Sometimes, a call time may not be determined ahead of time. In that case, the crew member's call time would be "per" their Department Head and listed with the Department Head's initials. For example, if I (Christine Sciortino) was your Department Head, and your call time was yet to be determined, in the box next to your name it would say "Per CS."

You will also notice a row with certain departments that says a Channel, i.e. "Ch. 6." This refers to the channel of walkie-talkie this department communicates on. Channel 1 tends to be general crew conversation led by the ADs. Channel 2 is often left "open" for private conversation. If two people who are on Channel 1 need to have a private conversation, one might tell the other person to "Go to 2," and they would respond "Switching," then both parties switch their walkies to have a private conversation. Most productions actually require hair and makeup artists *not* to have walkies because we are so constantly communicating with the actors, that consistent chatter in our ears can be very distracting when we should be giving the actors our full attention. In this case, you will need to rely heavily on your PAs to keep you informed about what is being shot and what is going on. Sometimes you

may be given an "Open" walkie to keep in the trailer – meaning the walkie is functioning with no earpiece like a radio telling you what is going on on-set. Walkies should *only* be left open when there are no cast members present.

Occasionally, production will need to "push" call. This means that once a final call sheet has been issued to crew members, "depending on cast or crew turnaround, you may need to 'push' the call half an hour later to accommodate a problem that has arisen or a delay" (Gill 128). So if you receive a call sheet and a few hours later receive another one that may say at the top in red ink "ALL CALLS PUSH ½ HOUR," it just means you come in half an hour later, as do all your actors, as do all your crew members. This saves time for the 2nd AD so they don't have to go through the entire call sheet changing each individual call by half an hour.

The exact format of each production's call sheets may vary based on the local union standards, the country, or the preference of the AD creating it. However, even if it is slightly rearranged, all of this important information will be present somewhere on the call sheet. You will see every day how vital it is to your workflow to have a call sheet right in front of you at all times, so you can follow the order of the scenes being shot that day and always be aware of what time the actors are coming in. Especially when you have been shooting full time for many days in a row, you are tired and days may be beginning to blur together, you should be checking the call sheet often to make sure you know what's going on. Many productions will assign their PAs at Basecamp to deliver printed call sheets to the hair and makeup trailer each morning. If this has not happened, politely ask the PA or 2nd AD.

Another document you can expect to receive each day is a packet called **sides**. Sides are often printed on half sheets to save paper. The top page is a miniature call sheet for the day (just the front). Stapled to the small call sheet are copies of the script pages for the scenes that will be shot that day. If there is a scene that is on part of a page that *is not* on the shooting schedule for the day, it will be crossed out. Each morning when I come in to the trailer, I write my name and department on my call sheet and on my sides in permanent marker. Then I put the call sheet out somewhere easily visible and place the sides in my bag to take to set when I go. Sides are smaller than a call sheet so they can easily be folded and put in your pocket. I also like to follow along with the scenes so that I am always aware of what is being shot. Checking the sides throughout the day helps you remember products and effects you might need to prepare for. This is easier than carrying an entire script with you. Finally, I cross off what has been done on the sides and it is always a satisfying feeling to know you are on the last scene of the day. When I'm done with my sides I often take them home to use the back of the pages as scrap paper around the house. Otherwise, just throw them away promptly so they aren't being found by others and leaking information about the production.

Liz Gill reminds us that "call sheets are highly confidential, privileged information, and must be hoarded with the appropriate care. If they leak out to the press or to interested parties, your shoot can suddenly become a nightmare, swarmed with paparazzi or crazy fans." Although you are keeping your call sheet a secret, still treasure it for yourself. Receiving your first call sheet is a milestone. You are officially a film crew member. Congratulations!

Production

In This Chapter

- **Who's Who in the Makeup Department**
- **Attire**
- **Your Station and Sanitation**
- **Working in Trailers and Out of Actor Bags**
- **What You Need in Your Kit**
- **Set Etiquette**
- **Last Looks**
- **Continuity**
- **Face Charts**

Who's Who in the Makeup Department

So you got your first film/TV makeup job! One of the first things to know as you enter any Makeup Department is the departmental hierarchy. The different roles may be strict or fluid, depending on the department and the vibe of the production, but it is essential to adhere to the pecking order as well as the typical responsibilities of each position.

Assistant

When you begin your career in makeup, it is common that you will start as an **assistant** or **trainee**. Roles of the assistant include cleaning brushes, tidying the trailer, shopping for products, making photocopies, preparing hot towels, and many other important tasks that help the department run smoothly. Assisting is also an excellent opportunity to learn and ask questions – if you have a private moment with a senior artist, or if you have been invited to do so. The best approach is to simply be a fly on the wall, release your ego, and do what you are told quietly and efficiently.

Day Player

Day players (also known as "**day checkers**" or "**daily hires**") are a vital cog in the Makeup Department machine. Day players are established artists who are not full-time on a film or TV show, but rather work on a freelance basis. They are still considered employees of the production company and fill out start paperwork, even if they only work on the production for one day. If you receive screen credit as a day player (you may or may not), you will usually be credited as "Additional Makeup Artist." As a day player, you must be prepared for any situation. You may not have had a chance to read the script, but you should thoroughly read the call sheet to get a sense of what is being shot and the time period. Day players are most commonly hired for

Production 61

large numbers of background actors but they could be brought on for any number of reasons. Overall, you want to be a support to the full-time Makeup Department on what is likely to be a heavy or difficult day. If you come prepared with a wide range of products and are able to take initiative and think on your feet, you will do well. Days with high numbers of background can be incredibly chaotic so you will need to be patient and level-headed supervising a large number of people at one time. Sometimes the tasks will be simple, like watching for shiny skin or even asking background performers to remove makeup they are already wearing. Other times you may be putting everyone in drag or period makeup. Working quickly is imperative. The process for getting jobs as a daily hire, can be very informal due to constant schedule changes of a production. A Department Head may text you and ask if you can work at 5AM the next day, and if you don't answer the text immediately, the job will likely be offered to someone else.

In other cases, you might receive an email asking if you are available for dates two weeks away. If you are, you may be asked to "hold" these days, meaning do not take any other jobs. Still, this is not a "confirmed" day of work. If the schedule changes and the department turns out not to need you, you can "release" your hold. Let's say you are holding dates for one production and another film production requests you to work. The unwritten rule would be to tell the second production that you have a "first hold" on those days and that you can give them a "second hold." Then you would call the Department Head of the first production and ask if he or she has a sense of whether or not those dates will "confirm." The Department Head may ask you to keep holding as they are expected to confirm, or may tell you to go ahead and take the confirmed job because they might be likely to fall through. It is acceptable and professional to go through this communication process. However, do pick your battles. Make sure the better career opportunity is the one you are holding for, even if you don't get those days and miss out on some money, you are staying in everyone's good graces. There can be a lot of unspoken politics in the film industry and if you seem like you are disloyal, difficult to work with, or just hungry for money, you will not continue to be hired.

Do not be surprised if your days as a day player are long ones. Not only are these days difficult, there is the chance that if things do lighten up towards the end of the day, it could be an opportunity for one of the full-time artists to finally get some rest! They are likely working upwards of 65 hours a week and will welcome a bit of an earlier departure. In that case, you are really helping out the department – plus you are the one who gets the overtime pay!

Makeup Artist

Also sometimes referred to as the "Third Artist," a makeup artist who is not the Key or the Department Head may or may not be full time. If they are only part time, they are the first choice of who is called when a third artist is needed. As a makeup artist or third artist, you most often will have your own station in

the trailer and be considered an integral part of the department. Your responsibilities will often be doing makeup for the smaller characters and stunt performers. If the department does not have an assistant, you also may be asked to take care of housekeeping tasks like making hot towels, prepping crepe hair for beards, or cleaning set bags.

You will also very commonly be the artist "covering set." What this means is that your Department Head and Key are taking care of business in the trailer – either working on the budget or doing makeups for actors who have come in throughout the day. You may be the only makeup artist on set and you may be covering makeup looks that they have done. It can be intimidating to maintain the work of your superiors or to work with big stars. It is vital to go over the bags of products with your Key/Department Head and learn about each element of a makeup look that you did not do so you are prepared to touch it up. Especially if you are the only artist present you will need to focus closely. You might wind up covering set for hours, or even a good portion of the day if your Key or Department Head needs to step out or go home. Just keep a positive attitude, communicate with the rest or your department via text if you need anything, and make sure you never leave set while shooting is happening!

Key Makeup Artist

The **Key Makeup Artist** works full-time under the Department Head, just like a Vice President. As a Key, you will be responsible for the makeup of several lead and supporting characters – you may or may not have the #1 on the call sheet (it is more common that the Department Head works with #1). A great deal of trust is placed in you to help keep the department organized. Other than completing makeup looks, your tasks often include ordering products or keeping track of the budget in other ways, helping load in to the trailer, hiring day players, and maintaining continuity books. It is good to meet with your department head before the shoot so you know exactly what will be expected of you.

Department Head

The **Makeup Department Head** (or "Makeup HOD," meaning "Makeup Head of Department") is the boss. They research and design the makeup looks in pre-production, meeting with the Director and contacting the actors. The HOD is also in charge of the budget and oversees the purchasing of products, receiving product sponsorship, and the budget for hiring additional artists. They are in charge of the schedule and each day will be the one to sit with the 2nd AD and plan out the call times for the next day. The HOD is in constant communication with other departments. They will also likely have a large assortment of tools that they bring in to be communal in the trailer. These items might be a printer, actor bags, crepe hair, and other items that the average artist would not be expected to have in their kit. The Department Head is in charge of setting up and stocking the trailer, which is not only a makeup space but also an office space. The HOD is also the primary person in charge

of relations with the cast and they typically do makeup for the stars or biggest celebrities in the production.

Some productions will have a Makeup Designer for the creative and research aspects and a Makeup Department Head who will work with them to oversee logistics and help implement the designs. If these roles are not separated, the terms Department Head and Designer may be used interchangeably or the Department Head may choose to be screen credited as "Makeup Designer." In this case it is also implied that they have run the department.

Attire

Recently I was roaming Dick's Sporting Goods shopping for some new long underwear and a fleece vest. The sales associate asked me if I was planning a winter camping trip. "No," I said. "I work in the film and television industry."

If you saw the 2015 Alejandro Iñarritu movie *The Revenant* then you saw Leonardo DiCaprio struggling to stay alive through the winter in the mountains of South Dakota. You saw the steam of his breath as he trudged through the snow, and the sweat turning to icicles on his beard. Originally, Iñarritu's plan was to shoot the entire film in Canada, but in fact it was too warm there. To find their snow-covered landscape, the cast *and crew* traveled to the frigid southern tip of Argentina near Rio Olivia. While DiCaprio shivered on a snowy mountain, his personal makeup artist Siân Grigg was out there shivering with him.

Occasionally film crews will create artificial snow or rain on sound stages. But this is not always feasible due to technology or budget, and it is not always desirable because the production may want a specific landscape "look." When doing hair and makeup for film and television you *must be prepared for anything*. As you know, most days are twelve hours – minimum. You may be in the trailer in the morning and indoors at lunch, but be prepared to shoot and travel in snow, rain, sleet, extreme cold, extreme heat, high humidity, fog, and anything else Mother Nature might throw at you. When it is extremely cold, it is smart to begin with layers such as long underwear, wool moisture-wicking

Heading to set dressed to work an outdoor overnight in late January 2017 – more gear would be added as the sun went down

64 Behind the Scenes

socks, and thermals. I also typically layer a fleece vest close to my body before putting on a sweater. I have fleece-lined leggings and some waterproof pants. Knee-high, insulated, weatherproof snow-boots are a must. Almost always, I will bring a pair of socks to work to change into at lunch. If your feet sweat when you are indoors, the moisture may get cold when you go back outside. Scarves, hats, high-tech gloves are all a necessity. You truly cannot be prepared enough. When working outside on local productions in wintertime, I have sometimes worn floor-length down coats with snow-pants or ski-pants, over all of my clothes. Viewers like to see the grit of the city, and the fire-fighters breathing into the freezing air – so that's where we are too.

For rain or high humidity, a light rain pant is a great thing to keep in your kit, as is a thin rain jacket that can be rolled up and stashed, ready to pull out as soon as the first raindrop hits. You can keep a full change of clothes in your car or in the trailer in case you do get soaked and need a new outfit.

In high heat, the temptation to wear skimpy clothing is understandable, but make sure you are always taking into account both your safety and your professionalism. Personally, I hesitate to wear shorts on set, even on the hottest and most humid days, because when shooting on location you could easily be swarmed by bugs or surrounded by poison ivy. A safer option is often breathable, lightweight pants with a little stretch and movement in them, or if you must wear shorts I advise doing so with boots and choosing a pair that is not too short. If you plan on wearing a tank top on set, I generally recommend another undershirt for men or a sports bra for women. We often get dirty in our work and if you are climbing up a muddy hill each take to get last looks, you will have an easier time and be taken more seriously if you arrive looking ready for the task. Yes, we do work in the beauty industry, but we are not there to show off our appearance – we are on set to work. Do not forget your sunscreen!

Some days you may be in a studio or experiencing a lovely weather day – fantastic! The biggest factors to remember on these days are to keep your look comfortable, functional, and professional. Pants with lots of pockets are handy and shirts to layer in case you get hot or cold make your day easier. I always recommend a shoe that fits your foot well. Find out if you have high arches or flatter feet and choose shoes that support your foot shape. Makeup artists stand on our feet for incredibly long hours, and while occasionally you may feel you are sacrificing fashion for comfort, having a shoe with the proper amount of support can save your back and knees and help ensure that you have a long career with good health throughout. Closed-toe shoes are a *must*, no matter where you are working, and in some states they are a legal regulation to keep you safe.

When it comes to being safe and prepared for every situation, the best bet is to assume the worst. I was day playing on a large film one February and, as a day player, I was not given the script. The call sheet said we would be shooting in a nightclub, so I wore a regular pair of jeans and a T-shirt, with some light tennis shoes – I assumed the club would be without windows and packed with people, making it very hot. I cannot express

how wrong I was! Turns out, the storyline was post-apocalyptic and the "night club" was actually a gathering of people in one of Chicago's abandoned warehouses – with *no* heat! What's more, our trailers – which I wound up traveling back and forth to many times – were stationed a decent walk away in a *snowy* parking lot. The day went into 15 hours and was one of the most challenging and miserable days of work I have ever had. It could have been so much better if I had just been prepared! Now I not only have clothing layers and shoe options with me at all times, I also stock up on travel essentials such as hand and foot warmers, insect repellent (both natural and chemical), sunblock of several varieties, a portable electric fan, and Benadryl cream in case I do get an insect bite or encounter poisonous plants.

If you love this industry, you will want to be in it for a long time. If you take care of your body, you will help guarantee a long and flourishing career.

> " If you love this industry, you will want to be in it for a long time. If you take care of your body, you will help guarantee a long and flourishing career. "

tables outdoors in fields, in a roof-less restaurant in rural Puerto Rico, "vintage" makeup trailers, and brand-new state-of-the-art makeup trailers … just to name a few. Regardless of your location or surrounding facilities, this principle remains the same: your station is your home. Not only is your station *your* home, it is

Your Station and Sanitation

Makeup artists are flexible and nomadic creatures. I have set up my station in the men's locker room of a fire safety training facility, the underbellies of historic playhouses, a mountain-top meditation retreat center, countless city apartments (both inhabited and abandoned), million-dollar mansions, hotel ballrooms, hallways of professional sports stadiums, photography studios (some nice, some not-so-nice), backstage of network news rooms, corporate offices, on folding

Makeup Artist Rochelle Uribe-Davila shows off her well-organized station in the trailer of a popular network television show

the home for the actors you will be taking care of, so the most important thing is to take pride in it.

Your station will be the first place you – and your actors – report to each morning. Sometimes they will do a wardrobe fitting or have breakfast first, but it is very common that they'll arrive at work and come straight to you. Keeping your space clean and organized is key to making it feel like a comfortable place. Invest in a sturdy kit with rolling wheels to make loading in and out easier. Clear pouches are great for seeing where your products are and keeping categories (e.g. foundations, eyeshadows, lipsticks, concealers, skincare products, etc.) separated.

Create labels for your pouches with a label maker – it's worth the money – I promise, your actors do not want to see the names of your products scrawled in Sharpie that's half-rubbed-off! If you are reporting to a trailer each day, stylish cups in which to keep your disposables like cotton swabs and mascara wands can really make your station feel cozy for your actors and allows you to add some personal flair that makes you excited to go to work there. If you are reporting to a new set where you will not have a trailer, arrive on set early enough to find where you will be **staging** (setting up) – usually the Production Department or the Assistant Director is a good person to ask about this. Your staging area should be at least semi-private for the comfort of the actors and should have access to electricity, nearby running water, a large table space, and a chair that can reach to your eye level. Often, it's beneficial to have these conversations with Production before the shoot starts so that if a six-foot folding table or a tall **director's chair** need to be rented, they can be accounted for in the budget, and the Locations Department can make arrangements to provide electricity for you. If the space is not well-lit, you may need your own lights (Glamcor or The Makeup Light have affordable and easily-portable options!) or work lights set up, but always remember the value of natural light – windows are great!

"Makeup artists are flexible and nomadic creatures … Regardless of your location or surrounding facilities, this principle remains the same: your station is your home."

While a sense of "hospitality" is key, so is efficiency. Do not forget that this is your *work*space and you will be working fast! This means, every product should have a "place," and it should be put back in that place immediately after being used. I like to set things out geometrically, imagining any loose products fit into an invisible grid. I keep my metal or glass working palette (a necessity for mixing colors and for keeping things sanitized) in the middle of my station for easy access. I am right-handed so generally I lay out my station on the right side of my body which reduces crossing my own body and my actor's body. I keep all my skincare products together, all my foundations/concealers together, all my shadow palettes together and stacked on top of each other, lip color sorted into liquid, lipstick, and lipgloss, etc. You must

Production 67

fall in love with organization! Time is of the essence in the film industry and if you are frantically searching your set-up for a specific lipliner under piles of products, you will not only appear unprofessional to those around you, you will be slowing yourself down. Since the actors are generally needed on set for the scenes to be shot, that means that you are slowing down the entire production, all because you can't find that lipliner. If you do happen to lose track of something, keep your cool – do not reveal anxiety to your actor and try to quickly improvise by mixing colors to create something new in place of the item you've misplaced.

Laying down mats, paper towels, or set-up towels at your table or counter space is imperative. You do not want to ruin the surface you're working on, plus having something under your set-up makes cleaning easier – just roll up the paper towel and throw away. It may seem wasteful but it is an important step to keep things sanitary in between actors.

It may seem tempting in the beginning to keep *all* of your palettes out and open – they look so pretty, right? Yes, but creams can dry out and/or attract dust, decreasing the shelf-life of those products you spent all that money on. Plus, once you accumulate more and more palettes and your kit grows, it'll likely be impossible to have a space large enough to lay all that product out!

In general, most men prefer to see minimal set-ups – especially if you are working with athletes, physicians, or other non-actors who are unaccustomed to having makeup applied. If you display all your eyeshadow, lip-gloss, and eyelashes because you have a funky pop star coming in as your next client, it might make things easier for you, but unfortunately it's likely to make your non-actor a little antsy.

Keep your clean and dirty brushes in separate cups. If you get backed up, you may not have time to clean brushes between every actor during a rush. Keep those dirty brushes in a separate cup so you are not tempted to use them and so they are not spreading bacteria all over the station. As soon as you have a free moment,

When you know you have a specific actor coming in, you can prepare for them by setting out their specific products on your station as Rochelle Uribe-Davila has done here

A clean, geometric station with multiple brush cups

you are not texting your friends – you are cleaning those brushes!

Overall, cleaning and sanitation is one of the most important aspects of our work as on-set makeup artists. It's not always pretty, but we deal with saliva, mucus, and, on rare occasions, with real blood. Brushes, disposables, and products can harbor bacteria and viruses from the common cold to Herpes Simplex Virus (HSV, especially manifesting as cold sores) and Human Immunodeficiency Virus (HIV). Let's say you are sharing eye products throughout the cast and bacteria begins to grow, you could theoretically spread Conjunctivitis ("Pink Eye") to all your actors, and probably lose your job. If actors, Producers, or Department Heads see that you have unsanitary habits you likely will not be asked back. It is in everyone's best interest to keep the cast safe and healthy for the duration of the project.

How to Sanitize Everything in Your Kit

Brushes – It is absolutely crucial to keep your brushes clean at all times. Not only do dirty brushes hold bacteria that can spread illnesses around your cast and cause them acne breakouts, you also run the risk of mixing with a color previously loaded in the brush. When you apply that to the actor's face, you will spread an unintended color around and ruin any work you have previously done.

For a quick change between lighter colors and powders, spraying a brush cleaner like Cinema Secrets Makeup Brush Cleaner onto a folded paper towel and then swirling the brush in it will take off enough product to get you from actor to actor throughout the day. I never spray onto the paper towel at my station – depending on where you set up you can really damage the surface underneath!

For heavy build-up of a dark color or waxy cream, artists often have a special dish on their station in which they will pour 99% alcohol or a brush cleanser with a strong solvent, and dip the brush quickly then wipe it with a paper towel. This is a quick and efficient way to clean your brushes between actors.

Dipping the brush in acetone will also break down some of your special effects products like silicones and adhesives but it's very harsh on the brush so I don't recommend it for frequent use.

These spray and alcohol-based cleaners are intended to be temporary solutions. They don't always clean perfectly and they can be drying. Therefore, brushes

A brush can be dipped in Cinema Secrets Makeup Brush Cleaner or similar for quick cleaning

do require a deep clean at the end of each day and I suggest doing so with an oil-based soap or brush shampoo (*not* regular shampoo or dish soap please!) Having the oil will not only dissolve your oil-based products, it will also help condition the fibers of your brushes. Place a little in your hand, on a rubber pad, or in a dish – or go straight off the solid if you are using solid soap – and swirl the brush bristles around mixing with warm – but not hot – water. Do your best not to soak the handle and the **ferrule**. The wood can swell and crack and the glue inside the ferrule can break down, significantly decreasing the longevity of your brush.

Once the bristles have been fully rinsed of any soap residue, shake them out, reshape the bristles with your hand or a paper towel, and then place them over the edge of a table or countertop to dry. Drying your brushes in a cup standing up will allow water to leak back down into the ferrule, again deteriorating the glue and the handle which is why I

Brushes should hang off the edge of the table for proper drying

always dry mine flat. Letting the fibers hang off the edge of a surface allows more air to circulate and the bristles will dry faster, also discouraging the growth of any mildew.

Pencil Liners – Eye and lipliners should be sprayed with 70% alcohol, then sharpened with a clean sharpener to remove any previously-used layers. Make sure to dab off the tip of the pencil on a tissue or paper towel to ensure

70 Behind the Scenes

that no alcohol remains on the pencil as it can irritate your actor's eye or lip. After use, spray once more before replacing the cap.

- **Shadows/Pressed Powders** – Your pressed powders can be wiped out with a tissue after every actor to gently remove the top layer. A light mist of rubbing alcohol with time to dry in between uses can be helpful but can also dry out our products if done too often. BeautySoClean offers a Cosmetic Sanitizer Mist that can also be lightly applied to cleanse products without deteriorating them and it smells great!

- **Lipstick** – Your stick lipstick should only be scraped off with a spatula. If it becomes contaminated, you can cut a bit off the top of the lipstick, mist with BeautySoClean and then swipe in a straight line along a paper towel.

- **Cream palettes (foundation, lipsticks, etc.)** – All your cream products should be scraped out of the palette or pot using your metal spatula – *NEVER double-dip!* – and used only off your metal palette for easy cleaning. If for some reason colors get mixed, scrape off that top layer with the spatula and dispose of it. It may seem wasteful but it's worth it to keep your actors safe and healthy and your colors pure. If the space in between colors in the palette gets dirty, take a doe-foot applicator (cotton-swabs leave lint) misted with 70% alcohol to carefully clean edges.

- **Mascara/Brow Gel** – Do not ever double-dip your mascara. ONLY use disposable mascara wands. If you do accidentally go from an actor straight back into the tube, you can politely give them the mascara to take home with them.

Production 71

However, 70% alcohol on a cotton bud/cotton pad or sometimes even a tiny bit of oil-based makeup remover may be necessary to remove certain products.

Some of your smaller items, like brushes or spatulas may also be placed in a UV light sterilizing box or an autoclave which are becoming more and more popular in trailers around the country. If so, your department may have rules on whose tools are allowed to go in the device at one time, so check with your Department Head.

Throw away your trash. This may seem obvious but I can't tell you how many times I see students wasting time searching for a mascara because it's scattered under a mountain of crumpled tissues. You are not only giving germs free run of your station, you are slowing yourself down and reducing your actors'

- **Lipgloss/Liquid Lipstick** – As with mascara, liquid lipsticks and lip glosses should never be double-dipped, but only used with disposable applicators. I love doe-foot applicators for this purpose but some people use disposable plastic brushes as well. It may depend on the viscosity of your lip product so keep both stocked in your kit.
- **Lotions/Oils/Liquids** – These should be dispensed directly onto your metal palette and applied with a brush or sponge. Using a tissue, wipe any excess off your palette promptly to avoid a mess spreading across your station.
- **Spatula and Metal Palette** – Both should be sprayed with 70% alcohol and wiped thoroughly with a tissue in between cast members.
- **Actor Bags** – **Actor bags** and **set bags** should be cleaned out often to avoid the build-up of powder dust and product. A simple swipe with an antibacterial wipe often works.

The Mini Can by simplehuman, LLC. makes a great counter-top trash can for your station

confidence in you! If you do not have a trash can right under your station (which you should try to get), a table-top trash is a great option – I love simplehuman's Mini Can – or even one made out of a cute pencil cup with a dog-waste bag as a liner works just fine. You can take it to a larger waste basket to empty trash between each actor. Don't forget to sanitize your hands after doing so, of course.

Once you have given yourself plenty of time at the top of the day to get set up and settled in, you are ready to welcome your actors "into the chair!" That means your makeup is on (or at least you look presentable – nothing is more unprofessional looking than having an actor walk in on you while you are sitting in the chair, halfway through applying mascara onto one eye). By now, your breakfast has been eaten or set aside and your personal trash is thrown away. If you are playing music, keep it low, or have a Bluetooth speaker set out for your lead actors to have the option to connect their own music. Check the time. As we know, actors' call times are dependent on how much time you estimate needing to get them ready before their set call so you'll want to make sure you are working on schedule. Having a watch or a discreet clock is great for this – even if you are just checking the time, your actors will feel ignored if they see you checking your phone every five minutes.

Before you leave to go to set, straighten up your station. This is important! It may be tricky at first to factor this into your working time, but it's necessary. You will often be stationed alongside other artists – especially in the cramped quarters of a trailer. Maybe the actor you just finished is in the first scene of the day and you need to travel up to set with them. However, the makeup artist who is stationed right next to you might have an actor coming in a little later for the second scene of that day – while you are out on set. It doesn't matter if they are an A-list Hollywood star or it's their first time on screen – no one wants to sit next to stray cotton swabs that may have been in someone else's eye or crumpled up tissues with someone else's lipgloss on them. Plus, if a Producer happens to pass by your station and sees a mess they may think you are disorganized or dirty and not trust you for future projects.

> *"Actors' call times are dependent on how much time you estimate needing to get them ready before their set call so you'll want to make sure you are working on schedule."*

If you're in a trailer, it's possible that after you prep the cast at the top of the day, you might do a company move and the trailer will have to relocate. In this case, a full breakdown of your station is required and all products and objects will need to be "saftied," meaning stored in wells or drawers so they do not tip or fall off the counters while the trailer is in transit. When you first arrive, double check on your call sheet or with your Department Head to see if any company moves are scheduled for that day.

Now you're ready for your actors. Take a deep breath, leave any stresses outside, and get ready to get to work!

Working in Trailers and Out of Actor Bags

Your beautifully set up station is not the only important part of your work if you are in a trailer. The trailer, as we know, is your home – it is also home to your department head, and likely about five other artists, shared between the Hair and Makeup Departments. This also functions as your office space. In the trailer you will find your start paperwork (and start paperwork for day-checkers), timecards, box rental inventories, and typically a copy of the current script and one-liner. Both Hair and Makeup Departments usually have their own little office areas as well as separate areas for snacks and coffee. Never take anything from the Hair Department without explicit permission.

It is generally appropriate for hair and makeup artists to enter and exit the trailer through separate doors even if you are friendly and arriving together. Hair is usually the left door, and makeup is usually the right door when facing the trailer from the outside. Not all Department Heads enforce this strictly, but others will definitely be rubbed up the wrong way if you enter or exit incorrectly.

Another important rule of trailer etiquette is to call "stepping!" when entering or exiting the trailer – you may also hear variations such as "stepping up!" "stepping down!" or "stepping out!" Any of these are fine, but it is

A Hair and Makeup trailer in Chicago, lined up with other trucks and trailers to form Basecamp. Trailer styles may vary around the country and around the world

an important courtesy to announce yourself and the fact that the trailer is about to bounce a little when you use the stairs. The last thing you want is for your Department Head to be working on the star of the film, your footsteps shaking the trailer and causing his or her hand to jab right into the star's eye, injuring her and ruining the eyeliner – just because you didn't call "stepping."

Trailer respect also involves putting things in the right place. Your Department Head (perhaps with your help) has likely spent a long time organizing each drawer and cabinet in the trailer and labeling what is inside it. Many items are communal and there is a great level of trust placed in each artist to use products and supplies responsibly and replace them when the makeup look has been completed. *Put supplies back exactly where they belong as soon as you are done.* It may seem like a simple rule but it is absolutely the key to keeping harmony in the trailer, especially on a TV season which may run up to ten months. If you see that you are running low on an item – for example,

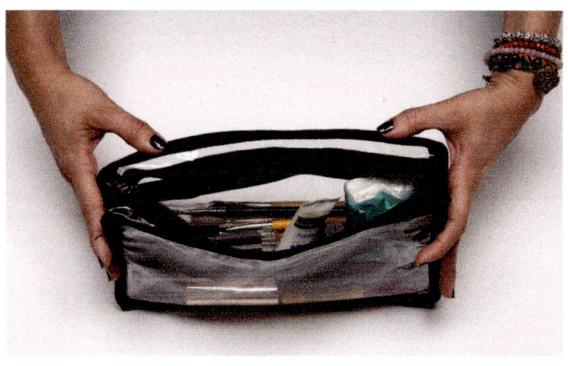 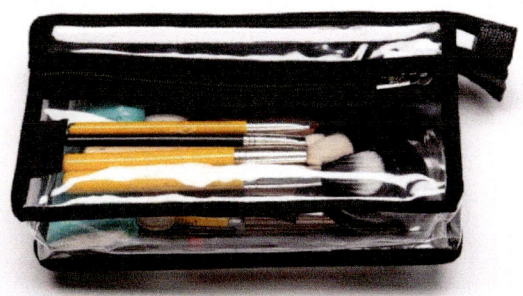

An "actor bag." Actor bags should be kept clean and organized

an actor who flosses his teeth every day after lunch has been burning through your flossers quicker than you may have expected – tell your Department Head or start a list so they can order more.

Another crucial element of makeup organization, is understanding how to work out of actor bags. All your principal cast members will likely have his or her own pouch with the products they use every day. What items go into these bags are often the result of conversations with the actors, but also of your observation.

Someone blows his nose a lot? Make sure he always has tissues. She drinks tons of water? You'll want extra lipstick for her plus straws for her to put into water bottles. Get to know your actors' likes and dislikes so you can be prepared. You can put items that need to stay sanitary like flossers or sponges in small jars to keep them clean inside the bag.

The actor bags will be labeled with the actor name, the character name and often the character number, and placed in a communal drawer or cabinet in the trailer. At the top of day, you will work out of the products in the bag because those are the colors that

Production 75

have been established for that actor. If a product seems missing, ask your Department Head. There may be an established color for the character that is lost or empty and needs to be replaced. It is not a good idea to supplement with your own design for an established character. Keep the inside of the bags clear of trash and debris, cleaning them frequently and also sanitizing the brushes so they don't spread product. When an actor travels to set, *make sure the bag travels with them, even if you are not traveling*. A PA will typically give you a five or ten minute warning so you can pack up the bag and send it with a driver or PA when the actor travels to set. It should then be intercepted by whatever makeup artist is covering set at that time. When the actor's scene is complete and they travel back to Basecamp, *the bag needs to come with them, be cleaned, and go back in the assigned drawer or cabinet*. Do not ever keep a bag in your kit or take it home with you. In the event that you are ill or have an emergency and cannot be on set one day, that actor won't have their approved products to use and that can cause problems if they have specific colors approved by the network, or need certain products for continuity. Throughout the day, if something gets misplaced, it is okay to send texts between your team members to keep track of the bags. Better to have too much information and know exactly where actor bags are than to not communicate and have supplies go missing.

Not only will you need to keep the communal trailer space clean and organized, it is also a good idea to keep it quiet. They are small spaces, and just because you do not have an actor in your chair does not mean another artist may not be working on an actor. Cast members do not need to hear about your date last night or hear you chewing those pretzels. It is okay to create a little distance and help maintain a respectful environment when you are not working.

What You Need in Your Kit

I frequently have nightmares that I show up to work with no makeup brushes. In my opinion, brushes are the most important thing to collect in your kit. Colors can be improvised, different consistencies and finishes can be mixed, but when it comes to application, cotton-swabs and sponges can only get you so far. Using your fingers will smudge your work and spread oil and bacteria on the face of your actor. With a good set of brushes, you can achieve countless looks. Focus on building a variety of shapes, sizes, and hair fiber types for different purposes. You will also want a high-quality brush sanitizer and a conditioning brush shampoo or soap to keep them clean and nice for as long as possible.

That being said, emphasizing the importance of brushes does not mean other products don't matter. Throughout your career you will work with innumerable actors of different ages, genders, ethnic backgrounds, and skin types. It is crucial to be prepared for *all* of them. One factor we may not know before an actor sits in our chair is what their skin care routine is like. They may not be cleansing or exfoliating the skin regularly. They may have acne or dry patches. They

may be concerned with age spots, fine lines, or dark under-eye circles. We must be prepared for all of it. You will become familiar with different skincare lines and what works for different skin types and skin issues. Start to build up a range of skincare products in your kit, including moisturizers, toners, eye creams, acne treatments, and different primers.

Once you have addressed the underlying skin needs of the person in your chair, it will be time to start applying makeup. Your skin coverage products (foundation and concealer) will also need to be incredibly varied based on skin type and skin tone. For example, a teenage actor with oily, acne-prone skin, might need a full-coverage foundation/concealer regimen to cover acne scars, but we would want it to be oil free and non-comedogenic so as not to exacerbate their acne. Conversely, an older actor with dry, dull skin but not a lot of age spots would likely need a medium-coverage, moisturizing and illuminating foundation. You will find skin coverage products in the form of creams, sticks, liquids, powders, tinted moisturizers and start to amass a wide variety to fit every face that you encounter.

For any makeup assignment it will be wise to arrive with a variety of tones of setting powders and a no-color or translucent powder just in case. Colorless HD powders are great at minimizing oil and shine and smoothing the appearance of skin on camera; just make sure you're buffing them in well to avoid any white reflections under the lights.

One thing I see frequently is new makeup artists showing up to sets then opening up and laying out an enormous variety of eyeshadow palettes. While these palettes may be on-trend and fun to collect, they will likely not be as helpful in your day-to-day work starting out in film and television. Keep in mind that you will often be prepping men and children *at least* half the time – populations that stereotypically do not wear extravagant eye looks but just need grooming and clean-looking skin. Having a few high-quality palettes of neutral colors for every skin tone will come in handy for most jobs. Of course, pay attention to your call sheet – if you are working on a scene that takes place at a drag bar or a circus for example, grab those bright colors and that glitter! Until then, keep investing in skincare, brushes, and skin coverage products. You will be using those on everyone and again, a variety is great to have.

Lip products follow the same principle. A few basic lip palettes and lipliners should serve you just fine for your basic TV and film jobs. Focus on classic colors like red, burgundy, nude, and rose in glossy, sheer, and matte finishes. Then have fun augmenting your kit with those bright and glitzy colors for use on specific characters. Often, your Department Head will let you know if they want a bright lip on a character, or it may be up to you to decide to use a high-impact lip color/finish based on the situation or the character you observe in the script.

I quickly learned to bring tattoo cover supplies to every job I do. Remember that every tattoo an actor, extra, or stunt performer has is the artwork of another person and therefore, that artist's legal property. If the Producers/Directors believe the actor's tattoo fits

the character he is portraying, they may want you to leave it, in which case the Makeup Department often contacts the tattoo artist asking them to fill out a form giving legal clearance to use their "artwork." However, in many situations, the tattoos do not fit the character, or production may not want to pay for clearance, so you will be asked to cover the tattoo (see step-by-step tutorial and products in Chapter 19). You may also be asked to change an existing tattoo because it looks good for the character but if the art is slightly different, it will no longer be the property of the tattoo artist and clearance will not be needed – this is called "Greeking" the tattoo. For that reason, I like to always keep a Skin Illustrator FX Palette and some K.D. 151 Tattoo Pens in my day-playing kit. Adding fine lines or shapes to a tattoo can quickly make a big difference in its appearance.

Of course, your main kit will be continuously evolving throughout your entire career. New products are released every day and you will always be building up and replacing old supplies. One thing to *always* have developed and ready to go is a day-checking set bag. Usually this is a clear bag with a strap so you can carry it all day and see everything inside. You will love collecting travel-size products to keep in your set bag and it is actually a good feeling to know that even if you are on set for hours at a time without going back to the trailer, you are prepared for any look or situation. Here is what I keep in mine:

- A cup of basic brushes
- Small scissors
- Eyelash curler
- Tweezers
- After-Bite – to apply as soon as possible so bites on actors don't get swollen and obvious
- Sunblock – SPF 15 or 30 because much higher than that you may encounter a white glare on the skin due to high talc content
- Lucas Paw Paw or other ointment that can double as a lip balm and a first aid ointment
- Small metal palette for mixing
- Paw Palette to mix products or apply lip color right from my hand
- Fine spatula
- Oil blotting sheets
- Pressed HD translucent powder
- A palette of pressed powders of different shades
- Tissues
- Cotton swabs
- Wet Ones wipes for hands
- Makeup remover wipes for face

A wide range of disposables should always be stocked – they can be kept clean and organized using a tackle box or other similar with small dividers

- 70% alcohol for sanitizing
- 99% alcohol for alcohol-activated makeup products
- Brush cleaner
- Folded paper towels in a pouch – used for cleaning brushes and dabbing sweat from actors
- Mascara
- Mascara wands
- Breath spray
- Mints
- Flossers or brush picks
- A small blush palette with several colors for different skin tones
- A small lip palette with several colors for different skin tones
- A small eyeshadow palette with several colors for different skin tones
- Compact mirror
- Hand lotion
- Evian Facial Mist spray
- Skin Illustrator On Set Palettes
- Eye drops
- Small trimmers that can also be used for nose or ear hair
- My own personal lip balm/lipstick with SPF

You will take all these products in your set bag and travel to set at the top of day, frequently not returning to the trailer until lunchtime. Along with your set bag, I recommend adding a folding **set chair** to your basic kit. It is not always guaranteed but it can be nice to find a place to set up your chair – even if you are just using it to hold your set bag, not even necessarily to sit on. I prefer to have a small, compact chair like a camping chair that folds quickly and is easy to travel with. Naturally, check with your Department Head before bringing a chair or sitting down on set – not all Department Heads like the way it looks to have all team members sitting around. If you *are* sitting, make sure you are watching the monitor and focusing on the scene, ready to hop up for a touch-up at any moment!

Set Etiquette

As a makeup artist, there are many unwritten rules about how to behave on-set. Luckily, a lot of these rules correspond to good, old-fashioned common sense. Here are my main **set etiquette** guidelines:

1. **Be early.**
I'm sure you've heard the phrase "If you're on time, you're late." That couldn't be more true anywhere than in a film/TV Makeup Department. Because the production usually needs actors to shoot most of the scenes, the whole production day hinges on whether or not the actors are ready – that means if you are late, you're holding everyone up. We frequently film in new locations every day, so give yourself ample time to figure things out at the top of the day and avoid being late.

2. **Be quiet.**
When working on-set, everyone must be still and silent while rolling, because the microphones can hear and record *everything*. That said, even when

not rolling, it is important to be quiet and discreet. If 100+ people are chit-chatting at full volume while working or setting up for a scene, the noise would be deafening. If you happen to be standing near the set, waiting for a rehearsal to finish so you can do a touch-up for example, wait patiently and discreetly – there is no need to start engaging in small talk.

3. **Be prepared.**

 We've gone over the set bag and proper attire for being on set. Those things are imperative for you to do a good job. When packing up to go to set, always plan on worst-case scenario – IF it starts to rain, IF the actor gets an insect bite, IF one of the background actors has a huge neck tattoo, etc. You also want to make sure you are mentally prepared – you have looked over the scenes being shot, the characters involved, and your Department Head's designs.

4. **Be efficient.**

 A film set is like a machine. Every person on set is highly specialized in their department and must be doing their best work to get everything done. You need to work quickly, especially if you are given a short time for touch-ups or if you are doing last looks. We will discuss that more in the next section. Being a makeup artist can at times be a delicate dance of doing a great job while staying out of the way.

5. **Be mindful of other departments.**

 There tends to be a workflow in setting up for a scene and in that workflow, makeup is typically the last department on set. You do *not* want to

> *" A film set is like a machine. Every person on set is highly specialized in their department and must be doing their best work to get everything done. "*

be doing touch-ups in the middle of the set while the Lighting Department is rigging equipment, the set decorators are moving furniture, or the camera is trying to "frame up" (decide on the next shot.) Your touch-ups either need to happen off-set where the actors have a designated sitting area, or wait until you are called in for last looks. If you are doing off-set touch-ups, try to avoid working on the actors while they are having their costumes or microphones adjusted. Keep in mind that you are never permitted to touch another department's work. This is especially divided on a Union production. That means if you are only in the Makeup Department, you cannot move a stray hair, pick a large piece of lint off a shirt, or stick on a piece of microphone tape that is peeling off. *Always* get a representative from the appropriate department and communicate with them respectfully if you believe there is a problem.

6. **Only use your phone for work-related reasons.**

 This issue has become more and more prevalent since the dawn of smartphones. As makeup artists, we usually are not given walkie-talkies so we *do* text often throughout the day within the department. We may have to text questions to the 2nd AD who isn't on set. We may be using the camera feature on our phones to take continuity photos. You may need to ask another makeup artist to bring you a product from the trailer that you forgot. So smartphones have become an acceptable form of communication on set. If you do need to use your phone for one of these reasons, do so away from the set, the Director, the actors, and the Executive Producers so as not to distract anyone or look unprofessional. Make sure your phone is *always* set to silent. In the past few years, many productions have instituted fines for anyone whose phone rings or makes a sound because it is so distracting and can ruin a take. Other than work-related use, just keep your phone in your pocket or set bag. There is nothing that looks more unprofessional than people sitting around scrolling through social media, online shopping, or laughing at memes together. Makeup artists are some of the only crew members permitted to touch, or even interact with the actors. Therefore they are generally compensated quite well, often more than other crew members. For this reason, I suggest makeup artists hold themselves to an especially high standard of professionalism.

7. **Be polite and friendly, but never flirtatious or careless.**

 The film industry is difficult. And crew members usually love their jobs – if they didn't love this industry, they wouldn't put up with all the long hours, bad weather, and manual labor. So at times, our industry can be informal and fun. It is nice to get to know other people on set and have a good working relationship. That said, you should still be careful about personal details you reveal and about the way you interact with others. It is still a workspace and attracting the wrong kind of attention to yourself by being loud, flirtatious, or gossipy, can really hurt your career in the long run. For more information about both on-set dating and on-set harassment, you can reference the "Note on Harassment" in the Appendix.

8. **Go through your department head at all times.**

 Film sets have a specific, yet often unspoken, hierarchy. There are employees that are considered more "high-value" than others. This includes the Director, the Writer, the Executive Producers, the actors, and the Cinematographer – to name a few. Unfortunately, general crew is easier to replace than these people. Therefore, if you are a member of the Makeup Department, you typically do not have a reason to talk to the Director or to the Executive Producers unless they initiate conversation with you as it can be viewed as "too casual." If you have a question about a look, your Department Head has likely already had a meeting with the Director about it so you should directly

ask them. They might want to ask the Director personally, or they might tell you it's okay for you to ask them. In which case, you'll introduce yourself, state your department, and ask the question. This is of course not a hard and fast rule so much as just a general guideline. Once you get on set, you will begin to understand the vibe. Each production is like its own ecosystem and some productions will be more informal than others. Just be mindful and try to use common sense.

9. **The actors' needs and the needs of the production are frequently more important than your personal life.**

 This is a tough one. In production, you want your actors to feel comfortable so that they can do their best work on screen. This often means treating them like the most important people in the world and gracefully approaching all of their issues and possible insecurities. It is not considered respectful or professional to volunteer personal information with your actors unless they ask you directly If you are asked about your personal life, keep it simple – do not talk forever and keep difficult topics like religion, politics, and sex out of the conversation. Naturally, if you are a regular makeup artist on a show that has been running for six or seven seasons, you may develop more of a casual and friendly relationship with the cast over the years. However, being as discreet as possible is a good place to start. Sometimes this can feel draining. You may get home at the end of the day and feel like you have been giving a lot of your emotional energy to the cast and eclipsing your personal needs. This is where self-care comes in. Make sure to really relax and take care of yourself when you aren't working. Keep up with hobbies, exercise, and get good sleep. If you cohabitate with family, a partner, or roommates, explain to them the nature of your job and respectfully ask for alone time to recharge if that's what you need. Try not to lash out at them when you are tired or stressed. As long as your loved ones understand where you are at mentally, they are generally pretty supportive.

10. ***Always*** **be paying attention and listening, even when you are not directly "needed."**

 There may be times on set when the Camera Department needs an hour to set up and you are far from Basecamp so you won't be going back to the trailer. This might mean sitting in your set chair in a dark corner somewhere just waiting. You'll hear the phrase "hurry up and wait" *a lot* in the film industry. That said, it's not a good idea to zone out, bring magazines, take personal phone calls, or take a nap – no matter how bored you may be. Especially because you probably won't be on walkie, you should always have your eyes and ears open because things can change all the time. You may have been told "Camera will take an hour to set up," and then after 20 minutes they are almost ready and if you are paying attention, you might hear the cinematographer tell the AD that they are running ahead of schedule, and the AD will tell a PA that they need the cast in

five minutes. That's a perfect time for you to do your touch-ups so the actors can be ready. You can learn a lot just from what you overhear and you need to always be ready to jump up and work.

11. **Do not hog the monitor.**

 Most productions will have some type of monitors set up connected to the cameras so crew members and production staff can see the work on set. Hands down, the Director is always the most important person who needs to see the monitor. Typically, the Script Supervisor sits next to them taking important notes on every single take. If your production only has one monitor set up, you will need to continue your delicate dance to make sure you can see your work. Stand to the side of the monitor or the back of the group – especially if this group includes Executive Producers, Writers, or important visitors from the network. If you need to get really up close to examine a makeup, try to do so when no one else is at the monitor. Luckily, many productions do have multiple monitors set up – sometimes the Cinematographer and Camera Department will have their own monitors, and you may even be lucky enough to be on a production that supplies a "Vanities" monitor. Here, Hair, Makeup, Wardrobe, and sometimes Props and Set Decoration Departments can congregate to really study their work up close. Watching each take is very important for keeping your continuity and keeping an eye on the actors. If you notice an actor twitching his or her nose and sniffling for example, you'll want to run in at an appropriate moment and offer a tissue. If you have been doing multiple takes in a hot room, keep an eye on your actor who may be developing beads of sweat which you will have to quickly step in and dab. It can be embarrassing and unprofessional to have a makeup issue happening on-screen that you haven't noticed simply because you weren't watching. The AD will generally announce it loudly and then it becomes clear that you have not been paying attention. So, although it can be both delicate and challenging at times, make sure you're always able to see your work without blocking the view of others.

12. **Do not cross the camera if you can avoid it.**

 This can be a little tricky. If you need to step in for a touch-up, the best thing to do is to come in around the back of the actor so you aren't crossing directly in front of camera. Of course, crossing camera, and even standing directly in front of the lens to make a quick adjustment is sometimes unavoidable. If you *do* need to cross camera, try to make your cross and then stand out of the frame so you aren't directly blocking the frame. In film school you may learn to call "crossing!" but it is not popular to do so on larger professional sets and can sometimes be viewed as somewhat immature. Try to get to know your camera operators and their preferences. When you get to know a camera operator really well, you may be able to communicate with non-verbal signals, like eye contact and a simple nod or gesture to determine the best time for you to step into or cross the frame.

13. **Know the lingo.**

 In the Appendix, you will find a glossary of film set slang. I cannot stress the importance of this enough. You will want to familiarize yourself with the colloquial terms of every single department to help you move as efficiently as possible and keep you safe while at work. For example, if you hear someone call "Points!" behind you it means someone is trying to get around you/walking past with a large pointed object such as a pole, a light stand, or a ladder. Watch your back! If you hear "Checking the gate!" for instance, it means the last take of a certain shot set-up is being reviewed by the DP and Director to see if it is good, in which case, you should be prepared to move to the next shot set-up or the next scene. Please refer to the Glossary which will make your life so much easier once you get on set!

14. **Communicate with your department constantly.**

 Regardless of your position within the Makeup Department, you will need to be in constant contact with the other makeup artists. Sometimes this is in-person or on a group text thread (or both!) It is important to let all the other makeup artists know when you are **10-1** (in the bathroom) or out at "crafty" (grabbing a quick snack) so that if an actor you cover needs something, another makeup artist can attend to it while you are away. It is also important to communicate status updates, such as when you finish a makeup look in the trailer. If you are the only person covering set, and the production is moving on to the next scene, let your Department Head know so that they can be prepared to come to set if they need to, or to send an actor's bag of makeup up to set. The best guideline is to *over*-communicate. *Always* let your Department Head know where you are and what you are doing. If, for example, your Department Head has gone home for the night and you make a mistake, make sure to let your Department Head know. I promise – they *will* get wind of it from someone the next day and they will not be happy with you when they think you were hiding the error from them. If you are even the slightest bit unsure about *anything* on set or in the trailer, always, always ask the Department Head rather than make an assumption and have it be the wrong one.

15. **Do stick up for yourself when necessary – but do so in private conversation.**

 Let's say you feel a specific actor or crew member is consistently disrespecting you. You do not have to put up with it. Instead of making a scene about it or calling them out on set, go to your Department Head or to the AD and ask if you can speak privately when they have time. This is the most professional way to handle the situation, and because you aren't escalating things by bringing everyone's attention to it, the problem is more likely to be solved with a simple conversation.

16. **Appreciate your PAs.**

 The Production Assistants work incredibly hard for the lowest amount of pay on-set. PAs help the Makeup Department enormously by escorting the actors to and from the makeup trailer at the

appropriate times, and by keeping the Makeup Department (not on walkie) apprised of what is going on on-set. They will also help by bringing you breakfast, distributing water, and sometimes transporting actor bags or products from Basecamp to set for you. In addition to helping you, they have an enormous amount of responsibility to help other departments and to do what the AD (their boss) has instructed them to do in order to keep production running smoothly. Keep this in mind and do not take advantage of their time and assistance. Be respectful to them, even though they are often younger and/or less experienced. *Everyone* on set is constantly learning, and no one is immune to making mistakes, regardless of how many years they have been in the industry. It is also customary for Hair and Makeup Departments to combine resources to get a gift for their main PAs at the end of production or around the holidays.

17. **Respect all identities.**

Film sets are comprised of artists and artists tend to be a diverse group of people. You may encounter people of different backgrounds, religions, sexual orientations, or gender identities and regardless of your previous experience or personal beliefs, you must be respectful of all of these differences. There are so many ways to be a human. This comes into play especially if you have an actor who is trans or non-gender-conforming. Be polite and respect that person's pronouns. Pronouns include: he/him/his (masculine), she/her/hers (feminine), they/them/theirs (non-binary). Not being respectful of your performer's wishes in this way can cause them to feel very uncomfortable both on and off screen, and because they likely have put a lot of thought in to how they present themselves, you need to make them feel comfortable because you are the one in charge of their appearance.

18. **Don't complain.**

As I've mentioned, film life is hard. You will be on your feet for *long* days — longer than most of your friends in any other industry (although, I've noticed emergency room nurses work 12-hour shifts that rival ours). You will never know your work schedule ahead of time and may find yourself cancelling doctor's appointments and plans with friends left and right. You

> *"Film sets are comprised of artists and artists tend to be a diverse group of people. You may encounter people of different backgrounds, religions, sexual orientations, or gender identities and regardless of your previous experience or personal beliefs, you must be respectful of all of these differences."*

will be cold, hot, out in the rain, and generally exhausted. You may be working with actors who don't have great attitudes. You may be waking up at 3:00AM to go to work, or you may be going to bed at 3:00AM after just getting home from work. The meals are catered and they may not be exactly your preference. This industry. Is. Not. Glamorous. But I promise you, if you don't like it, there are dozens of people in line to take your job, and if you are overheard complaining, you can be replaced the very next day. With that in mind, if set life *is* for you – you will feel it, deep in your bones. You will love the opportunity to collaborate with other artists, you will find fun in the comradery of miserable locations and long nights, you will get high off the excitement of seeing your work on the big screen. It will all be worth it. And, while there is absolutely no shame in doing a few productions and then deciding this industry *isn't* for you, I want to whole-heartedly tell you: I hope you love it.

Last Looks

An important part of our on-set routine is **last looks**. As Gretchen Davis and Mindy Hall explain in *The Makeup Artist Handbook,* "Once everyone is in place, and rehearsals and blocking have finished, the 1st AD calls out, 'Last looks.' This allows for last-minute finishing touches, whether to the set, to hair and makeup, to lights, or anything else" (Davis & Hall 298). "Last looks" is sometimes referred to as "looks," "final checks," "finals," "checks," or many other variations and occurs at the beginning of each new camera setup. If you have been waiting for a while for Camera to set up, you have likely done some touch-ups over by your actor's chair or they have recently left the trailer. So when you are called in to set for last looks, your time there should be minimal.

Always plan what you are going to do on your actor at last looks and have the necessary products ready in your set bag. Once you get to know your cast, you will get to know their preferences, their skin, their habits, everything. If an actor regularly gets shiny, you should always have blotting sheets and powder easily accessible for him. If an actress frequently gets that white film in the corners of her lips, be prepared with a mascara wand (a gentle way to clean this "gunk" off) and her lipstick to touch the lip color up. Most productions will do a camera rehearsal before calling last looks, so if you are paying attention to the monitor (which you should always be!) you will know exactly what to do when you go in for your looks. Keep in mind that makeup does not look the same in real life as it does under the lights, on camera – so checking in the monitor is vital before doing any touch-ups. You may be surprised!

While doing your last looks, be polite and quiet. Gently talk the actor through what you are going to do, or get their attention through eye contact, so they are prepared for you to touch them, even if they are in the middle of conversation with other cast members. You should err on the side of caution when the Director

is present. Some Directors and actors do not mind if you do your looks while they are giving direction, but many do. If the Director steps in to give a last-minute note, pause what you are doing and step aside.

You may sometimes need to give last looks to more than one actor in a scene at a time. In this case, sanitation is of the utmost importance. Your hand sanitizer should be easily accessible and it's a good idea to have a small trash bag attached to your set bag somehow to throw away your disposables like cotton swabs and tissues before moving to the next actor.

Your last looks for close-ups will be different than wide shots. In a close-up, every single thing on the actor's face will be visible, and will be distracting on the big screen. One eyebrow hair out of place, a crease of concealer under the eye, a tiny patch of dry skin on the lip. They should all be examined and fixed before a close-up – unless this look fits with the story you are telling. In the wide shot, you will worry more about color, overall shape, and shine – a sweaty "hot spot" on an actor's forehead can be especially distracting, even from far away.

Sometimes on large productions, you may be asked to "cover" a character whose makeup you did not do at the top of the day. In that case, the artist who did the makeup will typically explain to you what they did and what products are in that actor's set bag, but they may not always have time to introduce you. In this case, last looks might be your first time to meet them. It is perfectly acceptable to quickly say "Hi, my name is X and I'll be covering your makeup on set for this scene. Just let me know if there's anything you need or anything you want me to know." Actors are aware of the fact that this staffing sometimes needs to happen and most are quite nice and flexible about it. Keep your cool and treat even the biggest stars respectfully, but like any other normal person.

Last looks should never come as a surprise to you. You may be stationed near a monitor that is quite a distance away from set – in which case waiting until "last looks" is called is not the appropriate time to get out of your chair and spend three whole minutes walking in to set. You should be standing by with the appropriate products ready, somewhere nearby the set so you can easily get in and out. As soon as you and any other artists exit the set after last looks, the cameras will roll.

You may encounter a situation where you need to apply something after the camera has rolled, such as a tear stick or fake blood. In this case, make sure it is communicated in advance to your 1st AD. Stand by at last looks. Once the camera rolls, you can usually step in at the same time as the 2nd AC steps in to slate. You can apply your product as they are slating; that way when you all step out of the frame, the blood is actually dripping out of the "wound," or the actor is just beginning to cry. This creates the most realistic timing for your moving makeup elements. It just requires a bit of extra advance planning.

Continuity

Continuity is a word you will hear countless times per hour on set. It is one of the most important elements of your work as a makeup artist to keep the characters'

looks "continuous." When continuity is mentioned during production, what it essentially means is keeping things looking the same. Every department keeps track of continuity in their own ways. For example, if a woman is sitting at a table and a glass of water is on her right side in the wide shot, the Props Department will need to make sure the glass is in the exact same place when the camera moves to cover her medium shot – otherwise the glass will appear to be "jumping" around the table. The Hair Department is confronted with continuity constantly – sometimes in every single take. We have all been watching TV and noticed a curl of hair that sticks out, then disappears, then reappears the next time we see the character. This is considered a continuity error and unfortunately it can happen to the best of us.

The same principle of keeping visual elements the same holds true for the Makeup Department. Continuity is the reason for the non-stop touch-ups we perform throughout the day. Because it can sometimes take many hours to shoot one scene, an actress's red lipstick might look perfect at the top of the day, and then if she is drinking water or eating, it fades or gets messed up. These issues would need to be cleaned up because although she might appear in shots that were filmed hours apart, these shots may end up right next to each other in the edit. It looks crazy to see someone with lipstick on brightly applied, then lipstick faded, then back on brightly applied.

Beyond the daily continuity, we must keep track of overall looks throughout time. Sometimes film scripts will be set all on the same day but shot over many months. In that case, whatever is going on with the actors' skin and facial hair is what you will need to keep track of throughout. If an actress regularly gets eyelash extensions, she will need to do so at regular intervals during the entirety of the shoot. You may also encounter long work-drops for certain performers. Imagine an actor appears in the first episode of your television show, and then he is written back in episode twelve. By now, five months has probably passed. He might have gotten a tan, gained some pimples, and changed his facial hair style – but your challenge is to make him look the same as he did in episode one.

All of these reasons are why Makeup Departments (and other departments as well) keep the hallowed **continuity book**. The continuity book contains photos of every single performer in a television series or film and every detail of his or her makeup look. Multiple photos should be taken while the actor is in the bright lights of the trailer. Photos should include straight-on, both sides of the face, and both eyes open and closed if eye makeup is worn. Anyone with distinguishing elements on the hands such as nail polish or tattoos should also have their hands photographed. In fact, most Department Heads will still want photos of the hands of your female characters even if they do not have nail polish on because this will avoid the actress coming back three months later *with* nail polish on and then saying "I don't remember if my nails were painted or not!"

You might arrive on set with an actor you are covering and the Director doesn't like an element of the look – if that is the case, make sure you take new photos of the look once it has been changed. Later,

print them and put them into the continuity book, making sure your Department Head is aware of the change. Similarly, if something is planned to change on set (for example, someone is having blood splashed over their face *in* the scene) be sure to grab photos of this as well. Your photos should be clear quality and taken in a well-lit area so that all details are visible.

If you are shooting scenes that take place over more than one story (script) day on the same shooting day, you may need to change a character's look on-set. This is where the continuity book really comes in handy. You will be able to check the photos from each story day and match the makeup to that look.

Different productions may have variations in how they want their photos labeled in the continuity book. The most important information to be on the photos is:

- The character's name
- The character's number
- The scene number
- The story day (abbreviated with D or N and then the number, i.e. D2/N2)
- Any distinguishing information about the photo like "Costume Party Makeup Look" or "Scar on Left Ear"

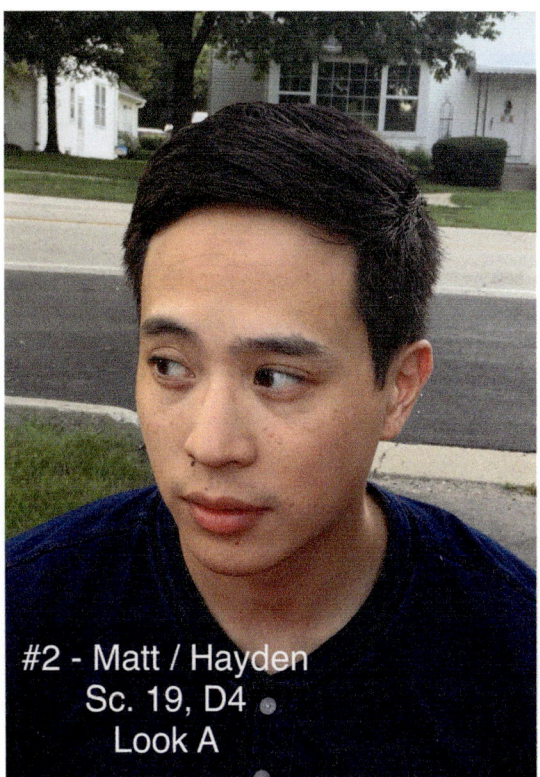

An on-set continuity photo of actor Hayden Szeto in the film *Come As You Are*

Make sure you ask your Department Head how and where he or she would like continuity elements labeled and recorded. "Everyone puts their own stamp on how the book is done," write Gretchen Davis and Mindy Hall in *The Makeup Artist's Handbook*. "Digital photos, notes illustrated with photos, sticky notes that attach to the back of the photo, makeup charts (face charts), labeling of the cosmetics used with the scene and actor on the label – and combinations of all of the above – are some of the tools used to document continuity" (Davis & Hall 30) . Some Department Heads will have you write directly on the photo, others may have tabs in a binder. If you are working on a television show there is generally a separate binder for each episode and these are kept easily accessible in the trailer so the looks of recurring characters can be referenced.

In addition to the traditional binder, electronic formats for continuity are becoming more popular. Online sharing with platforms such as Dropbox or Google Drive are used on occasion, as are mobile device apps including Makeup Continuity Pro or SyncOnSet. Still, printed photos and binders are still prevalent.

Different Department Heads will also have different preferences on who keeps the continuity records. In general, the Key Makeup Artist is considered the person in charge of continuity. They will create the binder or the electronic folders with character names ready to be filled with photos. Some departments might request you send every image to the Key Makeup Artist to print all the photos. Other Department Heads will instruct every artist to print his or her own photos during free time. Check with your Department Head on your first day what process they like to use. Even if you are day-playing, or covering background, you will need to take continuity photos of the characters whose makeup you do. With background actors you can typically get away with photographing them in groups, but again, ask your Department Head.

Face Charts

In addition to your photos, another important element of continuity is the **face chart**. You will not necessarily be doing a face chart for every character that you work on but, for your recurring or more complicated looks, this will be a great way to keep track of your designs and products. Face chart templates can be easily downloaded from the Internet or you can purchase a book of templates like my favorite, *Makeup Artist Face Charts,* created by Gina Reyna for The Beauty Studio Collection. They also offer face chart books for individual facial features like an entire book of eye templates or lip templates. You can also create your own template, simply by drawing a face or facial features with a marker and writing notes on the side.

Most purchased or downloaded face chart templates will have a section on the page where you can list all the products you used as well as different techniques and tools. This is a great way to keep looks continuous, especially throughout a long shooting period.

When I create a face chart, I typically use most of the makeup I have used on the actor or actress. Powders like eyeshadows, blush, and bronzer tend to work particularly well. Creams, however, do not hold up well on paper. That is another reason to make a list on the side. If you write down the brand and color name of a particular foundation, you can always put a small dot right next to the name, instead of wasting your product and making a mess by painting it all over the face template.

If you chose to use lip or eyeliner on the paper, make sure the pencil is very sharp. You can smooth out the line with a small brush if the line begins to smudge. Generally, it is enough to list the name of the lipliner. For eyeliner in particular, it can be effective to use colored pencil – the neutral colors (black, grey, brown, etc.) are usually similar enough to the actual eyeliner product, but they work much better on paper

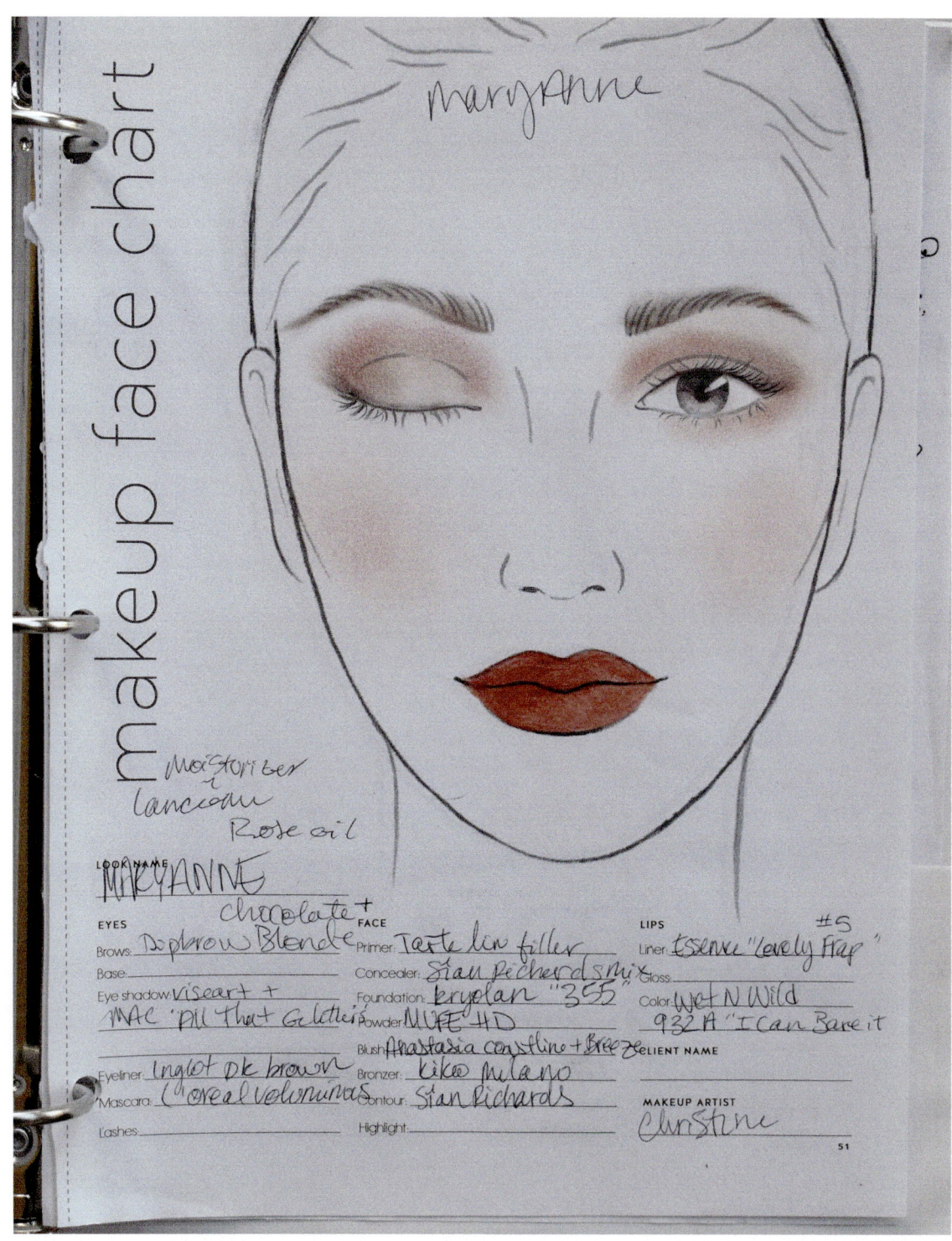

A face chart created using a template from *Makeup Artist Face Charts* by Gina M. Reyna for The Beauty Studio Collection

Production 91

than a waxy eyeliner. With lipsticks, I do often use the actual lipstick, using a brush and applying a very thin layer. You can dab off any oily residue and set it with translucent powder to avoid smudging. The key here is to work with a light hand.

If a character is wearing lots of mascara or a particular style of false eyelashes, I use a thin permanent marker to draw these on. I also know artists who use liquid eyeliner, colored pencil, or ballpoint pen. You will find a system that works for you.

Once you have completed the face chart, you can put it into your continuity book with the photos, or ask your Department Head if they would like them kept in a separate place.

An added bonus of face charts – they also can be used as a design tool! You can create many different looks for one character and bring the face charts to the Director to help them narrow down options. I have done this many times and it can be quite fun. If you aren't sure what products you will need for a design or don't want to buy the products before the look has been confirmed, feel free to use paints or other craft supplies to convey your ideas – then you get to figure out how to create them with makeup!

Wrap

In This Chapter

- **Invoices and Timecards**
- **Wrap Procedures**

Invoices and Timecards

Of course, you love doing makeup and you've had a great time working on set – but as fun as this job is, it is still a job. That means, you want to get paid!

There are so many ways to operate your business as a makeup artist, and every forum – film, episodic TV, fashion, commercial, bridal – has its own conventions on payment and paperwork. Regardless, for film and television, you can assume you will likely be considered, and paid as, one of two entities: an **employee** or an **independent contractor**.

As an employee, you legally work for whoever is producing the content – only for the duration of the shoot. For a film job, this may be a studio, production, company or network. For TV, it is most often the network or streaming service that owns the show (such as NBC or Netflix). Commercial shoots usually last only a few days so there is a good chance you would be an independent contractor, but if you are billed as an employee, you may be an employee of the production company, or the "client," – the brand being advertised in the commercial. Being billed as an employee does not mean that you go to NBC's offices for work every day, in the traditional sense of being an employee. However, as a crew member, you are covered under the employer's Workmen's Compensation policies and insurance if something happens to you. The employer is also required to withhold taxes from your paycheck. You will fill out the appropriate paperwork to make sure that this is done properly for your specifications and amounts you want withheld. As an employee, paychecks are generally given weekly or bi-weekly.

To get paid as an employee, the production will give you a timecard (get this from your Department Head on a large production or from the AD Department if you are the Department Head or only makeup artist) to fill out and turn in at the end of each week. Like we have discussed in previous chapters, different unions and locations have different standards for whether timecards are filled out with military time or not, so you will want to make sure you are clear with the production on the details of this. Weeks usually are considered to start on Sunday, making Sunday the "first" day of the week, and Monday the "second" on the timecard. If you only work on a show one day that week and that day is a Wednesday, you would fill out the line for the fourth day of the week. You first write

your call time. Then, most productions require you to sign in and out for unpaid meal breaks. You would write your lunch out-time (what time you went to lunch) and then in-time (what time you went back to work). When you leave for the day that is considered your wrap time. If your car is parked far away, *some* productions allow you to add a little extra time to get a shuttle to Crew Parking. It's best to ask before doing this.

The other way you can have your payment processed is as an independent contractor. In the United States, you can be paid as an individual this way using your Social Security Number, or if you have incorporated as a makeup artistry company, you can process the payment through your business using your corporation's **Federal Identification Number (FEIN)**. If you are working on a film with a smaller budget, they may prefer to process you that way because then they do not have to pay for insurance for you or withhold taxes for you, making it cheaper for the people or production company making the film. You will fill out a different form, called a W9, and then you will be expected to pay taxes on the wages you receive from this production. If your wages amount to more than $600, then at the end of the year, the production company is legally obligated to send you a document called a 1099, which declares that you did indeed work for them, and how much you earned. That will be the determining factor of how much you will need to pay in taxes on your earnings. I work with an experienced accountant each Spring to tally up all my different jobs and make sure I pay my taxes properly. I have an incorporated makeup business as a freelancer and I also work as an employee on several different productions throughout each year, so he is able to look at all my employee pay stubs from different production companies and all my 1099s and calculate how much I owe in both state and federal taxes – both on my personal tax return and a separate tax return for my business. As you get busier and busier, having a qualified accountant who is experienced in working with artists and freelancers is worth every penny!

On most productions as an independent contractor, you will not be given a timecard, but will be expected to turn in an invoice. This is also quite common for commercial and corporate video shoots. An **invoice** is essentially a receipt for the company of how much they paid you and for what services. I suggest you do this on the day you wrap, so your own bookkeeping doesn't get too far behind. You should keep a careful record of each and every invoice you send and when you receive the payment for it.

There is a lot of important information that needs to go on your invoices:

- An invoice number (you can make up your own numbering system)
- The name and contact information of the company you are billing
- Your name and contact information, including mailing address, and a company name if you have one
- The project name and shoot date(s)
- Your rate and how many units you worked (days or hours)

- Any additional expenses the client has agreed to pay, such as a "kit fee" for your materials, or parking (if for an item like parking or supplies, the receipt for this item should also be attached)
- The best way to pay you – many artists now accept electronic forms of payment, so if you do be sure to note that on your invoice and whether it is linked to a certain email address or phone number
- The due date for your payment!

A typical payment time frame for an independent contractor's invoice is 30 days, though some companies may advise you up front that they have a standard of 45 days or 90 days. If no such provision exists, I suggest writing "Due within 30 days," (or 14, or 45, depending on the contract) and the exact due date of payment on the invoice. If 28 days is approaching and you have not received payment, is it perfectly acceptable to send an email with a nudge, "To make sure the payment is in the mail." If the 30-day limit is up, you may email and request a status update, reminding the client of the due date of the invoice.

Unfortunately, it is not uncommon that you may have to chase down overdue invoices by emailing, calling, or texting the contact who hired you. You may be referred to Accounting Departments or Payroll Departments. Some artists have a percentage of interest listed on the invoice if the payment is particularly late, but it is up to your discretion if you think you need to do this. Hopefully your clients will be organized, well-funded, and respectful and this will not happen too frequently, but if it does, do not be afraid to be assertive. You always deserve to be compensated for services you have rendered.

As far as what rate to charge – it can be tricky to decide this when you are just starting out. While most television and film productions that are Union work on a contracted hourly rate, many smaller jobs like commercials, corporate shoots, and independent films, will ask you for a **day rate**. This can be your day rate for ten hours or 12 hours depending on the project. It is conventional to also give a **half-day rate** for five hours of work or less. If you decide to offer a half-day rate as part of your freelance business, make sure that the rate is enough that it justifies you packing and organizing your kit and traveling to the shoot – even if it's for only a few hours. You may be unsure about how to set your rates in the beginning, so feel free to connect with established artists in the community and humbly ask them for advice on this. Standard day rates for hair and makeup artists tend to differ between cities, so make sure you aren't aiming too low or too high for your market. Don't be afraid to

> "Don't be afraid to gradually increase your day rate as you build your experience, your education, and the number of professional products and tools in your kit."

Wrap

INVOICE
Invoice #: XXXXXX

Your Name
Your Brand
Your Mailing Address
Your Phone Number
Your Email Address

Bill To:
Client's Name
Client's Address
Client's Phone Number
Client Contact Email Address

Invoice Date: 7/3/20
Due: Within 14 days – 7/17/20

Production: Name of Production
Week Ending: July 6, 2020 (Shoot)

Item	Rate	Amount
Makeup Flat Rate	$500/day x 2 days	$1,000
Kit Fee	$35/day x 2 days	$70
Parking (receipts attached)	$6/day x 2 days	$12
	Total Due:	$1,082.00

Please make checks payable to
Your name OR Corporation

Electronic payment accepted with email address
Your Email or Username

Thank you!

A sample invoice

98 Behind the Scenes

gradually increase your day rate as you build your experience, your education, and the number of professional products and tools in your kit. Always remember – your time and your skills are valuable!

Wrap Procedures

When you finish or **wrap** a film or television project, the production team will expect certain documents and items from your department, either on the day the shoot wraps or within one or two days after wrap. You will need to organize and turn in the following:

- **Your Budget:** Different states' film commissions have different methods of how receipts should be organized in order for the production to receive a state tax credit, if offered. A standard format would be two receipts neatly taped to each blank sheet of paper, with the total amount circled. I always make a copy of my receipts for my records before turning them in. On the top, I will attach the finalized budget breakdown spreadsheet I have been keeping throughout the production. Note that TV productions often require you to turn in budget documents at the end of each month or episode.
- **Your Continuity Book or Electronic Report:** At the end of the shoot, production will want to keep your continuity documents. It is important for them to have your documents, because they may end up needing to do pickup shoots or reshoots with a different makeup artist. Possession of continuity documents ensures that the proper looks will be created even if you are not there. This procedure also ensures that any designs stay the property of the film. Most productions do not want you to use your continuity photos for your own publicity and you may even be required to sign a non-disclosure agreement that stipulates not sharing any images of makeup looks from the project until after a certain date – or ever.
- **Character-Specific Items:** Did a certain actor wear a specific wig during the shoot? Did a particular actress have fake facial piercings? Those items will need to be packaged and turned into Production. This is for a similar reason to the continuity documents – they can use them in reshoots or future seasons of the show if necessary. It also creates posterity for the project itself. Let's say the film becomes world-famous and three decades into the future a museum opens up a retrospective about it. That wig can also be included in the exhibit and is considered a piece of history.
- **Credits:** Who wants to go to the movie theater to view a film they worked hard on, only to get to the end of the movie and find their name misspelled in the credits? No one. In addition to spelling issues, Production may not know exactly what agreement you've made with the artists in your department or exactly what role you each had. For these reasons, it is vital to send an email to your Producers after wrap, detailing everyone who worked in the Makeup Department and what their job title was. It is never guaranteed that everyone will indeed receive screen credit, however if they do, you want to make sure it is correct. You will also want to make sure

that any product lines or technicians who have supplied anything for you, whether as a donation or for payment, receive credit. A sample credit sheet may look something like this:

Makeup Department Head

Key Makeup Artist

Makeup Artist

Additional Makeup Artists

Makeup Department Trainee

Contact Lenses by X

Special thanks to (X Cosmetics Companies) for your generous sponsorship.

In addition to wrapping various documents for the production upon a shoot's completion, you will also need to wrap your own equipment. If you are working out of a trailer you may have a lot of your personal items and makeup there. You will clean all this, pack it up, and take it home. If your department has received a lot of product donations or has a lot of leftover disposables, your Department Head might distribute some of these as a gift to the artists in the trailer. This really depends on the Department Head, so do not always expect that you will be leaving a project with "free product." Once you have packed up all your supplies, be sure to practice courtesy and wipe out each drawer of your station with a disinfecting wipe and to clean the mirror with glass cleaner.

You may be asked to "wrap bags," meaning to take apart the set bags of products the actors have been using. Note that you may also be asked to wrap actor bags throughout shooting as actors finish up what they need to film. First, throw away any trash in the bag such as tissues or cotton swabs – you have likely been cleaning the bags at the end of each shooting day so these should not have accumulated too much. Then, remove each of the makeup products and wipe off the outsides with 70% alcohol and a paper towel or a disinfecting wipe. Sanitize each product according to the procedures outlined in Chapter 3. The products in each actor's bag may be a combination of makeup belonging to different artists in your trailer, so make sure to check the bottom for labels. If you know where each artist keeps all their products and you have been given explicit permission to do so, you may put the products back where they go in other artists' station drawers. Otherwise, you can lay the products out neatly on a paper towel next to their station. You will clean the brushes in the bag and also leave them on a clean paper towel on the station of the artist to whom the brushes belong. To clean the bag itself, take a disinfecting wipe, or a paper towel sprayed with 99% alcohol, and wipe out each pocket of the bag to remove any dust or makeup residue.

If you have been using your personal kit on-location and not working out of a trailer, you will also need to clean and organize your own products, as you may have been using specific items for this shoot. Use your common sense as you reorganize your kit. I recommend doing this as soon as possible after wrap, while the shoot and the products are still fresh in your mind. On a few occasions, I have waited to wrap my own kit upon bringing it home and wound up finding cluttered bags of products that still needed to be cleaned and organized weeks later – this adds to the stress right before the start of a new shoot. Hopefully it won't be long before you book a new project and you will be preparing your kit for that!

Section II

Theory

5

Color Theory

By Christine Sciortino with Katie Middleton

> Color is one of the essential tools we have as artists. With any craft, it's important to fully understand how your tools function before you can use them efficiently.
> – Katie Middleton

In This Chapter

- The Basic Color Wheel
- Color Relationships and Makeup Design

The Basic Color Wheel

An understanding of color theory is imperative for any makeup artist. On the surface, it may seem simple. Digging a little deeper, it may seem overwhelming. As you study color theory and experiment with integrating its principles, this way of seeing will become second nature and you will be a much better makeup artist because of it.

Katie Middleton is a Make-up Artists and Hair Stylists Guild Award-nominated makeup artist, special effects makeup artist, and the author of *Color Theory for the Make-up Artist: Understanding Color and Light for Beauty and Special Effects;* a text which I highly recommend. I had the opportunity to ask Katie why color is so important and she emphasized:

Color is one of the essential tools we have as artists. With any craft, it's important to fully understand how your tools function before you can use them efficiently. Having a strong knowledge of color theory will give you the ability to see nuances and recognize colors within the skin, and help you make educated decisions when selecting colors to cancel, correct, contrast, or accentuate others.

So what even *is* color? Color is essentially the way reflected light is perceived by our eyes.

The human eye and brain together translate light into color. Light receptors within the eye transmit messages to the brain, which produces the familiar sensations of color. Newton observed that color is not inherent in objects. Rather, the surface of an object reflects some colors and absorbs all the others. We perceive only the reflected colors. Thus, red is not "in" an apple. The surface of the apple is reflecting the wavelengths we see as red and absorbing all the rest. An object appears white when it reflects all wavelengths and black when it absorbs them all

(www.Pantone.com).

Scientists have been developing ways to break down, name, and analyze these colored reflections for centuries, finally arriving on the **color wheel**. You are likely familiar with the basic color wheel – a color analysis system based on the three primary colors.

The three **primary colors** are red, yellow, and blue. "These are the base colors in mixing colored pigments because they cannot be created by intermixing any other colored pigments" (Middleton 7).

By mixing the primary colors as they appear on a triangle, we arrive at the **secondary colors.** "Secondary colors are the direct mixture of two primary colors" (Middleton 8).

Red + yellow = orange
Yellow + blue = green
Red + blue = purple

COLOR THEORY

CMYK/RGB Color Wheel

COOL, PASSIVE COLORS

WARM, ACTIVE COLORS

- SHADES (adding black, 10% intervals)
- Pure HUE
- TINTS (adding white, 10% intervals)

Color Systems

CMYK SUBTRACTIVE
Created with ink

RGB ADDITIVE
Created with light

Color Types

Primary
RED, YELLOW, BLUE
Colors that can not be mixed. All other colors are derived from these 3 hues.

Secondary
GREEN, ORANGE, PURPLE
Colors formed by mixing the primary colors.

Tertiary
YELLOW-ORANGE, RED-ORANGE, RED-PURPLE, BLUE-PURPLE, BLUE-GREEN, YELLOW-GREEN
colors formed by mixing a primary and a secondary color.

Complementary
Colors that are opposite each other on the color wheel.

Analogous
Analogous color schemes use colors that are next to each other on the color wheel.

Classic Color Schemes

Monochromatic
The monochromatic color scheme uses variations in lightness and saturation of a single color.

Analogous
The analogous color schemes use colors that are next to each other on the color wheel.

Complementary
The complementary color scheme use colors that are opposite each other on the color wheel.

Split complementary
The split-complementary color scheme is a variation of the complementary color scheme. In addition to the base color, it uses the two colors adjacent to its complement.

Double-Complementary
The rectangle or tetradic color scheme uses four colors arranged into two complementary pairs.

Triadic
The triadic color scheme uses colors that are evenly spaced around the color wheel.

Color Theory Reference Guide by Marin Bulat

Finally, we can create the **tertiary colors**, by mixing adjacent colors – this time one primary and one secondary color. Therefore we arrive at:

red-orange
yellow-orange
yellow-green
blue-green
blue-purple
red-purple

With these three classifications of colors, we get the basic color wheel consisting of 12 colors total.

The colors opposite from one another on the wheel are called **complementary colors** and these colors will be incredibly important part of your knowledge as a makeup designer.

The basic complementary colors

Complementary colors when placed side by side, enhance the appearance of one another. When mixed, however, they will neutralize one another, creating a dull brown or grey. This will be very important to keep in mind as you continue your work in makeup, especially in corrective and beauty makeup.

The pure colors of the color wheel (also known as **hues**) can also be dulled with neutrals such as white, black, and grey.

Any hue (a pure color) mixed with white is called a **tint**.
A **shade**, is a hue mixed with black.
A **tone** is created when a hue is mixed with grey.

While it is good to know all these terms as they appear in color theory and fine art, do keep in mind that they are not the same when it comes to makeup design. In the trailer, you may hear "tint," referring to a lightly pigmented product with a sheer coverage, such as a tinted moisturizer or a lip tint. "Shade" may refer to any color (hue) of blush, eyeshadow, or even lipstick – you may have another makeup artist telling you what they did for a character's eye makeup look and hear them say "I blended these two shades on the eyelid." A tone may refer to the pure baseline pigment of any makeup product, e.g. "Use a cool-toned red lipstick," or "He has really

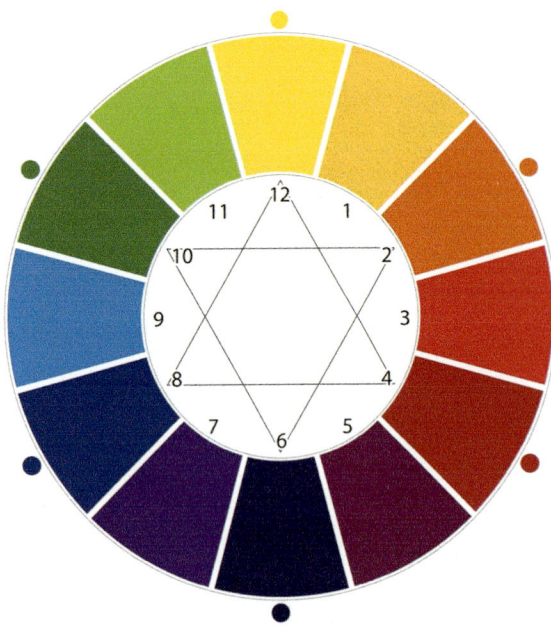

The full color wheel

106　Theory

rosy undertones in his face." Because there can be such a variety in the "lingo" of makeup artists, making sure you have a knowledge of color theory will help you to always be prepared and to be flexible even when you and another artist may be using different names for things.

Undertones

In order to be able to discuss color in casual ways with other makeup artists, you need to have a strong knowledge of **cool colors** vs. **warm colors**. Distinguishing if a color is cool or warm is usually the beginning of the process of recognizing a color's **undertone**.

According to Middleton,

"Color temperature classifications are based off physical and psychological effects and appear relative to their names. An undertone is the underlying color of the skin and does not relate to the darkness or lightness of a person's complexion. Warm colors are typically red, orange, and yellow, and are reminiscent of fire and warmth. Cool colors are typically blue, green, and purple, and are reminiscent of ice and coldness. [Therefore] warmer skin tones appear more yellow, while cooler skin tones appear more blue and red.

Warm colors

Cool colors

Neutral tones fall in the middle and don't have an obvious cast. Not every undertone is easy to classify, because there are different levels of how warm or cool a color can be."

One way I like to discern undertones of pigments is to simply break it down as you describe it:

1. Identify the overall color. "It's brown."
2. How would you describe the overall color using another color? "It's reddish-brown."
3. Look at your color wheel. Is red a primary color, secondary color, or tertiary color? (Primary)
4. Is red warm or cool? (Warm)
5. If you had identified a secondary color as the underlying color ("It's greenish-brown.") you would need to go back to your color wheel and see what primary colors make up the secondary color you are perceiving (yellow and blue). A color like green can be more warm if it has more yellow undertones and more cool if it contains more blue undertones.
6. Then ask yourself, which *primary* color is most dominant when I look at this color? If you can describe it as a "Yellow-y-greenish-brown," you

Color Theory 107

know it is a warm brown and if you can describe it as a "Kinda blue-ish-greenish brown" then you know it's a slightly cooler brown.

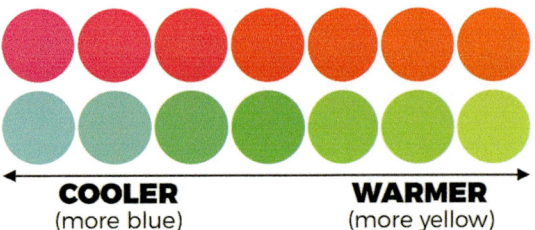

Complementary colors from cool to warm undertones

Of course, this is not the most scientific language to break down color! However, it *is* accessible and it activates your own baseline knowledge and your intuition of *how* you are perceiving something. This step-by-step process, however basic it may seem, can really help you train your eye when you are first starting out.

Katie Middleton proposes another way to continue examining warm vs. cool undertones in your palettes, which I also find to be very effective:

"I think the easiest way to determine an undertone is by comparison. It can be difficult to look at a color by itself and decide 'this is cool.' However, it's much easier to distinguish a warmer color when it's placed next to a cooler one. Try arranging your products in palettes so that they can be compared side-by-side like a color scale. This way you can hold them up to the face or body for comparison and easier identification."

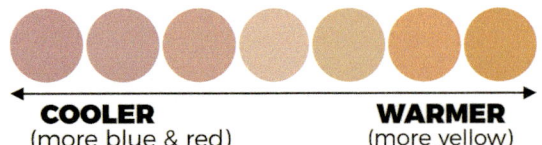

Undertones can be assessed from cool to warm in makeup and skin tones

Whatever techniques work for you, try to practice identifying undertones and describing colors frequently so that it becomes a natural process.

Color Relationships and Makeup Design

In order to effectively design makeup looks, we must understand how to pair colors together. "When one color is surrounded by another color, our eyes perceive them differently" (Middleton 24). This principle will factor into every makeup design you do – whether it is a beauty makeup or a special effects makeup. "This can explain why some people look better wearing certain colors, or why our eyes seem to stand out with certain eyeshadows. This effect is known as **simultaneous contrast**" (Middleton 25).

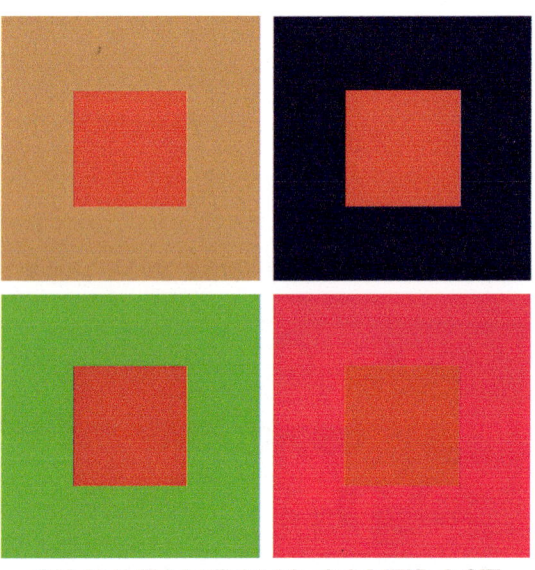

SIMULTANEOUS CONTRAST

The same color looks different when surrounded by different colors – this is the principle of simultaneous contrast. Simultaneous contrast can help you choose colors for your makeup designs

108 Theory

You can use the lessons of simultaneous contrast in your beauty makeup designs to enhance certain features of your actors. "If your intention is for the color of the eyes to stand out, you can try experimenting with complementary colors to contrast the eyes with eyeliner" (Middleton 77). Using an eye makeup that complements the color of the actor's eyes can really enhance their eye color. Keep in mind, however, that the look should still tell the story of the overall character, should suit the wardrobe, and should work well with the actor's overall skin tone.

My mom was a makeup artist in the 1970s and she has often told me the story of her first day as a makeup artist when a rosy skinned redhead entered the salon. My mom saw the pink, copper, and orange tones of client's natural coloring (and of course, it was the 70s when golds, oranges, and rust colors were *especially* popular!) and decided to do a look that was all coppers, rusts, and rosy toned. Needless to say, the client's blue eyes might have really stood out, but overall, in my mom's words, she looked "Freakish! Orange and swollen looking."

"Think about coordinating your eyeshadows with your skin tone, rather than your eye color," suggests Middleton. "For example, an orangey, golden color may complement your blue eyes nicely, but may not look as flattering on your skin if you have very pink undertones" (81). Use your best judgment and don't be afraid to experiment as you are learning – makeup can always be washed off!

If eye makeup colors are too red, pink, or orange, they can make the eyes look tired and irritated – this may not be a desirable look for beauty but can be a great effect for a character who hasn't slept in days, is ill, or is using drugs. So, by all means, use color theory in your designs, just do so in a way that fits your story.

I suggest investing in your own Flesh Tone Color Wheel, created by makeup artist and educator Terri Tomlinson. The Flesh Tone Color Wheel contains not only the basic color wheel, but skin tone variations from light to dark based off of those pure color undertones. It is an excellent resource for any artist looking to deepen their understanding of color theory and incorporate it more into their makeup designs. I always keep one in my kit.

You may find yourself creating discolorations or skin conditions relating to injury, illness, or even death.

When someone dies, blood is no longer circulating through the body, which results in a much more noticeable loss of color (especially in the face). If you're creating a death make-up or a very ill look, one of the quickest and most effective techniques is to add a pale flesh tone to the lips and to remove any redness from the face.

Accentuating dark circles under the eyes is another way of convincing the audience that someone is sick. Purples and reds can be effective, but be careful not to make them look like black eyes. Thinning out the product is a good way to keep the effect subtle.

Jaundice is a type of sickness that can occur which creates a yellowy skin color. This happens when the liver

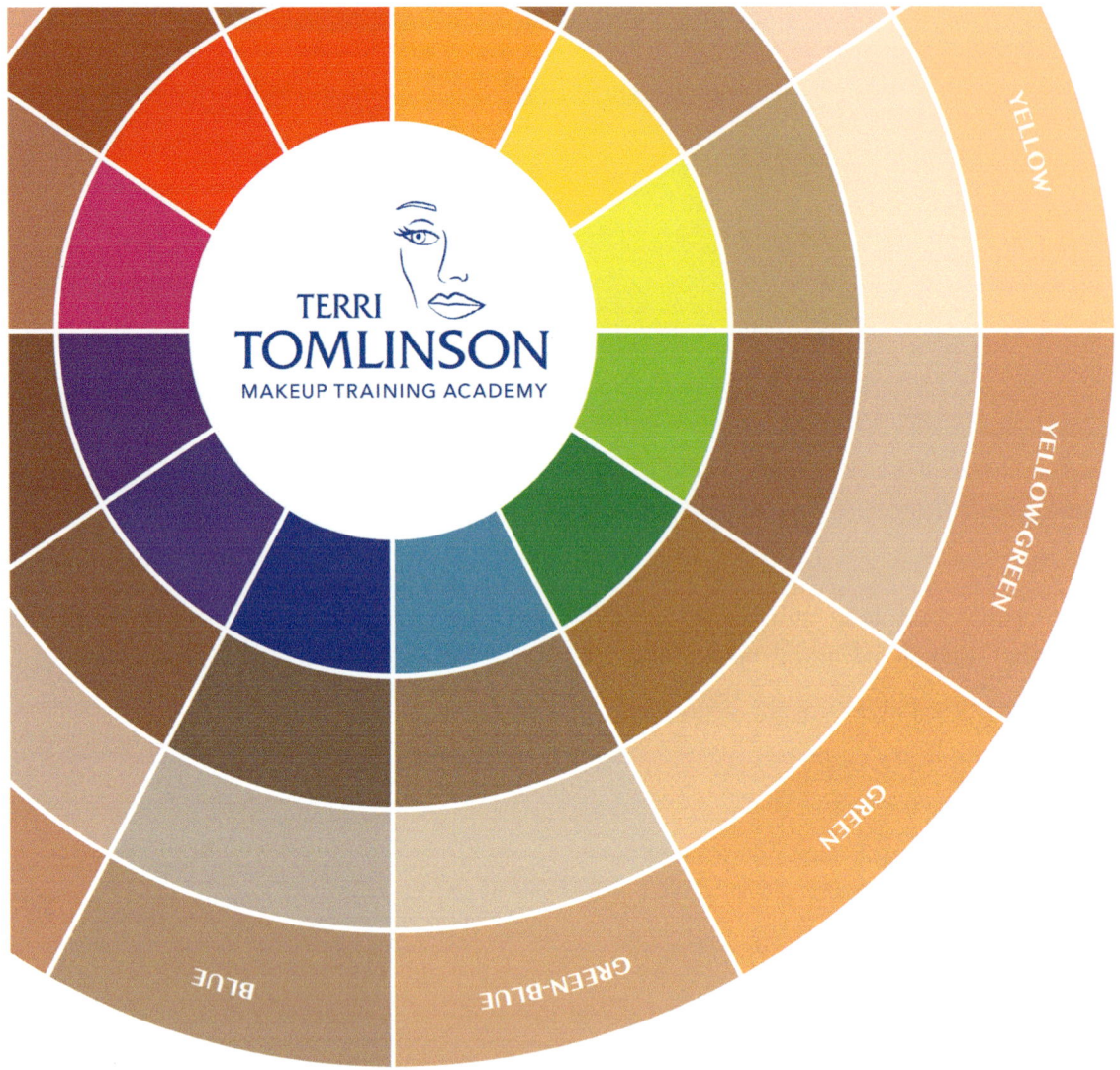

©Photo of Flesh Tone Color Wheel™ courtesy of Terri Tomlinson Makeup Training Academy.
All rights reserved

doesn't properly break down bilirubin (a yellow pigment found naturally in mucus and skin), so the color becomes noticeable. Jaundice is common in babies whose livers are still developing.

(Middleton 97).

You can use color theory in countless other ways when it comes to creating characters and we will continue to discuss this when we get into some of the specific techniques in Section III.

Lighting

By Tony Santiago
Edited by Christine Sciortino

In This Chapter

- **Commonly Used Types of Lights**
- **Lighting Design**
 - **Placement of Lights**
 - **Color of Light**
 - **Quality of Light**
 - **Quantity of Light**
- **The Lighting Department**

The work of the Cinematographer and their lighting team go hand in hand with the work of the Makeup Designer and their team. The lighting choices and style can often have an impact on the makeup and vice versa. Sometimes the lighting can enhance the look that has been created by a makeup artist, while other times it distracts from the desired look and aesthetic. This makes the relationship between the makeup artist and the cinematographer one of the most important in the filmmaking process. Understanding the basics and fundamentals of lighting can be a huge asset to the makeup artist in both preparation and execution.

First, let's establish a few common types of lights before we examine **lighting design** as the placement of these lights.

> *…lighting can enhance the look that has been created by a makeup artist, while other times it distracts from the desired look and aesthetic. This makes the relationship between the makeup artist and the cinematographer one of the most important in the filmmaking process.*

Commonly Used Types of Lights

Tungsten Lights

Tungsten lights are very common in studio situations. They come in a variety of sizes and power ranging from 100 watts to 10,000 watts. They are similar in design to household incandescent light bulbs that you might find in a desk lamp. Tungsten lights have a filament that emits light when heated up. The color temperature of tungsten lights is 3200K. They are not energy efficient and tend to get quite hot, requiring electricians to wear gloves when handling them. Mole Richardson is the most popular manufacturer of tungsten lights.

Artificial Daylight Sources

Sometimes called **HMIs**, these **artificial daylight sources** require less electricity than their tungsten equivalents. They contain a gas that is ignited inside the bulb that glows when burning – this creates the light. HMIs are "daylight balanced" and have a color temperature of 5600K. They are often used on location to mimic actual sunlight. Arri is the most popular manufacturer of HMIs.

Fluorescent Lights

These lights are often found in public buildings. They are cost-effective and work similarly to HMIs in that they ignite a gas to create the light. **Fluorescent lights** are described as having a "discontinuous spectrum." This means that they are deficient in certain colors which can sometimes give it a green or magenta hue. Kino Flo is a company that manufactures continuous-spectrum fluorescent lights which are very popular in the film world, particularly for interviews.

LEDs

Light Emitting Diodes (LEDs) are becoming popular with lighting crews for several reasons. First, they are

Tungsten Light

Artificial Daylight Source (HMI)

Fluorescent Light

Light Emitting Diode (LED)

energy-efficient which means they require less maintenance and electricity. They are also smaller and lighter than tungsten or HMI lights. Some LEDs can even be controlled from an app on a smartphone or tablet. The downside of LEDs is that they are more expensive than tungsten or HMI lights. There are several manufacturers of LED lights. Some of the most popular are the SkyPanel made by Arri and the Litemat made by LiteGear.

Lighting Design

Lighting design is all about how the types of lights are used, and can be broken down into four parts:

1. Placement
2. Color
3. Quality
4. Quantity

Placement

Basic Three-Point Lighting

Three-point lighting is the starting point for all portrait lighting setups. The Director of Photography (DP) can choose to use more than three or fewer lights, but three is a good basic set-up. Three-point lighting consists of the **key light**, **fill light**, and **back light**.

The **key light** is the main, motivated source of light. It could be coming from a lamp or window in the scene. It fits within the story. It is also the light that the DP will use as a reference for proper exposure. The key light dictates the placement and intensity of all the other lights in the scene.

The **fill light** is the variable that determines the contrast or shadows on the face. Changing the fill light will have an effect on the mood of the scene. (i.e. more shadows will create a more dramatic feel)

The **back light** will light the back of the subject's head or shoulder. The purpose of the back light is to separate the subject from the background.

Direction

The first thing the Cinematographer or Gaffer will establish is the placement of the light. More specifically, the direction of the light. Where is it coming from? What part of the face is the light hitting? Where are the highlights and shadows on the face? These questions are quickly answered by establishing the placement of the key light – the main, motivated light source.

The most common placement of the key light is called the **narrow side**. This is the side opposite the camera in regards to the actor's **eyeline**. The eyeline is where the actor is looking for the majority of the scene. This leaves the side of the face that is open to the camera in partial or full shadow.

Less commonly used is the **broad key**, which is placed on the same side of the eyeline as the camera. This makes the side of a face that is open to camera brighter than any other part of the face.

The shadow side of the face is open to the camera – note the shadow coming across the model's face on the left-hand side of the image, or "camera left."

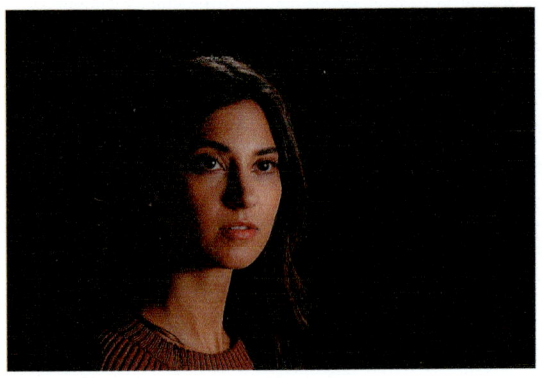

Narrow key

Broad key

The shadow side of the face is on the opposite side of the model's face from the camera – on the "camera right" side of the photo.

Sometimes a specific mood is desired and the Cinematographer will use **up lighting** in which the light is placed below the actor's face, or **top lighting** in which the light is placed directly above the actor's face. These decisions are sometimes made for aesthetic reasons designed to portray the character in a certain way and evoke certain emotions, like fear or anxiety. This type of lighting is generally seen in horror films.

There are times when the light is coming from below or above and not for artistic reasons but, rather, practical reasons. For instance, the DP might be in a situation where they are unable to avoid that light. Both top lighting and up lighting can present problems and are generally considered to be less flattering than a narrow key light, or even a broad key light. By having the light directly above or below the actor it creates shadows in places such as below the eyes.

The light is above the subject's head shining down and casting shadows under the eyes.

The light is shining from below and casting shadows above the eyes and on to the forehead.

Top light

Up light

116 Theory

Camera temperature: 3200K/Light temperature: 2000K (left) | "Camera temperature: 3200K/Light temperature: 3200K (center) | Camera temperature: 3200K/Light temperature: 5600K (right)

Color

There are several things to consider when working with color in regards to lighting. The first is **color temperature**. Color temperature refers to the color emitted by a light source at a specific temperature. Higher temperature light sources shift to the blue side of the spectrum, while lower temperature light sources shift more towards orange. Think about the blue flame of a hot blow torch compared to the orange flame of a single candle.

Color temperature is measured in units called **Kelvin**. The two most common temperatures are **tungsten** (3200K degrees) which appears as a warmer color, and **daylight** (5600K degrees) which appears cooler.

Color temperature can be adjusted in-camera by changing settings, as well as at the light source itself. If the color temperature in-camera and from the light source are the same then the color of the light will be white. If the color temperature of the light source is higher than the color temperature in camera then the light will appear blue. If the color temperature from the light is lower than the color temperature in camera then the light will appear orange.

Some light sources have what is called "discontinuous color spectrums." This means they are deficient in certain colors and the light they give off shifts towards the opposite color. Light sources like fluorescent lights are often deficient in magenta and can give off a green

Green shift (left) vs. Magenta shift (right)

Lighting 117

Note: When working with a scene that has mixed colors, watch the blocking rehearsal or camera rehearsal of the scene to see which color the DP is favoring for the closeups

hue. Sources like street lights shift towards yellow. Sometimes the DP will add those colors to studio lights to match existing lights that cannot be changed. Other times the DP will choose to mimic or recreate the natural look of the green fluorescent or yellow street lights.

Special Effects (FX) colors can be fun and in recent years LED technology has allowed DPs to achieve these colors much easier than in the past, making them popular, particularly in the music video world. These effects can be anything from the red glow of a neon sign to a purple strobe light at a nightclub. It's important to test the makeup with these colors to avoid color confusion. For example, a red lipstick is completely washed out under a red light. This makes the lips and cheeks appear to have the same tonality. The same red lip under a blue light does not appear as red but does come across as a different tonality and appears to have much more contrast. Working with colored light can be similar to working in black and white, where the makeup becomes more of a representation of dark to light values of the light color, rather than the makeup colors themselves.

Color confusion can also be a problem when shooting in black and white. Certain colors in the makeup might not translate as clearly in black and white as they do in color. This can leave actors' faces looking undefined, even if the definition is clear when color is present.

When shooting in black and white, it is important that the makeup uses color and shading to define the facial features. For example; in this image, the lips are visible in color with a neutral lipstick – however, in black and white, without more defined lip color, the lips appear to get 'lost,' blending into the rest of the face. The cheekbones and nose also lose definition

Quality

The *quality* of light is often confused for the *quantity* of light. Sometimes a light may be described as too "harsh" or too "hard," when in reality, the light is not hard at all, but rather just too bright. In other words, there is *too much* light – a measurement of quantity. The quality of the light, however, deals with hard vs. soft light and is most recognizable in the sharpness of the shadows.

The main way in which the makeup artist is affected by the quality of light is actually in the highlights. When lit with a soft light things like wrinkles and imperfections can be smoothed out. When the actor is lit with a hard light it can create problems in regards to shine or reflections. Conversely, hard light can be used to enhance the effect of things like glitter – just be aware that other parts of the skin will also reflect under hard light which might not be intentional.

> **Working with colored light can be similar to working in black and white, where the makeup becomes more of a representation of dark to light values of the light color, rather than the makeup colors themselves.**

The **soft light** creates soft edges from the shadows. This is noticeable on the left cheek and from the nose

The **hard light** creates a sharp line on the edges of the shadows on the left side of her face and from the nose shadow

Lighting 119

Quantity

Exposure, contrast, highlights, and shadows all fall under the umbrella of **quantity of light**. Contrast is the ratio of key light to fill light.

In Figures 6.13 and 6.14 below, the exposure on the **key side** of the face does not change from the first photo to the second. However, the amount of light on the **fill side** differs from shot to shot. By increasing the amount of fill light we create a low contrast scene. By reducing the amount of fill light we create high contrast shots. The high-contrast look will have parts of the face in partial or complete shadow. The low contrast look will look very similar in terms of exposure on both sides of the face.

High contrast – very little detail on the shadow side of the face

Low contrast – the amount of light from the fill light is nearly the same as the key light

The Lighting Department

The lighting team is divided into two separate departments: the **Grip Department** and the **Electric Department**. The Electric Department is in charge of the actual lights. They position the lights and also run power (for the lights, as well as electrical needs for other departments). The Grips handle the rigging and shaping of lights. The basic rule of thumb is that the Grips do not handle anything with a plug. They are responsible for any hardware needs, rigging, stands, ladders, etc.

The head of the Electric team is called the **Gaffer** and they work closely with the head of the Grip team, the **Key Grip** – both of these work under the DP to create a cohesive visual "look" between lighting and camera. As a makeup artist, it is useful to become acquainted with your lighting team to see how you can work together. For more information on the specific position titles within the Lighting Department, please refer to "Other Positions On Set and What They Do" in the Appendix.

Camera

By Tony Santiago and Tom Ciciura
Edited by Christine Sciortino

In This Chapter

- **Motion Picture Cameras**
- **Camera Technology**
 - *Manufacturers*
 - *Lenses*
 - *High Definition (HD)*
- **Camera Setups**
 - *Camera Movement*
 - *Types of Shots*
- **Additional Camera Department Terminology**
- **Camera Department Prep and Test Shoots**
- **Camera Department and Makeup Department Collaboration**

Motion Picture Cameras
by Tony Santiago

Motion picture cameras first developed in the late 1800s. Traditional motion picture cameras use film to capture the image. The film runs through the camera at an accelerated rate and is exposed to light passing through the lens. The camera is taking a series of pictures (or "frames") that, when pieced together, create movement in the image.

In the United States, the standard rate of frame movement for film and television is 24 **frames per second** (FPS). For content that is intended for direct broadcast, like the local news or live sporting events, the standard **frame rate** in the United States is 30 frames per second. In other parts of the world, such as Europe and Asia, the standard frame rate for motion pictures and broadcast is 25 frames per second.

Sometimes the term **high speed** is used when the film is running through the camera at a faster rate. When watching an image that has been filmed in "high speed" the image appears to move in slow motion. High speed frame rates can range anywhere from 32FPS up to 1000FPS.

While the traditional approach of shooting on film is still used in the industry, it is no longer the standard format. Digital cameras have revolutionized the industry and have become the commonly preferred format for motion pictures. The workflow is often smoother, quicker, and less expensive than shooting on film.

Camera 123

Digital cameras work similarly to film cameras in that light passes through the lens to help create the image. However, rather than burning the image onto a strip of film, the digital cameras will scan the image. Digital cameras record at the same frame rates as film cameras.

There are several differences between shooting film and **digital** formats. In terms of the overall "look," film generally has a softer texture, more graininess, and more saturated colors. Digital cameras generally have a more "crisp" look which sometimes has filmmakers choosing to use filters in front of the lens to soften the image. In recent years, high-end digital cameras engineered by RED and Arri have created a more "film-like" look which has made them very desirable in the industry.

> *"Digital cameras have revolutionized the industry and have become the commonly preferred format for motion pictures."*

Digital acquisition has streamlined the filmmaking process and is also more cost-effective. Creators can begin editing their movie immediately after they shoot it. When shooting on film, however, the film will be sent to a lab for processing and transferring to a digital format. Then it will be edited on a computer as digital files. This process can take anywhere from a day to a week before the filmmaker can begin editing their footage. Additionally, the cost of film can be anywhere from three to ten times the price of shooting a digital format.

Camera Technology
by Tony Santiago

Manufacturers

In recent years the industry has shifted to primarily use digital cameras, but there are still productions that choose to shoot on film. Popular vendors for film

cameras include Panavision and Arri. The most popular manufacturers of digital cameras are RED and Arri. Both RED and Arri are constantly upgrading their products and releasing new versions of their cameras every two years on average. The current models of RED cameras are the Gemini, Helium, and Weapon. Arri's top models are the Alexa Classic, Alexa Mini, and the Alexa LF. These are the cameras that will commonly be used for large-scale motion pictures or TV shows.

Other manufacturers like Canon and Sony are producing cameras that are sometimes used in large-scale productions but are more often used for independent ("indie") films, corporate videos, and documentaries.

Lenses

Lenses are often described by their **focal length** – the distance between the lens and the image sensor. Focal lengths can be broken down into three different categories: wide, normal, and telephoto. Each type of lens offers a different look that deals with image distortion or compression.

Different lenses are used for different effects when shooting

A **normal lens** will have a focal length roughly the same size as the image sensor. For example, on 35mm film a normal lens is anything between 35mm to 50mm. These lenses will capture the image the way the human eye sees things.

Wide angle lenses have much shorter focal lengths. A wide angle lens will exaggerate the distance between the foreground and background, making foreground elements appear relatively larger than background elements. They can also elongate a person's face in a way that makes their nose and chin seem bigger than they are in reality.

Telephoto lenses will compress the foreground and background. This will make foreground elements appear closer to background elements than they actually are in reality. These lenses are often used for **close-ups**.

Focal lengths are not the same between two different sized formats. A 25mm lens on 16mm film is equal to a 50mm lens on 35mm film.

High Definition (HD)

High definition, (as opposed to **standard definition** or "SD") refers to a certain level of resolution in both the camera sensor and the television or projector displaying the content. HD is sometimes also called "1080" which is the current resolution for high definition recordings. **Resolution** is the number of pixels per scan line that is being projected. The difference between high definition and standard definition is mostly associated with televisions and the resolution at which they display.

For decades, SD would display images at a resolution of 480i. Modern televisions and projectors display at 1080i. Displays with higher pixel counts will display images with more clarity and detail.

Modern digital cameras can record at 1080p, with some having the capability of recording at even higher resolutions. Most cameras now offer 4K resolution which is four times the amount of pixels as available in 1080p. Some cameras can get as high as 6K or 8K resolution offering the most clarity and detail in the image.

Camera Setups

Camera Movement
by Tony Santiago

- **Static/Static Shot/"Lock Off":** The camera is in a locked-down position. There is no camera movement at all.
- **Pan:** From a fixed position, the camera turns along a horizontal axis from one direction to the other.
- **Tilt:** From a fixed position, the camera turns along a vertical axis from one direction to the other.
- **Dolly:** The camera is mounted to a device that is on wheels (sometimes set on a track) allowing the camera to move, but without any shaking, during the shot.
- **Handheld:** The camera operator is holding the camera for the shot. It creates a shaky and disorienting feel for the viewer.

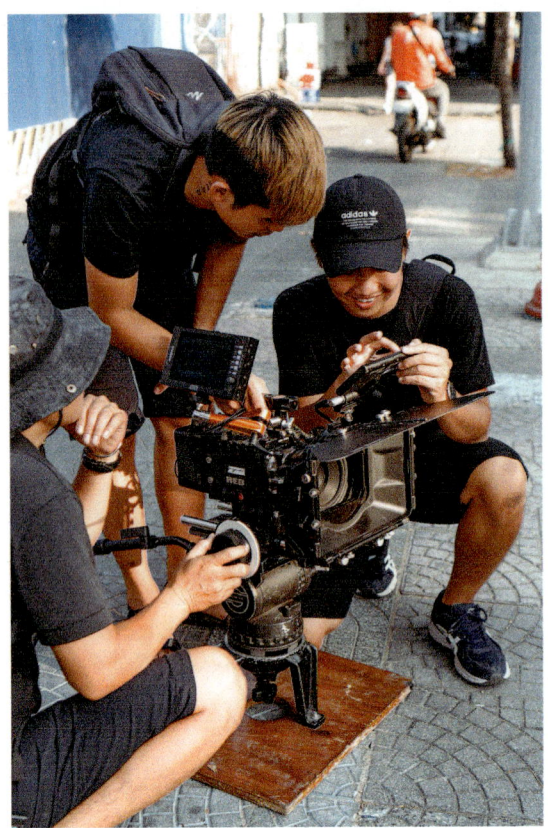

A setup for a static shot

- **Steadicam:** The camera is mounted to the camera operator with a stabilizing device that allows for smoother movement than handheld. It

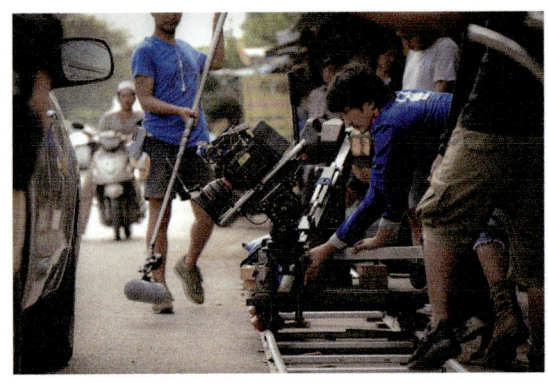

A dolly shot with the camera mounted on dolly track

Shooting handheld

Shooting steadicam

also allows the camera operator to move the camera in places that would otherwise be difficult and costly to set up, like going up and down stairs for example.

Types of Shots
by Tom Ciciura

Over the Shoulder/OTS: Camera is looking over the shoulder of one actor in the foreground usually onto a close up (CU) of another actor. This type of shot is typically used in a conversation scene.

"Body Bite": Similar to an OTS but filming a different part of the body than the shoulder like the hip or boot.

Extreme Wide Shot: Camera sees a lot of the scenery. People photographed are small in frame from afar. Usually all about the setting.

Wide Shot (WS): Camera sees a person or multiple people from head to toe. The fine details of the makeup may not be easy to perceive, but it is still important to stay on top of the work.

Medium Wide Shot/"Cowboy": Camera sees a person from the hips up. If you were

actually filming a traditional cowboy you would see from their gun belt and guns to the top of their cowboy hat.

Medium Close Up/MCU/"T Shot": Camera sees a person from chest up.

Close Up/CU: Camera sees a person from the collar up. Makeup Department's work is ready to shine!

Extreme Close Up/ECU: Camera sees only some of the face very closely – maybe just the mouth, eyes, or an ear. Makeup Department's work is most critically noticeable and under extreme inspection in this type of shot. Even small imperfections can be distracting in an ECU.

Additional Camera Department Terminology
by Tom Ciciura

Blocking Rehearsal: When the Director and DP walk through the scene with the talent, Camera Operators, and Department Heads to plan where and how the scene plays out. They will plan the positions and paths the actors and cameras will take on the set during the scenes. The actors will read the lines and move through the set. When watching a blocking rehearsal, it's best to observe from out of the way because no one has determined yet where the actors need to walk. Blocking rehearsals are often done semi-privately with only the minimum number of crew members necessary.

Marking Rehearsal: Generally, after the blocking rehearsal, the rest of the crew is invited to watch the blocking rehearsal. During this time, the 2nd AC (Assistant Camera) will mark critical positions with colored tape where the actors pause to say lines, give a look, or interact with a prop. During lighting and second team rehearsals the camera operators may slightly adjust the marks to facilitate better lighting or compositions.

Second Team Rehearsal: The stand-ins rehearse the scene, often while the main cast is getting touched up before coming in for a final rehearsal and a take.

"Swinging a Lens"/Going Tighter: The cameras are going to change lenses and usually go on a longer lens to get closer to the subject. This signifies to the makeup artist that now the makeup will be seen bigger and brighter. Time for critical touch-ups and perfection.

MOS: We are *not* recording sound on the shot.

SYNC: We *are* recording sound on the shot.

Magic Hour: The best light is usually right before and after sunrise and sunset, when the sun is just above or just below the horizon. The lower the sun's angle, the warmer its color will be. The light rays are often just low enough to paint the underside of clouds with amazing color. This is called "magic

hour" and you only get two a day if you are lucky. However, the color and brightness of the light changes rapidly so everything on set can seem chaotic and rushed. When filming during magic hour you have to be ready to work fast. All departments have "all hands on deck" and everyone focuses on getting as much footage as quickly as possible before the light is gone. Once the color of the light changes or the sky becomes too dark, the scene can no longer be edited in a continuous way. A magic hour shot is much like playing outside as kids: when the street lights come on it's time to go home.

Camera Department Prep and Test Shoots
by Tony Santiago

Pre-Production for the Camera Department consists of **camera tests** and camera **prep days**. Camera prep days are often the day or days just before principal photography begins. At a camera prep, the camera assistants and typically the Cinematographer and Camera Operator will do a thorough inspection of every piece of camera equipment. They will check the camera settings, as well as any cables or accessories they plan to use to ensure compatibility. They will also check the lenses for accurate focus.

The camera tests can involve several decisions the Director and Cinematographer need to make before

> *" Cinematographers and makeup artists are consistently using line, color, contrast, diffusion, and illusion to fool the audience and tell our story. "*

beginning production. Visual elements that are frequently tested in Pre-Production are lens comparisons, filter comparisons, camera settings that might affect the image or workflow, or complicated camera moves. Makeup artists may be brought in during camera tests to try different looks or colors of products on screen.

Camera Department and Makeup Department Collaboration
by Tom Cicuira

Camera Department and Makeup Department have similar jobs in many ways. We are both charged with the task of telling the story. Both positions require imagination and a mastery of our tools. We both see many

sunrises in our careers as we are usually up before dawn. We must roll with the punches and work with the existing circumstances: time pressures, budget constraints, location logistics, weather, technology, oily skin, bad food, etc. Lastly, both crafts work in a highly specified way with color. Cinematographers and makeup artists are consistently using line, color, contrast, diffusion, and illusion to fool the audience and tell our story.

Cinematographers usually can see when an actor's nose is shiny but, I would suspect, most of them have little knowledge of what happens in the makeup chair hours before an actor appears in front of the camera. The DP may not know how the makeup artist mattified an actor's shiny nose, but will appreciate that you were close by and took care of it quickly. The makeup artist may not know the exact gels being used on the lights, but will appreciate the look of the softer lighting for an emotional close up. The two must work together to make sure the actors look perfectly appropriate in each scene. Much of this communication can happen with simple observations, as well as subtle gestures, and eye contact.

For a makeup artist to know when to ask to step in while rolling is a bit of an art in itself. It's crucial to see the bigger picture of what is happening on set and in the performance. If you have a touchup that must be made urgently, let the AD know, and they will typically announce it – if this is the case you can also make eye contact with your camera operator as a bit of a heads-up that you are about to step in. Being in the right place at the right time with the right solution is important. Making sure you are able to see a monitor and communicate with your Camera team throughout the day will help you be prepared.

Every set varies and your place to stage your equipment and view the monitor may move around but you will start to see a pattern that's appropriate and comfortable. As you move from one set to another, an experienced eye will quickly scan the working environment and set up camp for their department and their tools in the best position to do their work. It is always possible to fit in, find a position, and work together in a way that flows.

Anatomy

It's very important for an artist, in any format, to understand anatomy – especially for makeup effects – so they know how a face emotes, the muscles, how far they can stretch things and exaggerate effects, and to work with the performer in how the face moves.
– J. Anthony Kosar

Whether you are creating a likeness makeup, old age, trauma, character or creature, your job is to trick the viewer's eye and convince them that what they are looking at is real, to keep them suspended in the story rather than taking them out of it. This all begins with a solid understanding of anatomy.
– Anna Cali

In This Chapter

- The Skeleton
- The Muscles
- The Blood
- Injuries and Illnesses

As makeup artists, the body is our canvas – we create all of our work on top of an actor's skin. It is also our greatest inspiration. We use it to tell stories of a character's age, their background, their choices in how to present themselves, their past injuries, their illnesses, and so much more. The human body – the vessel which contains and illustrates the entire human condition – is our greatest muse. It is for this reason that it is imperative for us to have an extensive knowledge of everything happening beneath the skin.

J. Anthony Kosar is a special effects makeup artist, owner of Kosart Effects Studio and School, and a winner of Syfy's *Face Off*. He reminds us that anatomy is used in makeup every single day:

We are working with faces, which is something we see all day long every day. It's very important for an artist, in any format, to understand anatomy – especially for makeup effects – so they know how a face emotes, the muscles, how far they can stretch things and exaggerate effects, and to work with the performer in how the face moves. Wrinkles have an anatomy. Muscles have their own anatomy. Everything has anatomy. So if you try to "fake it" or not look at reference, or don't fully understand the body, it will always appear wrong. With monsters, you have a lot more leeway with because they don't exist, but you still need to have it grounded in reality because otherwise it won't look like it could exist. It's very important.

Hundreds of processes are ongoing throughout human anatomy, in ways that we typically don't even realize on a daily basis. In fact, "more than 200 types of specialized cells populate the human body" (Parker & Walker 40). In this chapter we will focus on three major systems within the body – the **skeletal system** (the bones), the **muscular system** (the muscles), and the **cardiovascular system** (the veins) and explore how these systems directly relate to your work in makeup artistry.

If you want to learn even more about these processes, I recommend *The Human Body Book* by Richard Walker and Steve Parker or *The Atlas of Human Anatomy* by Frank H. Netter. Netter's work also has a companion coloring book – *Netter's Anatomy Coloring Book,* by John T. Hansen – which has labeled diagrams of the body which you can color in, giving you an intimate look at different systems and helping you remember them through interacting with them directly.

The Skeleton

Our skeleton consists of an average of 206 bones, accounting for almost one-fifth of the body's weight. The main importance for you in knowing the bones of the human body is to know how the muscles and skin drape over them, plus how the body responds when these bones are injured. The bone structure also gives us important clues of how to create highlights and shadows, and how to do effects like character makeup or age makeup.

When you think of the skeleton as a storytelling tool, think of the saying "a bag of bones," used to indicate someone who is quite skinny – because they have little fat tissue, their bones protrude more under their skin in comparison to someone with more dense fat tissue. This "boney" look can tell a story in itself, especially when viewed in extremes as part of the storyline (i.e. a character who is homeless and/or starving, a person with an illness or struggling with an eating disorder). It is our job in this case to emphasize these bones for the purpose of creating the character, and this cannot be done if we don't know where the bones are.

I suggest carefully studying diagrams of the skeleton. You will also see further how the skeleton casts shadows on itself; a way of visualizing the human body that can very much help you when you get on set and are dealing with light coming from all angles.

The bones of the skull and face are particularly important in your work because these create the landmarks for your work – peaks and valleys used for contouring, creating symmetry, and creating the story of a character.

"Two groups of bones make up the skull. The upper set of eight bones forms the domelike cranium (cranial skull or cranial vault), which encloses and protects the brain. The other 14 bones make the skeleton of the face," (Parker 58) a total of 22 bones in the skull.

Certain bones of the skull are incredibly obvious in the way they affect the face. Everyone's eyeballs sit within the eye socket; seven bones fitting together with the edge encircled by three connecting, protruding bones: the **zygomatic**, the **maxillary**, and

Diagram of human skeletal
(anterior view)

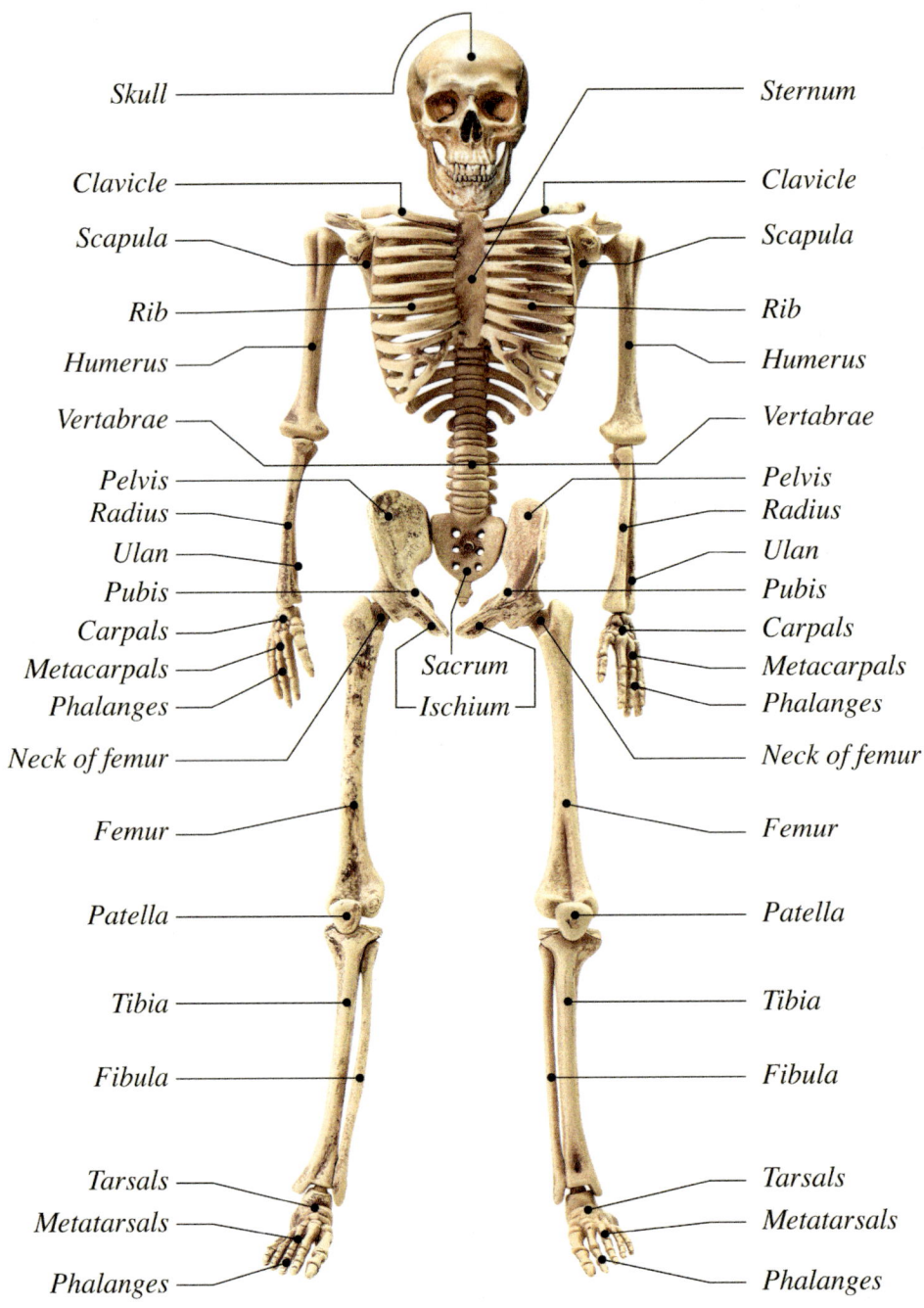

Someone who is very skinny may have bones that seem to protrude from beneath the skin - this may be a necessary look to enhance for some characters, so knowing how to contour and highlight the human skeleton will help you achieve this

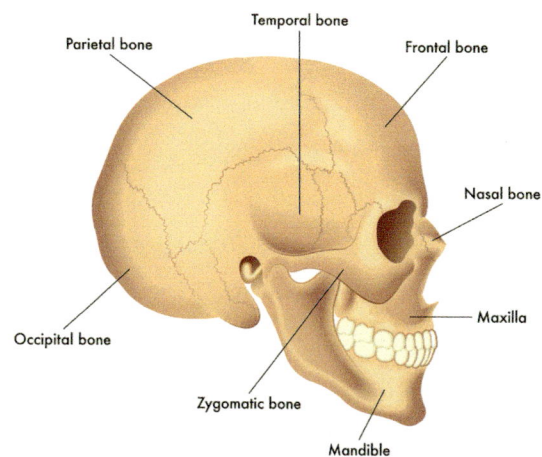

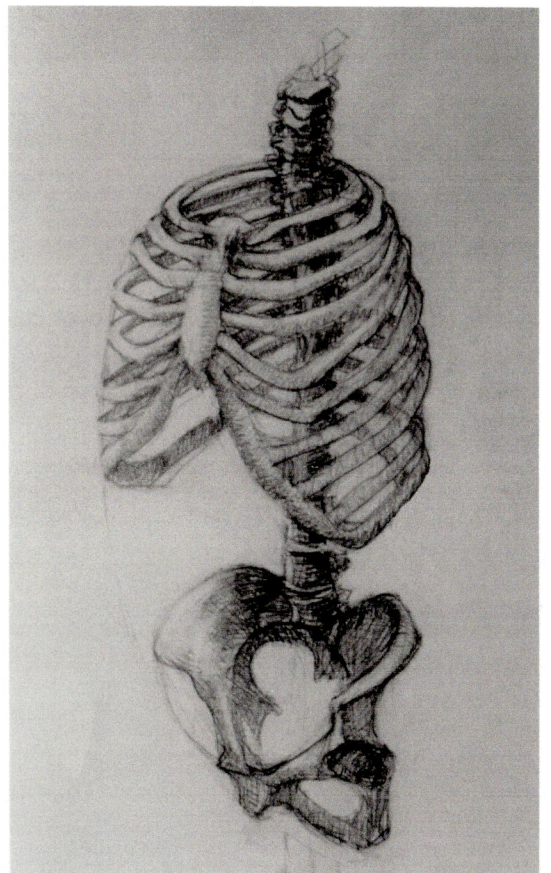

Sketching the skeleton is a great way to understand it better and learn how the bones fit together

the **frontal bone** – this entire area is considered the "**orbit**." Much of our work with eye makeup is actually to make the eyeball look as though it is positioned within the orbit in a particular way, so we learn to contour and highlight the eyeball within the confines of this orbital socket.

In makeup we also frequently discuss the cheekbones; creating highlight and shadow where there may be none. The area considered the "cheekbone" is actually comprised of the **temporal bone** and the **zygomatic bone** which connect on the side of the face, and then the joint of the **mandible** (or jaw) which hooks up into these two bones. This is a necessary joint in order for humans to speak, chew, and otherwise move their mouths – however, the way in which muscles, fat tissue, and skin fit over this area has become very significant in our culture. Significant meaning is attached to the cheekbone area, and ways to contour, highlight, and color it to define it a certain way are pervasive – not only in beauty makeup but in character makeup as well.

Anatomy 137

Jawlines are also a common focal point when dealing with actors. Indeed, biologically we are trained to believe that a strong, well-defined jawline in biological males indicates strength and is considered today as "manly." A petite, yet still well-defined jawline in women is considered dainty and "feminine." It is speculated that this perception actually relates to our evolution – when males did most of the hunting and a larger jaw corresponded with aggression, virility, strength, and therefore the ability to bring home more food. Depending on what we are trying to convey with a certain character, we can manipulate these facial structures and silhouettes with the contour and highlight process in makeup.

In order to give yourself the much-needed foundation of the shadows and highlights of the human skull, I suggest drawing the skull at different angles. You might use a book that shows many different angles and copy the diagrams out of there, or even purchase a skull and practice different lighting to truly understand how all these pieces fit together and how the light hits them.

The Muscles

Atop the skeleton sits a complex web of muscles, some attaching to the bones, all layered in different ways for the purpose of creating different movements. The average human body contains approximately 640 muscles consisting of three different types of tissue – **skeletal**, **smooth**, and **cardiac**.

Great significance has been placed within the social norms of many human cultures on the muscles and *how* they appear to be rippling under the skin. You may be asked to use body makeup to contour an actor to make them look more "muscular," or to make certain muscles stand out more than others.

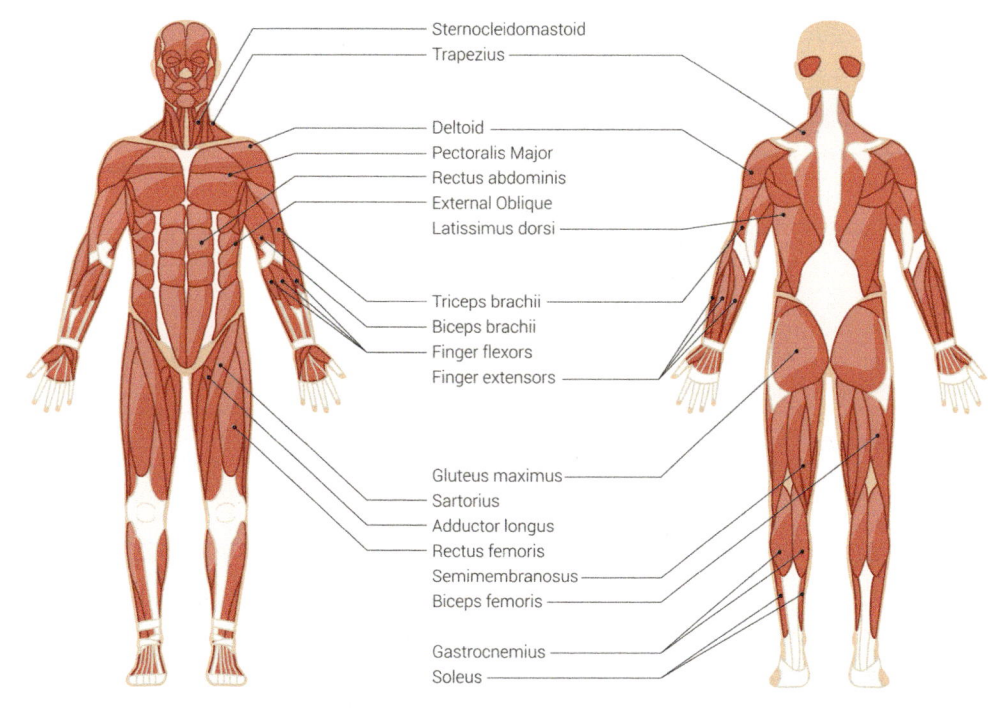

The Muscular System
Human Body Systems

It is also important to know the structure of the muscular system when it comes to special effects makeup because you may need to actually show what is underneath the skin if someone is terribly wounded.

The muscles influence our work in beauty and corrective makeup as well. Even the aging process of wrinkling is caused by the intersection of different muscles creating a fold in the skin as they move – these folds grow deeper and deeper with time. The popular cosmetic injection Botox paralyzes the muscle making a certain movement, therefore freezing it in a relaxed position, unable to make the wrinkle it typically makes.

Our facial muscles create our facial expressions. These expressions tell a great deal of the story and it is our job to enhance them. If you know which muscles make someone frown for example, you can use makeup to enhance or shade certain areas. For instance, if someone is supposed to look stern or angry, you might lightly enhance the frown lines around their mouth, or the downward slope of their

HEAD AND NECK MUSCLES

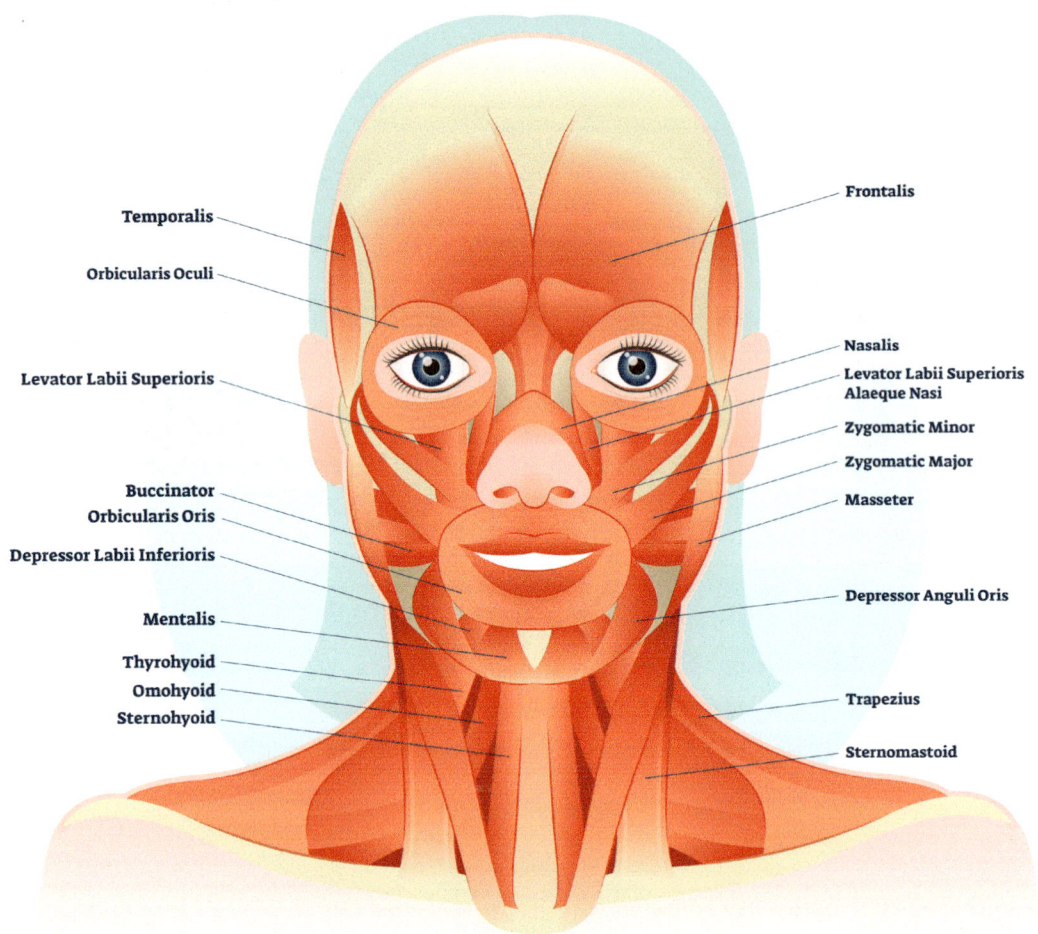

inner eyebrow, making them appear to be constantly glaring or scowling. Study and sketch the muscles of the face and head as pictured under the skin, and practice drawing

"Our facial muscles create our facial expressions. These expressions tell a great deal of the story and it is our job to enhance them."

the facial expressions as well. This will give you good ideas for how to create these specific character makeups, as well as how to do age makeup in specifically wrinkled areas.

Different facial expressions are made by activating different muscles. Sketching various facial expressions can help you understand how to create or enhance them with makeup

Special Effects Makeup Artist Anna Cali uses these principles in her work every day. She advises:

Our job as makeup artists is to enhance or alter the look of the actor for the story as well as create believable characters. It is important to understand the muscles underneath the skin and how they work with the skin. Consider how the muscles work in relation to the bone structure and how this affects the skin on top of it all when designing or applying your makeup. When adding highlight and shadow or sculpting a prosthetic to be applied on the actor, the bone structure, and wrinkle patterns have to be approached realistically. Whether you are creating a likeness makeup, old age, trauma, character or creature, your job is to trick the viewer's eye and convince them that what they are looking at is real, to keep them suspended in the story rather than taking them out of it. This all begins with a solid understanding of anatomy.

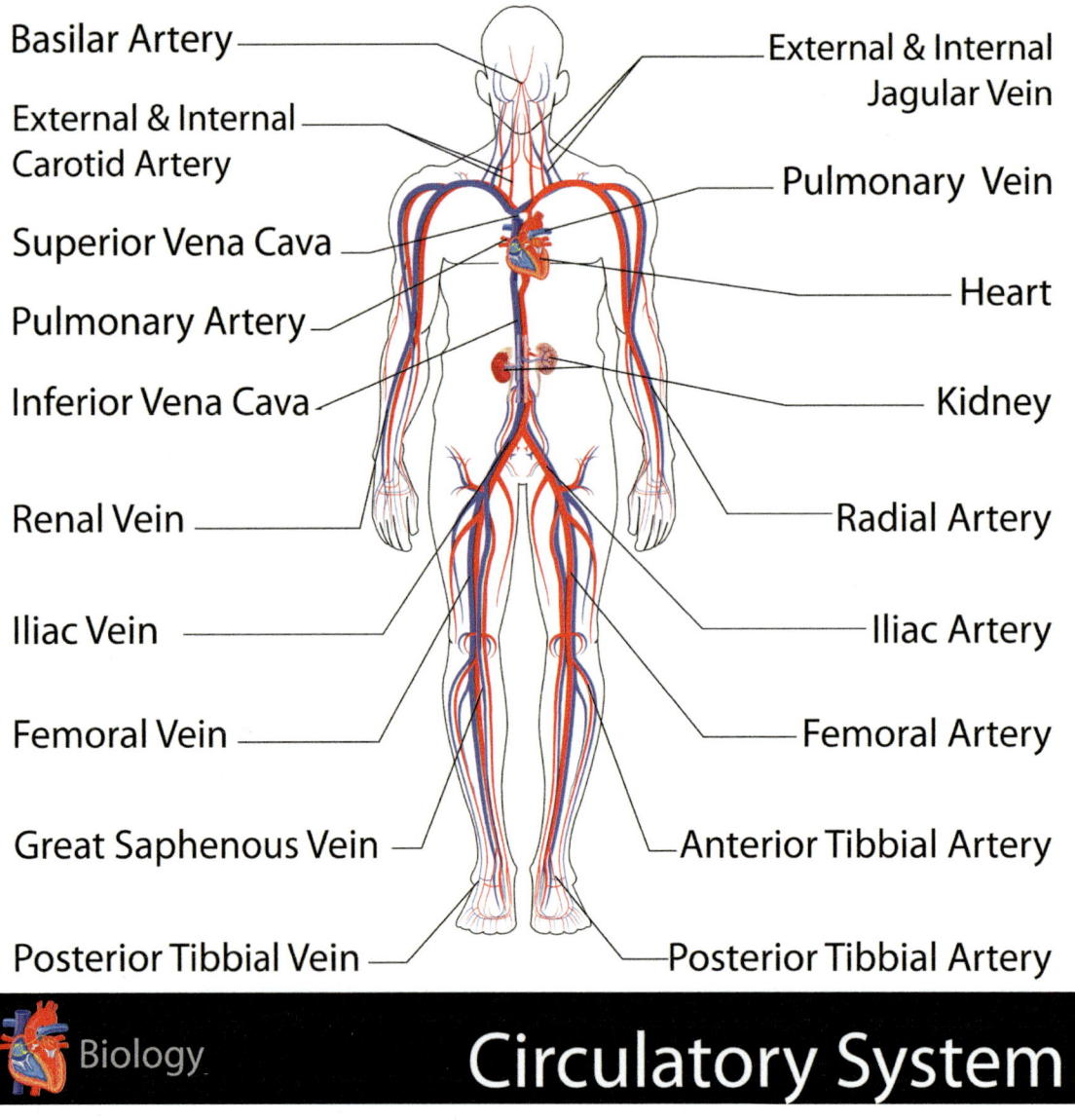

Circulatory System

The Blood

While the body's cardiovascular system is performing constant functions – carrying blood and fluids between the heart and the rest of the body – the part of the system we work with most in makeup is the blood vessels and the blood itself.

Blood vessels carrying oxygenated blood away from the heart to other areas of the body are typically **arteries**, and blood vessels carrying deoxygenated to the blood back to the heart are **veins**. These vessels also have smaller branches called **capillaries** "which have such thin walls that oxygen, nutrients, minerals, and other substances pass through to surrounding cells and tissues" (Parker & Walker 132).

FACIAL VEINS ANATOMY

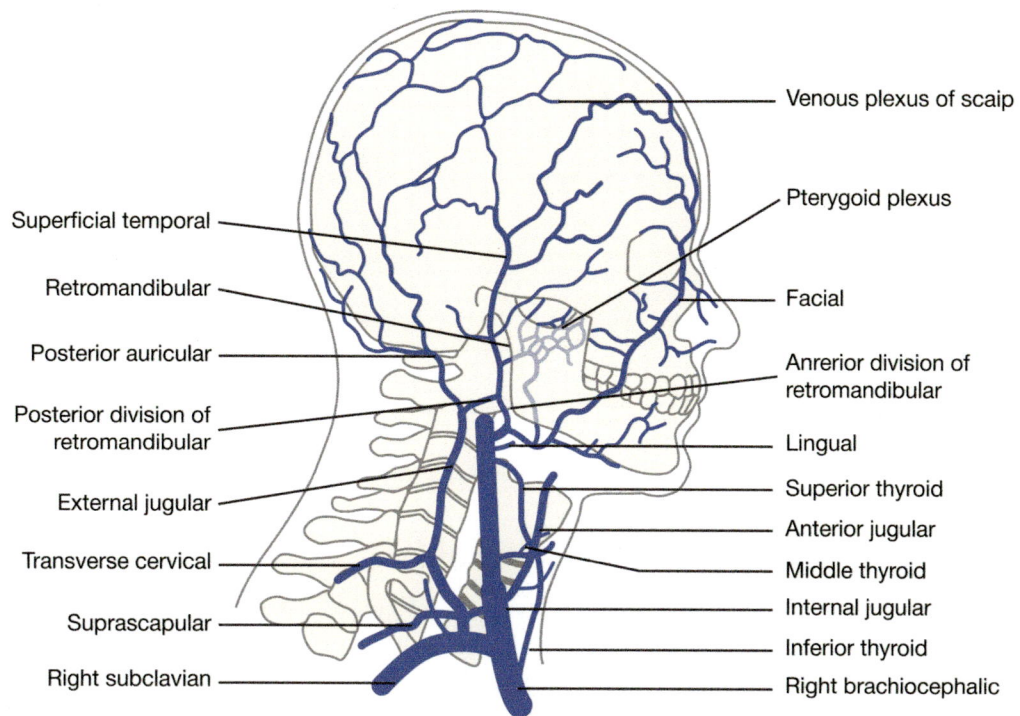

Blood is made up of about 50–55% plasma, 45–50% red blood cells and 1–2% white blood cells (Parker & Walker 134) but you'll notice that underneath the skin, most of our blood vessels that are visible to us appear green, purple, or blue. This is due to the way light is reflecting off of and passing through our skin. When we are cut or otherwise wounded, blood will spill bright red.

Injuries and Illness

Cali finds anatomy to be "very important in trauma makeups [portraying wounds or injuries] – particularly in applications where we see underneath the skin to the fatty tissue, muscle, and bone."

Much of our work with the body's anatomy is illustrating the visual effects of injuries or illnesses to tell the story. For our purposes, injuries can be generalized into two categories – those that puncture the skin, and those that do not.

One common injury indicator that we create easily with makeup is **inflammation**. "Inflammation is the body's rapid, general response to any kind of insult or injury, such as physical wounds and foreign objects, including infecting organisms, chemical toxins, heat, or radiation" (Parker & Walker 178).

Injuries can damage the blood vessels and other soft tissues of our bodies – these areas become inflamed because white blood cells swarm to them to help the healing process.

This is all happening at a microscopic level, so to our eye, it looks like a swollen area, larger than normal, with redness (blood vessels) gathered around it. "Once an inflammatory response is triggered, blood flow to the damaged area is increased. The blood vessels, especially capillaries, widen and the capillary walls become thinner and more permeable, allowing plasma and fluid to leak into the space between the cells" (Parker & Walker 179). This is why injured areas never look uniformly red or any other solid color – because there is a variety of fluid types moving through the area. This is important to remember when doing your special effects makeups.

After the initial impact and swelling of a wounded area, bruising often begins. A "contusion, or bruise, is a discolored area of skin caused by bleeding into underlying tissues, usually due to a physical impact." A bruise consists of "leaked blood cells [that] break down causing the bruise to change color from blue to brown-yellow" (Parker & Walker 171).

With wounding that *does* puncture the skin, blood will not only leak underneath the skin, but will flow in varying amounts based on the size of the wound and the area of the body. Several types of wounds include:

Puncture Wound: Punctures are small in area but deep in penetration. Healing is usually quick but infection is a risk, from microbes entering deep tissue.

Cut: Neat-edged cuts usually heal with only minimal scarring if they are properly cleaned, closed to promote skin-edge healing, and covered to keep out infection. Deeper cuts may need stitches (sutures) to avoid scars.

Abrasion: Scrapes, or abrasions, may affect a wide area of skin, damaging many nerve endings and causing considerable pain. Abrasions of the epidermis usually heal with no scar. Deeper abrasions are more likely to leave a scar (Parker & Walker 171).

When doing a wound makeup, consider the instrument or surface that caused the skin to break. You will read more about the process of creating wounds in Chapter 13 "Out-of-Kit Special Effects."

Illnesses also affect the body and its appearance. Each illness or infection is different. Some may cause a patient to look pale, others may cause flushing, and still others may cause jaundice (yellowing of the skin.) If the character has been excessively vomiting, they may be dehydrated and have dry lips. Certain

> **Regardless of the actual injury or illness being portrayed, you *must* do your research.**

illnesses may cause fever and a slightly clammy, sweaty appearance to the skin would be appropriate. The same physical responses should be taken into account whenever anyone is in an altered state, such as drunk or using drugs. Consider what each process does to each and every body part, from the toes to the fingertips to the top of the head and including the mucus membranes in the mouth, nose, and eyes. Make sure you have as many story details as possible so you can accurately and respectfully portray illnesses or conditions on screen – there is no "one-size-fits-all sick look."

I once worked on a film where an older woman was dying of cancer. I remembered the way my grandmother's hands had been bruised and how there had been broken blood vessels in the tops of her hands where the IV needles had been repeatedly inserted for her treatment. After discussing it with the director, I added this small, detailed bruising to the hands of the actress. The director thanked me for adding this personal and accurate detail he would not have thought of. It just helped make the story that much more real.

Regardless of the actual injury or illness being portrayed, you *must* do your research. Learn about the pathology of the disease or the healing process of the injury. Take your time and gather real images of these wounds and illnesses from medical textbooks or forensic journals. Go to a library and check out some anatomy textbooks. If you need to see a character's wound healing over time, sit down with the Script Supervisor and a calendar so you can later design every single stage of the healing process. As you do this research, hopefully you have a strong stomach!

Skin

In This Chapter

- **Skin Science Basics**
- **Consultations**
- **Skin Types**
- **Skin Disorders, Markings, and Conditions**
- **Skin Tones**
- **Skin and Age**
- **Additional Skincare Considerations**
 - **Shaving**
 - **Sun/Weather Protection**

I always say, it doesn't matter how much makeup you apply to someone – if their skin isn't well cared for, the makeup will never look nice. As makeup artists, our job involves every area of exposed skin on an actor. If an area is covered by clothing in the scene, you generally do not have to worry about it (Costumes will take care of it). If it is hair on their head, it is actually required by most unions that you do not even touch it. Facial hair, however, is part of the Makeup Department's purview. With this in mind, although we are not dermatologists nor aestheticians, it is absolutely imperative to maintain an awareness of both disciplines along with a base knowledge of the science of human skin. Every human being on the planet is different and these differences absolutely appear in their skin – not only in its color, but its texture, its moisture levels, its disorders, and so much more.

Skin Science Basics

Our skin is a multilayered organ with hundreds of microscopic processes happening nonstop.

The skin is one of the largest organs in the body, weighing 6–9 lbs and with a surface area of almost 21 square feet. It is a complex organ formed of two main layers, which contain many different types of cells, some of which produce hair and nail tissue … A patch of skin about the size of a fingernail contains 5 million microscopic cells of at least a dozen main kinds, 100 sweat glands and their pores, 1,000 touch sensors, 100-plus hairs with their sebaceous glands, up to 3 1/3 ft (1 m) of tiny blood vessels, and about 1 2/3 ft of nerve fibers

(Parker & Walker 65).

"Skin is made up of layers with different physical and chemical properties … the skin's two major layers, the **epidermis** and the **dermis**, differ remarkably in their composition and function" (Jablonski 11).

Skin Structure

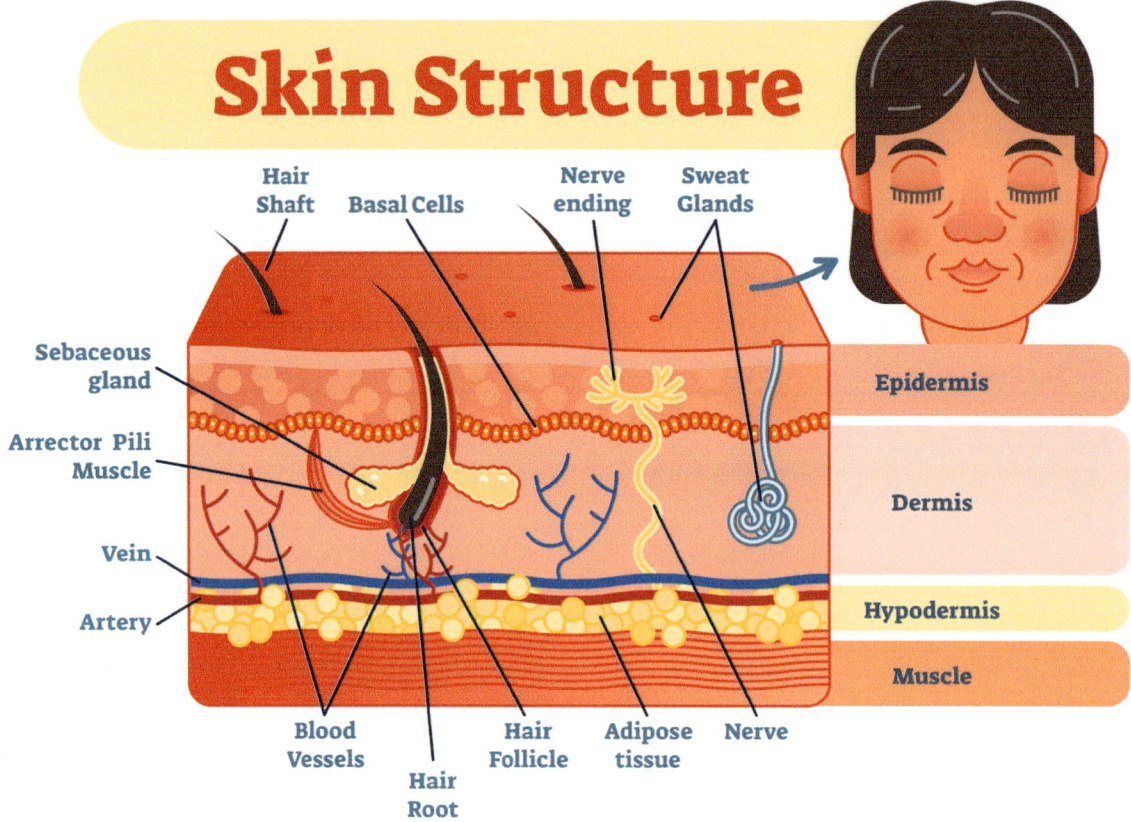

"The skin's outermost layer, the epidermis, shields us from environmental oxidants and heat, while it also resists water, abrasion, stains, microbes, and many chemicals" (Jablonski 11). This outer layer is the canvas for our work as makeup artists.

Probing beneath the epidermis, we reach the second of the skin's two primary layers, a thick layer of dense connective tissue called the dermis. This is the layer that really imparts toughness to the skin … The dermis is a composite tissue that gets its strength and toughness from a combination of collagen fibers and elastin fibers … Collagen constitutes 77 percent of the dry weight of skin … acts just like the way it looks, like tough little ropes of protein holding the dermis together. Interwoven with the collagen is a network of abundant elastin fibers that restore the skin to its normal configuration after stretching

(Jablonski 15).

While we all have these basic layers of our skin, the composition and condition of these layers are not all equal. Plus, external factors such as environment, weather, nutrition, and illness influence the human skin just as much as the basic factors of a person's age and genetics.

To accommodate these differences, it is easiest to break the skin down into types, and you may begin to

generalize and mentally categorize your actors' skin to make it easier to work with. The first step in identifying your actor's **skin type** and assessing their skin issues is the **consultation**.

Consultations

In his book *Skintervention* Scott-Vincent Borba suggests clients "map out" their skin and I suggest you do the same with your actors. "The average person usually has a handful of different issues with their skin," (1) Borba warns. When I first started out in makeup, our consultations were fairly simple – we would ask the actor if their skin tended towards dry or oily, and if they were allergic to any product ingredients.

As interest in skin care has become more widespread, and HD cameras have become more precise, we makeup artists must analyze every issue in the skin. We must also stock our kits with the proper products to treat these concerns.

Here's an example of an everyday situation: you have an actress who gets oily and enlarged pores around her T-Zone, but she forgot her moisturizer at home before traveling so her cheeks and chin are flaky and dry. Perhaps she has a bit of adult acne but also beginning to show signs of aging such as fine lines around the mouth and crow's feet around the eyes. Now imagine she took the "red-eye" flight to the location so her eyes are red from tiredness with puffy bags underneath and her lips are chapped from the dehydration of flying. She mentions a scar on her forehead from childhood that she is

> **"When we examine an actor's appearance, every single element must be analyzed carefully as soon as they get in the chair. And you must be graceful about this … without making the actor feel scrutinized."**

self-conscious about and wants covered. She may have a tiny tattoo behind her ear that the network wants hidden and she broke a nail in the airport so she needs a nail file. While on the plane, her lap dog may have created a light scratch on her arm. Top it all off with the fact that she has a faint but still visible stripe of hair on her upper lip that needs to be removed and she hasn't had her eyebrows done in weeks. Now, does it seem like enough to simply evaluate whether her skin is oily or dry?

When we examine an actor's appearance, *every single element* must be analyzed carefully as soon as they get in the chair. *And* you must be graceful about this, perhaps while carrying on a conversation, studying the face and other visible skin areas without making the

actor feel scrutinized. You will do this with your consultation – a short chat when the actor first sits down about their skin, how they care for it, and their overall lifestyle. Remember that you cannot change an actor's habits, so you need to learn to work with all their different particularities – these may include water consumption, touching their hair, holding their phone on the side of face, drinking alcohol or using drugs while not at work, consuming coffee and caffeinated tea which dehydrates the skin, avoiding eating, going out and getting a sunburn or a windburn, and many more! Make sure you ask your questions in a non-judgmental way. Over time, they will reveal more and more to you without you having to ask.

Some direct questions I ask up front are these:

"Are you allergic to anything?"
"Is there any skincare product or makeup on your skin right now?"
"How is your skin usually – do you tend more towards dry or oily?"

This is a good jumping off question to lead to follow up questions such as: "Oh, your skin's dry? Do you use a moisturizer at home that you like?"

If they say no, you can, over the first couple of days once they are comfortable, recommend something for them! If they say yes, make sure you take a look at the ingredients to see what is in it. The actor may tell you a certain product and upon looking it up, you find out it has **retinol** in it. Retinol is a strong Vitamin A derivative that is great for anti-aging benefits but can make the skin more sensitive to the sun. You need to know this so you can apply a higher SPF to protect them.

"Oh, it's acne-prone? What do you do to manage it?"

Again, if they say they don't have a skincare routine, you can recommend some cleansers, toners, and treatments as you get to know them. However, they may already be doing a lot. **Laser resurfacing**, **chemical peels**, such as "Hydroxy Acid Peels (Alphahydroxy Acid, Betahydroxy Acid), and **microdermabrasion** are popular skin smoothing treatments. A chemical peel [is] a facial treatment that uses a naturally occurring acid (glycolic acid, fruit acid, salicylic acid) combined with other skincare ingredients to peel off the uppermost layer of skin" (Taylor 110). Microdermabrasion is "[a] nonchemical treatment that provides a slightly deeper exfoliation than AHA or BHA facials. A machine first sprays a layer of fine aluminum oxide crystals over the skin, then vacuums the crystals, exfoliating the outer layer of the skin" (111). Whilst these treatments are popular, they have a side effect of making your actors' skin *much* more sensitive. Find out when they got their treatments done, by whom, and how often they get them, so you can be prepared with appropriate skin care and sun protection products.

During your consultation, if an actor warns you that they have multiple allergies or very sensitive skin, you can also perform a **patch test**. A patch test is when you apply a specific product to a thin, but inconspicuous area of skin – usually the inner wrist or inner elbow – to see how the product reacts. If any redness, itching, or burning occurs, do not use the product on

their face. Cleanse the area where the patch test was done with cool water and then apply a soothing lotion, allergy cream, or hydrocortisone cream to counteract the allergen. It is also a good idea to patch test new products on yourself before using them on anyone at all, just to have a good baseline idea for how others will react.

Essentially what you are looking for during your consultation is the overall skin type, any skin disorders, and actor preferences. Borba reminds us that when it comes to types of "'problem skin,' each come with their own set of issues, challenges, and obstacles, but none are so big they can't be conquered" (2). In this section, you'll read about many skin challenges, how to discuss them with your actors, and how to overcome them.

Skin Types

Acne-Prone Skin

When I was growing up, I had *terrible* acne. Kunin explains the science behind acne in her book *The DERMAdoctor Skinstruction Manual*:

> *Acne is a disorder of keratinization – the development of the cells lining the sebaceous (oil) glands. Instead of easily exfoliating themselves onto the surface, the cells become sticky, bind together, and plug the glands. But the sebaceous glands continue to secrete sebum, automatically triggered by DHT, the active form of testosterone. The excess sebum and lack of oxygen beneath the plug create a perfect environment for Proprionibacterium acnes (P. acnes), the bacteria that live on the skin. Too many P. acnes bacteria contribute to the inflammation within the gland. Eventually, a combination of persistent plugging, excessive oil buildup (envision an expanding water balloon), and inflammation produced by bacterial overgrowth causes the gland to rupture. On the surface, this manifests as an inflamed acne papule or cyst"*

(3).

There are several different types of acne lesions, and they may all be coexisting. These types include:

- **Open Comedone (the blackhead):** Blackheads are "clogged pores caused by a buildup of debris, oil, and dead skin cells. When they are open, the oxygen in the air turns them black" (Borba 149). They can be exfoliated or extracted.
- **Inflamed Papule:** A typical "pimple," this is an inflamed blemish, usually presenting as a reddish bump, that can turn into a pustule.
- **Pustule (the Whitehead):** Whiteheads "occur when oil and dead skin are trapped beneath the surface of your skin and aren't exposed to air. The best way to remove them is by lancing them open and extracting what's inside" (149–150).
- **Nodular Cysts:** A painful and severe type of acne that forms when bacteria, oil, and other debris get trapped deep beneath the surface of the skin.

Grade of Acne severity

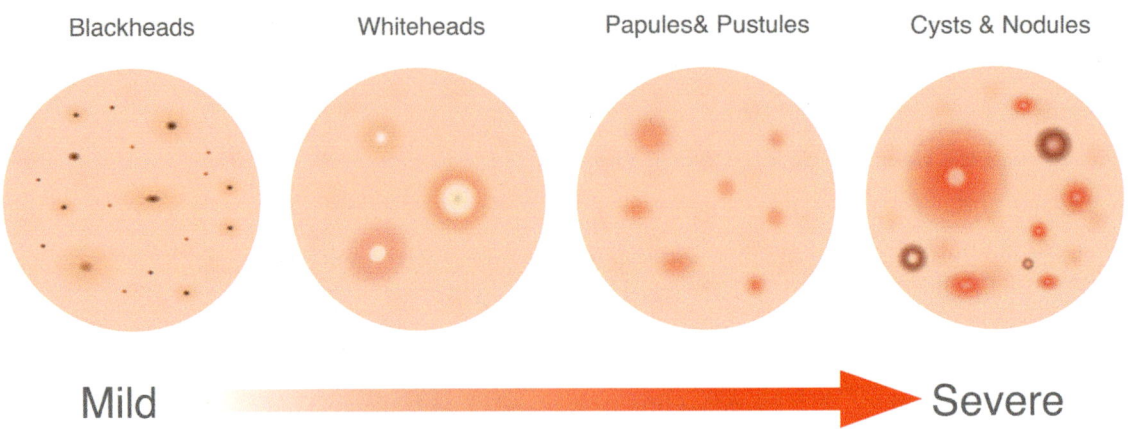

While the best method for dealing with acne is always to refer the actor to a reputable dermatologist for some prescriptions and treatment, there are things you can do on-set to help ease acne-prone skin.

- **Don't Forget To Moisturize:** "All skin requires moisture, and acne-prone skin is no different" (Borba 141).
- **Dry Up Excess Oil:** I suggest only spot-treating acne – you are not giving someone a facial peel.
- **Use Lightweight Products:** A main point to consider in your work is that if the actor already has acne-prone skin, you don't want to clog their pores more. Use lightweight products and those labeled **non-comedogenic** (meaning they won't clog pores). Acne may be caused by oil sitting on the skin and not cleansing or exfoliating well, sweating at the gym, bacteria, hormones, and other sources of inflammation. As you get to know your actor, try to find out their lifestyle habits and chat with them about proper skin care procedures "People with acne cannot use heavy foundations and oily concealers, period … Every major makeup company now makes oil-free and noncomedogenic foundations" (Jaliman 114).
- **Cleansing Is Crucial:** In her book *Skin Rules*, dermatologist Dr. Debra Jaliman warns "I cannot emphasize this enough: never go to bed without cleansing your face. If you don't the result will be clogged pores and breakouts" (Jaliman 17). This advice tracks for your actors. "Even the best skin in the world will look dull if it is not well exfoliated" (24). Because "the outer epidermis continually renews and replaces itself by cell division," dead, dry skin cells make up the very outermost layer (the stratum corneum) of the skin and are just waiting to be sloughed off. This dead skin can cause problems such as dryness, skin flakes,

clogged pores, and all types of acne lesions. If your actors are not exfoliating, there is a good chance their skin looks dull or textured on screen. We can cover discoloration much easier than we can texture. So, encourage your actors to exfoliate with a process suitable for their skin type and to visit a dermatologist if they have questions.

Sensitive Skin

Some people have skin that reacts easily to products, procedures, and even to touch – the reaction may be redness, itchiness, bumps, or any combination or variation of these. This skin is all considered "sensitive" but know that there are enormous variations in the types of irritants and reactions. "Proceed with caution when it comes to sensitive skin," (73) warns Jaliman. "It is hard to recommend products because sensitive or allergic people vary so greatly in their reactions" (74–75).

Scott-Vincent Borba also cautions:

The more natural a product you can get, the less potential irritation you'll experience. This also means you should try to avoid products with added fragrance (items scented by the actual oils themselves should be okay). Just be aware that some people with sensitive skin might not be able to tolerate many of the natural ingredients as well

(23).

Anti-inflammatory ingredients to look for include dimethicone or other silicones, olive oil, oat kernel extract, chamomile, grape seed oil, oatmeal, and glycerin (24). When it comes to sensitive skin, your patch test and consultation will be crucial!

Read your product labels carefully and choose products with as few ingredients as possible, in order to decrease potential irritants. "Hypo-allergenic is a vague and somewhat meaningless term; it just means while the chance of a reaction is reduced, it is still there." It can be hard to find true fragrance-free products. "Be aware that products labeled 'unscented' can still contain masking fragrances. Essential oils can also be highly irritating" (Jaliman 79).

Even if the actor doesn't describe their skin as sensitive but you see that their skin has hyperpigmentation, you know that it has been damaged – either by acne, sun, hormones, or shaving – so "avoid products that contain irritants such as alcohol or benzoyl peroxide" (Taylor 34).

Oily Skin

Oily skin is something we constantly combat with actors, as oil patches reflect light more than dry skin and this can cause a distracting glare. Skin care is the first step of dealing with this issue. Make sure the actors have a good cleaning and exfoliating regimen so bacteria and skin cells are not mixing with the oil to create acne. Do not skimp on the moisturizer though – even oily skin needs moisture.

Again, an extensive knowledge of the products in your kit is essential. "Oily skin will benefit from an oil-controlling moisturizer with salicylic acid, or opt for an oil-free formula that hydrates the skin. Consider products containing glycerin or other humectants like

hyaluronic acid that draw moisture to skin without clogging pores or imparting a greasy feel to the skin" (Taylor 40).

It may be tempting to use alcohol-based products on oily skin, but the effects are actually counterintuitive:

> While you may have had oily skin to begin with and the alcohol will remove all of the oil on your skin, it creates the never-ending oily-skin headache you're experiencing. Alcohol robs your body of the natural oil levels it needs to stay hydrated and tells your body you need to produce even more oil at an even faster and more copious rate to repair the imbalance you're creating
>
> (Borba 144).

Focus on balancing the skin instead.

When you do apply makeup, try oil-free or matte-finish products and avoid heavy and waxy creams. For your oily actors, make sure to keep blotting sheets and mattifier in their actor bags to soak up excess oil on set!

Dry Skin

Dry skin simply doesn't produce as much oil as oily skin. It also may be that environmental factors such as products, or climate are making the person's skin dry so try to find out a lot about their lifestyle. Hormonal changes can also result in less sebum production making skin dryer.

Look for flakey areas around the nostrils and eyebrows. If the skin's surface looks dull, there may be a lot of dead skin cells that need to be sloughed off. In that case, you can recommend a gentle exfoliating treatment to your actor. Dry skin has less barrier protection and can be quite itchy so exfoliation should be done sparingly, not every day.

Moisture, of course, is a must. Choose products containing "humectants, such as hyaluronic acid and glycerin; lipids, such as ceramides; and emollients, such as lanolin and propylene glycol" (Jaliman 82). Also take care to use an eye cream and a strong lip balm – all areas of the skin should be well moisturized before any makeup application.

If skin is really flaking off heavily you can try to buff some off with a warm wet washcloth, and then apply a healing salve or ointment, allowing this to soak in before makeup is applied. Check in with the actor throughout the day – possibly misting them with refreshing spray like rosewater spray, and making sure they are drinking lots of water.

Normal Skin

Every once in a while you will encounter someone who says they don't have many issues with their skin. Maybe they just rinse their face in the shower or wash it with bar soap. They may be free of acne, redness, or dry patches. This person is blessed, but they are the rarity! If you have an actor with "normal" skin, you will simply need to keep it clean and hydrated with a gentle moisturizer, and avoid flaring anything up with too much makeup. Often, because these people aren't combatting *issues*, they

can sort of let their skin care fall to the wayside, so do try to help with anti-aging products, eye creams, and sun-protection that they may not be doing on their own!

Combination Skin

Combination skin is a mixture of any of the aforementioned skin types. Someone may be oily in the **T-zone** (the nose, chin, and forehead) but dry in the cheeks. They may be dry and acne prone, or oily and sensitive. "When dealing with combination skin, you may need to treat individual areas of [skin] differently than other areas" (Borba 27). Ask lots of questions to see what the actor is dealing with and choose your skincare products accordingly.

As makeup artists, we are not physicians and if you notice something glaringly wrong with an actor's skin, it may be up to your discretion to advise that they consult a dermatologist. However, you will be expected to treat and work with many different skin disorders. Let's look at a few.

Skin Disorders, Markings, and Conditions

Striae Distensae ("Stretch Marks")

Symptoms: Light-colored or red lines or marks that commonly appear during pregnancy but also develop after sudden weight gain or loss, and in adolescents during growth spurts. The marks most often appear on the lower abdomen, buttocks, thighs, shoulders, and on the sides of the breasts.

Causes: Rapid stretching of skin, which damages the skin proteins collagen and elastin.

Treatment: In general it's very difficult to eliminate stretch marks. Pulsed dye laser treatments that stimulate the production of new collagen and elastin may be used. Topical Retin-A, a vitamin A derivative, may also help minimize the appearance of stretch marks (Taylor 144).

Vitiligo

A condition that causes milky-white patches of skin to emerge on the face or body. In individuals with skin of color, the milky white patches are highly noticeable against the brown or black skin (Taylor 149).

Under-eye patches and sheet masks can be a great way to treat different types of skin on different areas of the face. They are available in many different formulas for a variety of skin issues

Skin 155

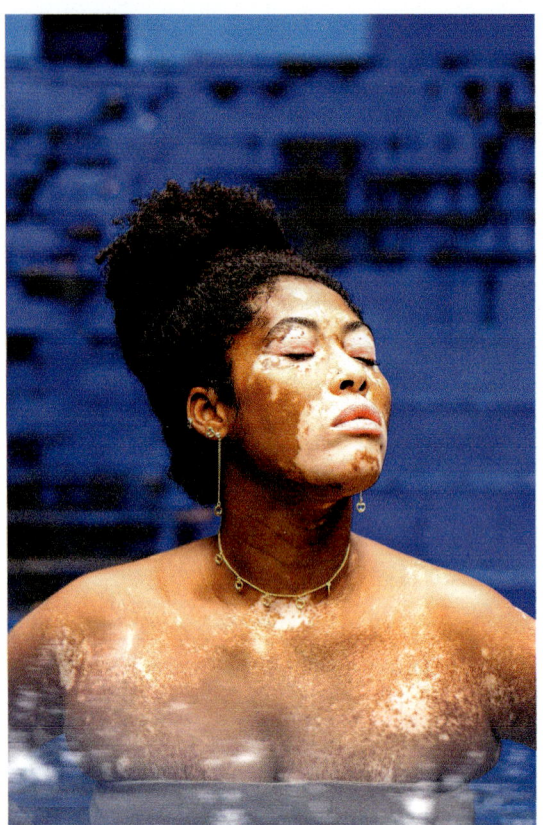

A person with the condition 'vitiligo'

Eczema

A common condition of the skin characterized by scaly, red, itchy, and sometimes oozing skin lesions. When scratched and rubbed, the inflamed skin can become thickened, crusted, and even hardened. On skin of color, eczema may appear ashen, brown, or grey. It's also more likely to be accompanied by dark brown skin discolorations once the eczema redness fades (Taylor 195). Although eczema most often appears on the neck, inside the elbows, and inside the knees, wrists, and ankles, it can crop up anywhere on the body. Moisture is crucial for preventing excess dryness and soothing irritated, eczema-prone skin (Taylor 199). Read labels and avoid moisturizers that contain any potential irritants such as alcohol or vitamin A (retinol), which can dry the skin and make eczema worse (Taylor 199).

Melasma

A condition characterized by brown or gray spots and patches on the face. The cheeks, forehead, upper lip, nose, and chin are commonly involved. Melasma can occur in [people] of all ages but it seems to cluster in women between the ages of 21 and 40. Hormonal factors including pregnancy and estrogens, genetics, sunlight, and overactive melanocyte cells are all thought to be contributing factors. Melasma is clearly exacerbated by exposure to sunlight, with most women reporting a recurrence or flare-up during the summer months (Taylor 160).

Cold Sores

"Cold sores, also known as fever blisters, are caused by an infection from the Herpes Simplex Virus (HSV). Patients often want to know whether they're infected with HSV-1 (the viral subtype usually associated with cold sores on the lip) or HSV-2 (the subtype linked to genital herpes). But with today's sexual mores and the fact that the virus can be transmitted by any skin-to-skin contact – a kiss on the cheek or a kiss in the bedroom – you're just as likely to be infected with HSV-2 as with HSV-1. "You can never be completely cured of cold sores; once infected with herpes, you

stay infected for life … When you *do* have a cold sore, you're contagious until the blister is completely dried out" (Kunin 48–49).

Psoriasis

"There are several types of psoriasis, mostly characterized by intermittently itchy patches of red, thickened, scaly skin, as dead epidermal cells accumulate. Common sites are behind the knees, elbows, lower back, scalp, and behind the ears" (Parker & Walker 169).

Rosacea

Rosacea is a redness across the middle of the face which often runs in families. The skin may become easily irritated or inflamed, especially by environmental factors. "Rosacea sometimes looks like acne; one way to tell them apart is that blackheads are not present with rosacea" (Jaliman 118). Make sure to keep a few anti-inflammatory products, or some specifically formulated for rosacea, in your kit so you are prepared for this.

Contact Allergies

"Contact dermatitis. (**Dermatitis** is a term dermatologists use for inflamed skin.). In contact dermatitis, the skin becomes red and rough, possibly with scaling, cracking, and weeping. Sometimes there are tiny, fluid-containing blisters. And it's likely to itch. A seemingly endless variety of substances can cause contact dermatitis. Patch testing is one of the most effective techniques a dermatologist can use to determine what's really happening to a patient with a chronic skin eruption that resembles contact dermatitis" (Kunin 53).

One common allergen in makeup is **carmine**:

Aztecs discovered a brilliant red color called cochineal, which was made from crushing tiny grey insects that expel a unique red colorant from their shells … Surprisingly cochineal is still often used today as a food colorant, and it is also found in lipsticks, blush, and eyeshadow. You may find it listed under ingredients and referred to as carmine, cochineal extract, or red 4.

(Middleton 36).

While this pigment can create some absolutely gorgeous makeup colors and was revered for centuries as an ingredient of luxury, you should note that it also comes with a high allergy risk. Those who are allergic to shellfish will often be allergic to carmine, especially in the eye area because they actually possess an allergy to the exoskeletons or the *shells*. These same individuals may be allergic to dust (because they are allergic to the shells of microscopic "dust mites," not to actual dust itself). Unfortunately, although I have green eyes, I cannot wear any pigments that are burgundy, purple, or red on my eyes because I have one of these unlucky allergies! When I first learned about complementary colors and simultaneous contrast in college, I was so excited to "pop" my green eyes and wasted probably hundreds of dollars on burgundy and purple

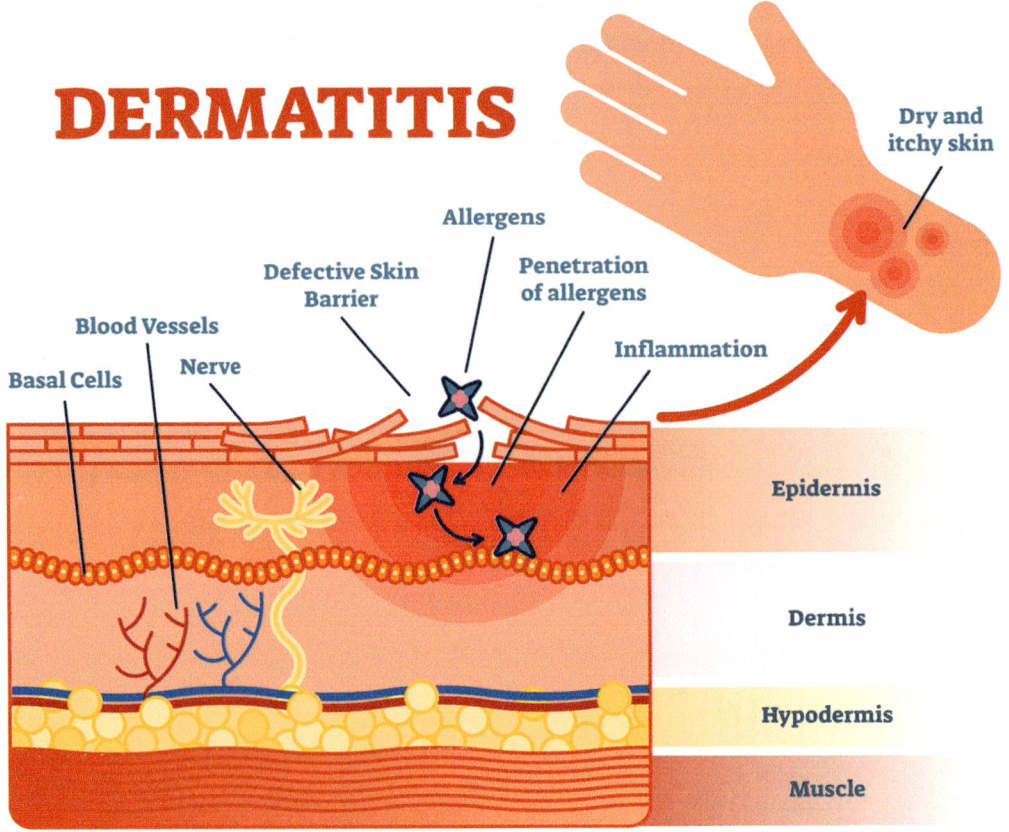

eye products, only to throw them away – I honestly thought I had pink eye all the time for about three years! My eyes would itch, water, become clouded over with oozing gunk – to say it was unpleasant was an understatement, and even if I only spent a few hours wearing these products, it would often take my eyes weeks or months to recover.

Therefore, it is incredibly important to ask your clients about *all* their allergies – not just to "cosmetic" products but to food and environmental allergens as well. If someone tells you they have a shellfish allergy, it may be wise to test certain colors on the inside of their arm or wrist to see if they develop a reaction to carmine. This also illustrates why it is so important to know the ingredients in all your products – including the different names for certain ingredients – and to keep in mind that not all colors will contain the same ingredients.

Sunscreen allergies

"Sunscreens come in two general types, chemical and physical. Chemical sunscreens are effective, but some people are allergic to the main ingredients" (Jaliman 44). If you notice after the first or second day that someone is developing tiny bumps, similar to

goosebumps, or any itching or redness, they may have a sunscreen allergy they didn't know about. Perform a patch test and double-check your product ingredients.

Skin Tones

I cannot stress this enough – regardless of your own personal skin tone, you *must* be an expert at matching and working with every single skin tone. If there's one single takeaway you have from this book, please let it be that! There truly is no excuse for not properly matching skin tones. If you had dry skin, there would be the expectation that you would still need to know how to deal with oily skin, even though it isn't your skin type. Just as a young makeup artist needs to know how to work on aging skin, or a female makeup artist needs to know how to work with men's skin, *every* makeup artist must learn to understand every skin tone.

In her book *Skin: A Natural History*, anthropologist, professor, and author Nina Jablonski writes that a

> ...distinctive attribute of human skin is that it comes naturally in a wide range of colors, from the darkest brown, nearly black, to the palest ivory, nearly white. This exquisite sepia rainbow shades from darkest near the equator to lightest near the poles ... Skin color is one of the ways in which evolution has fine-tuned our bodies to the environment, uniting humanity through a palette of adaptation

(3).

Skin tones vary because of the concentration of **melanin** within the skin, a chemical produced by special cells called **melanocytes**.

> Melanin is the name given to a family of complex polymeric pigments that exist in many forms. (A polymer is a chemical compound composed of multiple repeating units.) The primary form of melanin we find in the human body is an extremely dense, almost insoluble, and very dark brown pigment molecule that is attached to a protein

(Jablonski 65).

Melanocytes are "immigrant cells." They "produce the skin's primary pigment and natural sunscreen, melanin ... Some people produce a lot of melanin in their melanocytes, whereas others produce only a little, depending on the amount of UVR present in the environment of their ancestors" (Jablonski 14).

Because of their varied cellular make-ups, different skin tones have different reactions to irritants. Fair skin may be more likely to become red or irritated at a scratch or a chemical irritant. Skin of color on the other hand, is commonly more likely to develop **hyperpigmentation**, "Hyperpigmentation literally

> "...regardless of your own personal skin tone, you *must* be an expert at matching and working with *every single skin tone.*"

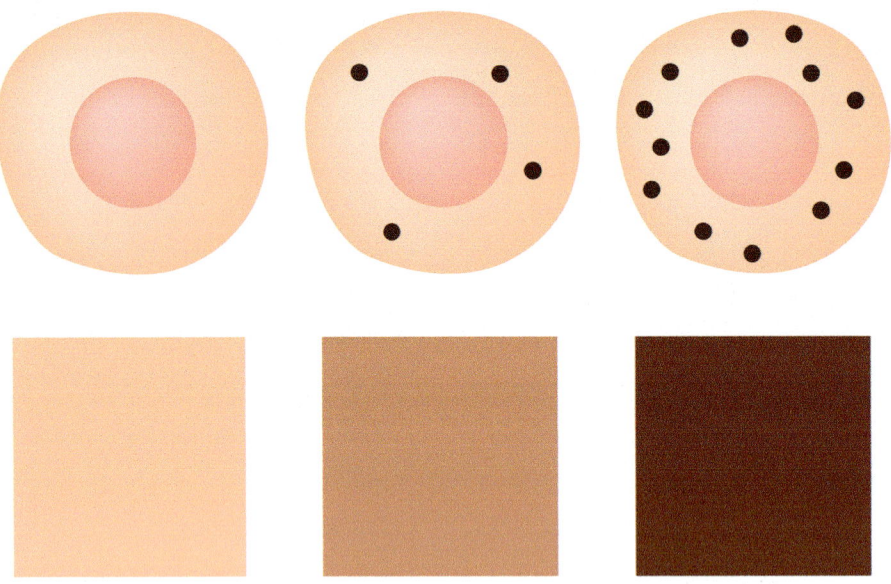

The concentration of melanocytes is what produces different skin tones

means 'excessive pigmentation or darkening of the skin.' Hyperpigmentation may develop all over the skin or in discrete patches" (Taylor 150).

Being aware of potential challenges with each and every skin tone will make you a more competent makeup artist, meaning your work will look better on screen, and actors will feel comfortable with you, whether or not you come from the same ethnic or racial background.

Dermatologist Dr. Susan Taylor writes about working with different skin tones in her book *Dr. Susan Taylor's Rx for*

"Being aware of potential challenges with each and every skin tone will make you a more competent makeup artist, meaning your work will look better on screen, and actors will feel comfortable with you, whether or not you come from the same ethnic or racial background."

Brown Skin (which I highly recommend for makeup artists of any skin tone or background!) "I recognized early in my career that all skin is not the same and that brown skin (Asian, Latin, African, African-American, Middle Eastern, Native American, and even Mediterranean) has special characteristics as well as potential problems that differ from Caucasian skin." This "special skin is often more reactive and easily damaged by everyday injuries, rashes, and pimples. It is more prone to particular problems, including unsightly discolorations and devastating scars" (1).

In Dr. Taylor's words,

"Skin of color" is defined as skin that contains increased amounts of melanin as compared to white skin. The amount of melanin among different women of color can vary dramatically ... Most Brown women in the United States are likely to have descended from Asian, African, Native American, Latin, and/or Middle Eastern ancestry. These combinations can produce an endless array of skin tones and hair textures. So the bottom line is that there is no one type of brown skin."

(3)

With that in mind, there are things you need to consider in your work with skin of color, just as there are with fair skin. When working with skin that has a high concentration of melanin, "Almost any stimulus – a rash, scratch, pimple, or inflammations – may trigger the production of *excess* melanin, resulting in dark marks or patches on the skin. These dark areas are the result of what is called *postinflammatory hyperpigmentation*" (Taylor 13). Because of this, you may need to shade match different areas of the skin, use several different foundation tones on different parts of the face and blend accordingly. This is normal.

Additionally, "Many women of color have lips that are two completely distinct shades - a darker shade on top and a lighter, more pink or reddish shade on the bottom" (Taylor 64). Blend your lipliners and lipsticks as needed if you wish to even out these tones on screen. You may need two different lipliners.

Dry, dead skin cells sit atop *all* skin tones, but can be more visible on skin of color because the dead skin becomes white as it dries and can appear grey on deeper skin tones. People may refer to this as "ashy." "Skin flaking or ashiness is also typical of dry skin" (Taylor 20). It is important to hydrate dry skin on all skin tones, but if you have an actor or actress on whom ashiness is particular visible, use a heavy body cream with some moisturizing oils, shea butter, or cocoa butter in it to really hydrate the skin and smooth out any flakes. Be mindful of over-exfoliating because this can actually create lighter patches in the skin called hypopigmentation.

Oil is also more visible on dark skin because of the reflections of light – therefore it is a myth that all people of color have oily skin. Each skin color in the entire range can have variations in moisture levels and oil production levels.

Skin 161

Keep in mind that all skin can be contoured and highlighted when the right products are chosen. If you are going to highlight dark skin, make sure there are warm, rich undertones to your products so they will not appear grey or ashy. If you are going to contour fair skin, make sure you don't pick a contour shade that is too dark or warm, to avoid making the actor look orange.

You should never find yourself in a situation where you don't have the colors to create a foundation for someone – even if you have to mix (which is common!), make sure you at least have the ingredients to mix with. Cosmetics companies are now carrying wider and wider ranges of products, so make sure you have products of every variation of light to dark, warm to cool, and can at least mix what you need to. For more in-depth practices of mixing different skin tones, reference Katie Middleton's book *Color Theory for the Makeup Artist* and try some of the suggested exercises to hone your color-mixing craft!

> "...all skin can be contoured and highlighted when the right products are chosen."

Skin and Age

In addition to becoming confident working with all skin tones, you need to become confident working with all skin ages. Aging skin should be carefully considered when it comes to both skin care and makeup application.

Healthy young skin contains resilient fibers made of the protein elastin, which help it return to its original position, for example, after smiling. With increasing age, the elastin degenerates and the skin's dermis becomes more loosely attached to the muscle beneath. This causes wrinkles since the skin can no longer stretch or shrink easily. Initially "crows feet" radiate from the corners of the eyes. These are followed by lines around the brow and mouth, in front of the ears, between the eyebrows, on the chin and bridge of the nose. Facial wrinkles are always at right angles to the muscle fibers so they reveal the pattern of facial muscles. Exposure to excessive sunlight and temperature hastens wrinkling

(Parker 76).

"One of the biggest signs of aging is a loss of elasticity in your epidermis in the form of sagging, loose, or crepey skin caused from skin movement damage, sun, or skin irritation" (Borba 152).

Skin discoloration and uneven skin tone are also common signs of aging that are caused by the sun. We generally want to combat these as makeup artists, if it is appropriate for the character. As Jaliman says,

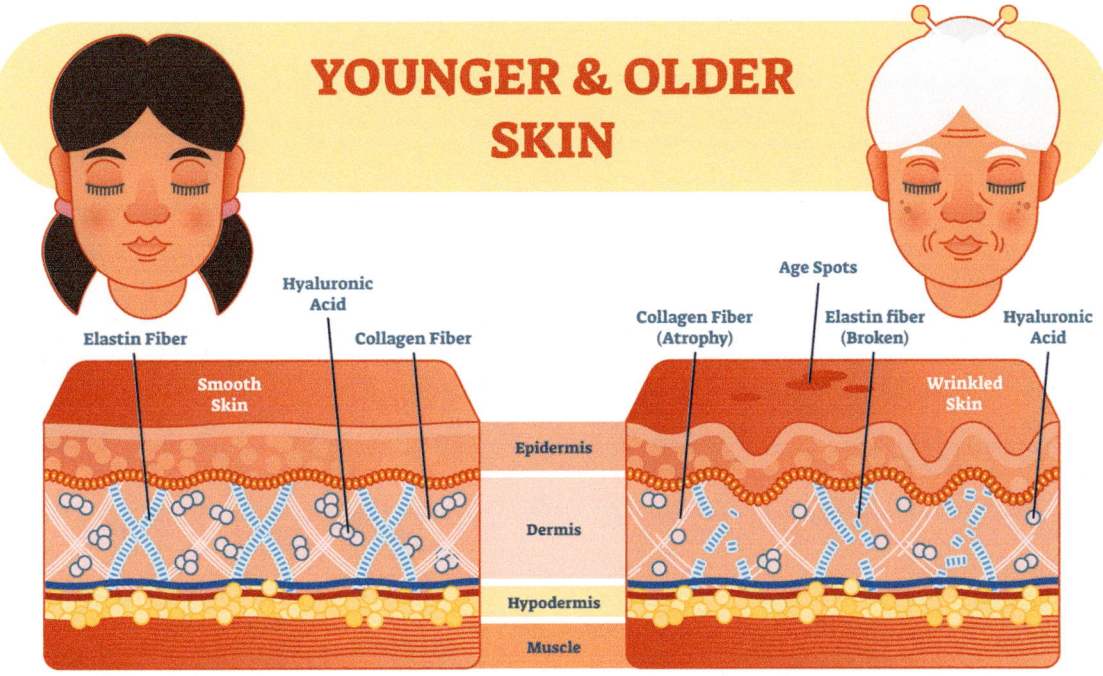

"A brighter, even-toned complexion can make people look ten years younger" (127).

No, if you don't want a character to look youthful, you won't want them to have this bright, even-toned complexion. If a character is meant to look elderly, or more "weathered," you may leave, or even enhance their age spots. You'll still want to apply sun protection for these actors so the skin aging does not get worse while you are shooting outside.

*There are three conditions that people tend to call **age spots**:*

***Liver spots**, or age-related freckles. Dermatologists call these solar lentigos.*

***Sebhorrheic keratoses**, thick, waxy, wartlike growths also commonly called "barnacles of life."*

***Actinic keratosis** (by far the most serious of the three conditions), a scaly spot that can be a precursor to skin cancer"*

(Kunin 25).

"Many older women of color also notice that their facial skin is significantly darker than the skin on their neck and chest – and not just in summertime. Skin growths also tend to crop up, particularly if they run in your family. These include *dermatosis papulose nigra* (raised brown or black growths) on the face, skin tags (raised brown or black growths) on the neck, *seborrheic keratoses* (waxy brown growths) on the body, and *angiomas* (red growths) on the body" (Taylor 237). Discuss age spots with your actors, and if they have any that seem worrisome, let them know a dermatologist can help.

As far as your skin care in the chair, older skin needs more moisture. Women who are post-menopausal are especially susceptible to dryer skin due to the decrease in estrogen. Keep highly moisturizing and anti-aging products in your kit. For anti-aging

Skin 163

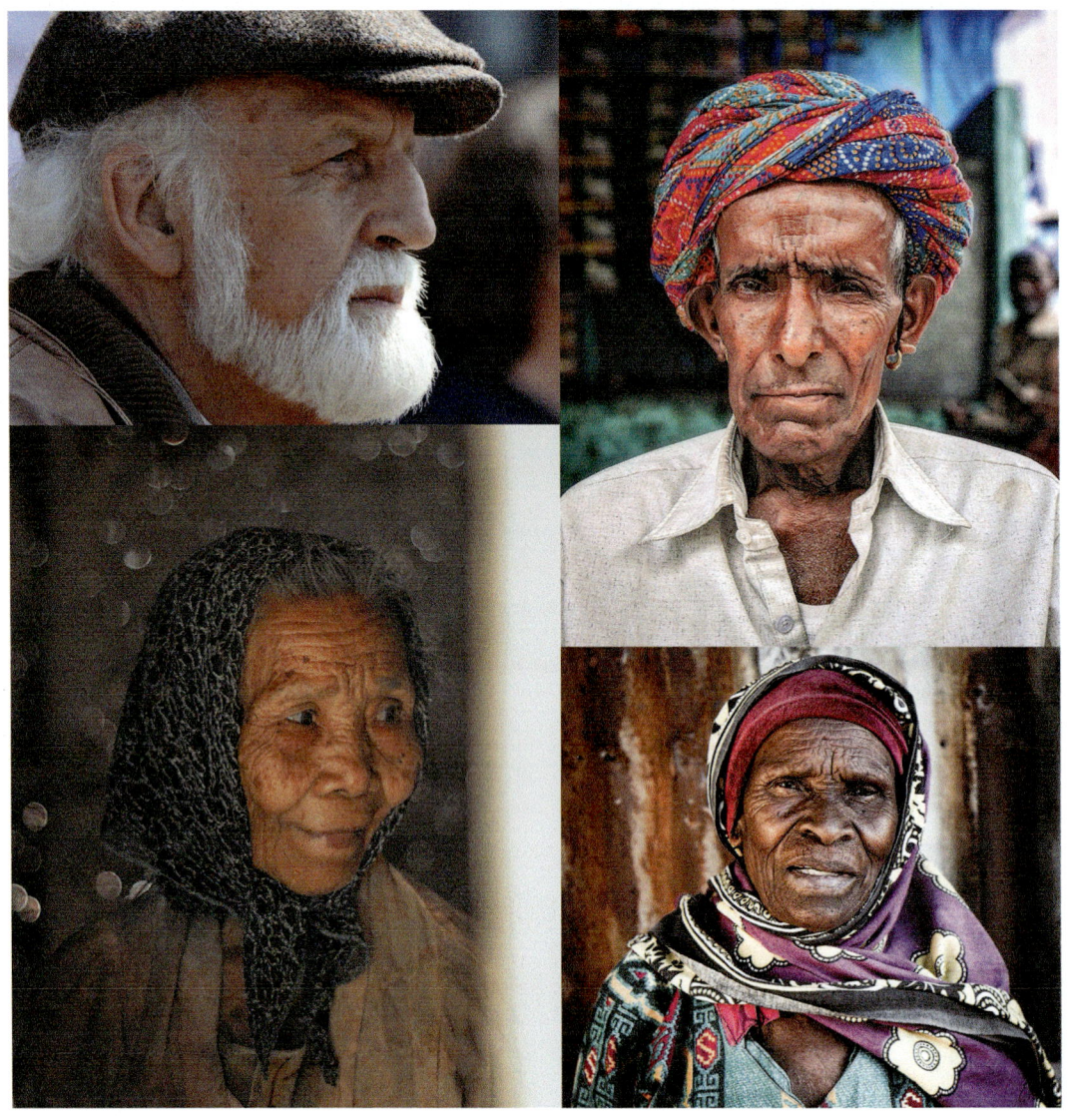

All skin tones are susceptible to signs of aging, such as age spots, wrinkles, and sagging due to loss of elasticity

treatment, "Look for products with DNA-repair ingredients or that contain growth factors, peptides (to stimulate collagen production), retinol, cytokinkins, reservatrol, caffeine, niacin and its derivatives, vitamin C (ascorbic acid), and green tea" (Jaliman 127).

Allow these intensely-hydrating products a bit of time to soak into the skin before applying makeup – this will help avoid product slippage and creasing.

For more information on how to apply a beautiful makeup look to aging skin, refer to Chapter 12 "Beauty Makeup."

Additional Skincare Considerations

Shaving

As the Makeup Department is responsible for facial hair, you will frequently be shaving actors' faces, or helping them with skin care as they maintain their facial hair at home. Talk to your actor about their experience with shaving as part of the consultation.

"Some people are just prone to red shaving bumps, especially if they have sensitive skin," (Jaliman 161) and your actor will know if they are one of these sensitive people.

While fair-skinned men tend to get red bumps and purple scars from ingrown hairs and inflamed hair follicles, men of color tend to get bumps from curled hair that curls back underneath the skin, and hyperpigmentation, or dark spots around the beard area.

"Men of color are particularly susceptible to two common skin conditions: *pseudofolliculitis barbae* (PFB), commonly known as razor bumps, and *acne keloidalis nuchae* (AKN), a problem characterized by bumps and keloids that develop at the nape of the neck after hair cutting" (Taylor 266). You must be extremely careful when shaving men of color so you do not cut the skin and cause more bumps, hyperpigmentation, or scarring.

Straight or wavy hair grows out of a wide open, round or oval-shaped follicle which may make shaving easier because you can generally shave in one direction. Tightly curled hair, however, grows out of an ellipse-shaped follicle, which means the hair strand is being compressed and that causes it

STRUCTURE OF THE HAIR

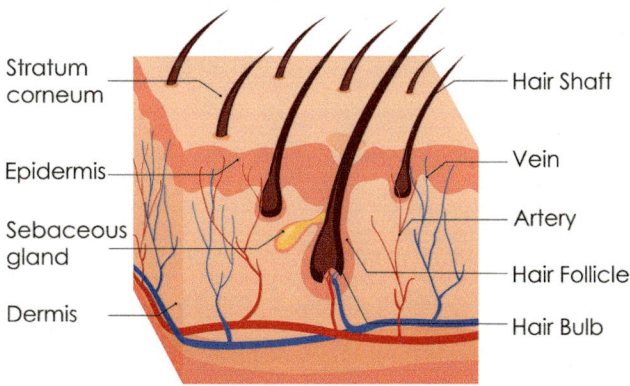

Hair grows out of pores in our skin, which can become irritated, clogged with oil and debris, or prone to ingrown hairs getting infected – these reactions are often called 'razor burn'

to curl tightly. Different growth directions and patterns all over the face and back of the neck are common, which may mean shaving in different directions as well. Tightly curled facial hair makes the man prone to **razor burn** and ingrown hairs because the hair doesn't grow all the same direction and grows out in a spiral shape. Because of this, men with tightly coiled hair have a "Greater incidence of pseudofolliculitis barbae (razor bumps)" (Taylor 266). Treat the skin with an anti-inflammatory and antibacterial aftershave. I especially like one with tea tree oil as an astringent. Encourage these actors to exfoliate in the shower, especially within the neck creases where oil can gather and hair follicles can become infected.

Become an expert at shaving *all* hair types. If this is not something you have experience with, you may wish to visit a local barber and ask if they offer lessons or private tutoring. More information on specific grooming procedures are listed in Chapter 11 "Grooming."

Sun/Weather Protection

Films shoot anywhere and everywhere. I remember crying on location during "Monsoon Season" in Puerto Rico because none of my special effects products would stick to the actor due to higher humidity levels than I had ever experienced in my life. As a film and TV makeup artist, you must be prepared for every climate, every season, every hour of day or night.

Sun protection is important on all skin, but especially on skin with freckles, which can actually become darker due to the sun's UV rays.

Sun protection is a necessity, as I have mentioned several times. That said, physical sunscreens with high SPFs can create a whitish glare on camera due to the concentration of certain ingredients they contain, so be careful not to use sunscreens that are too high in SPF. It may be valuable to do a camera test of different sunscreens if you know you will be frequently filming outside in a sunny location.

For hot and humid locations, you can fold clean paper towels into neat rectangles and keep these "sweat towels" in actor bags to dab them periodically if they aren't supposed to appear sweaty.

Skin protection from wind and cold is also crucial. *The first brisk day should act as the perfect reminder that reasonable, consistent use of a protective balm can prevent your lips from drying out in the first place ... That's right: your Chap-Stick or other wax-based lip balm is something you should apply* before *you've got problems. Think about it. How much moisture does a tube of wax give your lips? Very little. Wax is a protective barrier, not a healing agent.*

(Kunin 41)

"Since the lips have few sebaceous or oil glands, they tend to become very dry, especially during the winter months" (Taylor 44). Keep moisturizing ointments in the trailer and lip balm in all actor bags when shooting in the cold.

On cold and windy days, make sure to have extra tissues on hand for actors to blow their noses (plus concealer to touch up red noses). Cuticle creams and hand salves are good protection for the hands from wind burn and cracking.

If you have actors who live in different climates than the one in which you are shooting, their skin may change

> *" Keep an ongoing conversation with your actors about changes coming up for them and do your best to accommodate these new skin issues. "*

dramatically in new ways. Living in Chicago, I have had countless actors travel in from Los Angeles and exclaim things like "but I *never* break out in LA!" or "my skin has been *so* dry since I got here!" Keep an ongoing conversation with your actors about changes coming up for them and do your best to accommodate these new skin issues.

Section III

Technique

In this section, I aim to offer you some of my best-loved techniques: basic skills that I believe all film and television makeup artists should have in their arsenal. This is by no means an exhaustive list so for further makeup technique study I recommend these books:

- *The Makeup Artist Handbook: Techniques for Film, Television, Photography, and Theatre* by Gretchen Davis and Mindy Hall
- *The Art of Makeup* by Kevyn Aucoin
- *Making Faces* by Kevyn Aucoin
- *Face Forward* by Kevyn Aucoin
- *Bobbi Brown Makeup Manual: For Everyone From Beginner to Pro* by Bobbi Brown
- *Makeup Your Mind: Express Yourself* by Francois Nars
- *Makeup: The Art of Beauty* by Linda Mason
- *Special Makeup Effects for Stage and Screen* by Todd Debreceni
- *Dick Smith's Do-It-Yourself Monster Make-Up Handbook* by Dick Smith
- *A Complete Guide to Special Effects Makeup* by Tokyo SFX Makeup Workshop (Enjoy many different editions of these books with a different artistic focus in each!)

There are so many amazing books out there – these are just a few I have personally enjoyed working with! Subscriptions to professional magazines including *Makeup Artist Magazine* (which gives you access to their online database of past issues and exclusive videos!) and *On Makeup Magazine* can also be a hugely informative and fun way to stay informed about current makeup trends and technology.

10

HD "No-Makeup" Makeup

In This Chapter

- **Shade Matching**
- **Reducing Shine**
- **Color Correcting**
- **Basic HD Makeup on Children**
- **Considerations for HD Makeup on Aging Skin**

Shade Matching

After reading all about skin science, you know how to conduct a consultation with your actor and how to prepare their skin for makeup application. What's next? Makeup time! A basic makeup might be called "**corrective makeup**," "**no-makeup-makeup**," or "**HD makeup**." Confirm with your Department Head or Director so you are 100% sure about what the look needs to be before you do anything. You do not want to go covering under-eye bags on a character with a terminal illness, or concealing scars on a rough-and-tumble gang member. Assuming the Director does want a smooth, flawless, symmetrical look that will simply look nice on camera, you can proceed with these steps.

The first thing you will need to do in your corrective makeup is to find the actor's skin tone. Nina G. Jablonski writes about how light filtering through the skin creates what we perceive to be skin tones, with this example:

Light of different colors (and thus, of known wavelengths) is focused on a small area of skin. The light reflected from the skin is then measured by a photocell. The reading from the photocell represents the percentage of light relative to a standard pure white block. Lightly pigmented skin reflects more light than darkly pigmented skin, and different wavelengths are reflected to different extents. Since the 1950s, anthropologists and dermatologists have devised numerous instruments for measuring skin reflectance, but the principle behind the operation of these devices is the same. Measuring skin reflectance remains the method of choice for the study of skin pigmentation because the procedure is standardized and lacks the subjectivity inherent in visual matching of colors

(74).

There are countless skin tones on the planet and you may not always know what product to use right when someone sits in the chair, so your first step will be to **shade match**.

"For years, scientists have worked to develop objective and reproducible methods for measuring skin color in living people. In the seventeenth and eighteenth centuries, verbal descriptions of skin colors – "white," "yellow," "black," "brown," and "red" – had

to suffice. Such definitions have obvious problems. The actual colors that people associate with names of colors differ; what one person calls "light brown" may be another's "yellow." In the early twentieth century, these terms were replaced by less ambiguous methods of color matching, which involved the use of tablets or tiles of graduated color that were matched to the skin. The most popular such method was the von Luschan scale of skin color, which was widely used by anthropologists through the 1950s" (73).

Just as scientists have done their best to name different skin tones, so have different cosmetics companies.

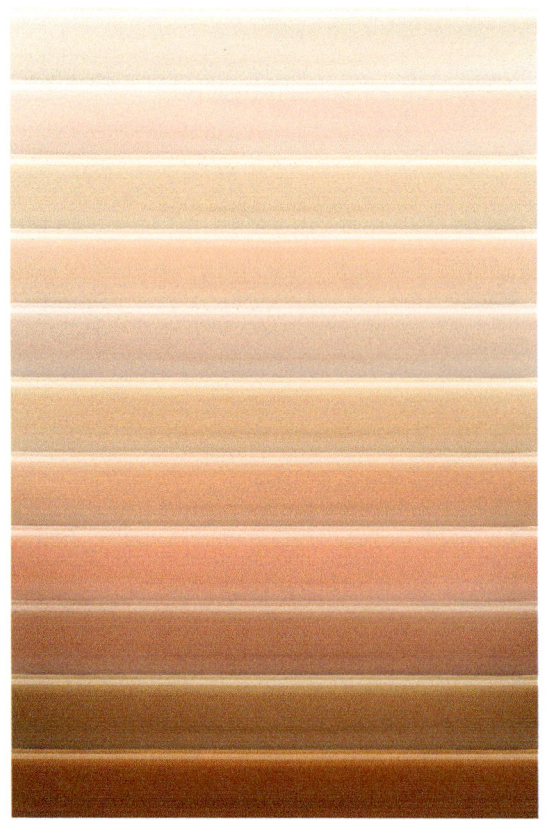

Several different shades of foundation in a palette – you will test three for your shade match

"Develop your eye, cultivate your own ability to see undertones, and practice to perfect your shade-matching."

Colors of foundation may be based off of colors or objects (i.e. "ivory" or "golden"), gradient scales (i.e. "fair" or "deep"), or even foods ("olive" or "mocha"). The bottom line is that these names do not matter. Discussing the skin tones and colors are not what is important to your work as a makeup artist, especially because everyone does see color differently. Develop your eye, cultivate your own ability to see undertones, and practice to perfect your shade-matching. This process can be done on any actor of any skin tone or gender. If the actor has a beard, you can still match on the side of the face, as close to the jawline as possible – it may be the side of the cheek.

Shade matching involves different colors of foundation, usually tested on the side of the jawline. We generally test on the jaw, because, due to its distance from the center of the face, it's less likely to be splotchy or affected by redness, sunburn, rosacea, freckling, and hypopigmentation and, being closer to the neck, it is more likely to represent the actor's "true" skintone. Of course, if you have an actor who

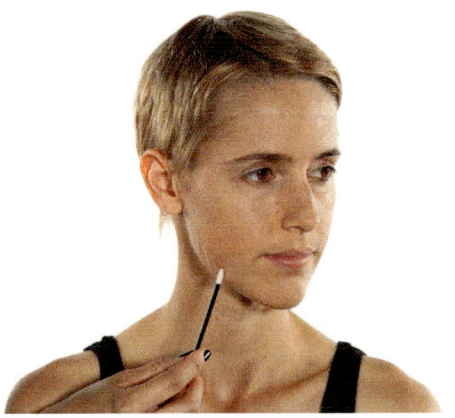 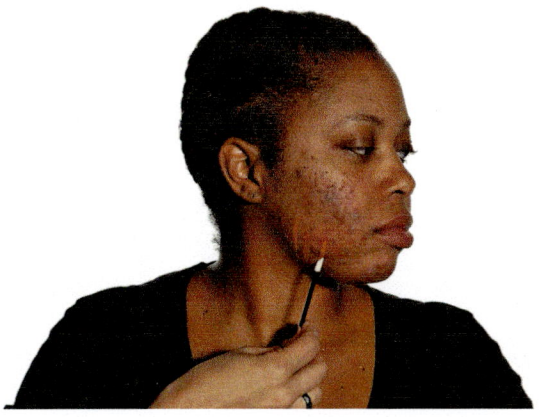

Choose three foundations that you believe will be close to the actor's skin tone and put a tiny bit onto your palette. Using a disposable applicator, apply these colors in stripes to the jawline. Testing on the jawline typically allows you to see the most true skin tone, because it is often less affected by the sun or by rosacea than the front of the face. It also allows you to recognize the color of the ears and neck as the color of the face must blend seamlessly into these areas as well.

Step back from your model and assess which color blends best into their skin. Colors that are too light or too pink in their undertone will appear "ashy" on the skin. Colors that are too warm will appear orange. Colors with too much of a golden undertone will appear bright yellow.

Keep in mind you may wind up mixing several colors or using different colors on different parts of the face.

Once you have found the proper shade, use a sponge to wipe away your stripes of foundation, so you have a clean canvas on which to apply your base.

HD "No-Makeup" Makeup

does have one of these conditions or a generally uneven skin tone, you may need to mix or blend several shades. This is quite common so if you do notice a drastic difference, you may want to shade match one patch on the jaw and one on the apple of the cheek as well.

Reducing Shine

First of all, it is important to remember that it is not only oily skin that can become shiny-looking on camera, though oily skin is prone to developing that greasy look much quicker than dry skin. Even someone whose skin feels as dry as paper, might simply have a lot of sweat glands, so they may get sweaty and shiny and begin to "glisten" rapidly as well. As both sweat production and oil production are natural processes of the human skin, we are constantly combatting shine.

If you've completed your consultation and the actor does indeed have oily skin, you'll want to begin with your oil-control moisturizer such as Dermalogica Oil-Control Lotion or Embryolisse Hydra-Mat. Next, you'll want to use a mattifying, silicone-based primer. Then, you must ensure the foundation you are using is not a luminous, but a *matte* formula. You can set your foundation generously with both colored and HD powder, though if you do choose to use HD powder, make sure it is buffed into the skin quite well to avoid any white cast of reflection. You may want to use a mattifying setting spray to set the makeup, especially if it is heavy coverage on a particularly oily person.

Throughout the day you will likely want to use oil-blotting sheets to absorb excess oil. Once any excess oil is dabbed off, you can use a sponge to apply a light layer of a translucent or lightly tinted anti-shine gel or cream. Dust powder over the anti-shine to set it and really mattify the skin. Especially with an actor with oily skin, make sure you use a small brush to powder around the creases of the nostrils and under the eyes. When I was in high school and we all carried blotting sheets in our backpacks, only blotting the T-zone was perfectly sufficient. On-camera and under lights, however, oil settling into the small areas on the face creates distracting and unattractive glares you will definitely want to correct.

In the case of an actor who is sweating profusely, a nicely folded Viva brand paper towel (or "sweat towel") will work wonders. Lightly use a towel to dab sweat off the actor (do not *wipe* in order to avoid smudging the makeup of course). We often use Viva because they are not quilted and will not pull makeup off the face, only absorb the liquid sweat. Once the sweat has been absorbed, you can proceed either with

> *"As both sweat production and oil production are natural processes of the human skin, we are constantly combatting shine."*

just powder, or the same anti-shine and powder trick, depending on if the person's skin is dry or oily.

One of your challenges during long days on set will be keeping your actors from getting shiny and greasy. This shine is incredibly prevalent and can be quickly distracting – especially on an actor who is bald.

Luckily, mattifying the skin is a quick and easy touch-up. You may find yourself repeating this process often throughout the day.

For your background players, especially gentlemen who don't require a lot of makeup, these steps may be the only ones you do for them on a busy day:

Assess how sweaty or shiny the actor is. If the glare is coming from sweat, you can dab the skin with a folded paper towel first. If the shine is coming more from grease, you may want to start with a blotting sheet to soak up excess oil from the skin.

The shine may also simply be caused by the reflection of light off the actor's skin – in that case, you can skip the above suggestions, and move right on to the next steps.

Using a sponge, apply a silicone-based mattifier to all skin areas – including the entire top, back, and sides of the head if the actor is bald.

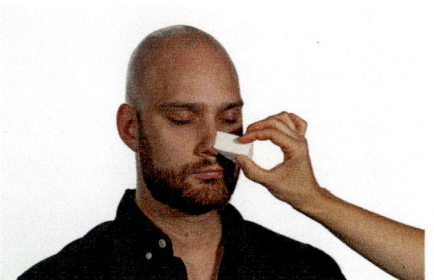

Keep in mind, not all shine comes from oil – the actor may be shiny and have dry skin. In that case, apply a light moisturizer before applying your silicone mattifier because otherwise the skin may flake as the mattifier is applied.

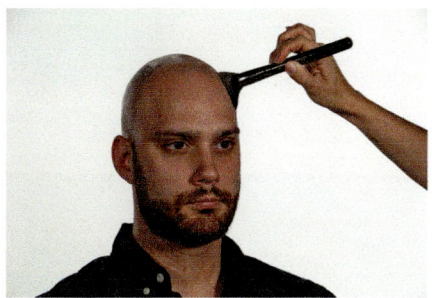

Buff on a tinted setting powder in a circular motion. Make sure to work the powder all over the crown of the head if the actor is bald.

HD "No-Makeup" Makeup 177

Color Correcting

When it comes to color correcting, a little bit can go a long way. Keep in mind that it is possible for any skin tone to have discolorations so you will need to keep a variety of color correctors in your kit.

Think back to Chapter 5 on Color Theory. You can learn everything you need to know about facial color correcting from the color wheel – it is just a matter of training your eye to see undertones.

Let's imagine you have an actress from a Mediterranean country with a strong olive undertone to her fair skin. Around her eyes she has deep, dark circles and she has a few pimples on her forehead as well. Right away you are dealing with many undertones. When examining the face, I try to look at the actor, not as a three-dimensional human, but more like an Impressionist painting – a blur of different tones slapped together. It might even help you to narrow your eyes so their face does become blurry to pick up on the different tones mingling together on the face.

Begin with her overall skin – that olive tone can be simplified to kind of a mix of green and yellow – think Chartreuse.

The dark circles around the eye, if you look closely, are created by broken capillaries under thin skin, and on fair skin will have a bit of a purple cast.

Pimples have a strong red undertone.

Now, find your color wheel. What's the opposite of Chartreuse (yellow-green)? Red-violet. So, a red-violet toned primer might be a great option to keep this actress's skin from looking sallow on camera.

What's the opposite of blue? Orange. So a warm, peachy-toned color corrector under the eyes will neutralize those dark circles and create a great canvas.

What's the opposite of red? Green. A green cream dabbed individually on to each pimple will cancel out that red tone and hide them much more effectively than regular concealer alone.

This process can be done with actors of any gender and any skin tone, as long as having perfect skin is appropriate to the character. If you need help identifying undertones, you can also look at the inside of your actor's wrists; an area likely to be less affected by sun and by skin conditions (this is not a fool-proof science! Just a trick that might help you.)

Practice finding different undertones in the face with people in public as you go about your day. If you see someone with an overall deep skin tone who possesses a slightly lighter tone across the middle of the face, and slight hyperpigmentation around the edges of the face, it is not enough to distinguish between light and dark. You must be able to discern the undertones of each shade because that lighter patch across the middle of the face could present with a golden

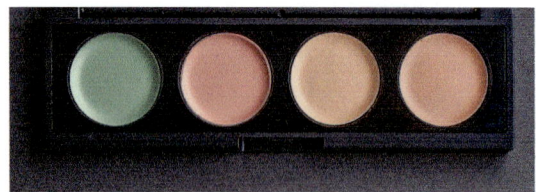

Color correctors are available in a wide variety of colors to address different concerns and discolorations

178 Technique

undertone, a rosy undertone, or even a greenish undertone depending on the person.

When it comes to color-correcting and finding skin tones, you truly cannot practice enough. Don't worry if it is overwhelming right now – it will become second nature as you train your "eye."

Basic HD Makeup on Children

When it comes to children, making them camera-ready can be simple but they should still get a few minutes of your attention. Due to fewer active hormones, most young children have even skin textures without too much oil or dryness. Still, a light moisturizer that's suitable for sensitive skin is a good idea. Also, be sure you do apply sunscreen if you will be shooting outside – children's skin is more delicate than adults'.

You will want to make sure they have a protective lip balm and possibly an HD primer and translucent powder, just to smooth out reflections in the face. Many children have ungroomed eyebrows so I usually apply a clear brow gel and smooth out the brows because they might be likely to touch their faces.

When working with kids, you might need to keep more of an eye on their habits as well – children with dry lips tend to lick their lips which may create redness or irritation around the lip area. Pay attention to their noses and don't be afraid to offer a tissue if needed – they are less likely to ask you than adults are and may go on camera with a runny nose.

> " When working with kids, you might need to keep more of an eye on their habits "

I rarely apply lots of beauty makeup to children, but it may be appropriate to use a light lip and/or cheek stain on young girls, if what the Director wants is a very "girly" and fresh-faced look.

Occasionally, I will see children – of any gender – whose parents or guardians regularly use large

HD "No-Makeup" Makeup 179

amounts of hair product on them. This can result in clogged pores and whiteheads on the forehead, so if you see this, you may want to discuss the child's routine with the caregiver. You can cover the color of these blemishes but not the texture, so educate the caregiver about using less hair product and about cleansing and exfoliating the child's skin before bedtime. Swiping a toner across the forehead after hairstyling can also help break down sebum in these bumps. You may feel awkward having this conversation but in order to avoid a recurring child character with a bumpy face, it could be worth it. Consult with your Department Head if you are unsure.

Considerations for HD Makeup on Aging Skin

If you have an older adult actor who is supposed to present with a "no-makeup makeup" look, make sure first that you know the age of the character they are portraying. It is possible that an actor who is age 75 has been cast to play a 90 year-old, in which case any dark circles or age spots that actor has, you would want to leave visible and you may even find yourself enhancing some of their spots and wrinkles. In this instance, you would mainly be moisturizing their skin and priming and powdering it to reduce shine in HD, but any discoloration should be left in order to make them look older.

If, however, you need to smooth out the skin of an actor whose skin is well into the aging process, the consultation is an incredibly important part of your work. For one thing, especially if you are young, the actor may assume that you do not know how to work with older skin – of course you will be able to compassionately prove this assumption wrong because you are now a skincare expert for everyone! Show them that they can trust you by listening. Learn about their routine and about their concerns. Many actors are aware of their aging process and some may be very self-conscious about it. If an actress tells you "I've lost all my eyebrows!" or "No matter what I do, these spots just keep popping up!" assure them that this is very common and ask questions relating to what they bring up, such as "Do you typically prefer a fuller eyebrow shape? Do you draw your eyebrows on on a daily basis?" "Do you prefer to cover hyperpigmentation or to allow it to show?" Make sure you use the scientific and technical names for skin conditions as saying the words "age spots" rather than "hyperpigmentation" can make someone feel more self-conscious.

> ". . . if you are young, the actor may assume that you do not know how to work with older skin – of course you will be able to compassionately prove this assumption wrong because you are now a skincare expert for everyone! Show them that they can trust you by listening."

As mentioned in Chapter 9 on Skin, it is not safe to assume that all older people have dry skin, but you should know that aging skin loses its moisture faster than younger skin due to the decline in collagen production, so you will need to use a suitable moisturizer on your older actors. Discuss what products they currently use that they like and what products don't work for them. Their skin type may have changed throughout the course of their life so products they loved forever may not be effective anymore.

Once you have moisturized, be sure to prime the skin with a pore-minimizing primer. A silicone-based primer can act almost like a spackle to fill in deep pores and fine lines. These products will need to be blended in very well with a sponge and may only be suitable for certain areas of the face lest they start to pill and roll off the skin.

"No facial flaw is more noticeable than dark circles under the eyes," writes Dr. Audrey Kunin in her book *The DERMAdoctor Skinstruction Manual: The Smart Guide to Healthy, Beautiful Skin and Looking Good at Any Age*.

> They age the face and create a tired, haggard appearance and a deceptively uninterested expression. A combination of different factors can conspire to form dark circles: aging, sun damage, heredity, allergies, and even poor lighting! Because of aging and years of sun damage (with perhaps a genetic tendency thrown in for good measure), microscopic blood vessels under the eyes can lose their stability and strength. The body compensates by forming lots of tiny new veins. A thinner fat pad [under the eye] means those veins are closer to the skin's surface. The result: dark circles (66).

One temptation when it comes to older actors is to see this darkness around the eyes and start to pile on loads of concealer. Unfortunately, this effort typically backfires. While the concealer may hide the color of the darkness, a thick product around the eyes will only enhance any crepey texture and settle into fine lines and crow's-feet, generally prompting your actress to say "I look older with makeup on!" Discuss with your actors (of any age!) the benefits of using a hydrating eye-cream nightly, as this can lessen that crepey appearance of makeup around the eyes.

A tiny bit of well-blended concealer, a bit of spot-color-correcting, and a well-blended, moisturizing foundation should be all you need on the face, finished off with a light dusting of powder to set. Because older skin can appear dry and dull, matte formulas can exacerbate this. Many women want a full-coverage look but if you do full coverage, use a moisturizing cream or liquid formula. Powdering very lightly will help avoid a look that cakes and settles into fine lines and creases.

When it comes to eye makeup, unless it is a character-specific that this lady wears sparkly or bright eyeshadow, less is more. Shimmery colors emphasize crepey skin as do very dry, matte, and light colors. Neutral, satin tones are your best bet – applied in a shape that frames and uplifts the eye. You likely will not need to emphasize the crease, because as skin sags, that crease between the browbone and the eyeball has likely become more visible anyway.

Women especially, do lose eyebrows and eyelash hair over time due to hormonal changes, but don't assume that just because she is an older lady, she won't want to wear false eyelashes. Small individual eyelashes placed right along the lashline and particularly at the outer corners of the eyes, can do wonders to open up the eyes, especially if the skin around the eye area has begun to droop with time. I suggest having the actress curl her eyelashes and applying a black or dark brown mascara first (depending on her hair color) When drawing on eyebrows, do create a nicely-defined shape, but do not attempt to recreate the eyebrow trend of a 20 year-old blogger. Those brows do not work for everyone and will only make your older lady look cartoonish and frightening rather than "on fleek." Work with the natural shape of her face and her browbone. When selecting a color, even if she is grey or white-haired, choose a color that is perhaps a lighter version of her hair color from before she was grey, making sure the undertone of this eyebrow color complements her skin tone. If there are not a lot of eyebrow hairs present, the brow pencil on top of the skin (with its blood vessels reflecting through) can give off a bit of a reddish or orange cast. Keep in mind that a pencil with a cooler tone may actually look totally neutral once applied to the face.

If the actress's skin has begun to sag and the cheekbones are very visible, you can skip contouring all together – it will only make her look more gaunt. Instead, bring life to the face with a warm blush right on the apples of the cheeks and blend this color out softly.

Lips can pose their challenges on older women, as lips lose plumpness with time. You may encounter an actress whose lip shape is not as even as it used to be, so lipliner is a must on your older clients. As lips lose plumpness, the shape isn't always even, so use lipliner to even out shape and check the mirror on your station often to make sure the shape you are creating is symmetrical and natural (not over-done). To avoid feathering (the blending of lip color outwards in to the fine lines around the lips,) you can use a clear, wax liner to fill in those tiny wrinkles and create a barrier around those feathered lip areas. Once I have lined the lips, I fill them in with the liner or with a lipstick that won't budge and I often powder over that to avoid feathering and smudging. Moisturizing lip color formulas make a difference in adding fullness and tend to look better than matte which can make

the lips appear wrinkled and dry. So in the middle of both the top and bottom lip, I'll use a brush to dab a more moisturizing lipstick or even a liquid lipstick or light gloss to bring a little bit of moisture and plumpness to the lip. Again, not too much or it will feather.

Of course, beauty makeup on aging skin does take a great attention to detail, but hopefully when you are done, you will have an actress in your chair who loves the way she looks – and when she has sat in countless makeup chairs throughout a career that spans decades, that's really a compliment!

Grooming

In This Chapter

- **Shaping Facial Hair**
- **Additional Grooming**
- **Skin Care**

The term **grooming** is traditionally used to describe any skincare procedure, makeup application, or facial-hair shaping you may perform on your cis-male clients or actors. You may also find yourself performing grooming techniques on transgender, transitioning, or gender-non-binary actors, so the term is more in reference to the skill-set of styling, shaping, and caring for naturally occurring facial hair which is meant to look intentional. Naturally growing facial hair is probably the most important part of grooming as it can greatly influence the story you are telling with a character. I highly suggest taking some classes or training alongside an experienced barber if you do not know how to properly trim, shave, or style all types of facial hair. Just make sure that in your facial hair shaping process you are staying away from the sideburns and the hairline on the back of the neck – these areas are considered the Hair Department's responsibility. If you have any questions or want to collaborate on a look, speak with your hair stylists.

Shaping Facial Hair

Different facial hair styles will not really be dictated by the preference of your actor (and they may have some very strong preferences) but by the needs of the story and the character they are portraying. There is a saying I remember hearing from a costume design teacher I had in college – "the shorter amount of time a character is on screen, the more of a caricature they have to be." While this does sometimes perpetuate stereotypes or result in unfortunate typecasting, there is an element of our job that consists of playing this game. We can do so as respectfully as possible. If a character is only seen for a brief amount of time, the audience needs to be able to discern right away, "Oh, *THAT'S* the king who's about to die of old age!" Film is a visual medium and we are visual storytellers, creating characters along with the Hair and Costume Departments. If a quite average-looking older man with scruffy facial hair and a T-shirt on *says* "I've been the King of this country for 60 years!" the audience may not be listening at that exact moment or they may simply not believe him. That results in a feeling of unease from the audience – they don't buy into the world of the story. So, it is up to you to tell the story of that king, even if he is only in

the film for 30 seconds. His hands should be impeccably clean. He should be both well-groomed and elderly looking. A reasonable facial-hair choice may be clean-shaven (perhaps he receives a relaxing straight-razor shave from a royal barber each morning), or sporting a vintage facial hair style that he may have worn since his glory days as a young king – though now it has greyed or even whitened with age. As you research, you will become more and more comfortable working with the archetypes that audiences are accustomed to seeing, and you will learn how to tell these stories with facial hair.

Here are a few styles to consider:

Clean-Shaven

Clean-shaven is neutral. It can send the message of "put-together" (it takes time each day for the man to execute it). It may be viewed as preppy. Especially if a young man is between the ages of roughly 18–30, it can certainly have an impact on how old he is perceived – clean-shaven may look more "baby-faced," young and innocent. It is also a more conservative look, appropriate for your businessman or politician characters. As far as law enforcement and government staff like firefighters,

> " *As you research, you will become more and more comfortable working with the archetypes that audiences are accustomed to seeing, and you will learn how to tell these stories with facial hair.* "

military, and police officers are concerned, clean-shaven faces are usually a requirement of the job. There may be slight variations to these rules, so it is worth checking with the local branch of law enforcement where the story takes place to find out what these exact regulations are.

If you have a character that needs to be clean-shaven, it may be a collaborative process with your actor. He may prefer to shave at home (in that case, find out if he is doing so morning or night) or he may prefer to shave in the makeup trailer or his own trailer when he arrives on set. Either way, you will need to make sure his skin is being adequately cared for, especially if he is a regular actor who will need to be shaving every single day. In this case, I try to have actors shave at home before coming to set because shaving in the trailer and then putting makeup

immediately on top of the open pores of a freshly shaved face can result in unnecessary pimples and bumps. If he has thick, dark hair, then he will usually need to shave just before coming to set because if he shaves the night before, a shadow will be visible. He will still have an hour or so between shaving at home and traveling to set, having breakfast, getting into costume, etc. which gives the pores a bit of time to close up so the skin will be less sensitive by the time he sits in your chair. Blondes or men with fine, sparse facial hair *may* be able to get away with shaving the night before. Actors who are transitioning may also shave or use other facial hair removal methods, and these can be highly personal. Discuss respectfully with them, try to understand their routines, and if they want you to facilitate in any way. Again, facial hair removal and shaving on any person is a collaborative process that may involve some trial-and-error.

If the actor chooses to shave in the trailer, do everything you can to make sure they have what they need according to their preferences – this may include a hot towel, shaving cream or gel, the razor itself, aftershave, bump treatment, a towel to dry off with, etc. Then check with the Hair Stylists to see if their routine can be to shave at the sink first, then go to Hair, and then come to you for makeup – these extra few minutes will give the skin more of a chance to calm down after the shave.

As we discussed in Chapter 9 "some people are just prone to red shaving bumps, especially if they have sensitive skin," (Jaliman 161) and especially in those with tightly coiled hair. Make sure that you are prepared with a variety of aftershave and ingrown-hair preventative treatments for all different skin types and hair types.

Your actor may also ask for you to shave their face for them using an electric razor, though if they have medium-to-thick hair this is not my preference because you can't always get a shave as close as you can with water, shaving cream, and a straight razor. If you do so, shave carefully and communicate with him the necessary adjustments such as "tilt your head back," or "keep your lips tightly closed." If you are making small talk, be sure to say "okay, stop speaking for a moment" when you go over the Adam's Apple and neck area as you can risk cutting your actor if there is any movement at all.

Whether you are using an electric shaver or a manual razor, keep in mind that "an ultra-clean razor is essential" (Jaliman 161). If using a manual razor, change

First, dip or spray the electric tool while it is powered on. Then turn it sideways to allow hairs to drip out into a dish for disposal

razor blades often. If using an electric razor, pick up a cleaning solution like Andis Cool Care Plus that can be sprayed onto the shaver or trimmer while it is "on," forcing hair to flow out from the sides of the blades. I also like Gabel's Cosmetics Dip-N-Clip, which can be poured into a dish. The electric shaver blades are inserted into the liquid and the tool is turned on, allowing the tiny hairs to shake loose from the blades in the cleaning solution. Both products disinfect your razor blades and lubricate them as well.

It is quite common that you will have to clean-shave an actor. If he has any more than two or three days growth (especially if he has dense hair) I will start with an electric trimmer (pictured here is the Wahl Peanut) to take the length down first. If you start trying to clean-shave when he already has scruff, you can easily tug the hairs, cut his skin, or cause ingrowns.

To get the most even shave, turn the trimmers several directions. Coordinate with your Hair Department about where you want the end of the sideburn to be.

Have him lift his chin and make sure he doesn't speak as you go over the neck and Adam's Apple area. Hair tends to grow in many different directions in this area so you may have to go against the direction of hair growth, turning the trimmer to several different angles.

Have him stretch his lips as you shave the mustache and soul-patch areas.

Once you have refined the overall length to stubble using a trimmer, you can send him to the sink to shave with a razor and shaving cream, or if you don't have access to running water, you will want to get the shave extra clean with a single-blade electric razor such as the Philips Norelco OneBlade (pictured here).

You will achieve the closest, most precise shave by using your non-dominant hand to pull and stretch the skin opposite the razor's movements. This is especially helpful on men with tightly curled beards as the hairs can tend to dip back down towards the skin. Creating this tension is actually more comfortable for the actor as well because it places less of a "pull" on the hairs themselves. Dragging the blade firmly against the skin, against the direction of hair growth will achieve the closest shave.

Clean up the mustache area.

Finish by wiping little excess hairs off with a clean towel, and misting or wiping aftershave or toner on the skin.

Grooming 189

Mustaches

Mustaches may not be an appropriate character choice for every character, but there are times when they are absolutely the perfect statement. There are certain eras throughout history when mustaches were en vogue or were used to determine class. There were indeed decades where it was frowned-upon to *not* wear a mustache. In recent years, mustaches have become associated with particular stereotypes such as the "hipster" mustache. Mustaches may be associated with certain celebrities from the past and evoke their demeanor. If you want your character to have a similar vibe to one of these characters, you could try a similar mustache style, as this facial hair choice is already part of the collective consciousness of many viewers.

The way a character cares for his mustache (or not) is a character statement in itself.

Does he keep it to a clean line above the lip, or is it long and unruly? Does he trim the mustache himself or does he frequently visit a barber? Does he use product such as mustache wax to create a style, or allow it to become bushy?

As the designer, you will want to make sure that you do your research well and choose a mustache style thatis character appropriate – both in regards to the time period and the level of fastidiousness with which the mustache is kept.

These same principles go for other groomed facial hair such as side-burns, "chin straps," "soul patches," and goatees. Each style has a time and a place – choose wisely and you will create a very convincing character!

Stubble or Scruff, Up To Ten-Days' Growth

I consider **scruff** to be anywhere from one day's worth of light stubble to up to ten-days' growth – before reaching the point of a full beard. There are many periods throughout history in which it was socially unacceptable for a man to have "scruff" on his face unless he truly had been living in the woods for a

week, stranded on a boat, crossing the desert, etc. Because of these associations, although it is now a socially acceptable style, it still does have a bit of an edge. It may be viewed as ruggedly sexy, or it could skew towards messy and unkempt. A lot of that distinction will have to come from the script and the actor. You can tell a bit of a story with scruffiness. For example, an investment banker who has been clean-shaven for the entire film, stops taking care of himself and appears "scruffy" in a few scenes after his wife has left him. When he's ready to start dating again, he cleans up and goes out on a blind date – clean-shaven. It's a bit of a cliché but it is quite effective at telling the visual story to your audience.

Especially in a contemporary project, your actor may want to keep the scruff he comes in with or it may be suggested that he grow a bit. The scruffy style has, in recent years, become more and more popular and is even becoming acceptable in business situations – especially when the neck is well-groomed. If this is the case you need to be very careful as the makeup artist.

On the actor's first day, you'll want to go over the scruff with clippers and a guard that you think is close to its length. Guards often come in up to eight different

"As the designer, you will want to make sure that you do your research well and choose a mustache style that is character appropriate – both in regards to the time period and the level of fastidiousness with which the mustache is kept."

Grooming 191

lengths, but the most common ones you will use are numbers 1–4.

Using the guard, carefully shave the actor's face so all scruff becomes one even length. Then make a note for yourself, either for his set bag or on his continuity photo, what guard length his facial hair is at. I have made the mistake of not doing this and when you need to recreate the length throughout the shoot, you run into trouble because you don't know how long it was the first time it was established. You may try to eyeball it but it will take much longer and any error will result in flawed continuity. This process should be repeated every 2–3 days depending on how quickly the actor's facial hair grows. If the character is meant to be more of a scruffy, sexy, city guy you will likely want to take an electric trimmer and line up the neck under the beard as well as the cheeks and mustache so they still look natural, but cleaner. These small adjustments can make a huge difference.

And of course, if he's a guy who has been lost in a desert for one week, this clean-up step likely won't be necessary. The messiness will tell your story.

Beards (Groomed)

A well-kept beard can be a powerful character choice and can also greatly alter the facial structure of your actor.

Beards sometimes convey certain time periods as can any goatee, sideburn, or "chinstrap" styles. They can also distinguish profession or class distinction, depending on the location where the story is set. Do your research thoroughly.

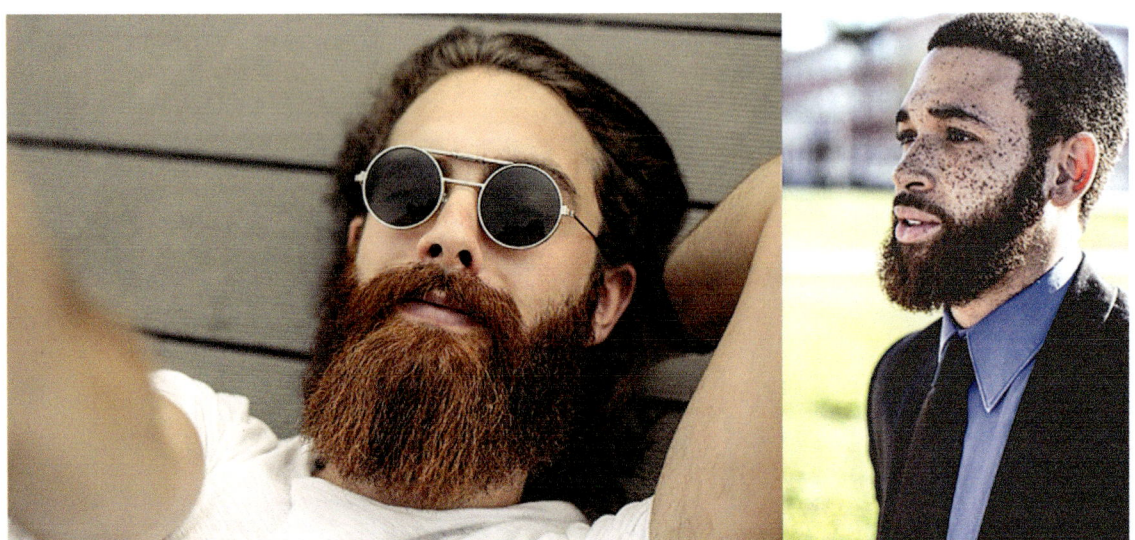

Beards considered to be well-groomed are shaped into one, cohesive weight line around the perimeter, have a clean-shaved neckline and cheekline, and feature a mustache trimmed evenly across the upper lip

192　Technique

"Beards first emerge after puberty and thus also indicate sexual maturity," writes Daniel McNeill in *The Face: A Natural History*.

> *They may send a stronger message. Psychologists Frank Muscarella and Michael Cunningham suggest they proclaim a man's aggressiveness, and thus aid his reproductive success. Since the signal is vaguely unsettling, some cultures suppress it. They can come to view the beard as vile and compelling, a fascinating beast-mark, as in cowboy melodramas of the fifties. The two scientists propose that beards enlarge the apparent size of the jaw, triggering a response left over from the days when our teeth were weapons. They do bolster "weak" chins and recontour double ones. Yet they kit a slightly different note than large chins, more feral and mysterious. Beards may also work by suggesting the chin-jut, a threat among both humans and chimps*
>
> (73).

Another important element of groomed beards is that they can greatly alter the shape of the actor's face – something that could be considered an advantage or a disadvantage depending on the situation. Consider the perimeter of the beard – the shape of this essentially becomes the bottom border of the face. If you have a man who has a naturally weak jawline in the chair, you can trim the end of his beard into a very angular or squared-off shape, thus mimicking the effect of a strong jawline. Traditionally, defined jawlines are considered more "masculine." The opposite is also true – if you have a man with a very square jawline and you round the bottom of his beard, it can make him look generally rounder – perhaps chubbier, and sometimes even older.

The sides and edges of the beard are equally important. Keep in mind that the edges of the beard have a similar role to the cheekbones. If you want to emphasize a smile and enhance angularity and "manliness" of the face, shape these lines in a downward angle, towards the mouth. This can also thin out a round face. If you round these lines, however, it will create the illusion of a wider, rounder face. Make sure you confirm that cleaning up the sides of the face at all fits with the character, or if it's better to leave a bit of stubble above the beard.

Once the beard is trimmed to your liking, it is a good idea to apply some beard moisturizer – either an oil or balm to keep the hairs looking nice. This can be brushed through or patted on with your fingers. Mustache wax can also be used to comb the mustache area into place once the mustache has been trimmed above the lip. Stray beard and mustache hairs are surprisingly noticeable in HD close-ups on the big screen, so make sure the facial hair style is well-groomed if that is what fits for the character.

Beards (Natural)

A natural, un-groomed beard also sends a strong message, though a much different one. Beards that are not well-groomed tell a story of their own and may be associated with certain stock characters, such as wizards, bikers, or homeless characters. Keep in mind, beards and other facial hair styles may also have religious or cultural connotations. Make sure you do your research to accurately and respectfully depict these facial hair styles.

Behind the scenes, even beards meant to look scraggly on-screen may still need some grooming. Beard oil will moisturize and a light pomade can be used to tame strays if they are catching the light and distracting on camera. If your actor keeps his beard long regularly, he likely knows how to maintain it, but make sure that you are in charge of trimming it and schedule this into your time with him every two weeks or so. If it fits the story, the beard should stay the same length all the time, even if you are shooting over a six-month period. If you have a character who requires a long beard but the actor does not have one, check out Chapter 17, "Applying Facial Hair" for several techniques on how to add hair to create this effect.

Additional Grooming

In a basic grooming process, you must also be certain to check the ears and nose for hair, and to check the eyebrows for hairs that may be extra-long and unruly. These hairs can catch the light and glimmer on screen, becoming very distracting especially in a close-up. Grooming will also require you to take a look at the

Invest in a nose and ear hair trimmer for grooming your actors. This is also great to bring to set in your set bag – just in case

hands of your actor, possibly trimming stray hangnails and offering him hand lotion or cuticle balm if his hands are not well-kept.

If you are working with stunt doubles, it is crucial to match the facial hair style of the double to that of the actor, because stunt doubles are often seen from far away or from the back. The facial hair silhouette can be incredibly important. This includes the hairline on the back of the neck and any stubble on the side of the face as well. If everyone is doing their job properly, you will never see stunt-doubles' faces straight on. However, seeing backs of heads or sides of faces, hands, and even arms is quite common – especially because their bodies will likely be in motion and may be flipping around the frame in dynamic ways.

I once had an actor who had very fine, straight, black hair on his arms. His stunt double had long, curly blond arm hair. Both men were completely bald

and had a similar skin tone, but when the double got into the frame, it turned out that he was being filmed from behind, being shot and killed. When the gunshot impacted him, he threw his arms up in the air and fell out of frame. As his arm came towards camera it was *incredibly* obvious that he had a halo of fuzzy blond arm hair and was not the same man. However quick the edit is, a mistake like this can completely ruin the illusion of a stunt for the audience. I had to take a moment on set to trim down the stunt double's arm hair with electric clippers, use a little mascara to make it look black, and slick it down flat against his arm with hair pomade to make it look straight. It was a quick job and it worked, but I *wish* I had done it properly in the trailer! When it comes to grooming and matching stunt doubles, you can truly never be too careful.

Skin Care

Any facial hair shaping is always my first step with an actor who grows facial hair because if you do need to trim or shave anything, you can then clean the skin of little cut hairs before applying makeup. Once that step is taken care of, the next thing you will do will be his skincare routine. Complete your consultation with the actor and find out everything you can about his skin type and current routine.

A complete, clean, groomed look with hydrated and color-corrected skin

Grooming 195

Then, to create a basic HD look, perform the following steps:

1. Hydrate the skin with a moisturizer appropriate to his skin type (this includes any other skin treatments you may use for the particular actor such as aftershave, eye cream, etc.)
2. Apply sunscreen if shooting outside – including on the arms, ears, and back of neck
3. Prime the skin if appropriate – oil control primer if he tends to get shiny
4. Conceal blemishes, discolorations, or scars – or enhance them depending on his character!
5. Lip balm (SPF lip balm if appropriate)
6. Light wash of foundation or tinted moisturizer
7. Set with powder
8. Fill in brows (only the bald spots if he has any – make sure the brows still look natural) and comb hairs down with a clear or tinted brow gel
9. Cover tattoos if necessary
10. If applicable, you can use a matte bronzer or a contour powder to define his cheeks and jawline a bit more or to warm up the face so it doesn't look like one solid color
11. If he is a recurring character, learn about his preferences and add necessary products such as hand lotion, floss picks, mints, etc. to his actor bag

12

Beauty Makeup

In This Chapter

- Beauty Makeup I: Focus on Correcting Imperfections and Creating Symmetry
- Beauty Makeup II: Focus on Contouring and Highlighting of Features
- Adding Drama to the Face

Beauty Makeup I: Focus on Correcting Imperfections and Creating symmetry

> **"The ideal face of all cultures may change dramatically, however the underlying principles are usually the same."**

From its conception, beauty makeup has served the purpose to "beautify" based on certain cultural standards for the ideal face. The ideal face of all cultures may change dramatically, however the underlying principles are usually the same. Overall, symmetry is favored. Every human has a degree of asymmetry to the face, and this is what keeps our faces looking natural rather than robotic and frightening. However, as makeup artists, we strive to correct glaring asymmetries for the reason that they may distract from the "expression-making" centers of the face – the mouth and eyes.

Drawing attention to the mouth and eyes also became the reason for **highlighting** and **contouring**.

Have you ever noticed how contouring the cheekbone creates a diagonal line pointing towards the mouth? Or how creating a highlight above the browbone makes the eyes appear bigger and emphasizes them? These are the effects we are constantly trying to achieve, though of course the trends may change.

We also correct "imperfections," such as acne and skin issues because these are also considered an unconscious distraction from these expression centers. On screen, unless they are meant to look ill, aged, or homeless, the majority of cis female and female-identifying characters wear makeup – even if that is just

a "**corrective makeup**," to smooth out their skin and enhance their natural features.

Make sure whatever look you have designed fits the character. Stay current with new products and trends so that if she is someone who cares about fashion and appearance, their look can be as modern as it needs to be.

Here you will see two examples of a simple beauty look, including "corrective makeup" for imperfections, on two different skin tones and types.

When Ashley came in for her photoshoot, she was experiencing a breakout and resulting hyperpigmentation. This is quite common, but of course, since reading all about skin science and skincare in Chapter 9, you are prepared to deal with any skin concern!

Moisturize skin with a product appropriate to the actor's skin type. For Ashley's blemish-prone skin, we used a lightweight, oil-free moisturizer.

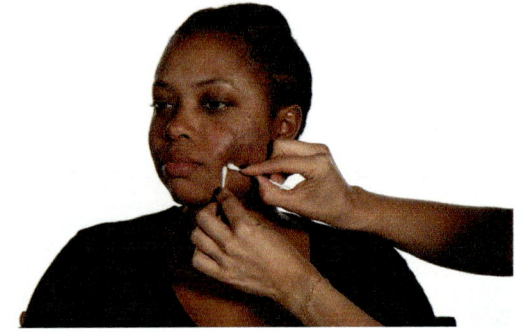

Blemishes can become continuity issues on screen. Generally, we attempt to treat an actor's skin with skincare products without picking at it or flaring it up more. However, if a large whitehead is present on a pimple, it *may* be safer to extract it when the actor is in the chair, then have it pop on set or become a continuity issue in the scene. To do this, apply a warm washcloth to the area first. Sanitize your hands and then apply alcohol to sanitize the skin area. Carefully apply pressure downward (not inward side-to-side) on either side of the whitehead. If it is ready, it should extract easily with just gentle pressure. If it does not right away, leave it alone to avoid inflaming the infection even more.

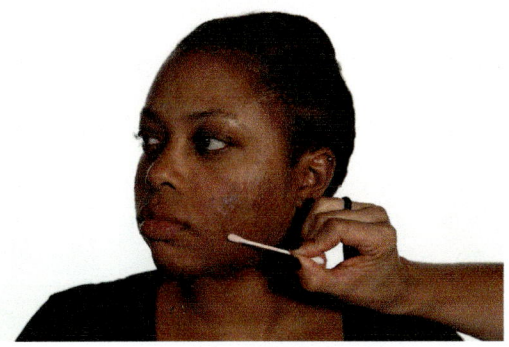
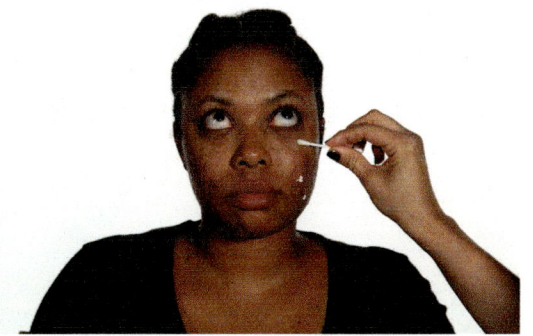

Apply a drying lotion with alcohol in it, such as Mario Badescu Drying Lotion, which will dry and disinfect the area. If the pimple is oozing, applying powdered zinc oxide will also help dry it up. Then leave it alone and allow the drying lotion some time to work on the pimple before applying make-up. If a large break is in the skin – whether you created it with an extraction, or the actor arrived with it – you can apply a bit of Liquid Bandage to the area, although keep in mind that any makeup applied over Liquid Bandage will also disappear once the Liquid Bandage peels off.

Apply an eye cream appropriate to the eye concern – in Ashley's case, I used a de-puffing eye cream which contains caffeine, reducing the appearance of a bag under the eye. Dark circles come from "ruptured capillaries in the delicate layer of skin above the bones surrounding the eye sockets" (Borba 137) and caffeine can help constrict these blood vessels. After eye cream, apply lip balm – I like to do this early on as part of the skincare routine so the product has time to soak into the lips, before we add our lipstick or lipgloss.

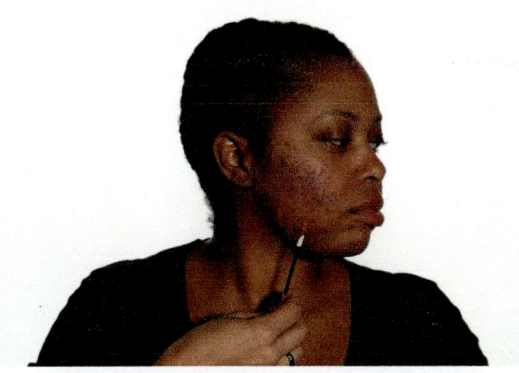
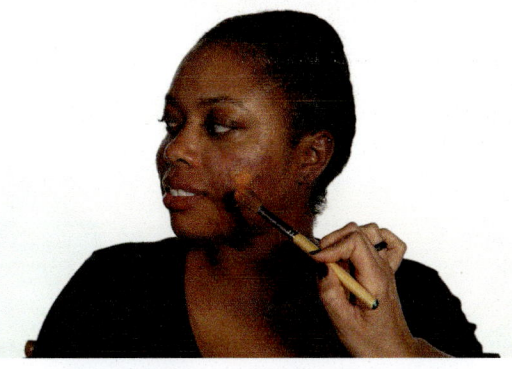

Shade match by testing three colors of foundation on the jawline as shown in Chapter 10.

Conceal blemishes or imperfections as necessary. For Ashley, I used a full-coverage cream concealer, stippled on.

Beauty Makeup

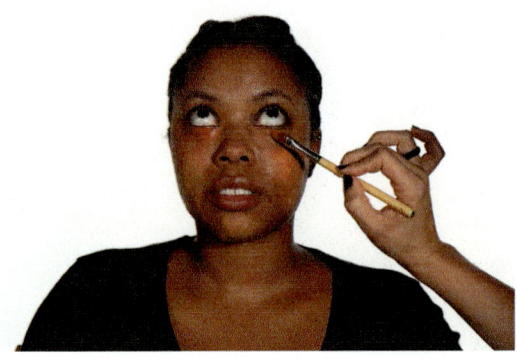

Color correct under the eye area and around nose as necessary. I used a peachy color-corrector here to combat any purple undertones beneath Ashley's eyes.

Highlight high points of the face using a cream one shade lighter than the model's skin tone. There are many types of highlight/contour procedures. On film, it is generally advisable to use matte products that are simply lighter or darker shades than the skin tone – any product with a shimmer to it may reflect the light strangely. This is only appropriate for certain time periods and certain specific characters. Notice how the areas with the light cream (especially above the brows, nose, and chin) appear to come forward towards the camera.

Apply foundation, starting at the jawline and using a circular buffing motion. If you encounter areas of acne, flaking skin, switch to a stippling motion to achieve fuller coverage.

Contour using a cream one shade darker than the model's skin tone. You'll notice a line of demarcation between the two colors below the cheekbone and towards the ear.

Blend, blend, blend! No lines of demarcation should be visible. You may blend into the neck, ears, and hairline as well for the most natural look.

Set foundation with a tinted powder, making sure to set under eyes to avoid creasing of concealer.

Since Ashley has a rounder face, I really wanted to define her cheekbone – I went back in with a powder one shade darker than her skin tone to enhance her contour.

Apply a matte blush. Since Ashley was breaking out, I avoided any shimmery products on her face because shimmer enhances texture and I did not want to highlight any unevenness in the skin.

Prime the eyelid with eyeshadow primer. Then apply eyeshadow in neutral tones, within the same family as the skin tones, with a lighter shade on the browbone. On her eyelid, I added some shimmer to pop her eyes.

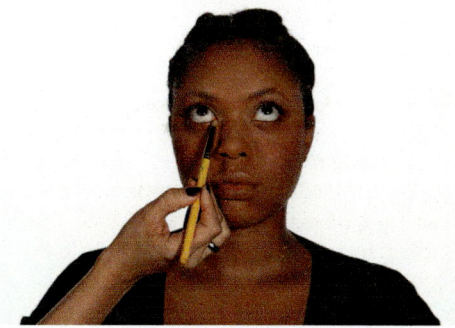

If a model has a bit of a puff under the eye, you can use what is called a "drop shadow," – a natural-looking, well blended matte eye shadow in a color a bit deeper than the model's skin tone. Applied right along the "puff" area, this creates an optical illusion, causing the bag to recede and helping the eye look more defined.

Beauty Makeup

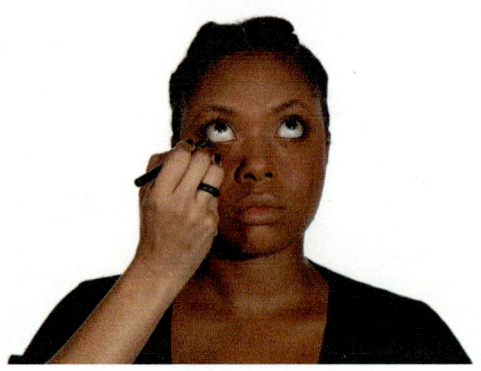

To further define and blend this shadow, I lined Ashley's waterline with black eye pencil.

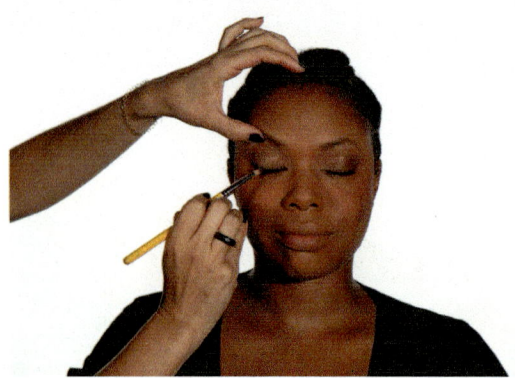

Apply liner to the top eyelid in black, brown, burgundy, or another neutral tone, depending on your model's hair color. In this case, I used a black pencil smudged right into the lashline, and then set it by blending a black powder over the liner. Add mascara to top and bottom lashes to finish eye look.

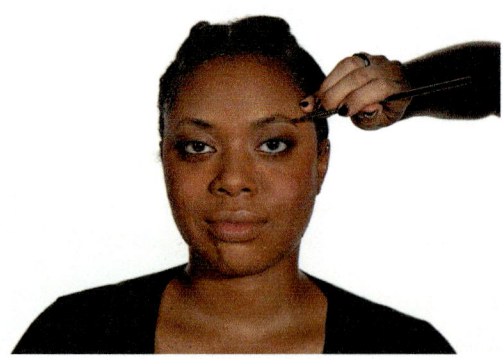

Fill in eyebrows. Ashley's brows are naturally sparse and I wanted them to look more dramatic. So I combed them with a mascara wand, and then used Anastasia Beverly Hills Dipbrow Pomade and an angled brush. I like to begin by underlining the eyebrow, even if there is no hair in the area. Then, create a wedge-shaped tail at the outer end of the brow.

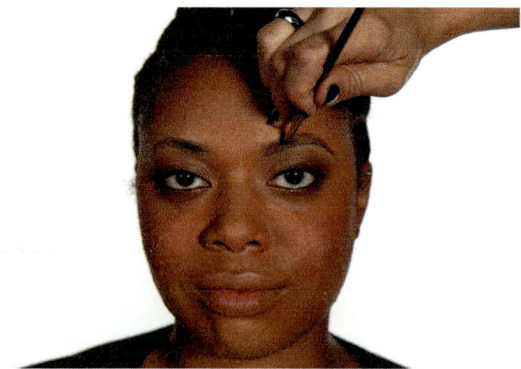

Once the outline of the brow is created, you may fill in hair-stroke shaped lines, in the direction of hair growth – only in the areas where there is no hair. You generally do not need to go over and color in the area where there *is* hair, because it is already defined. Doing so can create a brow that looks too dark and bold. Notice the difference in how much the brow defines the entire eye area, drawing attention to the eyes and framing them in the orbit area.

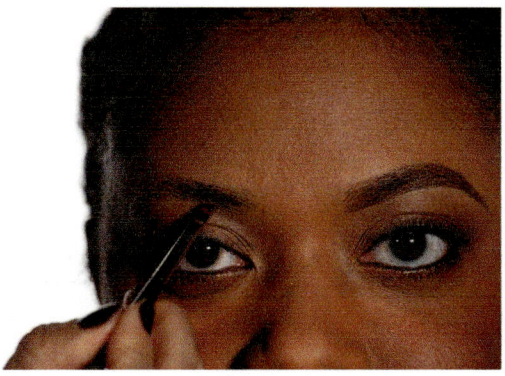

I start my underline a little bit inwards from the center of the brow, then I will go back to the center and even out both sides carefully once there is a little less product on the brush.

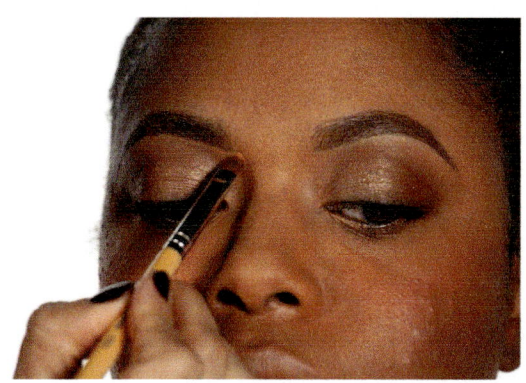

If you make any mistakes, use concealer on a small, flat brush to define the edges of the brow. Outlining the entire brow with concealer can also give a more dramatic effect, but keep in mind that it is not appropriate for every character.

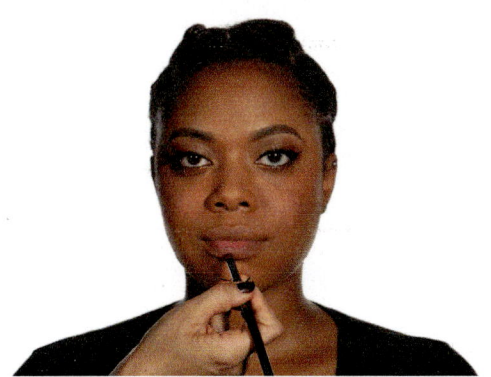

I finished Ashley's look with a neutral, plum-toned liquid lipstick, applied with a brush, and a winged eyeliner (close-ups and tutorial in the last section of this chapter.)

The completed look!

Beauty Makeup

Beauty Makeup II: Focus on Contouring and Highlighting of Features

Casey's skin type is combination, with slight oiliness in the T-zone and slight dryness on the cheeks. Her skin is typically not blemish-prone. It has redness and broken capillaries around the middle of the face, which many fair-skinned people are prone to.

First, shade match by testing different shades on the jawline as detailed in Chapter 10. Then, apply a moisturizer appropriate to the actor's skin type.

Color correct if necessary – in this makeup, I used a green color corrector to neutralize redness around the nose.

Apply a foundation primer using a sponge or brush.

206 Technique

Conceal dark circles, hyperpigmentation, and blemishes.

Apply foundation, starting at the jawline and buffing in a circular motion. The first place you touch the brush to the face is the place you will have the most product payoff, so starting on the jawline helps blend and conceal any potential mistakes, and avoids dense, cakey foundation right in the middle of the face.

After you've applied your foundation, the skin tone should be even, but it may look flat, so at this point we add definition and color back into the face. You may wish to contour the face with a cream two shades darker than the skin tone to define certain features or create more symmetry. When enhancing cheekbones, I like to think about drawing the number "3," starting at the forehead, scooping beneath the cheekbone, and then rounding underneath the face to define the jaw.

Blend your contour into the foundation. You can enhance the contoured areas with a contour powder or a matte bronzer. Blend these well into the ears and neck and beneath the jawline. Notice how the contoured areas visibly recede.

Beauty Makeup

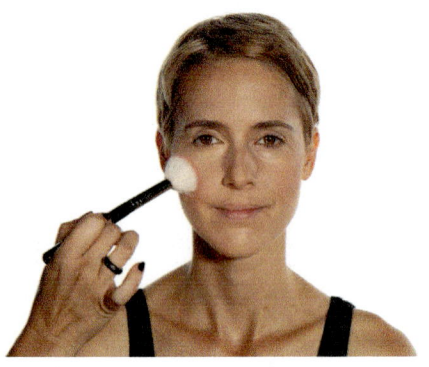

Apply a blusher to the apples of the cheek for a natural flush of color in the face.

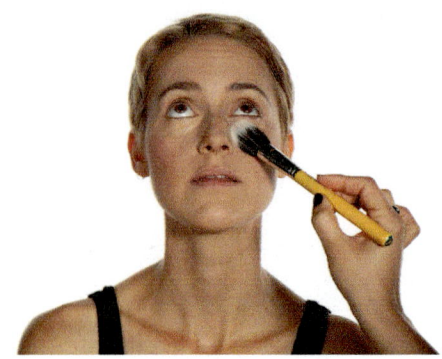

Apply a setting powder, focusing especially on the T-zone, which often becomes shiny, and under the eyes – which often crease due to wrinkles in the skin.

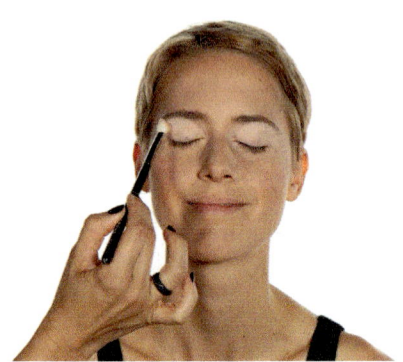

Apply an eyeshadow primer with a flat brush. Then, use a fluffy brush to apply a neutral base shadow to the entire eyelid area and up to the browbone.

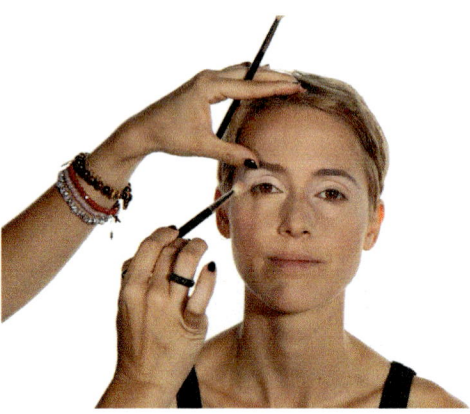

Blend eyeshadows with a clean, fluffy brush to preserve a natural appearance.

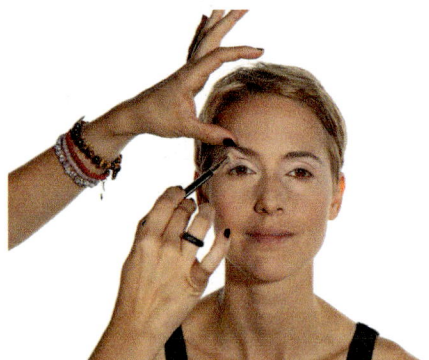

Apply a deeper neutral tone to contour the eyeball and enhance the eye area. I like to do this with the model's eyes open so I can see where I want the shadow of the crease to be.

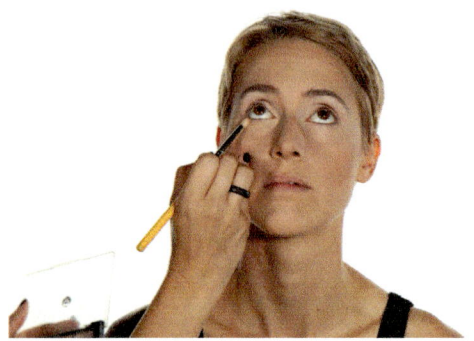

Smudge this same neutral eyeshadow under the eye to create subtle definition along the lower lashline.

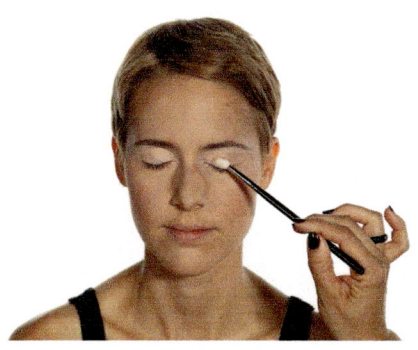

Blend the eyelids and crease with a fluffy brush for a natural look.

Comb brow gel into the eyebrows using a disposable mascara wand – this can be clear or tinted depending on how much of a dramatic look you want

Using a neutral color such as brown, grey, burgundy, or black (depending on the model's skin tone and hair color) smudge eyeliner right along the lashline. Soften and set this eyeliner using a small brush and a neutral eyeshadow.

Fill in eyebrows. Pencil, powder, and gel liner will all give you different looks so experiment with each. You do not need to fill in areas where the model already has hair – it's more about creating definition by adding color to the empty or sparse areas.

Underlining the brow, as pictured here, gives a more dramatic look, while simply creating tiny hair strokes with a pencil would offer a more natural appearance.

Beauty Makeup 209

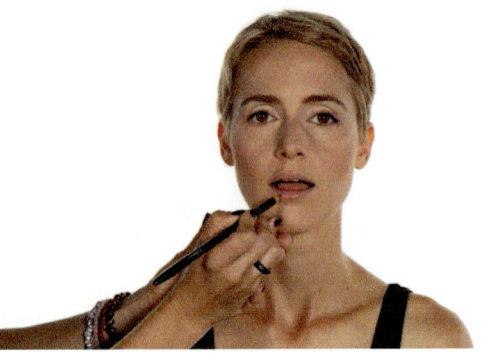

Apply black or dark brown (depending on your model's hair color) mascara to the tops and bottom of the lashes.

If your model's eyelashes point straight out or are down-turned, you may wish to curl the lashes (or have her curl her own lashes) with a sanitized eyelash curler first.

Apply a natural-colored lipliner to even out lip shape (note lipliner goes on the most smoothly and creates the most defined line when it is applied *before* lip balm).

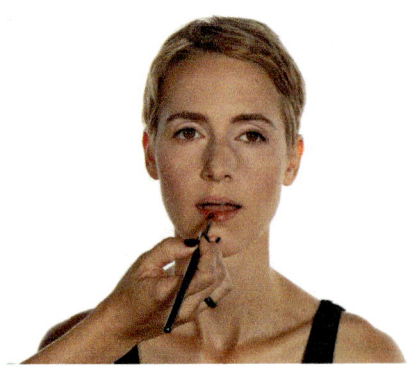

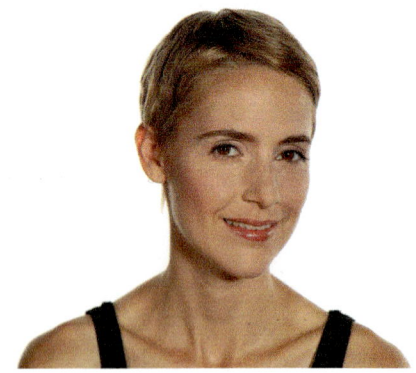

Apply a neutral lip color with a brush or disposable applicator.

Mist the face with a setting spray, and your look is complete! This kind of basic look can be adjusted based on the character's age, coloring, profession, economic status, etc! Remember that you are telling the story through the makeup.

Adding Drama to the Face

You may encounter a scene when your character who usually wears more natural makeup attends a party or needs to have a more "dressed up" makeup look for some reason. This can be achieved by simply adding a few changes to your existing natural beauty look.

Lips

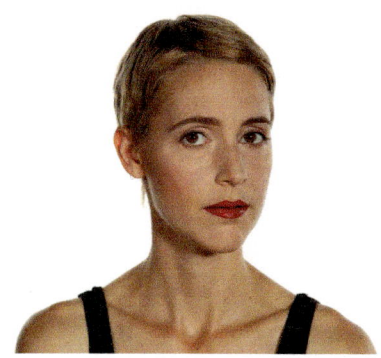

Adding a bolder, darker, or brighter lipcolor than your character typically wears can be a quick and simple way to achieve this. It can be fun to base this color choice off of the wardrobe or other design elements.

I always begin with a lipliner, then fill in the lips with the liner for added staying power, then apply a lipstick with a brush. Using a brush will give you precision, especially with bold colors. Once on set, you may touch up more often with a disposable doe-foot applicator if the precise edge of the lip-line has stayed in place. For a semi-matte lip you may also wish to set with translucent powder.

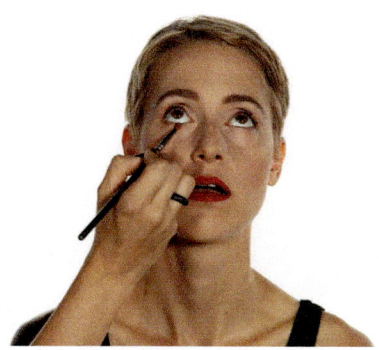

Enhancing the eyes with a more bold eye shadow is another great way to add drama to your look. You may find just adding a tiny bit of shadow to the corners of the eyes balances out a bold lip and prevents the eyes from getting "lost."

Remember, once your character's "dramatic" look is complete, make sure to take continuity photos and mark the scene number, the script day – and you may want to add a note such as "date night look."

Beauty Makeup

False Lashes

False lashes, when applied delicately, can be a great way to open up the eye area and emphasize the eyes. They come in all different variations of shapes and lengths for different effects. The two main types typically used on set are:

1. **"Individuals"** – a small cluster of hairs held together by a small dot of glue

2. **"Strip Lashes"** – a full strip of lashes curved and designed to hug the lashline

(Image placed vertically to allow for better visibility.)

Adhesives also come in many variations, including clear, dark-tinted, and latex-free. It is a good idea to have each of these different options in your kit, as different people and different effects call for different types of glue.

Individual Lashes

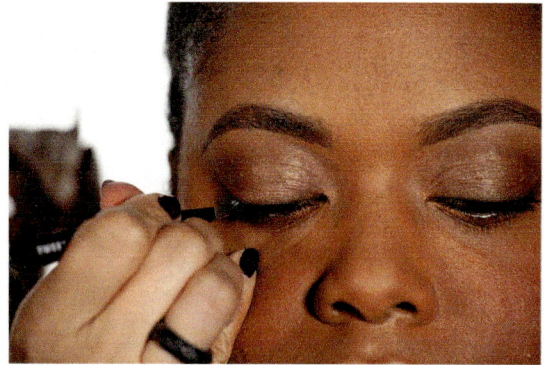 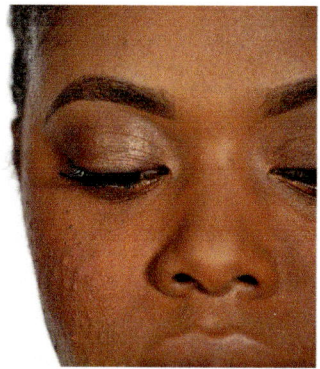

When applying individual lashes, squeeze some glue out of the tube and onto your mixing palette.

Using tweezers, gently select a lash from the package and dip the end of it into the glue.

Hold the lash out for about 20–30 seconds to give the glue a chance to dry and get tacky.

Have the model look down, and apply the lash cluster to their natural lashline – allowing the glue to nestle right between their natural lashes.

Encourage your model to keep their eyes as still as possible by finding a place on the floor and continuing to look down.

You may need to gently balance your hand by carefully resting the end of your pinky finger on the model's face. Do not rest any other parts of your hand on the face.

Continue to add lash clusters with your tweezers. Lashes placed close together will give a more dramatic effect and a more dense lashline.

Lash clusters spread out more will appear more natural.

Make sure the lashes are all turned the same way and are in line with the actor's natural lashes.

Allow the lash glue to dry fully before letting the model move their eyes around.

Strip Lashes

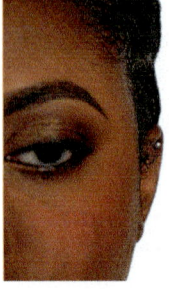

Gently remove the strip lash from the package using tweezers.

Before applying any glue, hold the strip up to the model's eye to check the fit – you may need to trim the *outer* edge of the strip off to fit the eye area if their eyes are on the smaller side. Always cut the outer, more flared edge – not the small lashes meant to sit in the inside corner of the eye to maintain a natural look.

Hold the lash in your non-dominant hand with tweezers. Squeeze glue onto your palette and then, using a disposable applicator, apply glue evenly to the strip.

Allow the glue to set for at least 30 seconds before applying to the eye – this drying time is crucial as it helps achieve a quick, smooth application of the lash, without smudging all around on wet glue.

Ask your model to look down – do not have them close their eye. This maintains the natural fold of the eyelid skin (rather than the skin crumpling up as the eye closes) and helps you ensure you are not gluing their top lashes to their bottom lashes.

Holding one end of the lash strip with clean fingers and the other end with tweezers, apply the lash to the top of the lashline, lining it right up to where the lashes grow out of the lid.

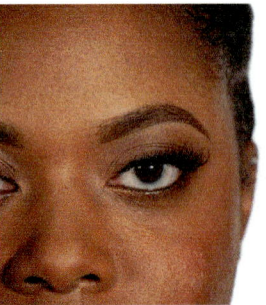

Line the edges of the strip up with the corners of the eye and gently press the glue into the lashline for firm adhesion.

You'll notice for this application, I chose the dark-toned glue, which goes on grey and dries down black because the model is wearing eyeliner and has dense, black lashes naturally. The dark-tone glue gives a natural definition to the eyeline. Clear glue is also versatile and appropriate for any character. Once the glue is dry, you may use clean fingers to pinch the natural lashes and the false lashes together, ensuring there is no division and they look natural.

You may need to smooth out the eyeliner on top of the eye to blend the appearance of the false lash into the natural lash.

Then you are done! Note the flare end of the lashes give drama and lift to the eye.

214 Technique

Winged Liner

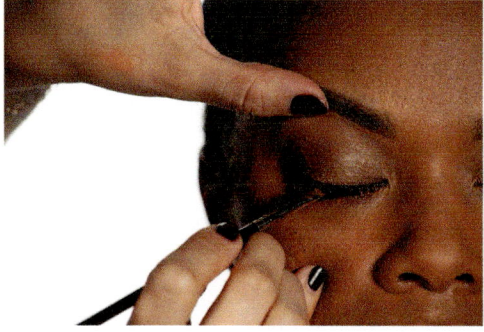 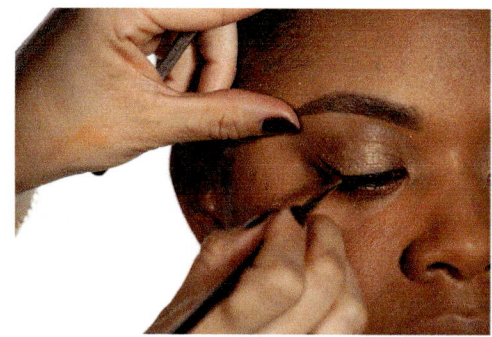

Defined winged liner, or "cat eyes," is appropriate for certain characters or time periods, and can be a fun way to add drama to your eye makeup design. As with any makeup product, the first time you touch the brush to the skin, the most product payoff will occur. For that reason, start your cat eye look in the middle of the eye, and then blend towards the inner corner (rather than starting directly in the outer corner).

Using your angled brush and a gel liner, create the "wing" flicked out over the corner of the eyelid. I have my actors keep their eyes open during this step because that will help you determine the angle at which you want the wing to show.

You may wish to very gently lift the eyebrow up with one finger from your opposite hand. This can help tighten the eyelid and give you a more precise application. Be careful not to pull the lid or surrounding skin out to the side as this can actually distort the shape of the wing.

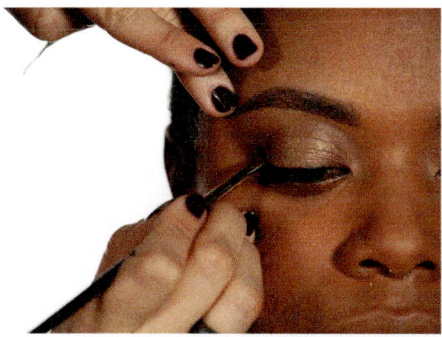 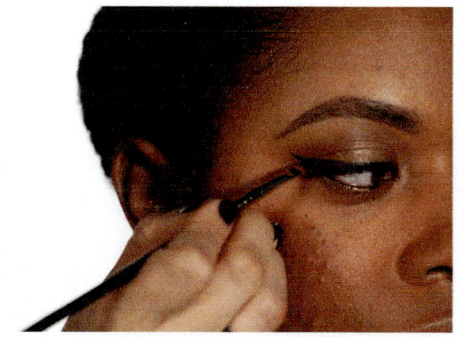

Connect the bottom portion of the winged liner into a pointed wedge shape at the edge of the eye. You can perform this procedure with any gel or liquid eyeliner.

Smooth out the bottom of the wedge shape so it looks clean and defined. If you make a mistake, you can use concealer and a small flat brush to touch up the shape of the point.

Beauty Makeup

13

"Out-of-Kit" Special Effects

In This Chapter

- **Bloody Nose**
- **Black Eye**
- **Split Lip**
- **Bloody Knuckles**
- **Road Rash**

Special effects makeup is an exciting storytelling tool. If the audience witnessed a character wipe out on a motorcycle and then get punched in the face, but then he got up and walked away with no scrapes, no redness, no blood, the audience probably wouldn't believe that he had been injured at all. Our job becomes incredibly important in showing the direct aftermath of countless different incidents.

The term **Out-of-Kit** when referring to special effects makeup pertains to anything that you should typically keep in your makeup kit and be able to apply on set for a specific effect. Prosthetics and masks typically have to be planned out and molded in the shop ahead of time, but for a few simple special effects, you should be ready to apply them straight out of your kit. Examples of Out-of-Kit effects would be a bloody nose, a black eye, a split lip, bloody knuckles, road rash, and simple cuts and scrapes. These may result from any variety of illness or injury. It is important to research the anatomy of these wounds from reliable sources such as medical or forensic journals and to be aware of the healing process.

Equally important in creating your effects on set, is collaborating with your Stunt Department. After reading the script, you'll want to talk to the Stunt Coordinator about the choreography of the scene. If the injury results from a fall, make sure you know which side of the body the actor is falling on, how they plan to brace themselves, and what type of surface they are falling onto. If the wound results from a fight, try to see a video of the rehearsal – if this option isn't available, ask lots of questions. You will need to know the approximate heights of everyone involved and the specifics of the wound (for example: "With which knee is he going to be kneeing him in the face?" or "Is the person throwing the punch right-handed or left-handed?") If there is a weapon involved, ask Stunts or Props if you can see it before creating the wound itself.

For effects that involve large amounts of blood spill, you must collaborate with other departments as well. Squibs and blood coming out of people or clothes is generally a task of the Special Effects Department, not the Makeup Department.

> **Special effects makeup is an exciting storytelling tool.**

A good rule of thumb is this:

Blood on clothes: Costume Department

Blood on the ground or furniture: Art Department

Blood squirting profusely from somewhere: Special Effects Department

Blood on skin: Makeup Department

Whatever the situation, when it comes to effects, as much communication as possible is key.

Bloody Nose

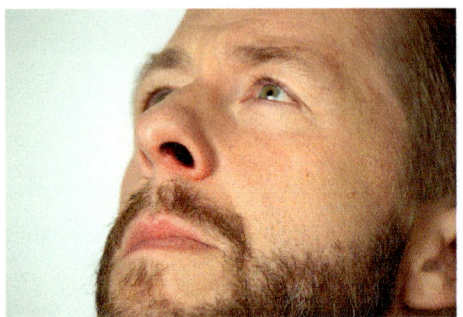

Using Skin Illustrator or another alcohol-based paint, color the inside of the nostril with a dark red. Warn your actor that they may smell the fumes from the alcohol.

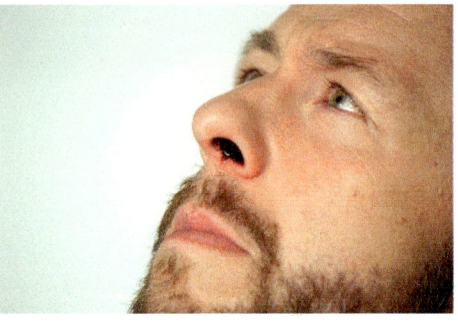

Apply a thick jam or scab blood, such as Ben Nye Fresh Scab up into the nostril using a cotton swab. I warn my actors that this "may feel like a big booger."

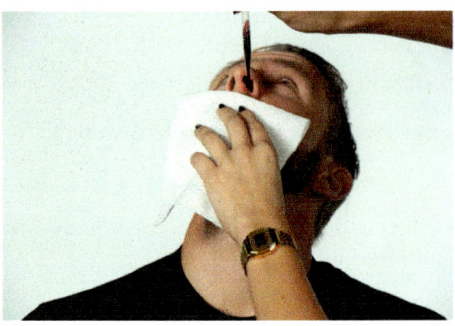

Ask the actor to tilt their head back slightly and apply a liquid flowing blood into the nostril. If you want the blood to be dripping out of the nose as the camera is rolling, you will need to make sure you apply the blood at the last minute. I typically coordinate with the AD so I can place the blood as the 2nd AC is slating, then I step out of the frame and the camera is already rolling as the blood drips.

Allow the liquid blood to drip out of the nostril. Make sure that this is happening in correspondence with the blocking. This blood is placed so that gravity allows it to drip straight downwards, as if the actor were standing or sitting upright. But if your character is lying on the ground, for example, you will want them in place before you apply your blood – that way, the drip will be going in the proper direction in accordance with gravity.

If it is supported by the scene, it can be a nice effect to have the actor wipe their own nose and see the smudged blood on the side of the face. They will also then have the dried blood on their hands which could be realistic based on the action of the scene. Make sure you take a continuity photo of any blood on the hands as well.

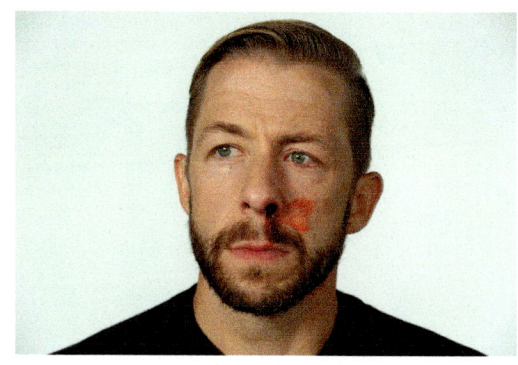

A fresh bloody nose (if it happened within the last few minutes of the story) does not need any "swelling" around the nostril or the nose because the blood vessels would not have had time to become inflamed yet.

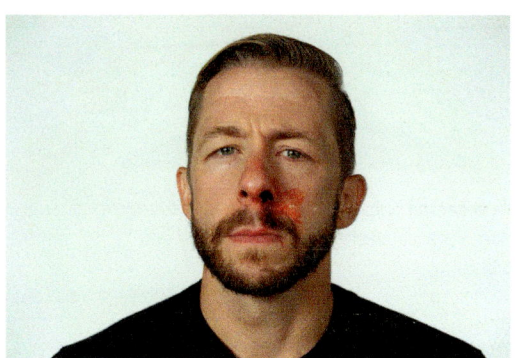

However, if the bloody nose was caused by an injury that happened anywhere from ten minutes prior or longer within the world of the script, you will want to add some pigment to the nose to create a swollen effect. I stippled on Skin Illustrator here across the bridge of the nose, and around the nostril and ball of the nose, leaving the ball of the nose natural to create a swollen appearance.

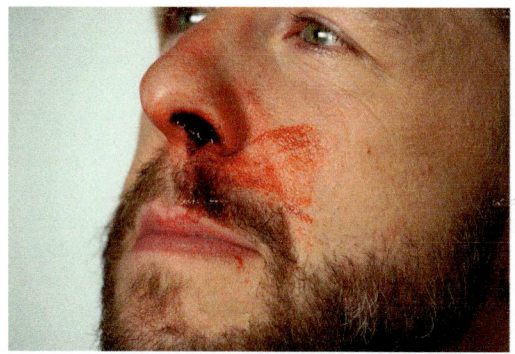

Completed bloody nose with dried blood – this bloody nose would have happened perhaps 5–10 minutes before as the result of an injury, and with the character wiping blood away from his mouth.

"Out-of-Kit" Special Effects 219

Black Eye

Imagining that this black eye occurred from an injury that happened roughly three days prior, the blood at the edges would have had time to begin to dry under the skin, creating the yellow-green bruise tones. I first stippled this tone on to the edge of the orbital area using the Ben Nye Bruise Wheel.

Carefully begin to stipple redness around the eye and eyebrow to achieve the appearance of broken capillaries. Add more redness around the outer edge of the eye.

With a deeper purple tone, begin to add depth to the bruise. The darkest tones in a black eye are typically closest to the eyeball because the skin there is thin and that area is packed with blood vessels. Continue adding depth with purple and red in the inner corner of the eye.

With a brush, stipple in the effect of broken blood vessels along the top of the eye.

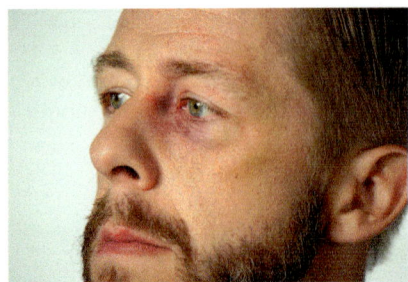 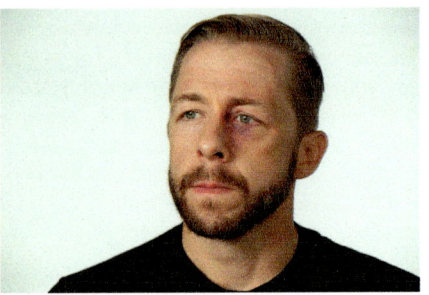

Line the inner corner of the eye and the waterline with red eyeliner. You may not need to do this all the way around, but just where the injury is the most intense to give the eye a red and swollen appearance.

The completed black eye should be very multidimensional, with many different colors layered beside one another – nothing too uniform or too dark to preserve a realistic effect.

Split Lip

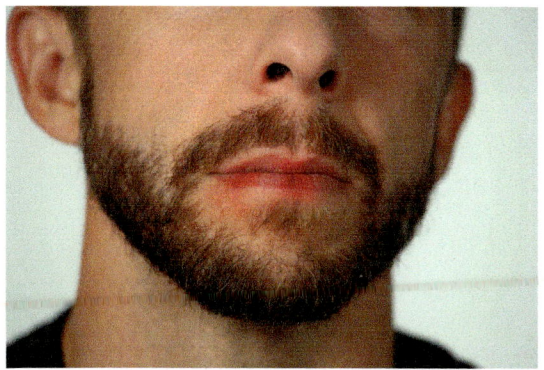 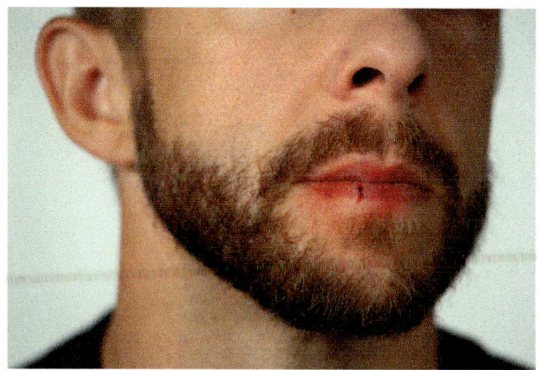

Using an alcohol-based paint such as Skin Illustrator and a stippling brush, create the appearance of swelling in a semi-circular shape on the affected part of the lip.

Make sure this swelling extends below the lip and that the skin in the middle is kept clean. This natural-colored skin will create the effect of swelling and will look like it is actually protruding forward.

Using an alcohol-based paint and a skinny brush, create a small line ("split") right in one of the natural grooves of the actor's lip. If you step back, from far away, this should look like a clear split, within a swollen bump.

Add a tiny line of Ben Nye Fresh Scab to create a shiny, scabbed over appearance on the split. When working with Fresh Scab, you can use warm water to remove it from your mixing palette and spatula – it is essentially a corn syrup base, so using alcohol to clean it off actually dehydrates it and hardens it on, but it dissolves quite easily with water.

"Out-of-Kit" Special Effects

Bloody Knuckles

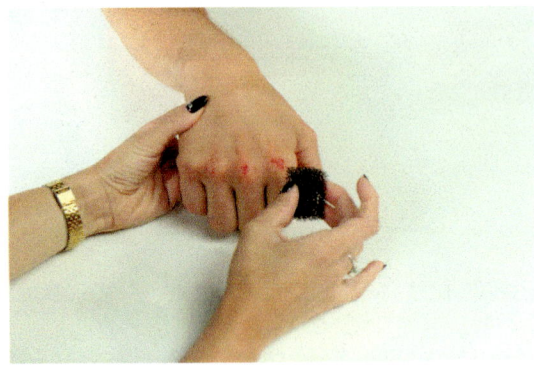

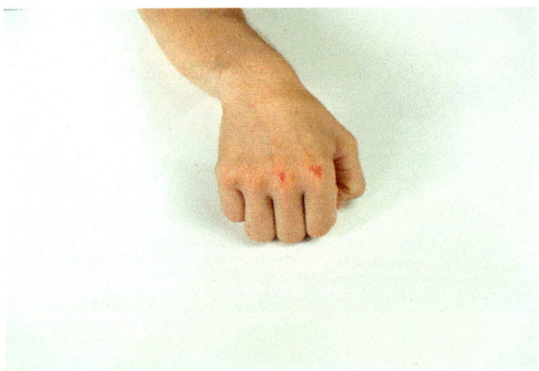

Ask your actor to make a fist. Bloody knuckles typically occur as the result of punching an object or another person.

When the actor makes a fist, you will be able to see which of their knuckles sticks forward the furthest, which means it would be the first to make impact and be the bloodiest.

In most cases, the first two knuckles are the most prominent points of contact for a punch.

Begin by stippling a dark red tone of Skin Illustrator onto the high points of the knuckles. Pull your stipple sponge in a bit of a downwards motion to create the effect of little lines of broken skin. You may add a bit to the outer knuckles if it feels supported by the blocking.

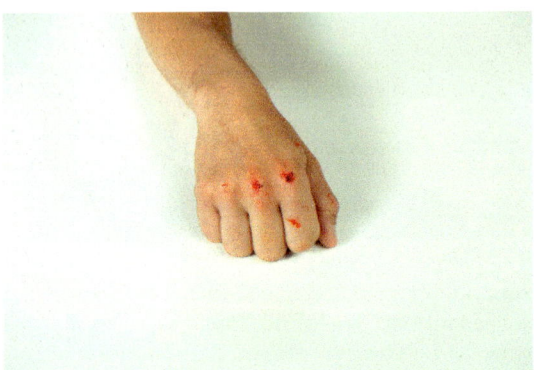

Stipple on a shiny jam blood such as Ben Nye Fresh Scab to the high points of the knuckles. While this type of injury typically does not gush blood, you may add small flecks of dried blood around the hand, as supported by the story.

Road Rash

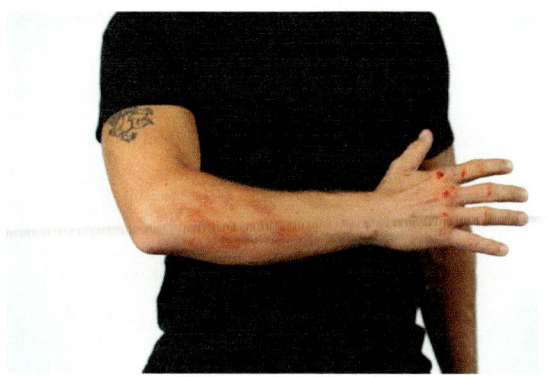

Road rash may occur as a result of a fall and is simply deep scratches in the skin as the person hits the ground. Talk with your Stunt Coordinator about the blocking for the scene and the affected area for the injury.

Begin by creating some redness and swelling with a stippling brush. Use a variation of different tones.

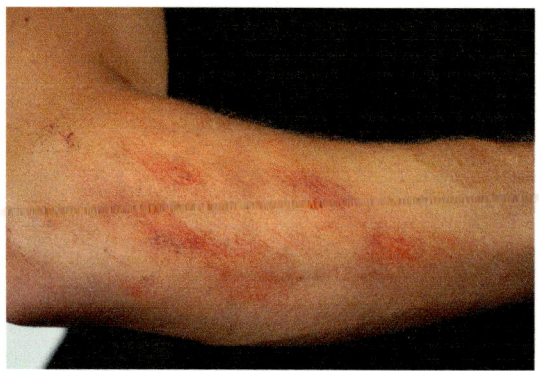

With a stipple sponge, begin to add streaks of a dark red Skin Illustrator as the "scratches."

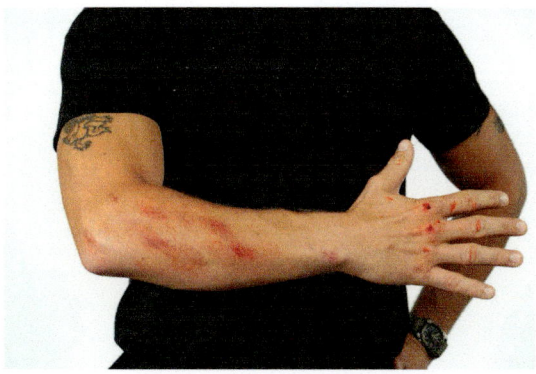

Make sure to add scratches to the bony high points of the area which would make direct contact with the ground as the result of a fall – in this case the bony side of the elbow and the wrist.

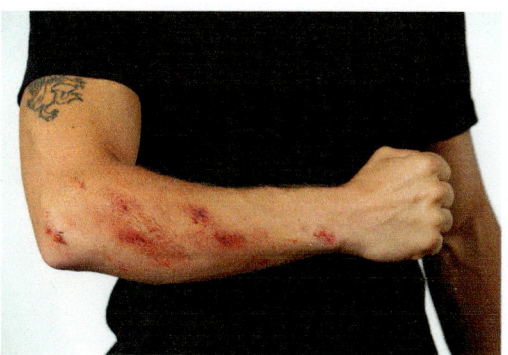

Using your stipple sponge, create some texture and scabbing with a jam blood such as Ben Nye Fresh Scab.

"Out-of-Kit" Special Effects 223

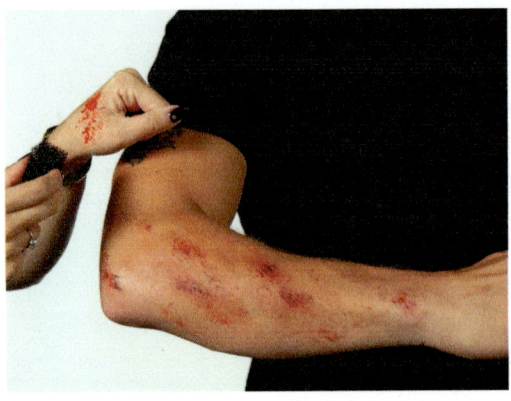

As I work with a stipple sponge, I always test it a bit on my hand, to make sure I'm dabbing off excess product and seeing what the opacity and consistency will look like. Use the stipple sponge to add a little bit more wet blood to the area.

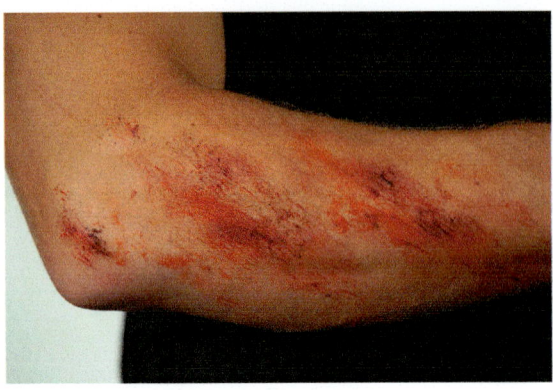

You should have a variety of different blood tones and textures in your road rash.

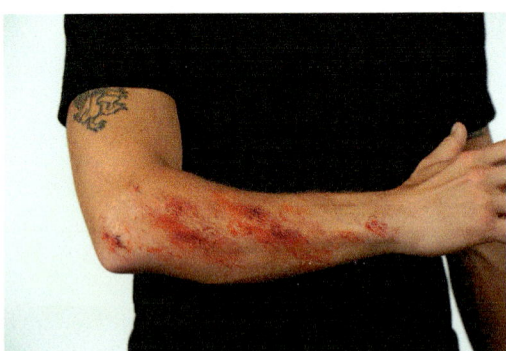

Completed road rash effect. Depending on where the character is falling, you may add powdered dirt at this point (not pictured.)

Burns

By Christine Sciortino and Christopher Payne

In This Chapter

- **Gelatin Burns**
- **Silicone Burns**

Burns are a common on-screen effect and they can be created many ways – both pre-sculpted and applied out-of-kit. "Burns may be caused by heat, electricity, radioactivity or chemicals, and can cause extensive and, sometimes, life-threatening cell damage. The skin is reddened and the epidermis damaged in the region of a burn. If the dermis beneath is also affected, blisters soon form" (Parker & Walker 171).

With six seasons as the Head of the Special Effects Makeup Department of NBC's *Chicago Fire* under his belt, my friend and colleague Christopher Payne is a burn master. For this section, he and I each demonstrated a burn using a different application technique. First, you will learn how to create a burn using **gelatin** – a classic and inexpensive technique. Second, you will see an out-of-kit burn using the **two-part silicone** compound 3rd Degree – a popular and quick-drying modeling silicone you can use to sculpt a wide variety of injuries and effects.

Gelatin Burns
by Christopher Payne

Burns are one of the most painful injuries a person can receive, and there are many different kinds with many different appearances. Chemical burns, electrical burns, steam burns, flash burns, and the list goes on. When creating a realistic burn, research is critical so that your burn is appropriate for the scene it appears in. I've lost track of the number of different burns I've created, and each one has been different. Here I'm demonstrating a basic thermal burn caused by an open fire.

You're going to start by cutting the gelatin cubes into small pieces to help them melt more evenly. In a microwave-safe bowl melt the pieces until they're runny, starting at about 20 seconds at a time and stirring them frequently to evenly distribute the heat. As the gelatin begins to melt, reduce the microwave time to ten and even five seconds at a time. During the melting process it's very important not to allow the gelatin to boil, which weakens it and can result in a sticky, spongy mess even after the gelatin has cooled.

"Burns are one of the most painful injuries a person can receive, and there are many different kinds with many different appearances."

Once the gelatin has completely melted it will be thin and VERY hot, so hot you could easily burn your model if you're not careful. Stir it for a while to help it cool. A good place to test it is on the inside of your wrist where the skin is a bit sensitive, if it's cool enough there it should be cool enough for the face. Take your time and be safe.

Begin by applying a thin coat of gelatin over the entire burn area. This is most easily achieved with a wooden craft stick – it doesn't absorb heat the way a metal spatula does and it can be discarded when too much gelatin has built up on it. Feather the edges of this first layer into the skin, creating as subtle of a transition as you can. Doing this early on will give you better edges than you'll get during what I call the "gooping stage," where you'll be dealing with a lot more material. You'll go back later and disguise the edges with makeup, but it's always better to start with good edges than try to hide bad ones.

Once your base coat is applied, it's time for the gooping stage. At this point the gelatin in your bowl should have started to cool and thicken a bit (you'll

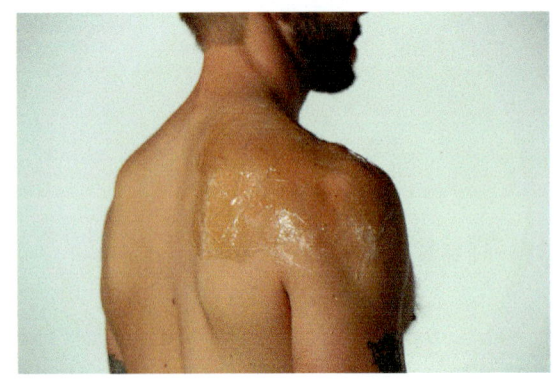

periodically have to reheat it for a few seconds as it gets too thick to work with). While it's roughly the viscosity of honey load up your craft stick and begin tapping the flat side onto your base coat. The gelatin will stick to itself and begin to create stringers that you will use to sculpt the burn right on your model. Keep this layer of gelatin slightly within the borders of the base coat to preserve the blending edge, and watch out for unwanted drips from the stick (constantly spinning it in your fingers while transporting the gelatin from the bowl to the skin helps to prevent these).

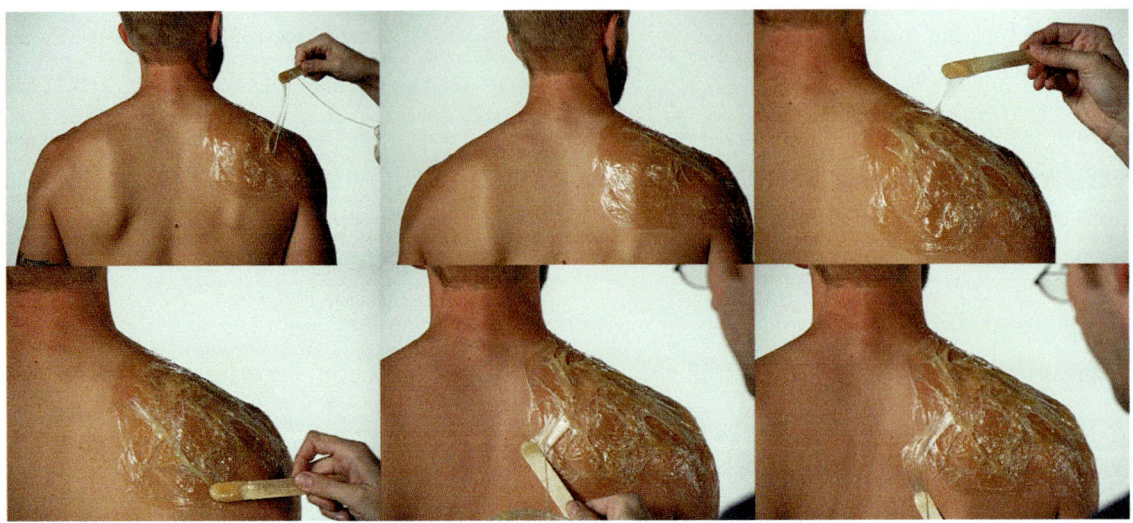

228 Technique

The stringers will be pretty subtle when the gelatin is hot, and will get more dynamic and textural as it cools. When you reach a point that you're beginning to feel resistance it's time to reheat the gelatin in the bowl before adding more. Trying to force gelatin that's cooled too much to keep gooping might pull up the base layer, ruining your nice edge.

When you're happy with the texture you've built up, allow the gelatin to cool completely. Gelatin stays sticky even after it's cooled, so give it a good coat of powder to prevent it from sticking to itself and ruining your work. At this point you can also put any unused gelatin in a Ziploc bag and store it in the refrigerator; one of the nice things about the material is that (so long as it hasn't boiled) you can melt and re-melt it many times.

I find stippling on the makeup with a texture brush gives me a more mottled and realistic appearance than using a makeup sponge, but a sponge works too so long as you tear up the edge to create an irregular surface. It's a question of personal preference; try both and see what works best for you.

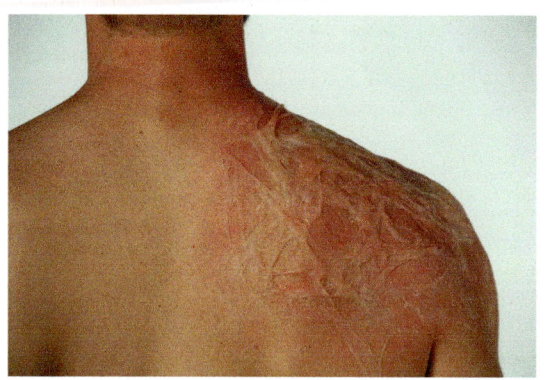

Now go in with a darker red, beginning to build up the rawness in the deeper areas. I used a combination of Skin Illustrator's Complexion and Reel Creation's Burn alcohol palettes for this makeup, though cream makeups thinned with rubbing alcohol can also be used.

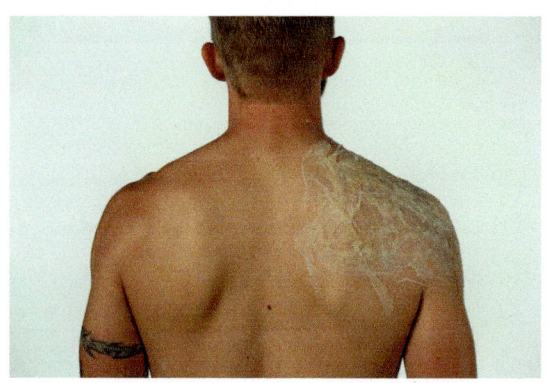

With the build-up complete, it's time to move on to color. Begin with a pale, irritated-looking pink that extends past the blending edge and fades out onto the skin. Keep it thin and subtle – you'll get much more realistic results building up layers of color than you would trying to do the whole thing in a single pass.

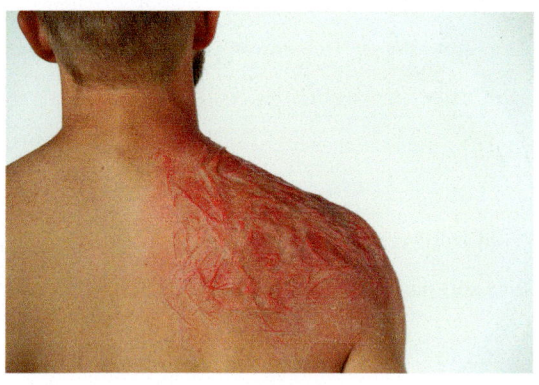

Burns 229

With a deep bloodtone red go in and reinforce only the deepest areas of the burn to really create the illusion of depth and damaged tissue.

A chip brush can be cut shorter for easier spattering

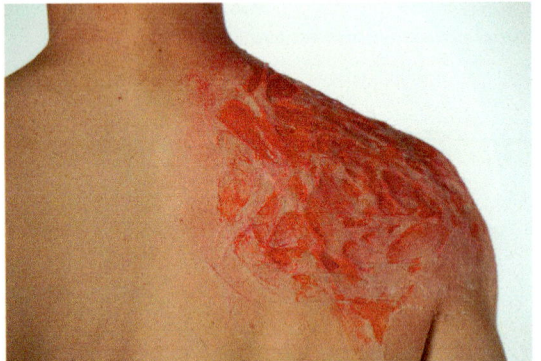

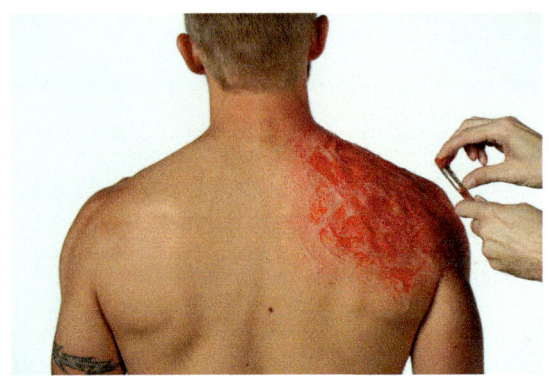

I'd like to note that while you're using a bloodtone makeup to create an organic rawness, DO NOT add liquid blood. Real burns bleed very little because the tissue has been cauterized. A burn makeup that's been smeared with blood is an amateur mistake that I constantly see all over social media. Remember, as a makeup artist your job is to create realism unless a director says otherwise.

At this point there are a lot of reds happening in the burn, but the color is all pretty smooth. You can now create some breakup with a technique called spattering. Cut the bristles on a one-inch chip brush short and use it to fleck thinned red makeup onto the burn area. As you build up the layers of spattered color your burn will begin to look more irregular and natural.

Spattering colors is fun and really brings a makeup to life, and some people may be tempted to jump right to that step. That's a mistake. For a proper makeup it's important to build up your base colors first before adding the fun little details.

Because this burn was caused by fire, we're now going to add soot and charred tissue. Begin with a dark gray (in this case Skin Illustrator's "Soot") and stipple it randomly around the edges of the burn and onto some of the high points.

Keep this layer irregular, playing with more and less intensity in different areas for a more natural appearance. Don't go too heavy right away; like the first coat of

gelatin and the initial pink color of makeup, this step is creating another base layer that you'll build upon.

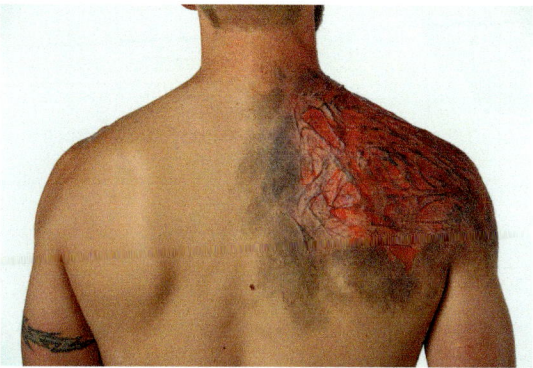

When the soot is in place, go back in and selectively stipple black to make the edges of the burn pop. Be careful with the black; it's easy to let it get out of control and turn the whole thing into a big mess. If you do go too heavily (and if you're working with alcohol colors) you can dial it back a bit by spraying a clean tissue with alcohol and lightly blotting the area that's too intense.

Use the black to carefully **dry-brush** across the highest edges of the gooped gelatin, creating the illusion of charred tissue with a raw burn underneath. Work the brush from different directions to avoid accidentally creating a noticeable pattern of brushstrokes.

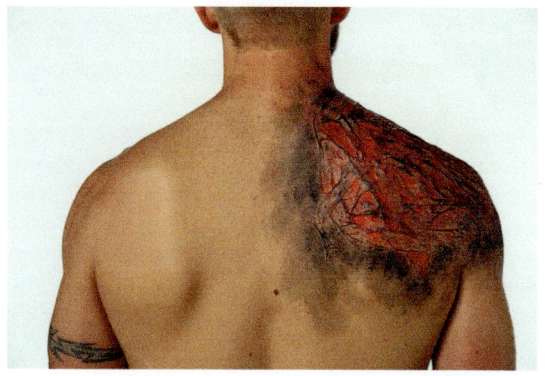

Finally add some KY Gel to the burn to create a raw, shiny texture. In the picture below I've done this on the right half to show the difference with and without the shine. The final picture shows the finished burn makeup.

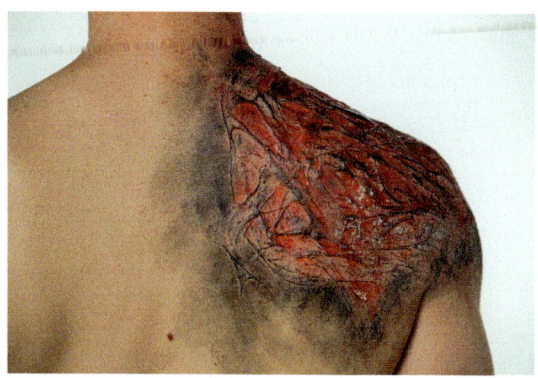

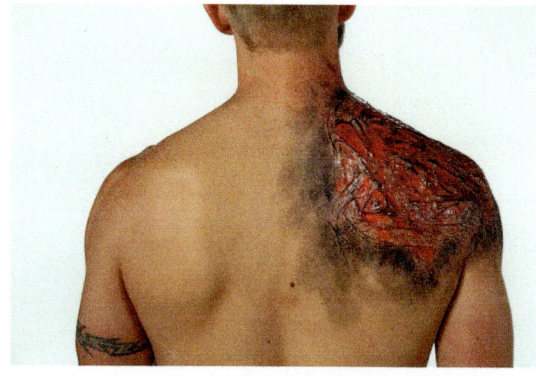

The completed burn

Silicone Burns
by Christine Sciortino

Burns affect the skin in several different levels of severity:

- **1st Degree Burn:** Affects the outer layer of skin only – this can generally be painted on to create redness, swelling, and uneven skin tone
- **2nd Degree Burn:** Affects the outer and the deeper layers of the skin – this can be a combination of paint for redness and swelling, and small prosthetics if blisters are desired
- **3rd Degree Burn:** Affects the deep layers of skin and fatty tissue
- **4th Degree Burn:** Affects structures below the skin like muscles, tendons, and bone and involves charring of skin

Below you will see a textured 3rd degree burn. A quick and easy way to apply burns on set, regardless of location, is with a two-part silicone product, appropriately named 3rd Degree. This method does not require heating, melting, or any other preparation ahead of time. You simply mix the product in a specific way and sculpt it as it cures – which happens in only five minutes. The following tutorial shows my process for working with 3rd Degree, which I believe has the smallest chance for product cross-contamination of the two silicone parts. Different makeup artists may use different methods.

When working with 3rd Degree, mixing part A and part B together creates a chemical reaction that will take the silicone from a gelatinous texture to a solid in five minutes. To start, place equal parts of part A and part B in two separate medicine cups, using two separate mixing sticks. Note that if the same mixing stick is used in jar A and jar B, the cross-contamination from the product on the stick will cause the hardening of the entire jar so be careful!

I tint my 3rd Degree with flocking (tiny fibers of felt – pictured left) and silicone pigment (right) before mixing them. This gives you more time to adjust the colors and quantities than if you were to start adding your tints once the two parts have been mixed and started curing.

Transfer your cup of part A and part B into a third clean cup, using a third *clean* mixing stick. This will help ensure equal parts go into the mixture. If the parts are not perfectly equal, they will not cure properly, leaving you with a sticky gel on the skin.

Clean the skin with alcohol to remove any oils, then spread a swatch of 3rd Degree onto the skin using a plastic palette knife. Wooden mixing sticks can splinter so they are not advisable. A contoured plastic palette knife (pictured) will be the most comfortable for your actor and give you the most precision.

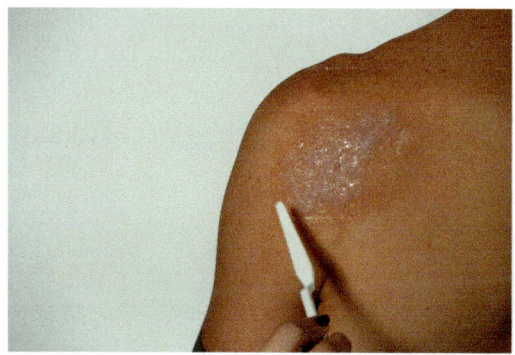

Blend your edges outward, feathering them smoothly into the surrounding skin area. Wiping your palette knife with paper towel between each swipe will help remove excess product and create a cleaner blend.

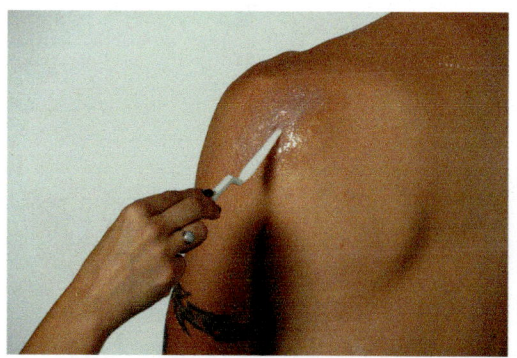

As the 3rd Degree begins to cure, you will be able to sculpt different shapes into it, directly on the skin. If it has not cured enough yet, these shapes will collapse back in on themselves, so make sure it has started to set. For a burn, use rounded shapes, similar to the effect of the boiled and bubbled up skin, sort of like popped blisters.

Burns

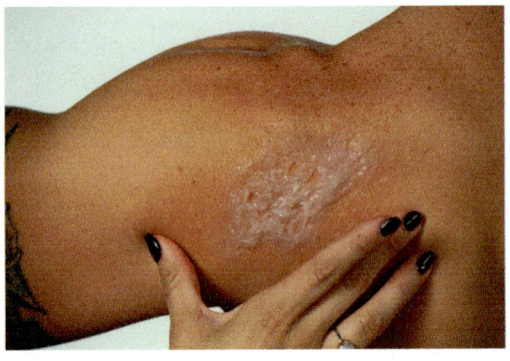

As the 3rd Degree dries, you can have the actor move their body part slightly so that it stretches and contours to the skin. This prevents the appliance from popping off later on when they do move.

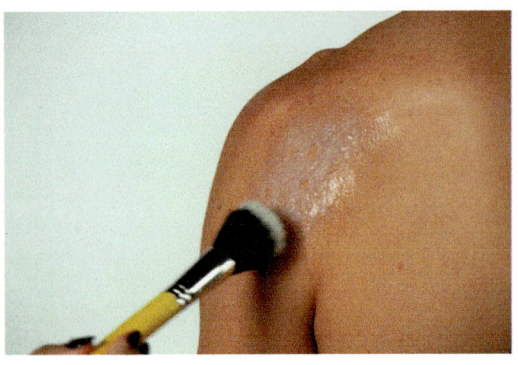

Silicone has a shiny texture. Powder over your 3rd Degree with a silicone matting powder

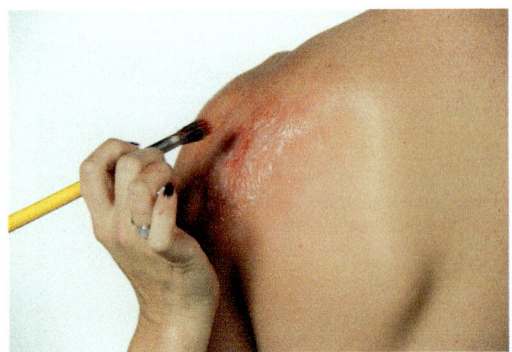

Begin to shade the burn with a light wash of an alcohol-based paint, allowing it to settle into the grooves of the burn, and create the appearance of swelling around the outer edges of the skin. Stipple more redness into the burn.

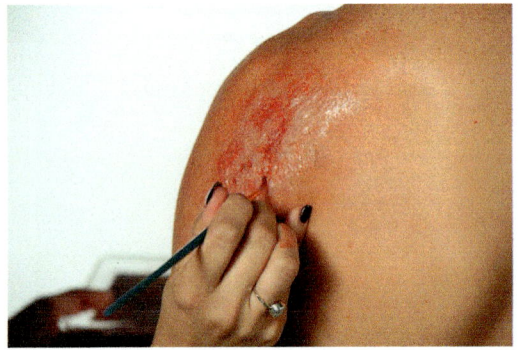

Go into the little craters you have sculpted with a dark red to give the appearance of exposed muscle and tissue layers. Continue painting and coloring your burn in a stippling motion for an uneven color and texture. Leave the high points un-painted to give the illusion of tissues bubbling up.

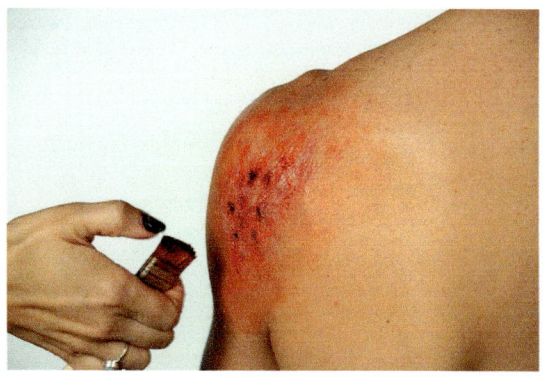 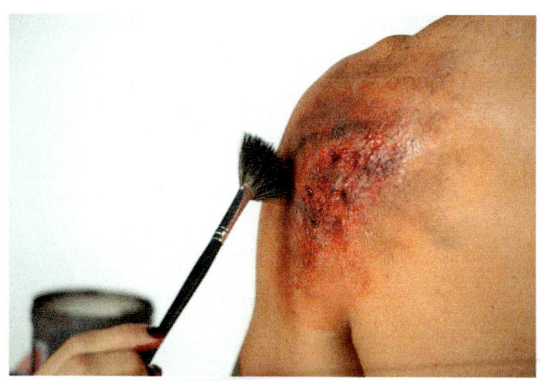

Using a jam-textured blood, such as Ben Nye Fresh Scab, create some shiny, bloody texture inside the craters of the burn. For these bloods I like to use craft brushes so as not to ruin my high-quality makeup brushes. Burns do not bleed because of cauterized skin, so don't go too crazy with this step. You really just want to show depth and muscle tissue, not gushing blood.

Then, with a chip brush, splatter textures and redness around the burn.

Depending on the environment where the burn takes place, you can dust some charcoal or ash powder over the edges of the burn to look like charring.

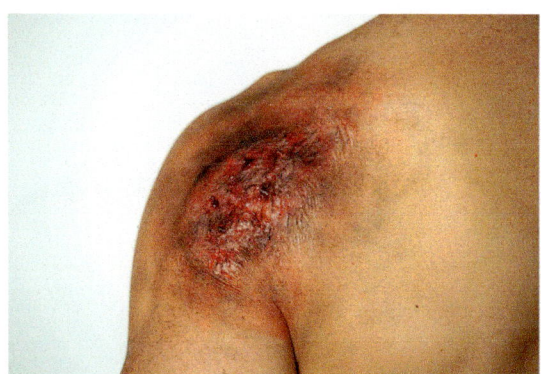 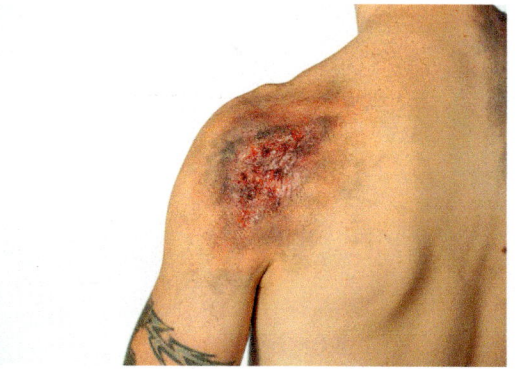

Burns of this degree have a shiny appearance due to the melting and oozing of fluids and fats within the skin. To add some of this shine, you may apply a personal lubricant to the high points of the burn.

The completed burn.

Burns 235

You can also use 3rd Degree 2-Part Silicone to create a large variety of wounds and other effects, sculpted directly onto the skin. It is an excellent tool to keep in the kit because of its versatility and quick drying time! The slit throat below was created in the exact same way as the burn, only a cut shape was sculpted into the appliance, rather than the bubbles and bumps of a burn.

(Makeup by Christopher Payne).

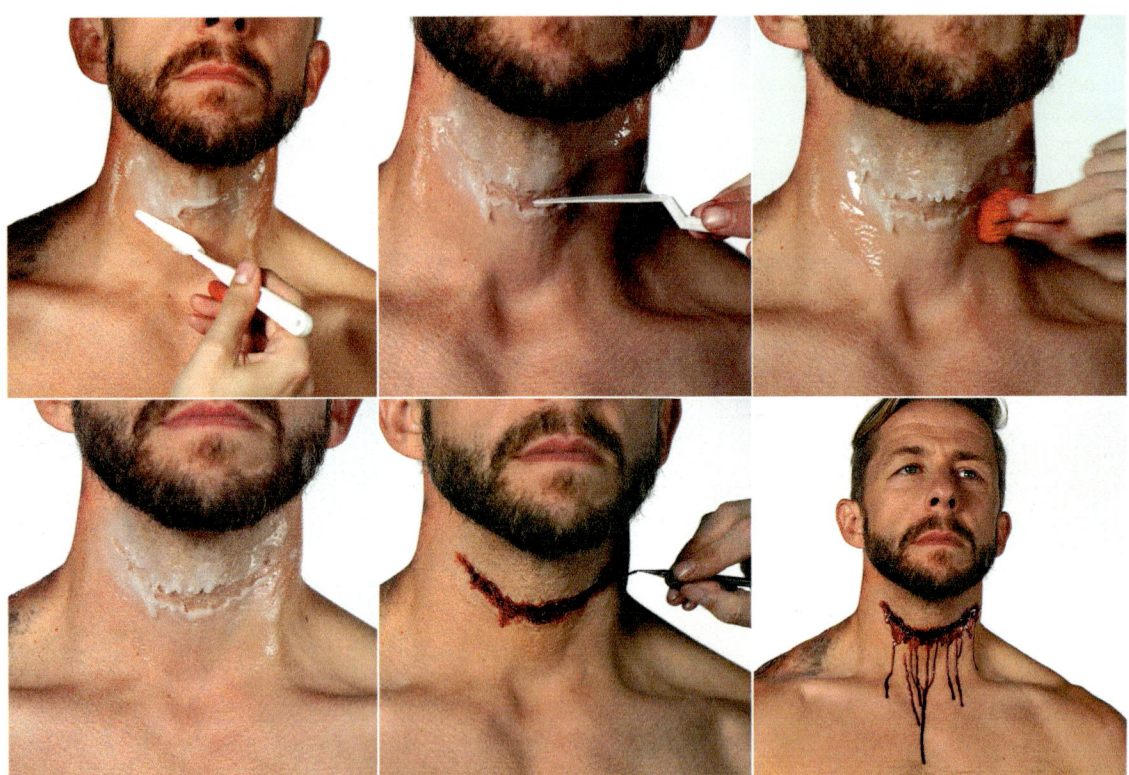

This wound was painted with the Skin Illustrator FX Palette. Skin Illustrator is a line of pigments created by Premiere Products which can be used on natural skin, different types of prosthetic transfers, even hair (as Hair Illustrator). The colors are solid, then activated with 99% alcohol or the Skin Illustrator Activator fluid, and then work much like a set of watercolors – the more liquid in the color pan, the more translucent the color will be. Many different Skin Illustrator palettes are used in these tutorials, as they are available in countless colors for a wide variety of purposes and effects. I definitely suggest purchasing a few of their basic palettes for your kit when you are first starting out and practicing with the layering and mixing of them. As you learn what colors you use most often on-set, you can add palettes to your kit and expand your color library.

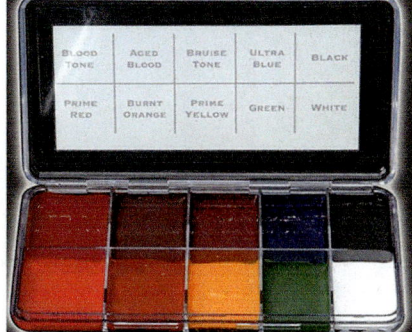

Applying Pre-Made Prosthetics

By Christopher Payne

In This Chapter

- **Encapsulated Silicone Prosthetics**
- **Pros-Aide Transfers**

Encapsulated Silicone Prosthetics

One of the main items used in special effects makeup are prosthetics. These are any pre-fabricated pieces that are glued to an actor to create a character. Unlike "build-up" materials such as silicone, putty, and wax, prosthetics are sculpted and molded in advance. The advantage to this is that you can create many identical copies of a wound, nose, or any other appliance that you might need. In film and television, where matching exact continuity from day to day is critical, this is a very important advantage prosthetics have over build-ups.

The two kinds of prosthetics that we're going to cover here are **silicone prosthetics** and **Pros-Aide transfers**. Silicone prosthetics (also called **gel filled appliances** or **GFAs**) are made of a silicone gel that is encapsulated inside layers of bald cap plastic. This plastic can be dissolved with either isopropyl alcohol or acetone depending on the type used, allowing an easy blend into the skin. Pros-Aide transfers are made of a thickened form of Pros-Aide adhesive, which is frozen in a mold and then dried to create a prosthetic that applies almost as easily as a temporary tattoo.

Let's start with silicone prosthetics. The first thing you'll notice is that they come with a thin band of silicone around the edges of the prosthetic. This is called flashing, and it's pretty important so don't cut it off.

You should clean a new prosthetic to make sure any release agents used in the mold have been completely removed so they don't interfere with your application. If the prosthetic edges are meant to be dissolved with acetone, you can clean it with rubbing alcohol. For alcohol-dissolvable ones use lighter fluid or **witch hazel** to clean the surface.

Once you've figured out exactly where the prosthetic wants to live on your actor's skin, begin to glue it in place with an adhesive such as Pros-Aide or Telesis. (Note: DO NOT use spirit gum to apply silicone prosthetics. It continues to release fumes for a while after drying, and since the silicone blocks those fumes from escaping you can end up with a chemical burn when those fumes have nowhere to go but into the skin.)

Typically you'll begin by gluing the center of the prosthetic down, then work your way outward making sure you glue every bit of the prosthetic down. If the

prosthetic goes onto a very specific contour of the face, such as the hollow between the eye and nose, you may want to start there even if it's not the exact center since getting a good fit is important.

Remember as you are sticking the prosthetic in place that any unglued areas won't move properly as your actor emotes, so take the time to be thorough. While you apply adhesive the flashing will give you a convenient handhold, which is very helpful in gluing down the delicate edges. Don't glue down the flashing itself though, stop just before you reach it.

When the prosthetic is completely glued in place, it is time to remove the flashing. Using either 99% alcohol or **acetone** (depending on which kind of plastic your prosthetic is encapsulated with) use a cotton swab or fine brush to melt through the edge just inside of the flashing. Continue removing the flashing around the entire prosthetic, using just enough solvent to soak the cotton swab or brush. It should only melt the plastic where you put it, not drip around all over the place. As you remove the flashing it can be helpful to trim away loose pieces with cuticle scissors as you work so you don't have the entire thing flopping around.

A silicone prosthetic glued in the center with the edges still unattached

Removing the flashing with a cotton swab

With the prosthetic applied, the next step will be to seal the edges. A little Pros-Aide stippled on with a wedge of red sponge works well. Since Pros-Aide is a white liquid but dries clear it's easy to see where your seal is dry and where it's not. If you have any edges that are still a little thick you can use Pros-Aide cream as a kind of spackle to fill in the gap. Build it up in thin layers, letting each dry until the edge disappears.

An optional step is to seal the entire prosthetic with a layer of Pros-Aide. I find this helpful with prosthetics

A completely glued silicone prosthetic

that blend with alcohol since I'm going to paint them with alcohol colors; the surface will be able to stand up to a little more aggressive painting if it has been sealed. Because Pros-Aide stays sticky after it dries, you must lightly powder it with color-free powder to eliminate that stickiness. A little water on a tissue will remove the excess powder so that you can see the true color.

The prosthetic before painting

Sealing and blending the edges with Pros-Aide

Warmed up with pink adjuster

One of the main benefits to a silicone prosthetic is that it's colored intrinsically (i.e. within the material) so hopefully when purchasing it you selected one that's already pretty close to your actor's skin tone. If in doubt try to get close to the undertone; it's always easier to darken it the rest of the way down than it is to brighten up a prosthetic that's already too dark.

On most skin tones my first step is to spatter on a thin wash of a reddish pink adjuster to warm the prosthetic up. With a good match this may be all you need. If not, go in with thin washes of skin tones until you have matched your actor's skin. Pay attention to the various colors in the skin and mimic them as closely as you can.

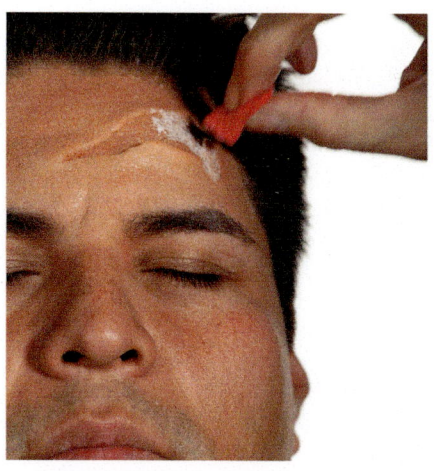

Fully painted with more Pros-Aide being added

Applying Pre-Made Prosthetics 241

Often with an alcohol-blended wound prosthetic I will seal the inside of the injury at this time with a second layer of Pros-Aide to help that area stand up to hand painting. This is done with various blood colors.

For a prosthetic that is rather shallow like this you need to create the illusion of depth by starting with a lighter color, then mottling in darker tones randomly within the wound. Avoid the temptation to use black to make the center of the wound look deep; it almost always looks fake.

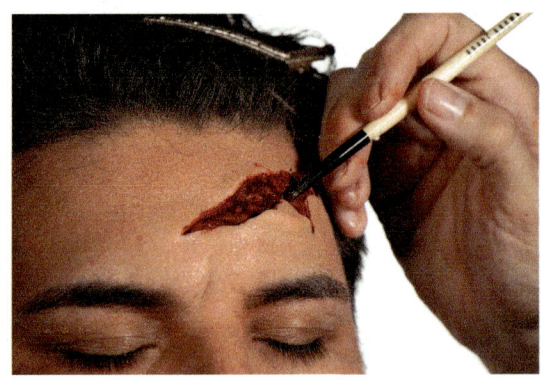

Painting the interior of the wound after the skin coloring is finished

Pros-Aide Transfers

Pros-Aide is a water-based adhesive invented in 1975 by Dr. Alfonso DiMino for medical applications. It is now widely used in film, stage, and television makeup to create many different effects. When mixed with cabosil, Pros-Aide creates a thick putty that can be placed in a mold and dried out to create a realistic-looking prosthetic piece.

Pros-Aide Original by ADM Tronics

Pros-Aide transfers apply a bit differently than encapsulated silicone ones. They essentially work like a 3D temporary tattoo. When you buy a transfer you will get the prosthetic itself, attached to plastic acetate, along with a piece of transfer paper. Before you can apply the prosthetic you need to prepare it.

I like to pre-paint a basic blood color inside of the wound. It doesn't need to be detailed at this point; you'll see why in a moment. Apply a thin coat of Pros-Aide to the surface of the prosthetic. When it dries press the glued prosthetic down on the SHINY side of the transfer paper. It's very important to get the right side or the whole process won't work.

Really smooth the prosthetic down through the acetate backing to make sure it's stuck to the paper really well.

Applying glue to a pre-painted wound

Adhering the prosthetic to the transfer paper

When the prosthetic is glued securely to the transfer paper, you can trim away the excess. You've now got a little sandwich with the acetate on one side, the paper on the other, and the prosthetic in between.

Hold the prosthetic up to the light and use a pen or marker to trace the wound onto the back of the paper. This is why I pre-painted the wound; it's much easier to see that way. This step isn't required, but it will make it much easier to line up the wound properly.

Marking the wound position

All of these steps should be done relatively close to the application time. You don't want to do this prep work days in advance because over time a transfer will squish flat, which defeats the purpose. I will typically do these steps as part of my morning prep before the actor arrives for makeup.

When it's time to apply the wound, carefully peel off the acetate, leaving just the prosthetic stuck to the transfer paper. Because the prosthetic is made of glue you could stick it directly to the skin, but for an extra hold I like to apply a little more Pros-Aide to the exposed back of the transfer first. Make sure you like the placement of the prosthetic because once you stick it

Applying Pre-Made Prosthetics 243

down there's no going back. When it's stuck to the actor, hold a wet makeup puff or paper towel against the paper for about 30 seconds. The shiny release agent on the paper will liquefy, allowing you to slide the paper right off. If the prosthetic sticks to the paper, lay it back down and use more water until it releases cleanly.

Activating the transfer paper with water

Removing the acetate

When you've removed the paper you can blend the thin edges of the prosthetic into your skin with a little 99% alcohol on a cotton swab. If needed, seal the edges with Pros-Aide and a sponge. After a quick powder to eliminate stickiness you're ready for paint. Because the transfer is mostly clear very little painting should be required. Use the same techniques as you would with a silicone prosthetic.

The transfer pressed in place

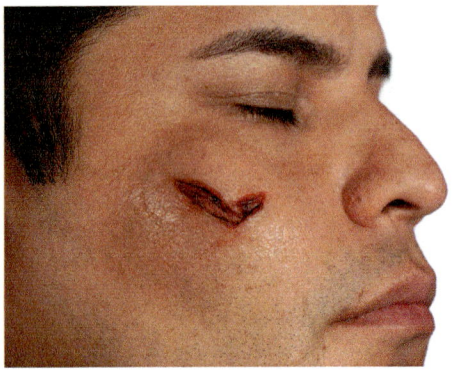

The blended and painted prosthetic

Now that the makeup is done, let's take a moment to talk about blood. Amateur makeup artists LOVE the stuff. As a professional, nothing drives me crazy like a makeup that is drowning in so much blood I can't see the *makeup* anymore. Have a look at these two pictures as an example:

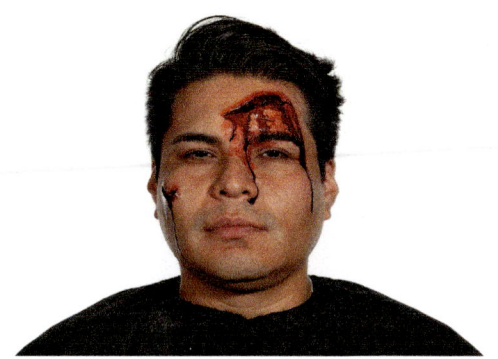

The blood in the second picture is *mild* compared to some gorefests I've seen. In the first picture you can see the makeup; the color and blending and *art* are still on display. In the second one there's almost no point in doing a good job in applying the prosthetic at all. Which, unfortunately, is why a lot of amateurs use tons of blood. It hides so many sins. Bad edges, a sloppy paint job, you name it. But it also makes the makeup look crude and low quality, even if it was done well. This is a "less is more" kind of situation.

Even though the director may ask me to bump up the blood (and some do want me to hike it up to a level that I call "Full Tarantino"), I like to start small to show off more of the makeup. Especially for a head wound, tons of blood may be more realistic, but sometimes you have to find a balance between realism and art.

My preferred technique for blood is to wet the skin with water before applying a thin base coat, then blotting a lot of that away with a wet tissue until what's left is mottled and accentuates the makeup. Only then will I strategically place my drips one by one. Sometimes I'll even paint those drips with a brush to make sure they're *exactly* where I want them. Doing the blood this way gives a much more nuanced and layered effect than you'll get by just smearing it on and walking away.

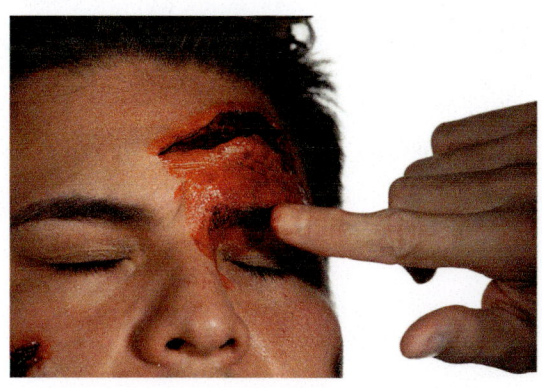

Applying a thin coat of blood to wet skin

Applying Pre-Made Prosthetics

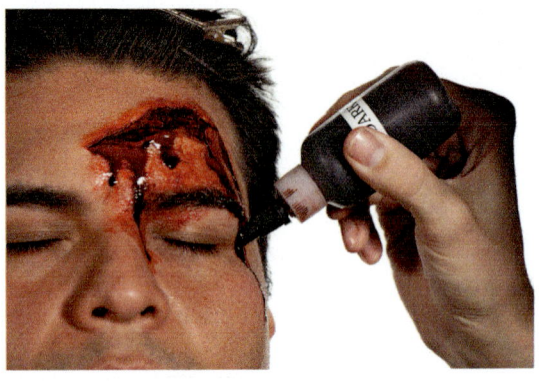

Applying the drips after blotting with a wet tissue

Another thing to consider is the direction of the blood. In that gory version, the blood is just smeared everywhere with no thought of why it's there. Look at all the blood above the wound, how did that happen? Blood doesn't flow upwards. And if the character is lying prone so that the blood could flow in that direction, why isn't it continuing to drip into his hairline? Why does it just stop? When I do a gory makeup, I usually wait until I get on set to add the blood. Only after the actor is in position – be it standing, lying prone or hanging upside down – will I add the blood to ensure that the direction makes sense.

At the end of the scene, it's time to remove the prosthetics from your actor's skin. This step is just as important as applying them because part of your job as a makeup artist is to maintain the health of your actor's skin. Especially in situations where they are wearing the same makeup many days in a row, breakouts and other skin problems will happen if you don't take removal as seriously as you do application.

Begin by letting your actor sit for a few minutes with a hot towel over his or her face, prepared either in a towel warmer or the microwave (or just with hot water). This not only feels good at the end of a long filming day, but will also start to soak up any blood and loosen the prosthetics a bit. Once you've cleaned off any excess blood, dirt, or other gunk, you can begin to remove the prosthetics with a remover appropriate to the glue you used. I personally prefer PPI Telesis Super Solv; it's gentle on the skin and works with just about any makeup adhesive.

Using a stiff but silky brush, begin to gently scrub at the edges of the prosthetics with remover until you tease one of them up. After that, simply use the brush to work the remover under the prosthetic, peeling it off gradually. Let the remover set the pace; if you try and work too fast you could hurt the actor's skin. Super Solv also has a gel version, which is handy when working on the eyelids or just under the actor's eyes so there is no chance of splashes or drips.

When the prosthetic is off there will still be leftover adhesive and material from the prosthetic, usually around the edges. Soak a large powder puff with remover and gently wipe these last bits off the skin. After the skin is clean, give the actor a second hot towel or have them wash their face in the sink to remove any residual remover. Finally, gently apply lotion to the skin to help rehydrate it.

Age Makeup

*By Rochelle Uribe-Davila, Dina Cimarusti, Christopher Payne
and Christine Sciortino*

In This Chapter

- **Paint-Only**
- **Stretch-and-Stipple**
- **Prosthetics**

Flashbacks and jumps forward in time are common storytelling tools in film and television. Therefore, it is important to have some aging techniques in your repertoire. As you know, the skin loses its elasticity as people age, and coloration changes based on sun exposure and environmental factors. You will need to connect with your Director and Script Supervisor to make sure you know the timeline and then research photos of people as they age for inspiration.

There are many different methods to age an actor. To illustrate this wide range of approaches, I asked three talented colleagues of mine to share their favorite techniques for aging characters.

Paint-Only
by Rochelle Uribe-Davila

Clean the skin with a toner such as Sea Breeze to remove any lotions or natural oils and to ensure that the makeup holds. Pull the hair back with any gel, clay, or wax.

Ask your actor or model to squint in order to accentuate their natural wrinkles. Deepen their wrinkles using an alcohol-based color such as Skin Illustrator or a long-lasting cream makeup about three shades darker than the model's skin tone. Use a very fine brush.

Use the same shade and a larger brush to add some depth to the neck.

Now it is time for the highlight and contour! Emphasize the shadows with a darker tone. Then use a tone about three shades lighter than your actor's skin tone to highlight the protruding areas such as the cheekbones, forehead, and browbone.

Add some bluish or greenish veins with a very fine brush. Add some age spots with the same color that you used to accentuate the wrinkles, or even a shade darker to add some variety.

Using a fan brush and a red liquid or cream makeup, create the look of broken capillaries across the cheeks.

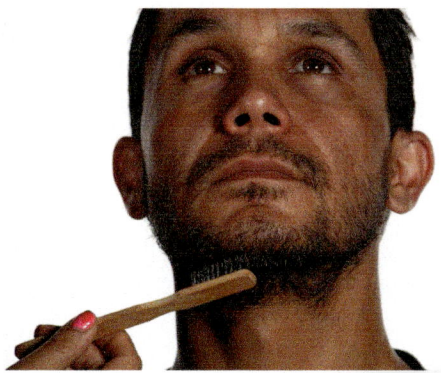

With a wide brush, fan brush, or mascara wand, use an alcohol-activated hair aging palette on the facial hair and hair. The Skin Illustrator Hair Aging Palette has a wide variety of natural-looking tones that work beautifully.

The completed look, before and after! This method can be adapted to create the effects of aging to make your actor look anywhere from about five to 20 years older, depending on their age to begin with! In this demo, our goal was to take Miguel from his 38 years old to about his late 40s.

Age Makeup

Stretch-and-Stipple
by Dina Cimarusti

While age makeups done with paint can define the skin and change its tonality, to make someone look even older, you will need to change the texture of the skin as well. This can be achieved with a classic technique called **stretch-and-stipple** which uses liquid latex to build up tiny wrinkles and crepiness on the skin's surface.

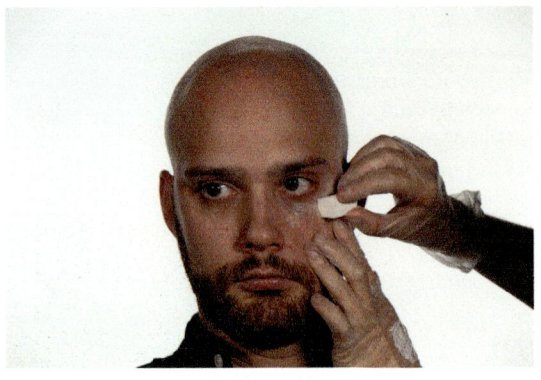

Prep the model's skin with witch hazel or other mild toner. Stretch the skin taut where it would naturally wrinkle. Stipple on a thin layer of liquid latex with a non-latex makeup sponge. Latex sticks to latex so your sponge *must* be non-latex for this look to work. Hold skin in place until the latex dries.

You can use a blow dryer to accelerate the drying process. Once dry, powder area with translucent powder to prevent the latex from sticking to itself."

With the actor's eyelids closed, stretch their skin up and stipple under the hood (between the browbone and the eyelid) using the same process. This will create a "droopy lid." You can build up on existing stippled layers to create deeper wrinkles. This will create an even older appearance. Powder to set.

Once you have all your latex in place, you can start coloring with alcohol-based colors. Start by spattering some flesh-toned color to create an even base tone.

Stipple on dark mauve and capillary tone (in the Skin Illustrator Complexion Palette) or similar colors to break up the evenness of the skin and add texture. Focus on high points like the cheeks, nose, forehead, and chin.

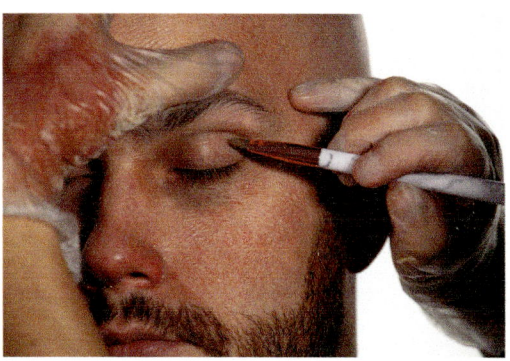

Start adding brown into wrinkle creases to add depth. Also add brown in the corner of eye sockets to create a sunken eye look."

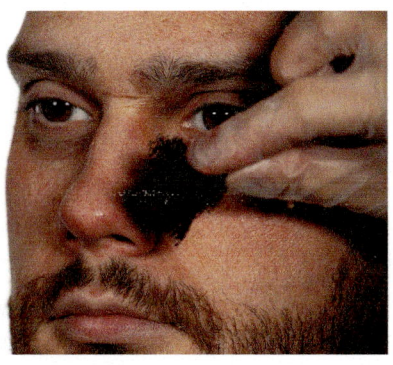

Stipple across the nose with capillary or similar red color using a black stipple sponge.

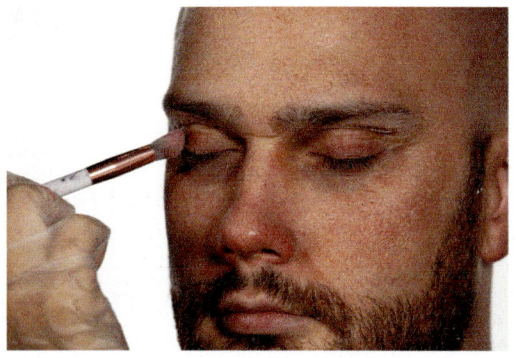

Stipple capillary color onto eyelids using a small stipple brush to create the appearance of broken blood vessels and veins in the eyelid.

Add age spots using a brown tone that is one or two shades darker than the model's skin tone. Don't forget to add depth with brown and red tones (choose depending on your model's skin tone) to the ears.

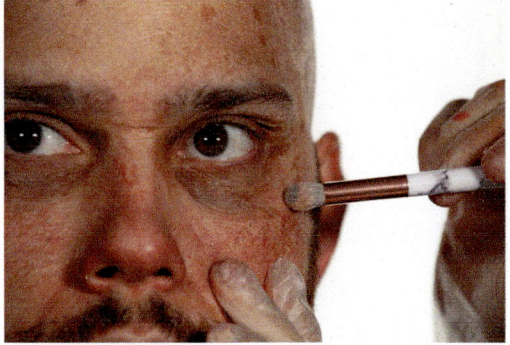

Add eye bags by mixing a little blue with brown and lightly brushing it on beneath the fatty pad of the lower eyelid.

Age Makeup 253

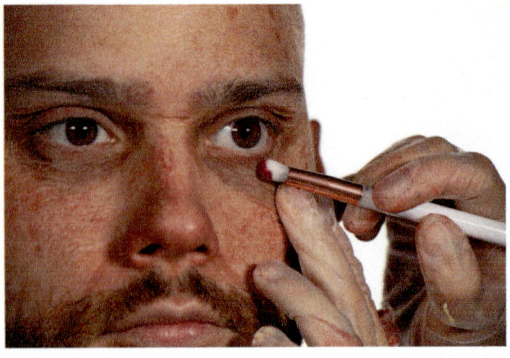

Add a thin line of capillary color or a dark purple (depending on model's skin tone) just below the eyelash line.

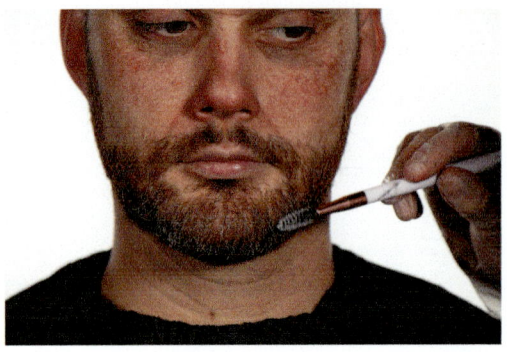

Using an eyelash wand, brush on white or silver Skin Illustrator color into the brows, hair, and beard.

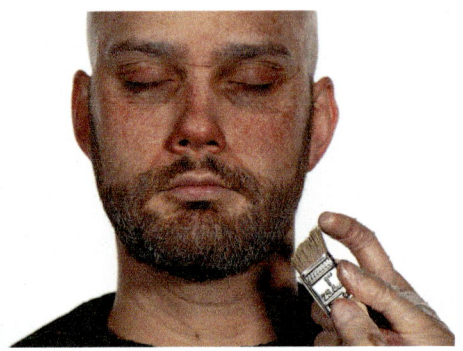

Using a mascara wand, brush on white or silver Skin Illustrator color into the brows, hair, and beard. Spatter on some of the color to help break up the strands and give a more natural look.

Stipple to add redness and the appearance of broken capillaries to the cheeks if appropriate, based on your model's skin tone.

Before and after – the completed aging effect.

Prosthetics
by Christopher Payne

If you need to add more age to your actor than can be accomplished with paint or stretch-and-stipple techniques, the next option is to add prosthetics. We decided to add about 20 years to Jorge using a combination of all three techniques.

I began by applying a light stretch and stipple to the forehead and crow's feet area. I used the same techniques covered in the previous section, but instead of latex I used a combination of Green Marble Sealer concentrate and a powdered filler called Attagel. I used four parts Green Marble to one part Attagel, but you can adjust the levels up or down depending on how extreme you want the final effect to be. In general the less Green Marble you use, the more intense the effect.

First, I applied a set of generic silicone cheek prosthetics sculpted by Todd Debreceni. The application was done the same way I detailed in Chapter 15 "Applying Pre-Made Prosthetics." In this case, I lined up the nasolabial fold (the line going from the nostril down to the side of the mouth) with Jorge's real lines. Seal and powder the prosthetics as you did with the injury pieces in Chapter 15 "Applying Pre-Made Prosthetics."

Next I added some prosthetic eye bags. Working this close under his eyes I had to do things a bit differently. I cut away the flashing on the part of the eye bag that goes just under the eyelid, leaving just enough cap plastic to allow blending. As I glued this area I had Jorge look up so that I didn't get glue in his lower eyelashes.

The rest of the prosthetic was applied and blended normally, using just enough alcohol on a cotton swab to melt off the lower edge without disturbing the cheek prosthetic underneath. Sealing the cheek with Pros-Aide before applying the eye bag also gives me a bit of a barrier to help keep me from melting a hole in the cheek's encapsulating plastic.

Your actor can keep their eyes closed to protect from fumes when blending most of the eye bags, but the area just under the eye has to be done with the eyes open. I like to use a small brush instead of a cotton swab to blend this area. To keep the fumes from irritating the eyes, use a small handheld fan or hairdryer on low (use one with a cool shot option) to blow air sideways across the face. This part of the application won't be fun for your actor, but the airflow keeps it from being painful. Their eyes may still tear up a bit so have a tissue at the ready.

With the prosthetics in place, I decided that Jorge's cheeks needed a bit more texture. I applied more stretch and stipple to this area, not expecting to see much wrinkling but more to achieve a consistent overall look. Be careful not to disturb your prosthetics.

Painting the prosthetics is done similarly to the previous two sections, using spattering and very light brush work to create a natural skin color. Resist the urge to fill in the wrinkles with dark painted-on lines; the makeup will start to look fake. You can, however, accent them with thin washes of color on a fine brush. Once the color match is complete, you can add fun details like age spots, broken capillaries on the nose,

etc. Use a cream makeup product under the eyes to avoid issues with fumes. At this point you can also add some light aging to the hair. I like to use alcohol colors for this, brushed on with a fan brush, but you can use creams as well so long as you apply them subtly. If you need to completely change the color of your actor's hair, a wig will be much more effective than trying to color it by hand.

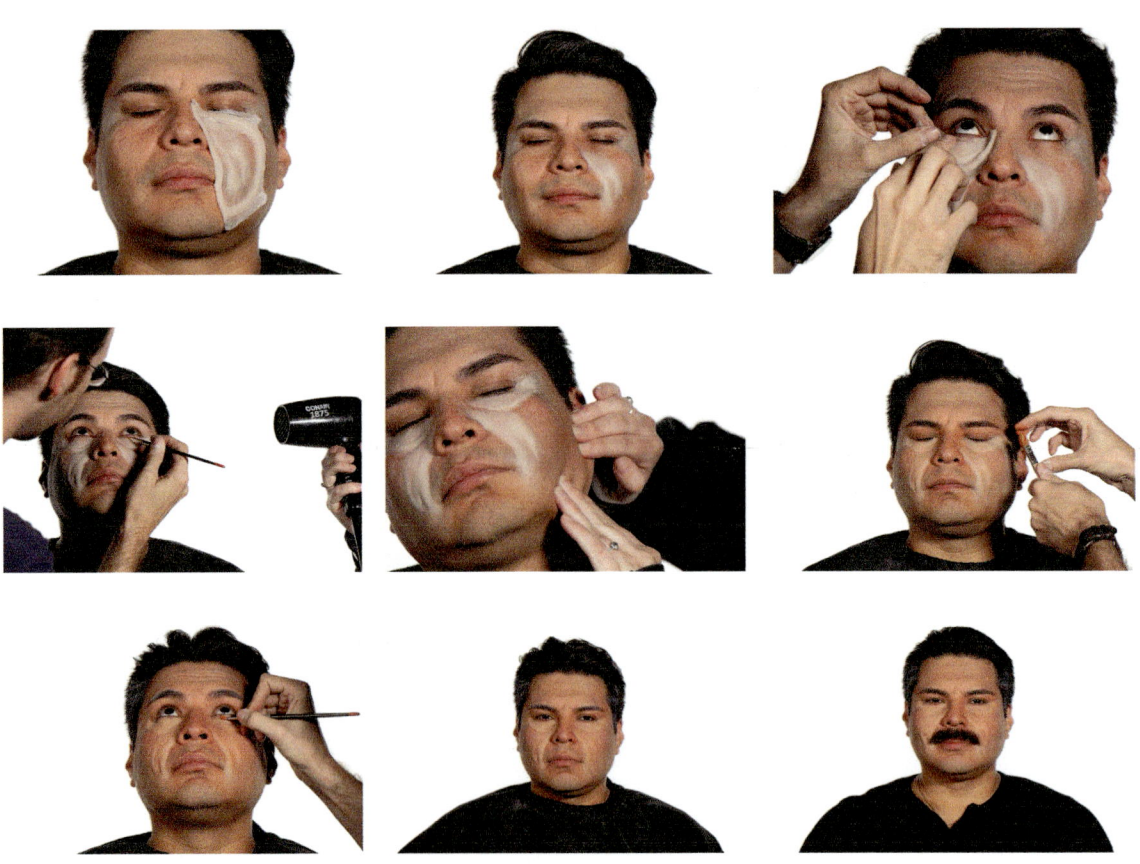

During the application I didn't apply anything to the upper lip because Christine and I decided that a mustache will help to add a little more age and complete the character. Christine hand-laid a mustache with **crepe wool hair** – a procedure that will be outlined in the next chapter, Chapter 17 "Applying Facial Hair."

This took Jorge to middle age, but I could have made him much older using prosthetics on the forehead, lips,

chin and neck. If you are doing an extreme old age makeup, consider yellowing the teeth slightly since most old people don't still have dazzling teeth as they age. You can also use contacts to dull the brightness of a young set of eyes. You will find more information on working with teeth and contacts in Chapter 19 "Additional Character Design Techniques." Finally, don't forget to age the hands as well, either with prosthetics or stretch-and-stipple. Nothing gives away an old age makeup faster than a young set of hands!

17

Applying Facial Hair

In This Chapter

- **Lace Facial Hair Pieces**
- **Hand-Laid Hair**

Lace Facial Hair Pieces

Probably the quickest way to apply facial hair to an actor is to apply a pre-made piece. Typically, these pieces are created by taking either false or human hairs and individually tying them to a piece of lace – a technique called **ventilating**.

Facial hair pieces can be carefully measured and custom-fit to an actor – which is preferable, especially for a lead character because it ensures a more natural look once the piece is on. However, lace facial hair pieces are also widely commercially available, and there are certain techniques you can use to make them appear more natural. These lace pieces can be cleaned with alcohol and then, once dry, the hairs can usually be restyled. If they are human hair they can even be curled with tiny curling irons for a natural appearance. If the pieces are made with synthetic hair, I will simply comb them, and then pin them to a board, using the pins to force the hairs into the desired position and let them air dry that way.

Many adhesives are available for applying facial hair pieces, and the actor's skin type, the activity they will be doing in the scene, the climate, and the makeup artist's preference will all play a role.

In this demonstration, I applied a commercial mustache from a costume store to the model using **spirit gum** – this is a simple option and spirit gum has been used to apply facial hair for a long time.

If you've purchased a commercial lace facial hair piece, it may come with a waxy, stiff coating on the hairs and the hairs will likely all be one length. Start by combing the mustache with a fine-toothed comb or mascara wand. Then, take a set of taper shears and use them to break up the even-ness of the hairs for a more natural look. Taper shears have notches that chip into the hair in an uneven way and they can be incredibly helpful when working with artificial facial hair.

Clean the model's skin with alcohol and a powder puff or sponge (not a cotton round or cotton ball because the tiny fibers can get stuck in the stubble.) Allow to dry fully.

Apply spirit gum to the skin. I personally like to apply a slightly larger area of adhesive than the area that the lace will cover – it is easier to remove glue from the skin than it is to add more under the edges of the lace once the piece has already been applied.

Apply the mustache, starting by applying pressure right in the center and working slowly outward. Press down on each side of the mustache, working towards the edges to ensure an even application of both ends.

Use a mascara wand to comb any stray hairs into the desired style and shape, and to fluff the hairs up for a natural effect.

If hairs extend too much over the upper lip, you can carefully trim them with a comb or a mascara wand and shears or small scissors. This will depend on the size of the actor's lips and the desired style.

The completed mustache.

To remove, use 99% alcohol and a craft brush. Work carefully, moving the brush back and forth along the skin and lifting the edge of the lace with the brush. Make sure the glue is fully dissolved before you begin to pull the facial hair piece away from the skin.

Applying Facial Hair 261

Hand-Laid Hair

There are instances in which you may not use a pre-made lace facial hair piece. For one thing, lace facial hair pieces may peel at the edges, especially if it is humid. They may not always look 100% realistic, because sometimes the hairs are too densely packed together in comparison to the actor's eyebrows or other hair. The facial hair effect may have been added last minute and you might not have time to purchase something or have a piece made. You might also want to use this hand-laying technique on stunt doubles to get a customized look that matches the actor they are doubling. Personally, I love the look of a hand-laid beard. It can be more time-consuming, but I find it looks realistic and it is easier to customize.

Hand-laid beards can be created with different types of human hair or synthetic hair – in this example I used crepe hair, which is made from wool. I thoroughly enjoy prepping crepe hair to be the proper texture for the actor and mixing several colors of hair to create a natural-looking color blend. Though it may take a while – especially at first – with practice, you will be able to perform this technique efficiently.

When you purchase crepe hair, it will generally come in a braid.

Pull this braid apart and cut off the section you will be using. When I "prep" crepe hair, I usually want to loosen the braided look.

To do this, wet down the hair that you will use with water. Hang it to let it dry a bit and gravity will pull out the kinks. You can then spread the hairs out on paper towels to let them dry completely.

For this application, I used Pros-Aide prosthetic adhesive for the beard, but you could use a silicone adhesive or spirit gum as well.

With Pros-Aide, paint it on, and give it a moment to dry and get tacky. If it's too liquidy, the hair will fall right off. It starts to turn clear as it dries.

The most important thing when laying facial hair, is that it looks like it is *growing out of the skin*, rather than stuck to the skin. So the ends of the hair fibers must be perpendicular to the face.

To achieve this, cut the section of hair you are using in a perfectly straight line so no hair strands bend and adhere sideways to the face. You must do this with every single section.

Starting at the sideburn, and continuing in a row down the chin area, apply sections of hair perpendicular to the skin. The in-process will look crazy, but let it stick out sideways as it dries, because once it's adhered well, you can comb it down for the most natural effect.

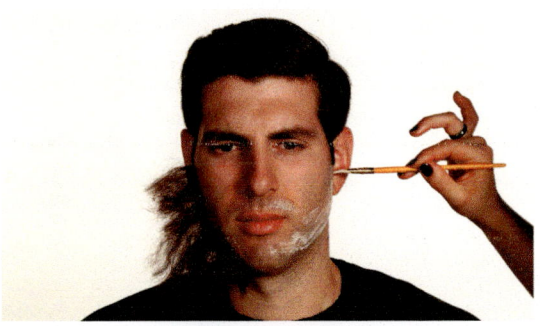 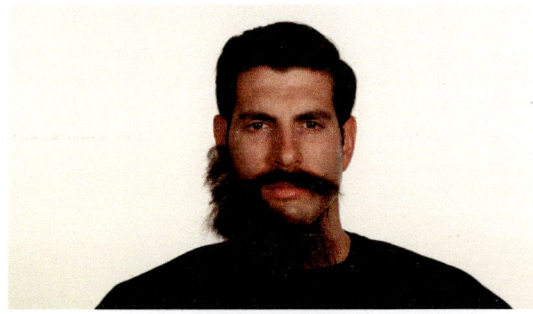

I start with the chin strap "neck beard" area, all around the face and work the face in layers.

These layers can intersect under the chin and at the side of the mustache.

Continue to apply hair over the mustache area. It will stick out straight over the upper lip and be quite itchy for your actor until you trim it.

I like to do the entire mustache all at once, because it minimizes the time that the actor is uncomfortable.

Applying Facial Hair 263

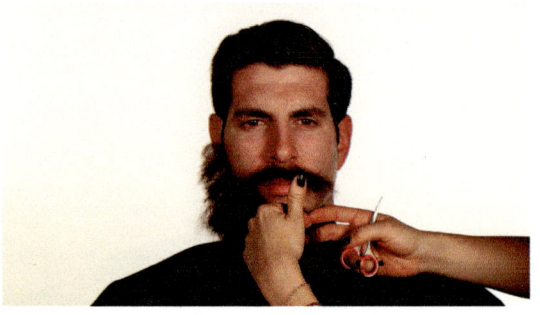

Continue applying hair around the face.

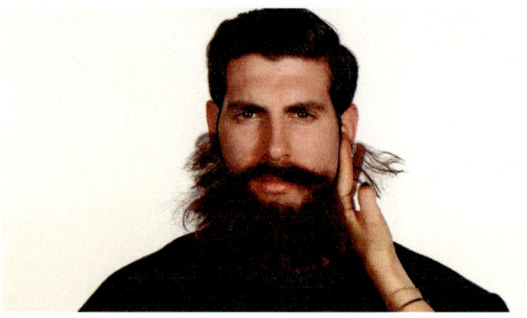

Always hold the hair sections in between your first two fingers – this ensures that the sections adhere in a straight line, rather than shifting. It also helps you avoid getting glue on your fingertips.

At the edges, you may use a plastic palette knife or the end of your brush to add pressure to the hairs and make sure they are stuck on securely.

Once the full beard is applied, use your electric trimmers and a comb to groom the commercial facial hair the same way you would with natural facial hair. It is especially important to blend the added beard with the natural sideburns in this way.

Warn your actor to keep their mouth closed and groom over the upper lip to create a defined mustache. Even if the look is a little more "unkempt," I will still perform this step on the mustache because otherwise some hairs will be too long and it will be uncomfortable for the actor, and unnatural looking.

Make sure to carefully clean your trimmers after this step. Some artists even have a set of separate trimmers that they only use on commercial/artificial hair.

You can use shears and taper shears for this step as well, depending on the effect you want to achieve with the beard.

264 **Technique**

Let's say you want the beard to look somewhat scraggly, as I did with this look. A great way to achieve that is to take hair fibers, and chop them up finely. Apply some Pros-Aide to a craft brush and then use that brush to pick up hair fibers and tap them gently on the skin. This is my favorite technique for creating stubble! You might even find yourself using this procedure on an actor if he has a scar you want to cover with hair, or if he chips too far into his own scruff while shaving himself!

If the Pros-Aide appears shiny once dry, powder it with an HD translucent powder.

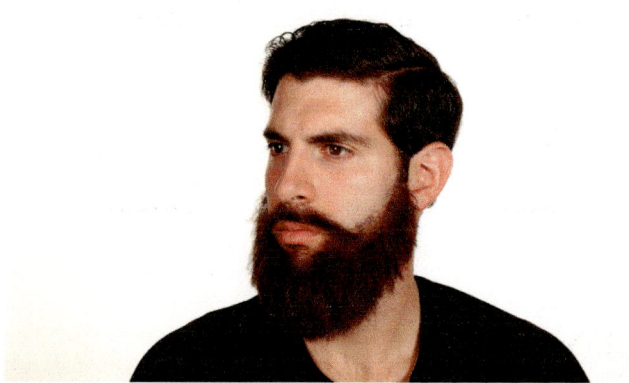

The completed beard!

I wanted this beard to remain full and messy (although a character who had this beard likely wouldn't have such a clean haircut as our model, so it would be a great opportunity to collaborate with the Hair Department!)

Applying Facial Hair 265

Dirt and Sweat

In This Chapter

- Dirt
- Sweat

Dirt

There are countless situations in which you may need to make a character look dirty – *realistically*. Based on the story, consider why you need to make them dirty. Are they homeless in a city? Are they a cowboy? Are they lost in the woods or stranded on a desert island? Just finished playing a game of baseball? What is the weather like? All of these scenarios will have different effects, different colors of dirt, different levels of humidity. Below is the basic procedure for making someone generally dirty, imagining that he has been living outside for a long time, perhaps lost in a forest, and has made the woods his home.

You will see the hand-laid beard from the previous chapter, and the rough effect it offers to the overall

> *we use many different techniques to create one cohesive character.*

look. In Chapter 19, we also add to this look by staining the teeth to look as though they have begun to decay. This multi-step design is a great example of how we use many different techniques to create one cohesive character.

This procedure can be adjusted for any type of situation. For instance, someone spending lots of time outside would have a dryer, more dusty look and a lighter color of dirt. If they have not been outside for a long time, but maybe just got a bit dirty, you wouldn't have as much dirt and grime settled into the ears and nails. As with every look, simply do lots of research! I suggest even visiting the location or communicating with your Set Decorating Department to find out the color of the environment.

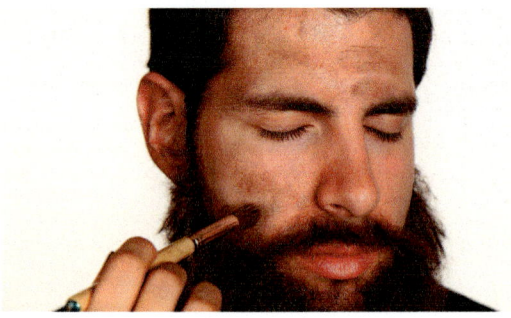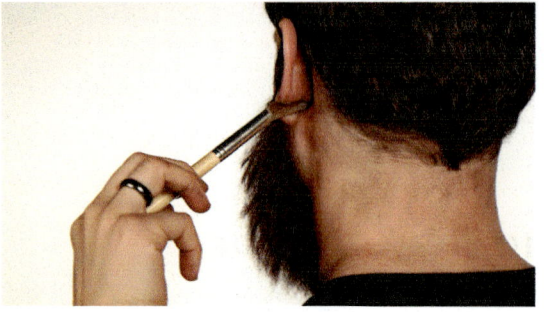

Here, I began with the Skin Illustrator "Grunge" palette and layered several of the alcohol-based colors together using a stippling brush. Buff your first thin layers on in a circular motion, creating *uneven* product distribution.

The design was for this character to have not bathed in several weeks, so dirt should be settled into all the grooves of the skin – including the ears.

Wiggle the brush in back-and forth, and use buffing, and stippling motions – variation of hand movements will create a natural-looking texture and diminish the appearance of brush strokes.

Work your way around the back of the neck, allowing product to settle into any wrinkles in the skin. Make sure in the neck area, you bring the makeup down below the edge of the costume – I only use alcohol-based paint for this so it doesn't rub off on the clothes. Don't forget the backs of the ears!

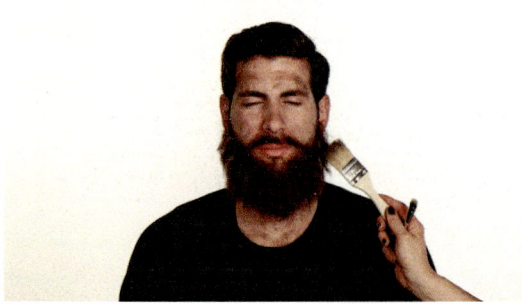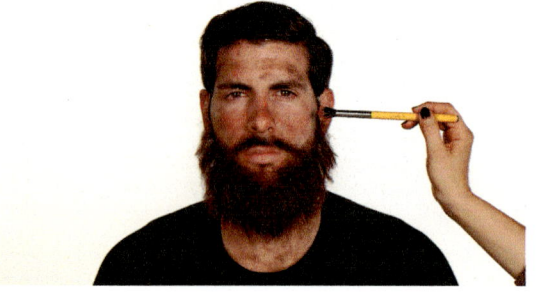

Once you have roughed color in with paint, you can add a layer of powdered dirt for more texture – I also like to add this into the facial hair itself to give a matted look.

I stippled a bit of redness onto the model's cheeks and nose for the appearance of sunburn.

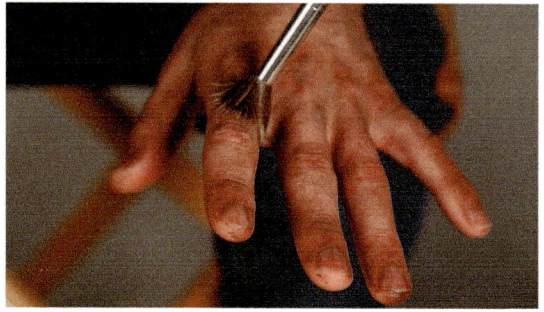

Don't forget the hands! Appropriately dirty hands go a long way in telling a character's story realistically. Here I used the Skin Illustrator Grunge palette under the nails and in the grooves on the skin.

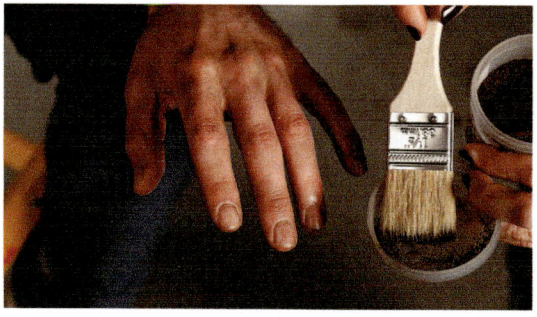

You may use a chip brush to dust the right color of dirt powder over the actor – this is especially if the dirtiness should look dusty or matte, rather than greasy.

Completed "dirty" look. You'll notice I put a bit of concealer over the lips to make them look dry. Another effect I used was to have the model wipe his own brow as if he were wiping off sweat – this allows for a natural fingerprint on the forehead.

Dirt and Sweat 269

Sweat

Characters may be sweaty for any number of reasons. This is a common request if a character is running, if they are stressed, fighting, vomiting, or even in the middle of an intimate scene. The key with your sweat designs is realistic placement.

It is a pet peeve of mine when I see actors who are sweaty all over the cheeks and chin but then have a totally dry head and neck for example. Learn where the sweat glands are and which areas sweat the most so you can realistically create the effect.

To achieve sweat, several different methods are common.

PERSPIRING ANATOMY

Temperature

Sweat

Sweat Secreting Cells

Skin

Hair Shaft
Pores
Epidermis
Dermis
Hypodermis
Muscle
Blood Vessels
Hair Follicle
Adipose tissue
Sweat Gland

One option is to stipple glycerin, or a mixture of glycerin and water straight onto the skin. This can be great for sweat that is just beginning to appear, such as in vomiting or stress. With a small stipple sponge or brush, it is easy to concentrate sweaty areas such as the brow, hairline, or bridge of the nose.

You can also add a bit of natural body oil to the actor and then mist them with a clean water, such as Evian natural mineral water facial spray. The oil on the skin causes the water to form beads and glisten. This is an excellent effect if someone is playing sports or working out and needs to have a general wetness and shine. Just be careful not to get your actors so greasy that it inhibits performance.

Some companies make products specifically for creating sweaty looks. Those can be fun to experiment with as well. Try out Mehron's Sweat and Tears Special Effects Liquid or RCMA Artificial Tears and Perspiration.

> *"Characters may be sweaty for any number of reasons. This is a common request if a character is running, if they are stressed, fighting, vomiting, or even in the middle of an intimate scene."*

Dirt and Sweat 271

Additional Character Design Techniques

Today, tattoos are the most popular form of permanent skin art, with an estimated eighty million people in industrialized countries sporting some form of 'ink.'
– Nina G. Jablonski

In This Chapter

- **Covering Tattoos**
- **Adding Tattoos**
- **Nails**
- **Teeth**
- **Eyes and Contact Lenses**

Covering Tattoos

If I had a dollar for every tattoo I've covered in my career, I'd probably be the richest woman in the world. Tattoos are incredibly common, with many actors now having at least one somewhere on the body. "Today, tattoos are the most popular form of permanent skin art, with an estimated eighty million people in industrialized countries sporting some form of 'ink,'" writes Nina G. Jablonski (150).

You may encounter any of these reasons – or a combination of them – for why you would want to cover a tattoo on set:

- The film is a period piece and the tattoo is not historically accurate for that period or culture.
- The style of the tattoo just doesn't fit with the overall "vibe" of a character.
- The stunt double is tattooed but the principal actor is not, so you must cover the stunt double's tattoo to match their actor.
- The production does not have legal clearance to use the image. Tattoos are the property of the tattoo artist who did them – even if that was decades ago. The production can encounter legal issues if they use the intellectual property of the tattoo artist on screen without written

permission, so it may be easiest to cover the tattoo. If the actor does have a tattoo that is period-appropriate and fits their character, the director may want to showcase that tattoo. In this case, it is the responsibility of the Makeup Department to obtain clearance in the form of paperwork and a signature from the tattoo artist. Talk to your production to get documentation you need if you want to obtain **tattoo clearance**.

If you need to cover tattoos, there are many products and procedures you can use to do so and every artist has their own process that works for them. Experiment and find what works best for you. Some companies make cream makeups that boast they can cover tattoos in one step. I always find it's better to neutralize and color correct first – especially if the ink is black. That greenish-blue undertone is *strong*. With cream makeup, even if the product has been sealed, you still run the risk of the product rubbing off on the costume or the bedsheets if the actor is doing an intimacy scene. Although it takes a bit longer than using creams, my preferred method of tattoo coverage is to use an alcohol-based paint such as PAX, Skin Illustrator, or European Body Art and build up several layers. These paints are less likely to smudge and they just take a bit of practice learning to create the layers. For the demonstration below, I used Skin Illustrator solid alcohol-activated paints.

A note on brushes and Skin Illustrator:

Dense brushes work if using one thick coat of Skin Illustrator, but they can be difficult to work with for tattoo covers. When working in multiple layers, as is needed for a tattoo cover, a dense brush can make your layers too thick, meaning the application is more likely to crack apart. Dense brushes can also pull away your product as you add your next layer, ruining the work you've already done. A fluffier, synthetic, duo-fiber brush is great because it allows you to work in three or four thin coats as well as to stipple for your last step to realistically blend with the skin's varied texture.

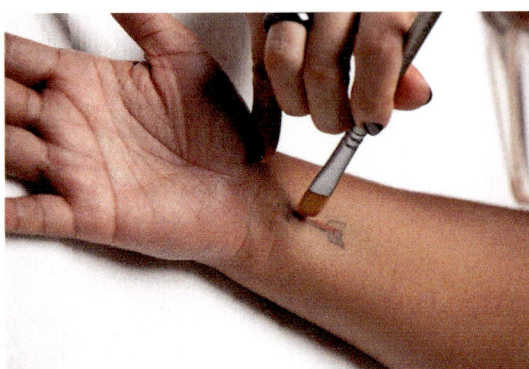

Tattoo A: Neutralize greenish-blue using orangey-red

First identify the dominant tone of the tattoo – reference a color wheel or your Flesh Tone Color Wheel if necessary. **Tattoo A** has a greenish-blue undertone – as most tattoos done with black ink do once they are healed and faded a bit.

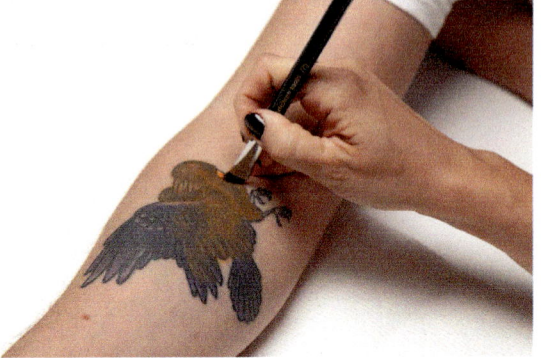

Tattoo B: Neutralize purple using warm gold

Tattoo B contains a lot of purple ink, so we color-correct the purple as the predominant tone.

Color correct this tone using a light wash (does not need to be a full coverage in this step!) Let this layer dry completely (it doesn't take long if you aren't using too much product!)

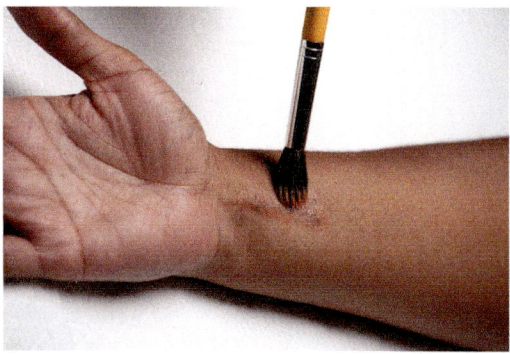 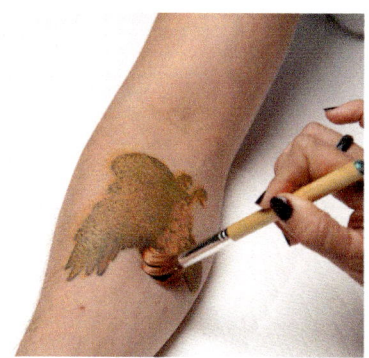

Tattoo A: The model has a rosy undertone

Tattoo B: The model has an olive undertone

Using a **stippling** motion, not a painting or wiping motion, add another thin layer. This layer should be the color of the actor's *skin's undertone* (i.e. rosy, olive, golden, etc).

Apply – using a stippling motion, not a painting or wiping motion – another thin layer. This layer should be the color of the darker parts of the skin area (note that Skin Illustrator dries down a bit darker).

Stipple on the color of the lightest areas in the surrounding skin

Work quickly and in thin layers – Illustrator can be counter-intuitive; the more product you use, and the slower you work, the more likely you are to pull layers of product *off* the skin.

Additional Character Design Techniques

Blend by stippling out around tattoo

If applicable, add freckling and/or veining to blend with the skin's texture. A great technique for this freckling is to flick paint on using a chip brush.

Veins can be painted on using a very sheer wash of paint to match the model's natural vein tone.

Skin Illustrator does not need to be set with powder (and you do not need to powder between each layer). If it's very humid outside, you may want to use a setting spray (you do *not* always need to!) – use an oil-free spray formulated for FX makeup, such as Green Marble Selr or Bluebird FX Matt Sealer.

Some extra tips and tricks:

- If the actor has more than one tattoo, work layer-by-layer on all the tattoos at once. For example, color correct *all* tattoos, then go back to the first one to add the next layer, then the next, then do your stippling on top of all of them all at once. This allows the tattoos to dry in between layers so you aren't wasting your time standing over them with a fan waiting for them to dry!
- Use one stippling brush for color-correcting, then set it aside, use another stippling brush for the rest of the application – this ensures that your correction tone doesn't blend into your top layers and create a blob with a strange cast of color.
- Skin Illustrator essentially creates a layer of plastic on the skin – this means it can crack and separate when the body moves, similar to a tattoo transfer. Sometimes it can be helpful to have the actor move their arm throughout the application, so the skin can stretch in different positions.
- If the actor has arm hair or neck hair in the area where the tattoo is being covered, use a mascara wand to comb out and clean off hairs in between each layer. This will avoid the hairs getting caked into the makeup, and will clean excess product off the hair, preserving a natural look.

Adding Tattoos

Humans get tattoos for countless reasons and different styles and techniques have been popular at different points throughout history. You will find

K.D. 151 Tattoo Pens

yourself frequently adding tattoos to help establish a character.

If the design is something small that doesn't need to repeat in any kind of continuity, you can simply paint it on with an alcohol-based paint, or draw something on with a tattoo pen such as K.D. 151 Tattoo Pens, created by makeup and makeup effects artist Ken Diaz. The pens are available in various colors and ink opacities for a realistic look. They are also great to keep in your set bag in case you need to touch up a tattoo transfer throughout the day

If the tattoo is a featured piece that is going to be continuous, the best bet is to custom design the tattoo based on the character and story.

Tattooing was an integral part of most human cultures for thousands of years, but it clearly fell out of favor in most of Europe in the early Christian era, probably for reasons related to the biblical injunction against it. In subsequent centuries, the Western world came to associate tattooing

Additional Character Design Techniques 279

either with the somewhat disreputable and marginal elements of society, such as prisoners and prostitutes, or with the primitive and the exotic, given the persistence of tattoos in other cultures around the world…

Tattoo designs – once imprinted on the skin – can be indelible reminders of a significant life event. They explicitly lack the transience of the souvenir t-shirt or a temporary hair color. In an increasingly globalized world of look-alike clothing, cosmetics, and hairstyles, tattoos are permanent reflections of personality, carefully calculated representations of core beliefs and sentiments that can make a uniquely powerful statement of individuality. For many, tattoos signify a permanent and visible commitment to a group or class and thus serve as a badge of affiliation or disassociation ... Modern tattoos are classified by style, with traditional, tribal, and gangster styles among the most popular

(Jablonski 152).

When designing your tattoo, you must consider the style and what outcome the design will have as far as establishing the backstory. I think this process can be really fun. It's the perfect time to head to your local library and get specific with researching. Perhaps you've learned from the script that an elderly man was in the Navy during World War II. The script mentions a tattoo on his forearm. Research what tattoo images were popular for sailors during the time he was in his service. Then, consider this tattoo has now aged almost 80 years and this gentleman would likely be in his 90s. So the appearance of the tattoo should be very faded and blown out – if he got it on the ship, it likely wasn't the best quality job to begin with.

As the makeup designer, you can have the tattoos designed and printed by someone else – an artist who you know who provides this service, or a company who prints custom tattoos such as Tinsley Transfers. You can also do it yourself, by printing the design on transfer paper! I love to design tattoos, so I try to do this procedure myself as often as possible. You can purchase transfer paper from a professional supplier such as Naimie's Beauty Center or Frends (in person in Los Angeles or online) or even a commercial brand such as Silhouette that you can find in a craft store or on Amazon will work.

Once you have your tattoo drawn and designed, transfer the file into Photoshop or another image-editing software to adjust the color and the softness as necessary. You may want blurred lines. If it is a black ink tattoo, it may have faded to that greenish-blue we see quite frequently. Tattoos that contain lettering must be flipped in the design so that when they transfer onto the skin, the letters are facing the correct direction. Once you are happy with your design, you can print it on the transfer paper using a regular inkjet printer.

Below is the procedure for adding tattoo transfers with Pros-Aide adhesive, which looks more realistic and lasts longer than the commercial tattoo transfer paper adhesive. I imagined that this tattoo was obtained within the past year, so the colors are still vibrant and the lines are still crisp.

Start with your tattoo transfer face-up. Cut out your tattoo design, paying close attention to the details – if the outline of your design is more detailed, you may use a blade on a cutting board. You need to leave a very thin border – if it's too wide, the border around the tattoo will discolor on the skin. If you do not leave a border, however, you will not be able to pick up your tattoo without ruining the ink.

Lightly apply a thin layer of Pros-Aide to the tattoo using a sponge in a very gentle tapping motion. Too much Pros-Aide, or too much pulling action with the sponge will cause the ink of the tattoo to smudge.

Allow to dry *completely* until the Pros-Aide is fully translucent.

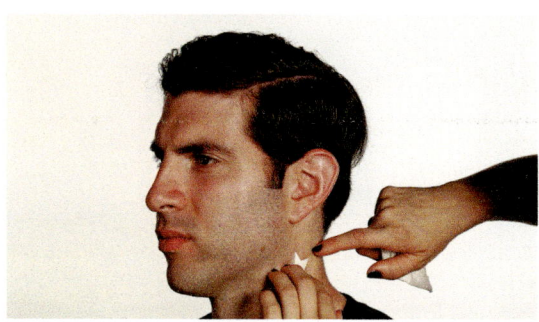 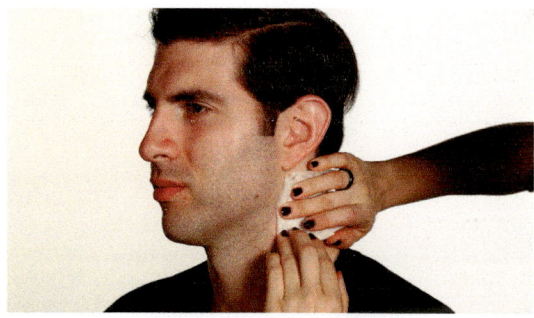

First, cleanse the skin thoroughly with alcohol and a sponge.

Then, carefully lay the tattoo transfer down on the skin.

Apply pressure with a wet towel. For a tiny tattoo like we used here, it may be okay to use paper towel, but for a larger piece, you would want to use a real towel, dipped in a bowl or cup of warm water to fully and evenly saturate the back of the paper. Be careful not to make the towel too wet or to get water between the transfer paper and the skin, as these mistakes will cause peeled edges or bubbles under the tattoo.

Additional Character Design Techniques

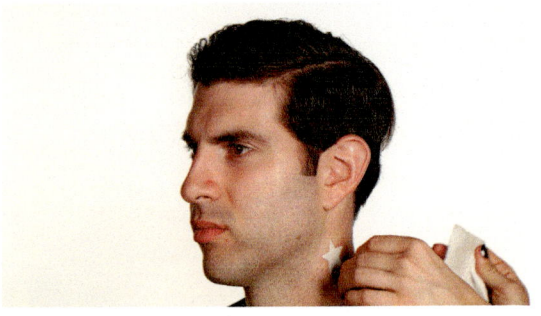

Once the tattoo transfer paper is evenly saturated and the ink has separated, slowly peel the paper backing off.

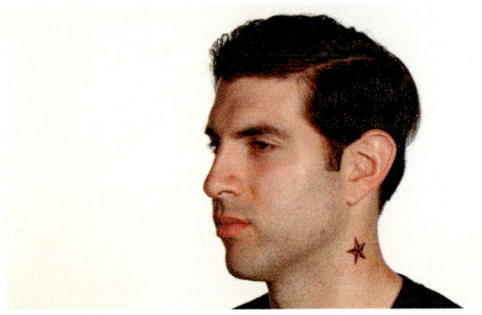

Allow the area to dry completely. At this point, you may use a small brush and 99% alcohol to remove any excess Pros-Aide from the skin around the tattoo itself.

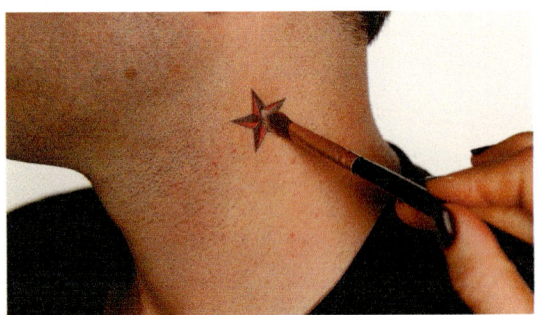

Once the tattoo has dried, apply a tinted powder to mattify the transfer and give the appearance that the tattoo is sitting under the skin. Depending on the weather, you may also want to seal the tattoo or to apply an anti-shine over it.

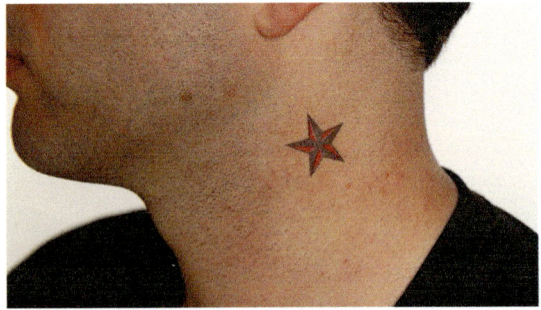

Finished Tattoo

Nails

On film and television sets, nails are considered part of the makeup design. Sometimes, this includes polished nails which you may be painting yourself. In other instances, you may send your actor to a nail salon to have a set of fake nails applied if that fits the character. Even if the design for the nails should be totally bare, dead skin and uneven nail shapes can be distracting if they don't fit that character's story – especially in a close up on their hands doing something important! Giving an efficient manicure is a skill that is often not discussed, but is essential to your work as a makeup artist.

Get in the habit of checking your actors' hands to make sure they look good and to include the hands in the continuity photos so you know what their nails looked like on a given shooting day.

Nails are part of the **integumentary system**, the same system as the skin and hair – they are also made up of keratin protein. The nail plates grow out of a fold of flesh at the base of the nail called a **cuticle** much like paper being fed through a printer (Parker 165). Most of your nail is attached to the nail bed until the **free edge** (the light-colored part of your nail that extends past the fingertip). In humans, the biological purpose of the free edge is quite simply to protect the tip of the finger – it may break or get cut off before your actual finger does.

Of course, nails have taken on many meanings in different cultures beyond simply as tools for survival. The style of someone's nails can speak volumes about their character. Perhaps this person values long acrylic nails with flashy nail art – that would be a much different character than someone who wears their nails short with chipped black nail polish. Nails can also speak to period styles and even to gender norms and other subcultures.

Keep in mind, there are frequent instances in filmmaking when hand-doubles are used (for example – the character is a concert pianist but the lead actor doesn't play piano. Production will shoot the close-up hand movements of an actual concert pianist playing, to lend a realistic effect.) Always study the hands of the principal cast member and their hand double and do what you need to do to make the hands a perfect match – this usually includes shaping the nails to be the same shape and length.

If you don't currently do nails, begin practicing on everyone who will let you! Makeup Department shapes and paints nails incredibly often, and you never know when there will be a close up on actor's hands. Sloppy nail polish and uneven, jagged claws on a wealthy socialite can totally take the audience out of the moment.

> *"Nails can … speak to period styles and even to gender norms and other subcultures."*

Basic Manicure

Even if nail polish is not involved, you will find yourself needing to make an actor's hands look nice on camera for a close-up – this holds true regardless of their gender. I once worked with a chef who had his hands featured in a close-up for a knife commercial. I gave him a quick and simple manicure, following the steps below. That way, the focus stays on the action or product (the knife) rather than on his cracked skin or hangnails.

Remove existing nail polish with nail polish remover

You may find it valuable to keep individually wrapped nail polish remover pads in your kit or set bag in case you need to quickly remove someone's polish on set.

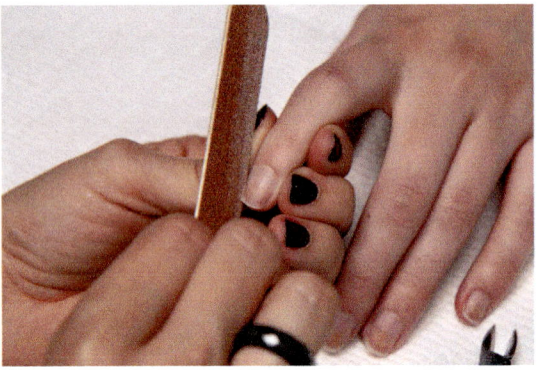

File nails to desired shape

Buff nail in a side-to-side motion, starting with the strongest grit and then progressing to finer grits

Working in an upwards motion, use the side of the buffing block to smooth the free edge of the nail and remove any excess skin

Apply a cuticle oil or cuticle removing cream to cuticle area.

Allow fingers to soak in a bowl of warm, soapy water to cleanse the nail area and soften cuticles. Then, brush nails with a nail brush to clean off debris and dead skin.

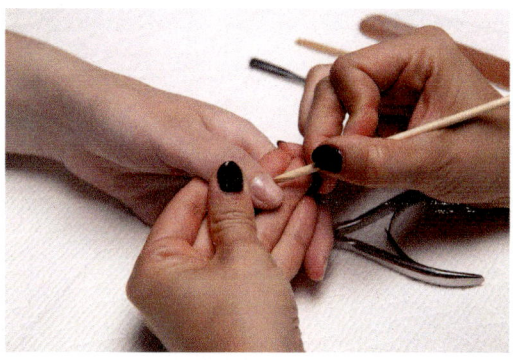

Using a sterile metal cuticle pushing tool, or an orangewood stick, push cuticles back gently away from nail bed and clean out around the nail and under the free edge.

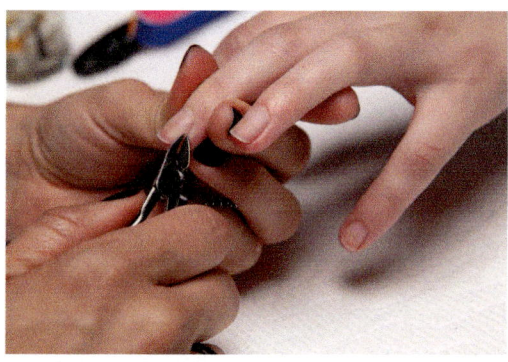

Trim hangnails or dead skin from nail area. Keep the point of the cuticle nippers pointing up and away from the skin to avoid cutting the actor.

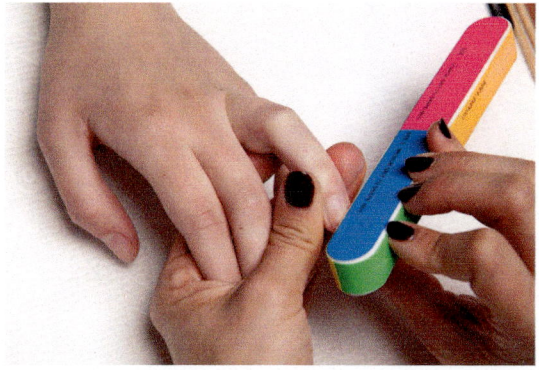

Buff and then shine the nail with a buff and shine block

Massage hand lotion into the actor's hands and you are all done!

Additional Character Design Techniques 285

Teeth

Although white teeth are valued in contemporary society, there are many film and TV characters whose teeth should not be white. The character may be a smoker and you'll want that nicotine stain on the teeth. It may be a period piece where oral hygiene was not as advanced as it is now. Or you may need a dramatic effect of decay for a zombie or a pirate. Luckily, you have many options for coloring the teeth to specific characters

"The crown's outside layer is made of a tough bonelike material called enamel, which is the hardest substance in the body ... made of U-shaped enamel prisms packed with the crystalline mineral substance hydroxyapatite" (Parker 192). This enamel can be easily painted to achieve different effects.

One of the most basic tooth coloring procedures is to paint directly on the teeth. This process is fairly simple. Ben Nye and other companies make temporary tooth paints that are safe for the actor and brush off easily. Several colors are available for different effects, including a brown "Decay" tone (pictured below), a commonly-used "Nicotine" stain, even a green "Zombie" color and more! Make sure you always have a toothbrush, toothpaste, and floss on standby for the actors' comfort after the scene.

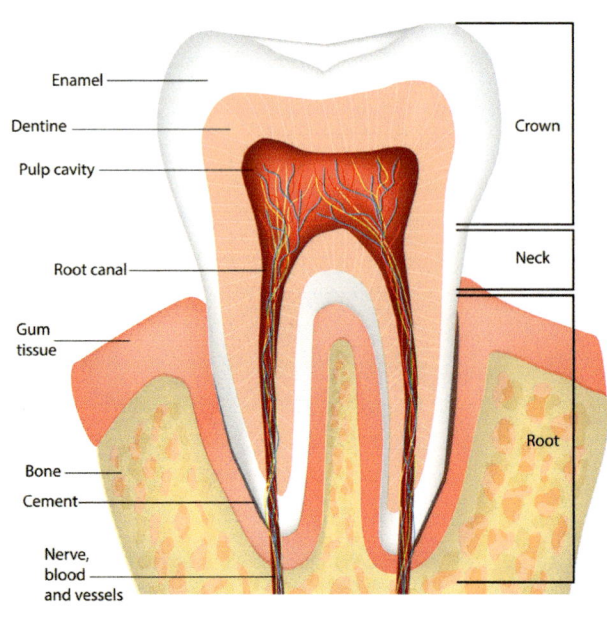

Anatomy of the tooth

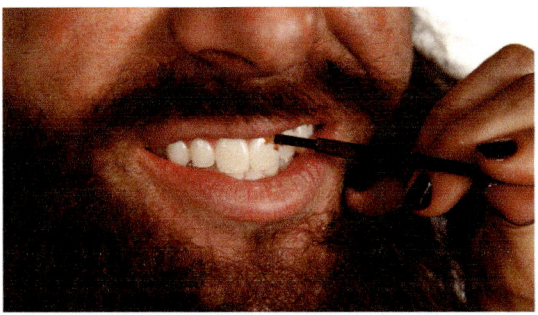 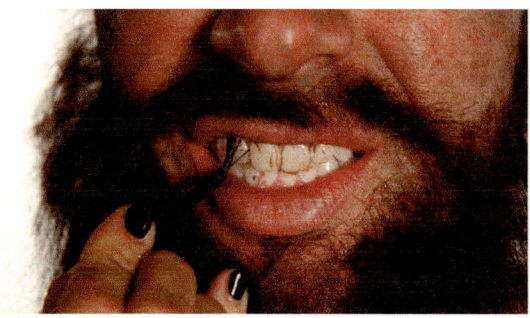

First, dry the teeth with a cotton swab. Then, using a disposable brush, apply your temporary tooth paint.

The actor may need a few breaks during this, as they need to keep their mouth open. Work quickly.

Concentrate on areas where plaque and decay settle in – around the gums and between the teeth first. These will be the worst-looking spots.

You can use a doe-foot applicator, cotton swab, or another brush to move the paint into desired areas and wipe it away from others – work quickly as it dries fast.

Once the teeth are complete, clean excess stain off the lips.

In the event that you need a more consistent or more specific look, you can have veneers or false teeth made for the actor.

I caught up with Special Effect Makeup Artist and owner of Kosart Effects Studios, J. Anthony Kosar, to ask him about his experience working with teeth.

Anthony, we recently worked together on a project in which you created a gold tooth for one of the cast members – tell me about that process.
To create a gold tooth, we just life-casted the actor's upper palate in dental-grade alginate and figured out which teeth he wanted. I had to run around a little – I went to one jewelry place which didn't exist. I found a place in Florida who could cast the tooth but they weren't sure they could make the turnaround. I ended up finding a place here in Chicago who did it, but they referred me to a dentist who had someone who worked in his lab and could make the tooth with a quick turnaround of just a couple days. I did a back-up just in case we couldn't get the gold tooth in time – I made a set of dental veneers for which we used vacu-form plastic and painted one tooth gold but we didn't need the backup veneers.

The actor just pops the gold tooth on and off his own tooth. He keeps it in his set bag (in a case) and the Makeup Department cleans it daily.

What is the process like making a full set of veneers, such as the set you used on this show?
To make the full set of veneers, we did an upper and lower dental impression. After we got the dental

Additional Character Design Techniques 287

impression with the alginate, we filled it with dental stone and made a master set of [the actress's] upper and lower teeth. We got rid of any undercuts and cleaned up any imperfections, then we made a mold of that and cast it in 1630, which is a very hard resin. Then we used .20 splint material and dental vacuform. After we vacu-formed it, we started the process of making sure it was comfortable for her and fits her like a glove. It's very thin plastic so we had to keep cutting bits away until it would fit the way it needed to without inhibiting her speech in any way. Once we got that figured out, I stained it with acrylic tooth stains. They are acrylic paints from PPI and they have lots of nice colors. She just pops the trays in and out [like conventional orthodontic retainers]. At first, she took a set to practice with and they didn't inhibit her speech at all, but they were still cutting up the back of her mouth a bit because her character does a lot of eating, and that's a whole different movement of the mouth and tongue. We cut some more off so they were comfortable and sanded down the edges for her – it's a pretty collaborative process.

What is your biggest challenge when working with teeth?
With teeth, the biggest challenge is the actor's comfort. It all depends on what they have to do. We've done things where people have to talk even with monster teeth in – so there's a balance of getting the veneers as thin as possible, making sure that nothing is inhibiting their speech with their tongue and the way that they articulate. Sometimes you can only go so far, so then it's up to the performer to practice with them and learn how to articulate with the pieces in.

Eyes and Contact Lenses

Nothing else shows thought like the eyes. They are the psychological center of the face, Pliny's 'window to the soul,' whose glow can speak intelligence and love. They are little pools of being, and they can bewitch us. The eyes are as close as we get to seeing a mind. … Hence the eyes are the most powerful and most intimate part of the face

(McNeill 22).

Because the eyes can express so much about a character, it is imperative that we know how to work with them from a character design perspective – and how to keep the actor's eyes safe.

An average eyeball is 1inch (25mm) in diameter and has three main outer layers: the clear, choroid, and retina. Near the front, the sclera can be seen as the white of the eye, and at the front it becomes the clear cornea. The main bulk of the eye, between the lens and retina, is filled with a clear, jellylike fluid known as vitreous humor. This maintains the eyeball's spherical shape"

(Parker 109).

"With teeth, the biggest challenge is the actor's comfort."
— J. Anthony Kosar

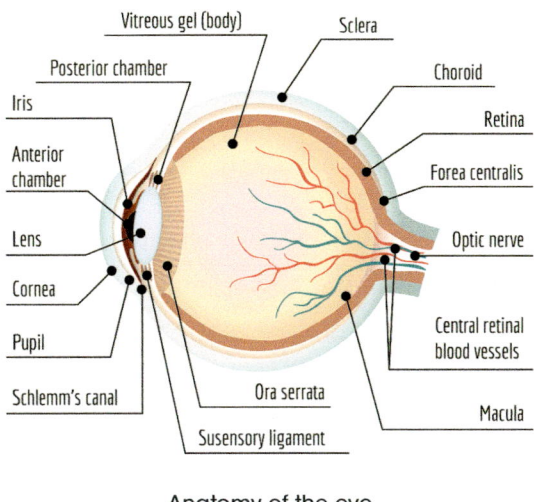

Anatomy of the eye

The most important parts of the eye we deal with in our work are the following:

> **Sclera:** Also known as the white of the eye – the tough protective outer sheath of eyeball
>
> **Choroid:** Blood-rich layer that supplies retina and sclera
>
> **Iris:** Ring of muscle that changes size of pupil to regulate amount of light entering the eye.
>
> **Pupil:** Hole in iris that becomes wider in dim light
>
> **Cornea:** Domed transparent 'window' at front of eye
>
> **Conjunctiva:** Delicate, sensitive covering of cornea and eyelid lining
>
> (Parker 108).

These structures may become inflamed or irritated due to environmental factors, such as pollutants or allergens or due to lack of sleep or drug use. "The choroid layer of the eye has a dense network of tiny blood

" *Because the eyes can express so much about a character, it is imperative that we know how to work with them from a character design perspective – and how to keep the actor's eyes safe.* "

vessels that provide the eyeball's other layers with oxygen and nourishment" (Parker 108). The eyes may feel dry or itch, or may appear red or watery. None of these effects are generally desirable for your cast members, so it may be up to you to offer some simple treatments for the eyes.

Eye drops are a common solution, with dozens of formulas available to address many different eye concerns. Stock a variety of eye drops in your trailer or kit, and always make sure you have some saline drops suitable for contact lenses. Individual travel-sized drops are great for actor bags.

The actor will often ask you to apply the eyedrops for them. In this instance, ask them to tilt their head

Additional Character Design Techniques 289

back and hold a tissue right beneath their eye. Hold the drop above the eyeball as you pull their eyelid open a bit. Do not touch the tip of the eyedrop bottle to the actor's skin or eye at all, to avoid contamination. Carefully insert one drop. Allow them to close their eye or blink to move the drop around in whatever way feels natural.

You will also encounter situations in which a character needs to be crying on screen. In this case, it is the responsibility of the Makeup Department to make sure the desired look is achieved.

Tearing of the natural eye is controlled by the lacrimal gland, which "is under the soft tissues of the upper eyelid's outer part and under the bony part of the orbit." Every day, this "secretes tears to keep the eye clean and moist" and with the help of "5–10 [lacrimal] ducts convey fluid to the eye's surface" (Parker 108). Tears usually pool at the inner corner of the eyelid, near the "lacrimal canals which collect tears draining through small holes in the corner of the eyelid." The effect of a single tear dripping down from the outer corner of the eye would only be achieved if the character does not blink and force tear fluid out of the eye. If the eye stays still enough, the tear will well up in the eye and be forced out from the outer corner. So if you are placing a tear with an eyedrop, make sure the placement of inner corner vs. outer corner of the eye is supported by the action of the scene.

In addition to placing artificial tears in the eye with a drop, there are several products you can use to stimulate the natural tear process of the eye. Most of these products contain menthol, so make sure allergies are not an issue. I try to only use these products when absolutely necessary as the menthol does irritate the eye a bit.

One common option is a **menthol tear blower.** A menthol blower contains acrylic glass and tiny menthol crystals. The open end of the blower should always be packed with cotton to filter the crystals, and some makeup artists will also put a cut piece of a nylon over the opening of the blower as well. This ensures that tiny menthol crystals don't fly into the eye and scratch the cornea. The makeup artist blows through the mouth piece to direct the vapors of the crystals into the actors' eye, stimulating tear production.

Menthol Tear Blower – Courtesy of Kryolan Professional Make-up

The other popular option is a menthol-based **tear stick.** This is a waxy stick, which rolls up like a lipstick and can be directly applied to the eye area, right along the lashline and edges of the eyelid. To keep things sanitary, you'll want to scrape some product off with your spatula and use a doe-foot applicator to apply it to the skin.

Tear Stick - Courtesy of Kryolan Professional Make-up

Experiment with each product and see which works best for you.

If I've been using either of these menthol options, I will make sure to have some soothing face wash and some lubricating drops on hand for the actor at the end of the day. You may also wish to re-hydrate the skin around the eye with a soothing eye cream.

Working with Contact Lenses as Part of Character Design
by Kimberly Boundas and Christine Sciortino

We have all seen **contact lenses** used on film and the dramatic impact they can have on developing a story. It may be that a character opens their eyes and suddenly we know that they are no longer the original character, but have transformed into a demon. Or perhaps, you simply have a flashback scene and the actor cast to play someone as a young man resembles him very closely – with the exception of his eye color – and needs colored lenses to change the color of his eyes. Regardless of how dramatic the impact or effect you are hoping to achieve, contacts can be a crucial part of character design which you must take into consideration.

Kimberly Boundas is a contact lens technician for film and television productions including *Nightmare on Elm Street* and *Fargo*. Kimberly says the best part of her job is seeing the dramatic effect of the character design achieved. "The Makeup and Hair team play such an essential role in a character's look," she says. "There's an overall excitement by the team for the actor. A complete transformation is created. The actor is in full character mode and there's a satisfaction for the work and time that has been set forth. It's very rewarding!"

Here, Kimberly offers some of her extensive knowledge on working with contact lenses and the importance of taking all the correct steps to ensure the health and safety of the actor's eyes.

There are two types of contact lenses that are most often used for film and television:

- **Corneal Lenses** – These are a traditional size, soft lens that covers the iris. This is often used for an actor to simply change the eye color.
- **Scleral lenses** – these are large lenses covering the entire white part of the eyes. They are used for a more dramatic effect such as a hemorrhaged, milky, jaundiced, or a black demon look.

Hand-painted lenses are often used and the attention to detail can be well worth the money for a production. To properly care for the lenses, always ask the manufacturer for the recommended saline solution – especially for hand-painted lenses, as the wrong solution may erode the paint. Preservative-free artificial tears are also helpful to reapply throughout the day for the actor's comfort.

The #1 most important rule of working with contact lenses for a film or TV production is for the actor to get a proper contact lens fit. Contact lenses are *not* one-size-fits-all. It is absolutely crucial that an actor get an eye exam for both proper measurements and for the basic health of the eye. A contact lens fitting is done prior to filming by an eye care professional for a TV/Film production.

If you are the makeup designer and there is not a separate Special Effects Makeup Department, it will be up to you to coordinate the fitting, purchase, and design of specialty contact lenses. You may need to organize an appointment for the actor to see an eye doctor in their location and then to get those measurements to the person or company creating the lenses. It is not safe to buy lenses online and assume they will work – custom-made, hand-painted lenses are a necessity for productions to keep the actors safe.

On-Set Protocol

When special effects lenses are needed, there must be an eye care professional on set for reasons of production liability and actor safety. A contact lens technician provides insertion, removal, and care of the lenses. Most importantly, a lens technician is there to care for the actors' eyes. Although the lenses are typically the last thing to be applied before the actor goes on screen, they can become uncomfortable. Actors wearing lenses and working long hours need extra artificial tears to lubricate the eyes throughout the day. Scleral lenses typically are worn 4–5 hours and then a break is needed. These

lenses are larger than a standard lens so they limit both tear production and oxygen getting into the eye. The scleral lenses can then be reinserted and worn for an additional 4–5 hours if the actor feels comfortable doing so.

The biggest challenge when working with lenses is the misconception that it is easy to wear and insert a contact lens. Productions believe the insertion should be quick, but it may take time to perform properly. It can take several attempts to get the contacts into their eyes in some cases. There are different techniques that work for different actors and finding the best method can take time – especially with an actor wearing lenses for the first time. Educating an actor about the lenses and building a rapport with them is important.

There is a degree of unpredictability when it comes to contact lenses. Occasionally, air bubbles form under the lens and a quick eye massage is needed. Weather can also play a factor. Wind, cold temperatures, and even the lighting of a scene can all dry out an actor's eyes. The contact lens technician must often be an advocate for the actor, looking out for them and the health of their eyes.

> *"The biggest challenge when working with lenses is the misconception that it is easy to wear and insert a contact lens."*
> *– Kimberly Boundas*

Conclusion

By now you know how to break down a script, plan a budget, find undertones based off a color wheel, create a bloody nose – and more! I hope that these skills serve you well as you move forward in your career. There is just one more bit of knowledge I'd like to share with you.

It would be easy for me to tell you that the most important lesson in the book is to "keep a positive attitude." But that would not be easy for you to maintain.

Inevitably, you would fall into a trap of falsehood, of people-pleasing, and self-abandonment, motivated by the fear of not getting the next gig.

So instead, the most important lesson I'd like to leave you with is: love yourself.

Sounds cliché, right?

The film industry involves long hours, demanding physical routines, and, as makeup artists, we are in close contact with others making it easy for us to absorb their energy.

You must hold yourself in the absolute highest regard in order to take care of yourself the way you need to in order to avoid burnout in this industry – or in anything else you do. You must love and care for yourself.

I do not mean "self-care" in terms of indulgence. I mean caring for and loving yourself as if you are your own little child. True self-care is not knocking back a few glasses of wine and a pizza in front of the TV, getting an expensive manicure or object, smoking in the bathtub, etc. These are distractions, and because you are distracted, you may temporarily feel good and able to manage the pressures of the job.

The film industry can be glamorous, yes, but we have all heard of countless celebrities who "have it all" but have sadly died of substance overdose or taken their own lives. If you're carrying pain, shame, or trauma from your past, the glitz, the money, and the ego boost of the film industry will perhaps distract you for a little while, but it will not fix it.

Sooner or later, our coping mechanisms break. You may find it harder to maintain healthy relationships, you may find yourself in chronic physical pain, and it may become more and more difficult to act positive at work, because you may not actually feel genuine joy and positivity in your heart.

To really bring an authentic positive attitude to the workplace, you must treat yourself with love and compassion of a strong and healthy parent when outside of work.

Nourish your body with healthy, anti-inflammatory food and beverages. Sleep as much as possible and rest when you feel called to. If it is difficult for you to relax without numbing substances, consider connecting with a therapist or trusted friend who may be able to help you explore why it is so challenging to feel safe relaxing into your body.

Perhaps there is a local group you could join where you feel comfortable expressing your emotions, either about your job or about other topics in your past or present. Unprocessed, stifled emotions create chronic pain and health issues, and those can be exacerbated at work or can even end your career.

When your body feels called to move, listen to it – through dance, yoga, exercise, sport – whatever works for you. If your body is aching, consider alternative medicine to shift old and stagnant energy such as acupuncture, somatic experience, or reiki, in addition to Western medicine.

Cultivate a practice of connecting to your inner world – this will help you be more present and more sure of yourself while on the job. Excellent techniques for this include meditation, breathwork, and journaling.

Consider starting your day with music that makes you happy, with an inspirational podcast, or with an affirmations track, so you can bring those positive thoughts to set with you. When you feel good about yourself at a core level, you naturally express kindness and respect to others. It will be genuine; it won't be a mask you wear for people to like you.

Learn to say no to every job, social engagement, or relationship that doesn't excite your soul. Know when you need to cut cords with people who drain your energy and instead invite friendships and relationships into your life that support you in being your true self. These people will be your best collaborators, because you are making art together, rather than fueling each other's egos.

You can't always choose the energy your actors and coworkers bring to the trailer, but you can keep your energy clear. Techniques I like for this are visualizing the water of my daily shower as golden cleansing light and asking it to wash away any negativity or imprints that aren't mine and taking salt baths and asking the salt water to purify me. Cry in the bath if you need to cry!

You can burn incense or herbs to cleanse yourself or you can try wearing protective crystals as jewelry or keep them on your station to shield you. Crystals are of the earth, so they hold the same energy of being out in nature which can be quite grounding in stressful work situations! You can research online or visit a local crystal shop for info on which may be right for you.

For smoother interactions at work, do some reading up on personal responsibility and interpersonal communication – my favorite books on this subject include *Conscious Loving: The Journey to Co-Commitment* by Gay and Kathlyn Hendricks, and *The Four Agreements: A Practical Guide to Personal Freedom* by Don Miguel Ruiz. Once

you begin taking responsibility for the energy you bring into every situation and the actions you do or don't take towards others, your relationships both at work and outside of work will become more harmonious.

Acknowledge and process what you carry with you. Avoid getting caught up in the ego, the money, the pressure to look and act a certain way. Your alignment and health are the most valuable things in your life – if you don't have these, no amount of money, Instagram "likes," or IMDB credits will fulfil you.

But, if you do your inner work and keep your energy clear and your body healthy, your self-love will shine from your heart like a light, seemingly effortlessly. Your happiness and groundedness will permeate your workspace and you won't have to "hustle" to get work because work that you are passionate about will naturally flow to you. You won't be faking a positive attitude because you will be showing up authentically in each moment, therefore staying true to yourself.

The people who accept you in all your forms will stay and you will create amazing art together. Those who don't will naturally fall away and you will have even more energy, because you won't be out playing a part, being someone those people wanted you to be.

Always come back to your heart. Heal everything that stands in the way of self-love.

I'm sending you so much love and support on your journeys – your personal journey, your career journey, and wherever they intersect!

Appendix

A Note on Harassment

Although the #MeToo movement, created by Tarana Burke, has been around since 2006, you may have first seen it when it was embraced by Hollywood actors and personnel in 2017. On October 15, 2017, it took off on social media and became a global sensation – thanks to one tweet. Actress Alyssa Milano, unaware of the origins of #MeToo at first, told her followers: "If you've been sexually harassed or assaulted write 'me too' as a reply to this tweet." More than 66,000 users replied and the tweet kicked off an online tidal wave overnight as women flooded social media with their stories of being harassed and abused – using the #MeToo hashtag. Hollywood celebrities quickly followed suit. Since the beginning of the Time's Up Movement, officially founded on January 1st 2018, people have been coming forward with their stories of sexual harassment in media industries (film, television, journalism, etc) at a truly remarkable rate. Famous directors, actors, executives, and others have been exposed for their acts of workplace harassment.

I admire the survivors who have come forward and am deeply grateful, because the voices of celebrities speaking out has made it easier to open up dialogue about this topic within smaller communities worldwide.

As unfortunate as it is, harassment is a common reality of our industry, and while it is being faced and the culture *is* slowly changing, I want you to be aware of your rights and responsibilities regarding harassment on a film set.

So why *is* our industry so susceptible to harassment?

For one thing, our industry works with an unspoken concept of high-level employees. While team players know every position is important, the director or cinematographer is considered more "important" than the additional grip or the production assistant. This can create a feeling of insecurity amongst employees that is heightened by the fact that you can be released from a project at any time. Secondly, we work in informal settings quite often. You may be shooting in a restaurant, or a forest, or a parking garage. Even within many production offices there is a sense of informality because many projects are short-term. People may speak in casual ways or joke around more than they would in a corporation with a more formal,

established structure. Additionally, we do sometimes shoot content that is romantic or sexual in nature. Actors, models, or hosts who come in for castings are typically partially evaluated based on a societal standard of attractiveness, and this is uniquely acceptable in our industry. Another element is the informal nature of the time we spend together outside of work hours. This may involve networking over drinks or traveling together for long periods of time. In this mixing of professional and personal lives, it is particularly important that everyone keep their intentions clear. Of course, this is not an exhaustive list, just a few contributing factors for our industry's incredibly high rates of sexual harassment.

Okay, so what even is sexual harassment?

According to the *Oxford Dictionary*, sexual harassment is "Behavior characterized by the making of unwelcome and inappropriate remarks or physical advances, especially in a workplace or professional situation." It may include sexually suggestive comments or jokes, intrusive questions about one's appearance or sexuality, staring or leering, unwelcome physical conduct and more. The US Department of Labor recognizes two types of workplace sexual harassment:

Quid Pro Quo

When someone demands sexual favors in exchange for favorable employment conditions or opportunities or, conversely, when someone threatens to negatively impact an employee's job status.

Examples:
- Guaranteed continual employment for someone who performs a sexual act
- Promising a job or opportunity to someone who agrees to an unwanted date
- Taking away a job or resource, or penalizing someone who refuses to take sexual pictures

Hostile Workplace

Characterized by conduct that has the *purpose* or *effect* of unreasonably interfering with an individual's work performance, or creating an intimidating, hostile, or offensive work environment. The conduct is severe and/or pervasive.

Examples:

- Sexually explicit or implicit comments
- Unwanted attention, such as texts, emails, calls, gifts
- Lewd gestures, staring, or leering
- Obscene or suggestive images
- Physically aggressive behavior such as grabbing, groping, etc.
- Threatening or humiliating behavior of a sexual nature

So what should you do if you experience or witness harassment on a film set?

Remember that harassment is illegal and, as the employer, that the network or production company is responsible and liable for incidents of sexual harassment. Most productions now have a zero-tolerance policy for this type of behavior, so do not be afraid to speak up. Starting documentation right away is important to show that the conduct is *unwelcomed* – you can use the "3 R's": **Respond, Record, Report.**

1. RESPOND

If someone is comfortable they can tell the offending party that his/her behavior is unwelcome and needs to stop; it communicates that it is unwanted and educates the harasser on their behavior; be firm, be specific, never apologize. Legally, a victim does not need to have "responded" in the moment if the harasser was a supervisor or superior, because there is reasonable belief that they would have wanted to "keep quiet" to keep their job.

2. RECORD

What happened? What was said? When did it occur? Where did it take place? Who was present? Tell it to a trusted co-worker, family member or Union representative, so the incident can be corroborated if needed.

3. REPORT

To the local Union, network, production company, or to the employer's HR department. Refer to your start paperwork or ask your department head or producer if they have a copy of the employee handbook if you no longer have yours. Victims can call the IATSE Safety Hotline and or the Actor's Fund – a national human services organization with resources for entertainment industry professionals.

Investigate local non-profits that help with workplace harassment. For example, Chicago has an organization called the Coalition Against Workplace Sexual Violence which has resources. You can search for organizations in your area online.

Do not be afraid to seek help if you are a survivor of sexual harassment experiencing distress. Some unions offer free counseling services to members. You can also look up mental health or crisis hotlines online if you just need someone to talk to about the experience. In the US, you can text 741-741 to text with a volunteer who can help you in times of emotional upset.

How can you help end the epidemic of media industry sexual harassment?

- Create responsible media with complex roles for people of all genders and with consensual intimacy scenes.
- Respect everyone around you regardless of gender identity, sexual preference, race, age, or any other factors. We are all humans.
- Engage in #MeToo and #TimesUpNow on social media.
- Hold fellow workers accountable for their behavior on set. A simple "that's not cool," can go a long way. Or just *don't* laugh at the joke. If sexually inappropriate jokes are being made but no one laughs, they lose their power and the offender likely has less motivation to make jokes of this nature again.
- Attend and promote your production's or your Union's sexual harassment workshop if it is offered!
- Refrain from giving compliments about another's appearance. There are so many other ways to start a conversation with someone! If you truly admire the work that they do, respectfully let them know – but keep their appearance out of the conversation.
- If you do genuinely have romantic feelings for someone you work with in the industry, it is not illegal or unheard of for people to fall in love and spend their lives together. Pay attention to clues to see if your feelings are reciprocated, and then try expressing your feelings (verbally, not physically) in a respectful way in a public space. If the fellow employee turns you down, listen to them and respect their response.
- Practice your consent skills with fellow crew-members and friends by asking if you can give a hug, take their picture, or offer advice. Consent isn't just for sex, but about generally respecting the individual experience of others!
- Support survivors by listening to them and learning about their experience. Question how local systems made these actions possible and what you can do to change the culture in which harassment exists.

You can find out more about #MeToo at www.metoomvnt.org and about Time's Up at www.timesupnow.org. Both pages have resources for survivors as well as ways to get involved in ending harassment in your own community.

Remember, we *can* change culture behind the scenes. You have my solidarity. #MeToo.

Glossary of Common On-Set Terminology and Slang

Hold the work: Stop working, be still and quiet.

Quiet on set/quiet all around for a take: Be still and quiet.

Picture is up: The actors are in the frame, we have rehearsed, and we are close to shooting.

Camera is set: The camera is ready, framed, pointed at the scene, just about ready to shoot.

Rolling/Camera rolls/Speeding/Camera speeds: The first step to starting the shot – the AD will ask the DP if they are speeding or rolling and the DP can respond any of the above answers. Then the AD asks the same of the sound department. If Camera and Sound are both "speeding/rolling" it means we are recording video and sound and ready to shoot the scene.

Mark/Mark it/Slate it: The slate is used to sync up the video and sound later. Once the slate has been clapped, the scene has officially started recording so be still and quiet.

Action: Once everything is "speeding," and we have slated, it is time to start the action. "Action" will cue the performers to start the scene.

Cut: Performers stop their action, camera and sound stop recording, everyone can move and breathe a little bit.

Take: The take is the number of times we are shooting this shot. If it is the first take, it's our first go at getting this shot, by take five we have shot the same thing four times already and are going for a fifth.

Reset/Back to one/Going again: We are filming another take. Reset everything and everyone in the scene back to the beginning marks and looks to try again. *(Tom Cicuira)*

Checking the gate/"Checking it": This is when the director and DP play back the take to see if they are happy with what they've shot or if they need to go again.

Moving on: That's the last "take" we are going to do of that particular shot. If you need to go to your station to get some supplies, go get a snack, now is the time to do it, you might have a minute to breathe while the crew sets up the next shot. Then you will want to get your touch-ups while the scene is still being set up.

Crafty/Craft Services: While this is another department on set, I also include it here so you know, this is where food is! Craft Services provides snacks, coffee, and water throughout the day but breakfast and lunch are typically catered on set – that's a different department!

Points: If someone calls "points!" it means they are walking through with a stand or large object with sharp ends. Watch your back and get out of the way.

Striking: Meaning someone is about to turn on a bright light – your best bet is to look at the floor.

Glass moves: Someone is carrying a fragile and expensive camera lens.

"Swinging a lens:" This means the lens is being changed, so you will likely want to find out what the new shot is – if they are shooting tighter coverage on your actors or a wider shot, etc.

Camera moves: Someone is carrying the expensive camera – freeze and/or get out of the way

Spraying: If you are spraying hairspray, sunscreen, water, or anything else around other people or equipment, you *must* yell "spraying!" Try to make eye contact with your camera operators to make sure you coordinate with them and do not spray liquid onto the camera lens.

First team: The lead actors.

Second team: The stand-ins.

"Flying in:" Coming over, coming your way, stepping into the frame, etc.

Last looks: Very important for our department. This is when an MUA will go to the actors on set before a shot to touch them up to make sure they look perfect for that shot!

86: Never mind what I just said/cancel.

10-1: Using the restroom.

Copy that: While this is typically used to confirm you have heard something on the walkie-talkie, film crew members often use it in daily conversation to confirm they've understood an instruction.

Other Positions On Set and What They Do

Director

A Director is the person who leads a film's overall artistic and dramatic elements essential to telling a story on screen. They are responsible for visualizing each dramatic beat of a story while collaborating with their crew, actors, and other members of production to fulfill an evocative result of their vision. *(Jon Santiago, Director;* Blame *and Script Supervisor;* Chicago PD*)*

Producer

Overseer of the production. The Producer works with the Director and the other department heads to ensure the quality of the project meets the creative vision of the script within budget and within safe means. *(Robin D'Oench)*

Unit Production Manager (UPM)

Works closely with the Producer to staff the production and assist in maintaining the budget line throughout the shoot. *(Robin D'Oench)*

Production Supervisor and Production Coordinator

The Production Supervisor is a non-union position just under the Unit Production Manager. The Production Coordinator is a union position who reports directly to the Production Supervisor. The Production Supervisor and/or the Production Coordinator position help oversee the communication and organization between all departments on a show. They facilitate building/setting up the department for success to complete their

artist needs for the production and to fulfill the studio or network required deliverables for any show.

Overall the supervisor/coordinator services the studio/network, the crew members, vendors, cast/agents/managers, and unions – in no particular order and more or less on any given day. These are the entities that are reported to continually throughout a show. *(RoseMary Prodonovich)*

Production Assistant

An entry level position that serves as the backbone to any successful production. Production Assistants work within the AD Department to assist with lock-ups, Background paperwork and placement, and communication between departments. They also help attend to the needs of actors and other crew members. *(Robin D'Oench)*

Script Supervisor

A Script Supervisor is one of the essential film crew members responsible for monitoring the continuity of a production. They collaborate with props, set dressing, wardrobe, makeup, actors, cinematographers, and directors during the shooting production to ensure continuity throughout a scene. Script Supervisors simultaneously record notes about continuity, camera, shots, and preferred takes which are used to assist an editor in completing the final cut of a project. *(Jon Santiago)*

Assistant Director/First Assistant Director/1st AD

Works closely with the director, DP, and producers to create the shooting schedule during pre-production. During production, the 1st AD is responsible for maintaining, communicating, and safely facilitating the shooting schedule with the crew for the entirety of the film shoot. *(Robin D'Oench)*

Second Assistant Director/2nd AD

Works under the 1st AD to assist in facilitating and communicating all required schedule elements to the rest of the shooting crew and the cast. The 2nd AD is responsible for the creation and distribution of the daily call sheet and production reports. The 2nd AD also oversees the processing of Background as well as getting actors "through the works." *(Robin D'Oench)*

Director of Photography (DP)/Cinematographer

Sometimes called the "DOP" in the UK or in Australia, the Director of Photography is responsible for what the camera sees and how it sees it including where the cameras are placed, what lenses are used, deciding camera settings, how the lighting shall look. Ultimately responsible for the look of the photography. *(Tom Ciciura)*

Camera Operator

The person who physically controls the camera during a shot. The crew member in charge of composing the image and what is photographed. The camera operator has several tools to help them move and control the camera depending on the style and requirements of the shot such as hand-held, on a tripod, on a dolly, steadicam, on a crane, or using a remote head. *(Tom Ciciura)*

1st AC/1st Assistant Camera/Focus Puller

The crew member responsible for the technical operation and maintenance of the camera including changing lenses, manipulating camera settings, loading and unloading film or media cards, powering and configuring camera accessories such as wireless focus lens motors and wireless video transmitters and most importantly, keeping the action on the image in focus. The focus puller has a unique and difficult job of keeping things "sharp" and in focus by manipulating the lens' internal glass elements. Moving them closer and farther apart changes the distance of the focal plane or how far from the camera's sensor something would appear in focus. This is usually done via a remote wireless lens control motor system while watching from a nearby monitor. It is tempting to look over the shoulder of the AC to get a look at their monitor on set as it's convenient and usually nearby, however they often tune their focus monitor differently to help them see focus better such as zooming in, using a black and white video image, and using "peaking" or adjusting the monitor to look crisper. Best for you to find a different monitor to observe to give the AC their space when they really need to "focus." *(Tom Ciciura)*

Gaffer/Chief Lighting Technician

Sometimes referred to as the Chief Lighting Technician, the Gaffer is the head of the lighting department. They work for the DP and help to design the lighting plan. They also work closely with the Key Grip to execute the lighting on set. *(Tony Santiago)*

Best Boy Electric

Responsible for distributing power throughout the set. They also oversee the day to day business of the electric department. Their duties include hiring electricians, filling out timesheets, keeping track of rental and purchasing budgets for the electric department, and coordinating equipment rentals with the rental houses. *(Tony Santiago)*

Key Grip

Head of the Grip department. They work closely with the Gaffer to execute the lighting plan. *(Tony Santiago)*

Best Boy Grip

They oversee the day to day business of the Grip department. Their duties include hiring grips, filling out timesheets, keeping track of rental and purchasing budgets for the Grip department, and coordinating equipment rentals with the rental houses. *(Tony Santiago)*

Craft Services

When people ask where the term "Craft Service" comes from I explain all members in our Union have mastered their "crafts" and we are there to "service" them with food, drinks, and keeping the set tidy. But Craft Service can also boost a crew's morale by supplying a delicious and visual feast. There's much more to it than putting out donuts and bananas; it's about caring about what we serve and also actually waiting on them. It's about knowing the set and the timing with things. It's guaranteed a good Craft Service can brighten someone's moment on an otherwise long and grueling day. *(Kenny Cabrera, Craft Services;* The Dark Knight*)*

Sound Department

The Sound Department specifically handles the recording and playback of sound on set. Helmed by the Production Sound Mixer, who manages the recording and quality control (QC) of the audio tracks, this department is typically comprised of two additional crew: the Boom Operator, who operates the primary microphone used for recording, and the Sound Utility who is often responsible for wireless microphone placement on the talent themselves – whether on their clothes, or sometimes even in their hair! *(Nick Ray Harris, Production Sound Mixer)*

Production Designer

The person who decides on the look of the project based on the script and directorial vision. They also propose which scenes happen on what location or which sets have to be built on stages. They oversee the art department in distributing the information to all other departments and coordinate execution of the same vision by all involved. *(Joanna Iwanicka, Paint Foreman;* Empire*)*

Art Director

A person responsible for relaying the Production Designer's vision to all the departments, overseeing construction and finishes on the sets, allocating budgets and keeping track of how they are spent. *(Joanna Iwanicka)*

Construction Coordinator

Oversees the construction of the sets, answers to the Art Director, collaborates with other departments on bringing the sets to completion. *(Joanna Iwanicka)*

Paint Supervisor

A person responsible for surface finishing on all the sets and for restoration locations to their original state after the work is done. *(Joanna Iwanicka)*

Set Decorator

A person in charge of picking and placing the appropriate furnishings, rugs, wall coverings, draperies, machinery, cabling or piping appropriate for the Production Designer's vision and story told. *(Joanna Iwanicka)*

Props Department

The Props Department is responsible for providing all objects that are handled by a performer. The Prop Master is the head of the department and oversees all logistics and other members within the Props Department. Props frequently works with other departments, like Costumes and Set Decoration, to coordinate what is needed for a character or scene. *(Linda Wyatt, Props Assistant and On-Set Dresser;* Knives and Skin*)*

Greens Department

Department responsible for all that is plant/soil-based on set – from potted plants indoors to exterior lawns, trees, flowers, and fields. *(Joanna Iwanicka)*

Costume Designer

The Costume Designer is in charge of designing and planning the actors' costumes based on the script. They meet with the Director, conduct fittings, and lead a team of shoppers, costumers, and other craftspeople and assistants to purchase or create all the necessary clothing items.

On-Set Costumer

On-Set Costumers keep track of the costumes during shooting. They typically travel with actors to set and may have additional wardrobe pieces with them if changes are needed during the scene or throughout the day. They are responsible for continuity of the clothing from shot-to-shot as well as taking care of any spills, messes, or other issues the actor may have with their costume. On-Set Costumers also usually place blood on actors' clothing when warranted by the scene.

Stunt Coordinator

A Stunt Coordinator's job is first and foremost the safety of the actors and stunt doubles. They coordinate, cast, and choreograph all action sequences that take place in a production. Stunt coordinators work very closely with the Director to achieve the vision of what they are trying to create in the safest way possible. *(Kelli Victoria Scarangello, Stuntwoman;* Batwoman*)*

Set Medic

A Set Medic is a first responder for film crews. They give medical attention when needed and make sure that the crew is in a safe work environment. In addition to first aid materials, the Set Medic also typically has supplies to make the crew more comfortable, such as cough drops or hand warmers. *(Mike Shannon, Set Medic;* Utopia*)*

Where To Buy Products

(Not an exhaustive list!)

Nationwide, some worldwide

Sephora

Visit www.sephora.com for a location nearest you.

Ulta Beauty

Visit www.ulta.com for a location nearest you.

Blue Mercury

Visit www.bluemercury.com for a location nearest you.

Kryolan Professional Makeup

Visit https://us.kryolan.com for a location nearest you. Kryolan offers a 20% discount to professionals and boutiques in many major US cities including Boston, Chicago, New York, San Francisco, the Los Angeles area, as well as worldwide.

MAC Pro

Visit www.maccosmetics.com for a location nearest you.

MAC offers several different tiers of discounts, usable at both free-standing MAC stores, and MAC Pro stores nationwide and worldwide. You may also order online using your discount.

Makeup Forever

Makeup Forever offers a 40% discount to pros, but the discount can only be used in the boutique locations, or in a Makeup Forever Boutique inside Sephora. Visit their website to find a boutique location nearest you. You may also order online or over the phone using your discount. www.makeupforever.com.

A Few Boutique Locations

Many still offer discounts to professionals when shopping online.

Atlanta

The Engineer Guy
1000 Tradeport Blvd #1011
Atlanta, GA 30354
www.theengineerguy.com

The Glamatory
1675 Cumberland Pkway SE #408
Smyrna, GA 30080
www.theglamatory.com

Norcostco Theatrical Supply
2089 Monroe Drive NE, Atlanta, GA 30325
www.norcostco.com

Chicago

Che Sguardo
208 W Huron St.
Chicago, IL 60654
www.chesguardo.com

Chicago Costume
1120 W Fullerton Ave.
Chicago, IL 60614
www.chicagocostume.com

Makeup First School
100 N LaSalle St #1010
Chicago, IL 60602
www.makeupfirst.com

Las Vegas

The Cosmetics Company Store
875 S Grand Central Pkwy
Las Vegas, NV 89106

Inglot Cosmetics
The Forum Shops at Caesars
3500 Las Vegas Blvd S.
Las Vegas, NV 89109
www.inglotusa.com

Star Costume and Theatrical Supply
3230 South Valley View, Suite 120
Las Vegas, NV 89102

Los Angeles

Frends Beauty
5244 Laurel Canyon Blvd.
Valley Village, CA 91607
www.frendsbeauty.com

Naimie's Beauty Center
12640 Riverside Dr.
Valley Village, CA 91607
www.naimies.com

Nigel Beauty Emporium

11252 W Magnolia Blvd

North Hollywood, CA 91601

www.Nigelbeautyemporium.com

PPI | Premiere Products

10312 Norris Avenue, Suite C

Pacoima, CA 91331

www.ppipremiereproducts.com

Miami

Kiko Milano

939 Lincoln Road

Miami Beach, FL 33139

Inglot Boutique South Beach

224 8th St

Miami Beach, FL 33139

www.inglotmiami.com

New York

Alcone

322 W 49th St

New York, NY 10019

www.alconemakeup.com

Makeup Forever Pro Studio

8 E 12th St.

New York, NY 10003

www.makeupforever.com

Manhattan Wardrobe Supply

245 West 29th Street, 8th Floor

New York, NY 90014

www.wardrobesupplies.com

Ricky's NYC

830 Broadway

New York, NY 10003

www.rickysnyc.com

Vancouver

Studio F/X

Cathedral Place, 925 W Georgia St #150

Vancouver, BC V6C 3L2, Canada

Online

Terri Tomlinson Makeup Training Academy

www.Makeup101.com

The following brands offer various professional discounts if you submit credentials and are approved. The pro discounts can be used online, but most often are not usable inside department stores or chain makeup retailers.

Anastasia Beverly Hills

www.anastasiabeverlyhills.com

Backstage Cosmetics

www.backstage-cosmetics-inc.myshopify.com

Bobbi Brown

www.bobbibrowncosmetics.com

Laura Mercier

www.lauramercier.com

NARS

www.narscosmetics.com

Smashbox

www.smashbox.com

Tarte

www.tartecosmetics.com

Urban Decay

www.urbandecay.com

Annual Trade Shows

You may visit the websites listed to find out the dates for these traveling trade shows in the city nearest you.

IMATS

www.IMATS.net

The Makeup Show

www.themakeupshow.com

America's Beauty Show

www.americasbeautyshow.com

Contributors

Tony Santiago

Tony Santiago is a Chicago native who has been part of the film community for over 15 years, working as a Cinematographer, Grip and Electric Department crew member, and Director. He is a Professor of Lighting and Cinematography at Columbia College Chicago where he also facilitates student projects as the Lighting Stage Coordinator.

Christopher Payne

Christopher Payne is a professional Makeup and Special Effects Makeup Artist with experience in film, television, and theater. He holds an MFA in Makeup and Wig Design from the University of Cincinnati and has taught at several schools around the country. He has been the Head of the Special Effects Makeup Department for NBC's *Chicago Fire* since Season 2.

Katie Middleton

Katie Middleton is the author of the book *Color Theory for the Make-up Artist: Understanding Color and Light for Beauty and Special Effects*. She is a professional Makeup Artist and Special Effects Makeup Artist for film and television. She received her BFA in painting from Pratt Institute in Brooklyn, New York, where she was honored with the Early Career Achievement Award in 2016. She was also nominated for a Make-up Artists and Hair Stylists Guild Award in 2017 for her work on the film *Loving*.

Dina Cimarusti

Dina Cimarusti is a Special Effects Makeup Artist from Chicago, IL. She is an IATSE Local #476 Union member specializing in medically accurate SFX makeups and props. She is the winner of SyFy's *Face Off*, Season 7 and has also won awards for her cake decorations.

Rochelle Uribe-Davila

Rochelle Uribe-Davila is an IATSE Local #476 Union member who has been working as a Makeup Artist for over 15 years. Her work spans theater,

commercial, film, and television – both in the United States and internationally. Her recent projects include makeup artistry and special effects for the Universal Studios live show *Grinchmas* and NBC's *Chicago Med*. She has been the 3rd Artist on Fox's *Empire* since Season 4.

Tom Ciciura

Tom Ciciura is a Cinematographer and Camera Operator from Chicago, known for his work on *Spider Man 2*, *War of the Worlds*, and *Soul Sessions*. He is also the owner of 2nd Ciné Professional Motion Picture Equipment Rentals in Elgin, IL.

J. Anthony Kosar

J. Anthony Kosar is an award-winning Artist, Entrepreneur, and Educator who specializes in Sculpture, Special FX Makeup, Concept Art, Illustration, and Fine Art through his company Kosart Studios, LLC. His credits include *Candyman* (2020), *Fargo;* Season 4, *Station Eleven*, *Empire*, *Chicago PD*, *Lovecraft Country*, and others. In 2013, he became the *Face Off* Season 4 Champion after winning the most challenges by a single contestant in a single season. You can follow Kosar on social media @KOSARTeffects and see his work online at www.KOSART.com.

Anna Cali

Anna Cali is a professional Special Effects and Makeup Artist, Educator and proud member of the IATSE Studio Mechanics Local 476 in Chicago, IL. With over 15 years of experience, Anna's credits include Jordan Peele's *Candyman*, *Fargo;* Season 4, *Lovecraft Country*, *Empire*, *Chicago PD*, 2016's *The Exorcist*, and more. She also appeared on SyFy's hit show *Face Off*, competing on Season 10. Anna's work can be seen, not only in film and television, but also music videos, commercials, theater, and print as a published makeup artist. Visit www.imdb.me/annacali for more.

Kimberly Boundas

Kimberly Boundas is a Chicago-based Contact Lens Specialist with recent projects including *Nightmare on Elm Street*, *Contagion*, *Lovecraft Country*, and *Fargo;* Season 4.

RoseMary Prodonovich

RoseMary Prodonovich is a freelance Production Supervisor in the film and television industry. She is based in Chicago, IL where she has worked for Fox, ABC, New Regency, Amazon, FX, and other studios. RoseMary has been a guest speaker at Indiana University, DePaul University, and Tribeca Flashpoint Academy to help guide students and young

professionals interested in film and television to a deeper understanding of the business, logistics, and breaking into the industry.

Robin D'Oench

Robin D'Oench is an Assistant Director based in New York City with a focus on features, commercials, and music videos.

Lola Mosanya

Lola Mosanya is an emerging British Journalist and Documentary Producer. With a Fulbright award in Journalism under her belt, she moved to the States in 2019 for Columbia College Chicago's Creative Producing MFA program. She's now working towards a career developing and producing TV drama.

Models

Natasha Adib – *Lighting*
Jorge Anaya Jr. – *Age Makeup (Prosthetics), Prosthetics*
Miguel Badillo – *Age Makeup (Paint-Only)*

Ashley Renée Bob – *Beauty Makeup I, Tattoo Cover*
Patrick Bowler – *Age Makeup (Stretch-and-Stipple), Mattifying*
Casey Calhoun – *Beauty Makeup II*
Christian Litke – *Out-of-Kit SFX, Burns*
Paul Sciortino – *Grooming, Adding Facial Hair, Dirtying*
Breanne Wilhite Soto – *Manicure*

Media Assistant

Lola Mosanya

Photoshoot Lighting Assistants

Karena Ashleman
Julia Benson

Photoshoot Makeup Assistants

Charlie Lenny
Breanne Wilhite Soto

Photo Credits

Chapter 2

Image 7: Photo by Jopwell via Pexels
Images 11-14: Created by Robin D'Oench

Chapter 3

Image 1: Photo by Justine Losoya
Images 2-3: Photo by Rochelle Uribe-Davila
Images 4: Photo by Tony Santiago
Image 5: Photo by Christine Sciortino
Image 6: Photo by Tony Santiago
Images 7-10: Photo by Christine Sciortino
Image 11: Photo courtesy of simplehuman, LLC.
Image 12: Photo by Victoria Miranda
Image 13: Photo by Tony Santiago
Images 14-15: Photo by Christine Sciortino
Image 16: Photo by Tony Santiago
Image 17: Photo by Christine Sciortino, with permission from Actor Hayden Szeto
Image 18: Created by Christine Sciortino

Chapter 5

Image 1: Photo by Sharon McCutcheon via Pexels
Image 2: Photo by Magda Ehlers via Pexels
Image 3: ID 23575898 © Marin Bulat | Dreamstime.com.
Image 4: ID 7042700 © Gines Valera Marin | Dreamstime.com
Image 5: ID 157860875 © Odyssei | Dreamstime.com
Image 6: Photo by Taken by Tablo via Pexels
Image 7: Photo by Johannes Plenio via Pexels
Images 8-10: Created by Katie Middleton
Image 11: ©Photo of Flesh Tone Color Wheel™ courtesy of Terri Tomlinson Makeup Training Academy. All rights reserved.

Chapter 6

Images 3-14: Photo by Tony Santiago; Makeup by Breanne Wilhite Soto | Model: Natasha Adib

Chapter 7

Image 1: Photo by Luis Quintero via Pexels
Image 2: Photo by Cottonbro via Pexels
Image 3: Photo by ATC Comm Photo via Pexels
Image 4: Photo by Lê Minh via Pexels
Image 5: Photo by Sippakorn Yamkasikorn via Pexels
Image 6: Photo by Kyle Loftus via Pexels
Image 7: Photo by Cottonbro via Pexels

Chapter 8

Image 1: ID 73338717 © Chinnasorn Pangcharoen | Dreamstime.com
Image 2: Photo by mail272 via Canva
Image 3: Photo by Eink via Canva
Image 4: ID 98085563 © Rob3000 | Dreamstime.com
Image 5: Photo by greenleaf123 via Canva
Image 6: ID 58712607 © Elenabsl | Dreamstime.com
Image 7: Photo by Pikx By Panther via Pexels
Image 8: ID 118338016 © VectorMine | Dreamstime.com
Image 9: Andrea Piacquadio via Pexels, edited by Bill Sciortino
Image 10: ID 31172058 © Snapgalleria | Dreamstime.com
Image 11: ID 59939369 © Iryna Bezianova | Dreamstime.com

Chapter 9

Image 1: ID 107604229 © VectorMine | Dreamstime.com
Image 2: ID 138763238 © Suriya Siritam | Dreamstime.com
Image 3: Photo by Anna Shvets via Pexels
Image 4: Photo by Meireles via Pexels
Image 5: ID 107609511 © VectorMine | Dreamstime.com
Image 6: ID 150531061 © Gritsalak Karalak | Dreamstime.com
Image 7: Photo by Oleg Magni via Pexels
Image 8: ID 108052372 © VectorMine | Dreamstime.com
Image 9: Photo by Pixabay via Pexels; Photo by Wildan Zainul Faki via Pexels; Photo by Hitesh Ghate via Pexels; Photo by Chaucharanje via Pexels
Image 10: ID 127197020 © Nataliia Darmoroz | Dreamstime.com
Image 11: Photo by Ike louie Natividad via Pexels

Chapter 10

Image 1: Photo by Tarzhanova via Canva
Images 2-9: Photo by Tony Santiago
Image 10: Photo by Unknown via Canva
Image 11: Photo by Nappy via Pexels
Image 12: Photo by Unknown via Canva

Chapter 11

Image 1: Photo by Royal A via Pexels
Image 2: Photo by Christine Sciortino
Images 3-10: Photo by Tony Santiago; Makeup by Christine Sciortino | Model: Paul Sciortino
Image 11: Photo by Johan De Jager via Pexels; Photo by Alexander Zvir via Pexels; Photo by Thgusstavo Santana via Pexels
Image 12: Photo by Phuc (Xù) Pham via Pexels; Photo by Kevin Bidwell via Pexels; Photo by The Baljinder via Pexels
Image 13: Photo by Tony Santiago; Makeup by Christine Sciortino | Model: Paul Sciortino
Image 14: Photo by Andrea Piacquadio via Pexels
Image 15: Photo by Zhanzat Mamytova via Pexels
Image 16: Photo by Tony Santiago; Makeup by Christine Sciortino | Model: Paul Sciortino
Image 17: Photo by Tony Santiago; Makeup by Christine Sciortino | Model: Christian Litke

Chapter 12

Images 1-24: Photo by Tony Santiago; Makeup by Christine Sciortino | Model: Ashley Renée Bob
Images 25-50: Photo by Tony Santiago; Makeup by Christine Sciortino | Model: Casey Calhoun
Images 53-54: Photo by Tony Santiago; Makeup by Christine Sciortino | Model: Ashley Renée Bob
Images 56-62: Photo by Tony Santiago; Makeup by Christine Sciortino | Model: Ashley Renée Bob

Chapter 13

Images 1-27: Photo by Tony Santiago; Makeup by Christine Sciortino | Model: Christian Litke

Chapter 14

Images 1-21: Photo by Tony Santiago; Makeup by Christopher Payne | Model: Christian Litke
Images 22-26: Photo by Tony Santiago; Makeup by Christine Sciortino | Model: Christian Litke
Image 27: Photo by Tony Santiago; Makeup by Christopher Payne | Model: Christian Litke

Chapter 15

Images 1-8: Photo by Tony Santiago; Makeup by Christopher Payne | Model: Jorge Anaya Jr.
Images 10-20: Photo by Tony Santiago; Makeup by Christopher Payne | Model: Jorge Anaya Jr.

Chapter 16

Images 1-8: Photo by Tony Santiago; Makeup by Rochelle Uribe-Davila | Model: Miguel Badillo
Images 9-23: Photo by Tony Santiago; Makeup by Dina Cimarusti | Model: Patrick Bowler
Image 24: Photo by Tony Santiago; Makeup by Christopher Payne | Model: Jorge Anaya Jr.

Chapter 17

Images 1-23: Photo by Tony Santiago; Makeup by Christine Sciortino | Model: Paul Sciortino

Chapter 18

Images 1-8: Photo by Tony Santiago; Makeup by Christine Sciortino | Model: Paul Sciortino
Image 9: ID 114243167 © VectorMine | Dreamstime.com
Image 10: Photo by Nappy via Pexels

Chapter 19

Images 2-14: Photo by Tony Santiago; Makeup by Christine Sciortino
Image 15: Photo courtesy of Ken Diaz
Images 16-23: Photo by Tony Santiago; Makeup by Christine Sciortino | Model: Paul Sciortino
Images 24-33: Photo by Tony Santiago; Manicure by Christine Sciortino | Model: Breanne Wilhite Soto
Image 34: ID 125924960 © Viktoriia Kasyanyuk | Dreamstime.com
Images 35-36: Photo by Tony Santiago; Makeup by Christine Sciortino | Model: Paul Sciortino
Image 37: ID 145183473 © Anatolii Riabokon | Dreamstime.com
Images 38-39: Kryolan Professional Make-up

Author Headshot

Photo by Tony Santiago

Works Cited

Bennett, Jessica. *Feminist Fight Club: An Office Survival Manual for a Sexist Workplace*. New York, Harper Wave, 2016.

Borba, Scott-Vincent. *Skintervention: The Personalized Solution for Healthier, Younger, and Flawless-Looking Skin*. Florida, HCI, 2011.

Davis, Gretchen and Mindy Hall. *The Makeup Artist Handbook: Techniques for Film, Television, Photography, and Theatre*. 2nd ed., Massachusetts, Focal Press, 2012.

Gill, Liz. *Running the Show: The Essential Guide to Being an Assistant Director*. Massachusetts, Focal Press, 2012.

Jablonski, Nina G. *Skin: A Natural History*. Berkeley, University of California Press, 2006.

Jaliman, Debra. *Skin Rules: Trade Secrets from a Top New York Dermatologist*. Spokane, Griffin, 2013.

Kunin, Audrey with Bill Gottlieb. *The DERMAdoctor Skinstruction Manual*. New York, Simon & Schuster, 2007.

McNeill, Daniel. *The Face*. New York, Back Bay Books, 2000.

Middleton, Katie. *Color Theory for the Makeup Artist: Understanding Color and Light for Beauty and Special Effects*. New York, Routledge, 2018.

Parker, Steve and Walker, Richard. *The Human Body Book: An Illustrated Guide to its Structure, Function, and Disorders*. New York, DK, 2019.

Taylor, Susan C. *Dr. Susan Taylor's Rx for Brown Skin: Your Prescription for Flawless Skin, Hair, and Nails*. New York, Amistad, 2008.

Index

Note: Page numbers in *italic* refer to illustrated sample techniques

acne 77, 151–153
actor bags 72, 74–76, 100, 154, 166, 167
actors 22, 35–38, 52–54, 85
ADs *see* Assistant Directors (ADs)
Advance Schedule 58
aging makeup techniques 249, 256–257; mustaches 256; painting *249–251*, 255–256; prosthetics 255, 256–257; stretch-and-stipple *249–251*, 255
aging skin 162, 164, 180–183
allergies 36, 149, 157–158
anatomy 134–135; cardiovascular system 134, 142–145; muscular system 134, 138–141; skeletal system 134, 135, *136*, 137–138
artificial daylight sources (HMIs) 114
Assistant Directors 23, 35, 44, 45, 46, 52, 53
attire *see* clothing

back light 115
background actors 34–35, 40, 49, 55, 62, 90
Barcsay, J. 31
Basecamp 55, 58, 59
basic HD look 195–196, *201–205*, *206–210*
beards 174; groomed 192–193; hand-laid 262, *263–265*, 267; natural un-groomed 193–194
beauty makeup 199–200, *201–205*, *206–210*, *211*; false lashes 212, *213*, *214*; winged liner *215*
Bennett, J. 14

black and white shoots 118
black eye *220*
blemishes 180, *200*, *201*
blood 31, 38, 142–143, 144, 217–218, 245–246
bloody knuckles *222*
bloody nose *218–219*
Borba, S.-V. 149, 153
Boundas, K. 291
box rentals 16, 40
branding 8–9, 10
broad key lighting 115, *116*
brow gel 71
bruises 144
brushes 69–70, 76, 100, *276*
budgets 36, 39–40, 44, 99
burns 227, 232; gelatin burns 227–231; silicone burns 227, 232, *233–235*
business cards 10, 11

Cali, A. 141, 143
call sheets 23, 26, 51–54, 55, *56–57*, 58, 59, 61, 73, 77
call times 51, 53–55, 58
Camera Department 82, 83, 129–130
camera movement 126–127
camera setups 126–127
camera shots 127–128

camera temperatures *117*
camera tests 29, 38–39, 129, 166
cameras 123–129
cardiovascular system (the veins) 134, 142–145
carmine 157, 158
catering 55
character design 23–26, 27–32, 39, 109–110; collaboration 34–38, 130; face charts 90, *91*, 92; mood boards 28, 32–34
character lists 20
character numbers 23, 46
character research 27–32, 44
character-specific Items 99
cheekbones *118*, 137, 182, 199
child actors 35, 46, 179–180
cleanliness 69–73, 100
clean-shaven 186–188, *189*
close-ups 87, 125, 128, 194, 284
clothing 64–66
cold sores 156–157
collaboration 34–38, 130
color 103–104
color confusion 118
color correcting 178–179
color temperature 114, 117
color theory 103, *105*, 106–110
color wheel 104, 106, 107, 178
colorless HD powders 77
combination skin 155
company moves 52, 73
company sponsorships 36
complementary colors 106
consultations 149–151
contact allergies *see* allergies
contact dermatitis 157–158
contact lenses 291–293

continuity 29, 46, 48, 76, 83, 87–90
continuity books 88–90, 99
contouring 199
contracts 15, 16
cool colors 107–108
corrective makeup 173–174, *175*, 176, 199–200, *201–205, 206–210*
Corson, R. 28
Costume Designers 30, 35, 49
covering sets 63
cream palettes 71
credits 99–100
crepe hair 262
crew contracts 15
Crew Parking 55, 58, 96
crying 290–291
cultural standards 28

daily hires 61–62
Davis, G. 86, 89
day checkers 61–62
day players 61–62
day rates 16, 97, 99
day-checking set bags 78–79
Day-Out-of-Days (DOODs) 48–49, *50*
deal memos 15
Diaz, K. 28
digital cameras 123–124, 125, 126
Directors 31, 32, 34, 35, 83; character design 36, 37, 39; test shoots 39
dirt 267, *268–269*
discontinuous color spectrums 117–118
document binders 43–44
DOODs *see* Day-Out-of-Days (DOODs)
Draft Call Sheet 53–54
dry skin 87, 154, 161

eczema 156
Eldridge, L. 27
Electric Department 120
electronic continuity books 90
employees 61, 95–96
eye makeup 109, 182
eyebrows 182, 194
eyeliners 70–71, 90
eyes 288–291; contact lenses 291–293
eyeshadow palettes 77

face charts 90, *91*, 92
Facebook 10
facial hair 147, 165–166, 195, 259; beards 174, 192–194, 262, *263–265*, 267; clean-shaven 186–188, *189*; lace facial hair pieces 259, *260–261*, 262; mustaches 190, 193, 256, 259, *260–261*; scruff 190–192; *see also* grooming
facial muscles 139–140
false lashes 212, *213*, 214
feedback 34, 39
fill light 115, 120
film cameras 123, 124–125
film festivals 10–11
film set terminology (slang) 84, 302–303
Flesh Tone Color Wheel 109, *110*
fluorescent lights 114
follow-up letters 14
freelancers 17, 61–62

gel filled appliances (GFAs) 239–242
gelatin burns 227–231
Gill, L. 44–45, 51, 59
Google Images 27
Grip Department 120

grooming 185–186, 194–195; beards 192–194; clean-shaven 186–188, *189*; mustaches 190, 193; scruff 190–192

Hair Department 74, 88
hair styles 28, 36
half-day rates 97
Hall, M. 86, 89
hand doubles 283
hand-laid beards 262, *263–265*, 267
hands *269*, 283; nails 283, *284–285*
harassment 81, 298–301
hard light 119
HD makeup 173–174, *175*, 176; basic HD look 195–196, *201–205*, *206–210*
head hair 147
high contrast 120
high definition (HD) 125, 126
highlighting 199
historical accuracy 27–30
HMIs *see* artificial daylight sources (HMIs)
Holding 55
honesty 11
hourly rates 16
hyperpigmentation 159–160, 165

IATSE *see* International Alliance of Theatrical Stage Employees (IATSE)
illnesses 143, 144–145
imperfections 199, *201–205*
independent contractors 95, 96–97
individual false lashes 212, *213*
inflammation 143–144
injuries 143–144, 145, 217, 236; black eye *220*; bloody knuckles *222*; bloody nose *218–219*; burns 227–231, *232*, *233–235*; road rash *223–224*; slit throat 236; split lip *221*

International Alliance of Theatrical Stage Employees (IATSE) 17
interviews 12–15
invoices 96–97, *98*

Jablonski, N. G. 159, 173, 274
Jaliman, D. 152, 153, 162–163
jawlines 138

K.D. 151 Tattoo Pens 279
key light 115, 120
Key Makeup Artist 63, 90
kit fees 16, 40
kit inventory 16
Kosar, J. A. 134, 287–288
Kunin, A. 181

labor unions *see* unions
lace facial hair pieces 259, *260–261*, 262
last looks 86–87
lenses (cameras) 125
libraries 27, 28
Light Emitting Diodes (LEDs) 114–115, 118
lighting 113–115, 117–118, 173
Lighting Department 120
lighting design 115
lighting direction 115–116
lighting quality 119
lighting quantity 120
lip palettes 77
lipgloss 72
lipliners 70–71, 77
lips 182–183, *211*
lipsticks 71, 72
locked scripts 44, 45

lotions 72
low contrast 120

McNeill, D. 193
Makeup Artist Face Charts (Reyna) 90, *91*
makeup artists 3, 5, 8–9, 62–63, 294
Makeup Department 61–64, 74, 129–130
Makeup Department Head 63–64, 81–82, 84
Makeup Designer 64
makeup kits 76–79, 100; brushes 69–70, 76, 100, *276*
makeup moments 21–22
makeup research 27, 28–29
makeup stations 66–69, 73, 100; cleanliness 69–73, 100; sanitation 69–73, 100
makeup techniques 170, 173–174, 195–196; aging skin 162, 164, 180–183; beauty makeup 199–200, *201–205, 206–210, 211*; child actors 179–180; color correcting 178–179; eye makeup 182; older actors 180–183; shade matching *175*, 176, 178–179; shine 176–177; *see also* aging makeup techniques
makeup tests 38–39
makeup trailers *66, 67*, 73, 74–76, 100
manicures *284–285*
marketing 9–12
mascara 71
medical textbooks 31
meet-up websites 10
melanocytes 159, *160*
melasma 156
menthol tear blower 290
#MeToo movement 298, 301
Middleton, K. 103, 107, 108, 109
mood boards 28, 32–34, 44

motion picture cameras 123, 124–125
muscular system (the muscles) 134, 138–141
museums 27–28
mustaches 190, 193, 256, 259, *260–261*

nails 283, *284–285*
narrow key lighting 115, *116*
natural beards 193–194
networking 9, 10–12
no-makeup-makeup 173–174, *175*, 176
non-descript (ND) stunt performers 53
non-disclosure agreements (NDAs) 9, 16
non-union freelancers 17
non-union projects 16
normal lenses (cameras) 125
normal skin 154–155

oils 72
oily skin 153–154, 176
older actors 77, 180–183
one-liners 45–46, *47*
online portfolios 3, 7–9
on-set harassment 81, 298–301
out-of-kit effects: black eye *220*; bloody knuckles *222*; bloody nose *218–219*; burns 227–231, *232*, *233–235*; road rash *223–224*; slit throat *236*; special effects makeup 217; split lip *221*

painting aging makeup *249–251*, 255–256
patch tests 150–151, 157
payment 16, 17, 95–97, *98*, 99
Payne, C. 227
pencil liners 70–71
portfolios 3, 7–9
pre-call 51, 58

Preliminary Call Sheets (Prelims) 53–54
pre-production 19–26, 27–32, 35, 39–40, 43–44, 129
primary colors 104, 107
primary sources 27, 29
Prodonovich, R. 15, 16
product requests 36, 39
product sponsorships 9
Production Assistants (PAs) 84–85
Production Designers 30, 35
production documents 44
production drafts 44, 45
professional look 13
Props Departments 31, 88
Pros-Aide adhesive 239, 240–241, 242
Pros-Aide transfers 239, 242–244
prosthetics 239, 255, 256–257; Pros-Aide transfers 239, 242–244; removal of 246; silicone prosthetics 239–242
psoriasis 157
purchases records 40, *41*, *42*, 43
push calls 59

résumés, film and television 3–7; online portfolios 3, 7–9
road rash *223–224*
rosacea 157

sanitation 69–73, 100
scene headings 22
schedule revisions 46, 51
schedules 44, 58
scientific journals 31
screenplays 19–22
script breakdowns 22–26, 44
script days 23, 46
script revisions 44–45

Index 325

Script Supervisors 23, 83
scripts 19–26, 44–45
scruff 190–192
secondary colors 104, 107
secondary sources 27
self-care 82, 294–296
self-promotion 9–12
sensitive skin 153
set bags 72, 78–79
set chair, folding 79
set etiquette 79–86
setting powders 77
sexual harassment 81, 298, 299–301
shade 106
shade matching 173–174, *175*, 176, 178–179
shaving 165–166, 186–188, *189*
Sheppard, J. 31
shine 176–177
shoes 65
shooting calls 51
shooting days 45, 46
shooting orders 52
shooting scripts 44, 45
sides 59
silicone burns 227, 232, *233–235*
silicone prosthetics 239–242
simultaneous contrast 108–109
skeletal system (the bones) 134, 135, *136*, 137–138
skin 147–151
skin ages 162–164
skin coverage products 77
skin disorders 155–159
Skin Illustrator FX Palette 237, 275, *276–278*, 279
skin tones 159–162, 173–174, *175*, 176, 178–179

skin types 149, 150, 151–153; combination skin 155; dry skin 87, 154, 161; normal skin 154–155; oily skin 153–154, 176; sensitive skin 153
skincare 147, 149, 163, 166–167, 195–196
skincare products 76–77, 150, 153–155, 163–164
skull 135, 137
slang *see* film set terminology (slang)
slit throat 236
social media 7–9, 10, 29–30
soft light 119
special effects (FX) colors 118
special effects makeup 31, 217, 236, 237; black eye *220*; bloody knuckles *222*; bloody nose *218–219*; burns 227–231, 232, *233–235*; contact lenses 292–293; prosthetics 239; road rash *223–224*; slit throat 236; split lip *221*; trauma makeups 143–144
split lip *221*
sponsorships 9, 36
standard definition (SD) 125, 126
stretch-and-stipple aging makeup *249–251*, 255
striae distensae (stretch marks) 155
strip false lashes 212, *214*
stripboards 45–46, *47*
stubble 190–192
Stunt Coordinators 31, 35, 217
stunt doubles 22, 35, 46, 53, 194–195, 274
stunt performers 35, 46, 53
sun protection 166–167
sunscreen allergies 158–159
sweat 270–271
symmetry 199

tattoo artists 36, 77–78, 274–275
tattoo clearance 36, 77–78, 274–275

tattoo cover products 77–78, 275, *276–278*, 279

tattoo transfers 280, *281–282*

tattoos 35, 36, 77–78, 274–275, *276–278*, 279–280, *281–282*

tax incentives, state 43

Taylor, S. 160–161

tear sticks 291

tears 290–291

teeth 257, 267, 286–288

telephoto lenses (cameras) 125

tertiary colors 106

test shoots 29, 38–39, 129, 166

third artists 62–63

three-point lighting 115

timecards 95–96

timesheets 44

tint 106

tone 106–107

tooth paints 286

tooth veneers 287–288

top lighting 116

tradeshows 10

trailer etiquette 74

trash cans 72–73

trauma makeups *see* illnesses; injuries; special effects makeup; wounds

tungsten lights 114

turnaround times 51

undertones 107–108, 178–179

un-groomed beards 193–194

union contracts 15, 16–17

union projects 16–17

unions 15, 16–17, 51

up lighting 116

vitiligo 155

walkie-talkies 58–59

warm colors 107–108

weather protection 64–66, 166–167

websites 7–8

white scripts 44, 45

wide angle lenses (cameras) 125

winged liner *215*

wounds 144, 217, 236; black eye *220*; bloody knuckles *222*; bloody nose *218–219*; burns 227–231, 232, *233–235*; road rash *223–224*; slit throat 236; split lip *221*